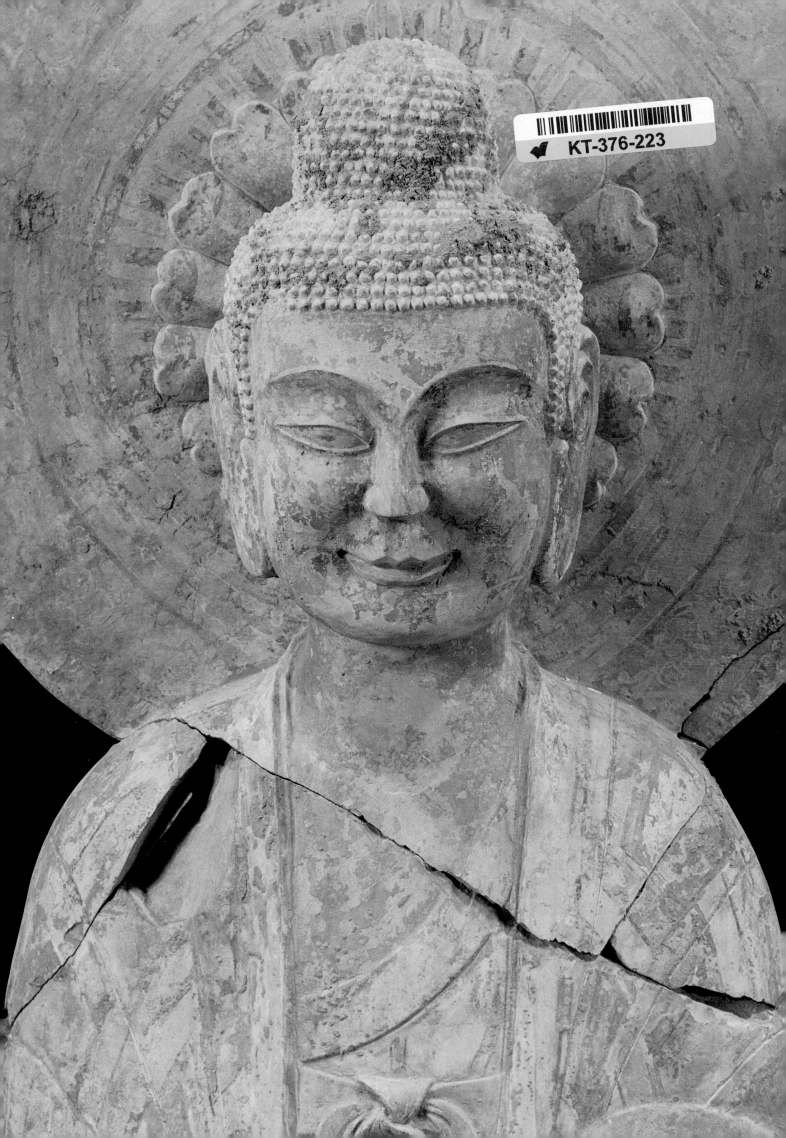

This edition first published
on the occasion of the exhibition
'Return of the Buddha:
The Qingzhou Discoveries'

Royal Academy of Arts, London
26 April – 14 July 2002

Supported by the
RA Exhibition Patrons Group

CATALOGUE EDITOR
Lukas Nickel,
Museum Rietberg Zürich

This English edition is
based upon the catalogue
Die Rückkehr des Buddha,
Zürich, 2001

Altes Museum,
Staatliche Museen zu Berlin
20 September – 18 November 2001

Museum Rietberg Zürich
13 January – 7 April 2002

EXHIBITION COMMITTEE IN CHINA
Wang Limei
Yang Yang
Yin Jia
Zhang Jianxin
Chen Shujie
Xie Zhixiu
Wang Huaqing

Photographs of exhibits:
Wang Shude, Zong Tongchang
English translation:
Andreas Leisinger

The Royal Academy of Arts
is grateful to Her Majesty's
Government for its help in agreeing
to indemnify the exhibition under
the National Heritage Act 1980,
and to the Museums and Galleries
Commission for their help
in arranging this indemnity.

EXHIBITIONS SECRETARY
Norman Rosenthal

EXHIBITION CURATOR
Cecilia Treves

EXHIBITION ORGANISATION
Emeline Max

PHOTOGRAPHIC AND
COPYRIGHT CO-ORDINATION
Andreja Brulc

CATALOGUE
Royal Academy Publications
David Breuer
Harry Burden
Carola Krueger
Fiona McHardy
Peter Sawbridge
Nick Tite

Copy-editor: Mike Foster
Additional photography:
Hagen Weimann
Design: Maggi Smith
Proofreader: Antony Wood
Colour origination:
Robert Marcuson Publishing
Services in association with
Field Print & Graphics Ltd

Printed in Florence, Italy,
by Conti Tipocolor Arti Grafiche

© The State Administration
of Cultural Heritage,
The People's Republic of China,
and Museum Rietberg Zürich
Texts © the authors
English translation © Museum
Rietberg Zürich
This edition © 2002 Royal Academy
of Arts, London

British Library Cataloguing-in-
Publication Data

A catalogue record for this
book is available from the
British Library

Distributed outside the
United States and Canada
by Thames & Hudson Ltd, London
ISBN 1-903973-05-8

Distributed in the
United States and Canada
by Harry N. Abrams, Inc., New York
ISBN 0-8109-6643-3

EDITOR'S NOTE
All works are loaned by Qingzhou
Municipal Museum. The Museum's
inventory numbers appear after the
dimensions of each sculpture.
Measurements are given in
centimetres, height before width
before depth.

ENTRY CONTRIBUTORS
AB Angelika Borchert
CW Claudia Wenzel
LN Lukas Nickel
NT Nicole Tsuda
PR Petra Rösch
SG Simone Griessmayer

ILLUSTRATIONS
Pages 2–3: detail of cat. 13.
Page 7: detail of cat. 31.
Pages 10–11: detail of cat. 21.
Page 15: detail of cat. 11.
Pages 18–19: detail of cat. 8.
Pages 60–61: detail of cat. 27c.

CONTENTS

PRESIDENT'S FOREWORD

The first public showing in Beijing of the Qingzhou discoveries caused a sensation. The sheer beauty of the figures, their variety and the quality of the carving, not to mention the survival of original gilding and colouring, provoked universal admiration. To compound the excitement felt over their excavation was the realisation that this treasury of Buddhist stone sculptures from the Longxing Temple at Qingzhou was to become one of the hundred most significant cultural monuments in China, whose counterparts include other great Buddhist monuments, such as the cave temples of Dunhuang, Yungang and Longmen.

Since workmen clearing land for a sports field unearthed them, the most sensational pieces have been exhibited in Beijing, Shanghai and Hong Kong, with select sculptures also travelling to Japan and the United States. Together with the Altes Museum, Berlin, and the Museum Rietberg Zürich, we have succeeded in bringing 35 of the finest to Europe. We wish to extend our sincere thanks to the National Administration for Cultural Heritage and Art Exhibitions, China, and to the Qingzhou City Museum for allowing the exhibition to come to London.

This is not the first time the Chinese Government has supported great exhibitions of Chinese art at the Royal Academy of Arts. 'The Genius of China', an exhibition of spectacular finds from ancient tombs, caused a sensation when it came to London in 1973–74. The masterpieces on display then, spanning the centuries between the Palaeolithic period and the Yuan dynasty (1271–1368), indicated the archaeological riches available to those who dig in Chinese soil.

In 1935–36 a collection of treasures from the Peking Palace Museum came to Europe for the first time and formed the nucleus of a legendary assemblage of Chinese art – principally pottery, porcelain, paintings, calligraphy, jade, bronzes, textiles and lacquer – at the Royal Academy. On that occasion, Buddhist sculpture played a relatively minor role. As Laurence Binyon wrote in the introduction to the catalogue: 'Sculpture in China has not the esteem it has in Europe.' Perhaps today the reverse is true.

An attempt to redress any imbalance has resulted in this magnificent presentation of sixth-century sculpture. We are particularly indebted to Giuseppe Eskenazi, who first saw these works in Beijing. He has played a vital role in enabling us to bring these works to London. His passionate commitment to a deeper understanding of Chinese art ensured that this project came to fruition. We thank him for his unstinting support and invaluable advice in the realisation of this magnificent exhibition.

We are also grateful to Albert Lutz, Director of the Museum Rietberg Zürich, and to Edmund Capon, Director of the Art Gallery of New South Wales in Sydney, who, together with Norman Rosenthal, the Academy's Exhibitions Secretary, selected the exhibition from the works shown in Hong Kong in 2001. In addition we thank Peter-Klaus Schuster, Director-General of the Staatliche Museen zu Berlin, and Willibald Veit, Director of the Museum of East Asian Art in Berlin.

Professor Jessica Rawson, Warden of Merton College, Oxford, and an eminent scholar of Chinese art, has written a foreword to this catalogue for which we are most grateful. We are particularly indebted to the scholars in both China and Europe who have contributed to the catalogue. We thank also the Ambassador of the People's Republic of China, HE Ma Zhengang, and his Cultural Counsellor Yan Shixun for their unfailing interest and help. But above all our thanks go to the Chinese State Administration of Cultural Heritage, its Director-General, Zhang Wenbin, the Director of its Foreign Affairs Office, Wang Limei, the Director of the Qingzhou Municipal Museum, Wang Huaqing, and to the people of Qingzhou, who have allowed this exhibition to take place.

Finally, the exhibition would not have been possible without the support of the Royal Academy's Exhibition Patrons Group, together with the generosity of Mrs Arthur M. Sackler and two anonymous benefactors.

These rare Buddhist sculptures express serenity and compassion in three-dimensional form. It is our hope that in this exhibition, an important aspect of this ancient culture, until now inaccessible, will fully reveal itself.

Professor Phillip King CBE
President, Royal Academy of Arts

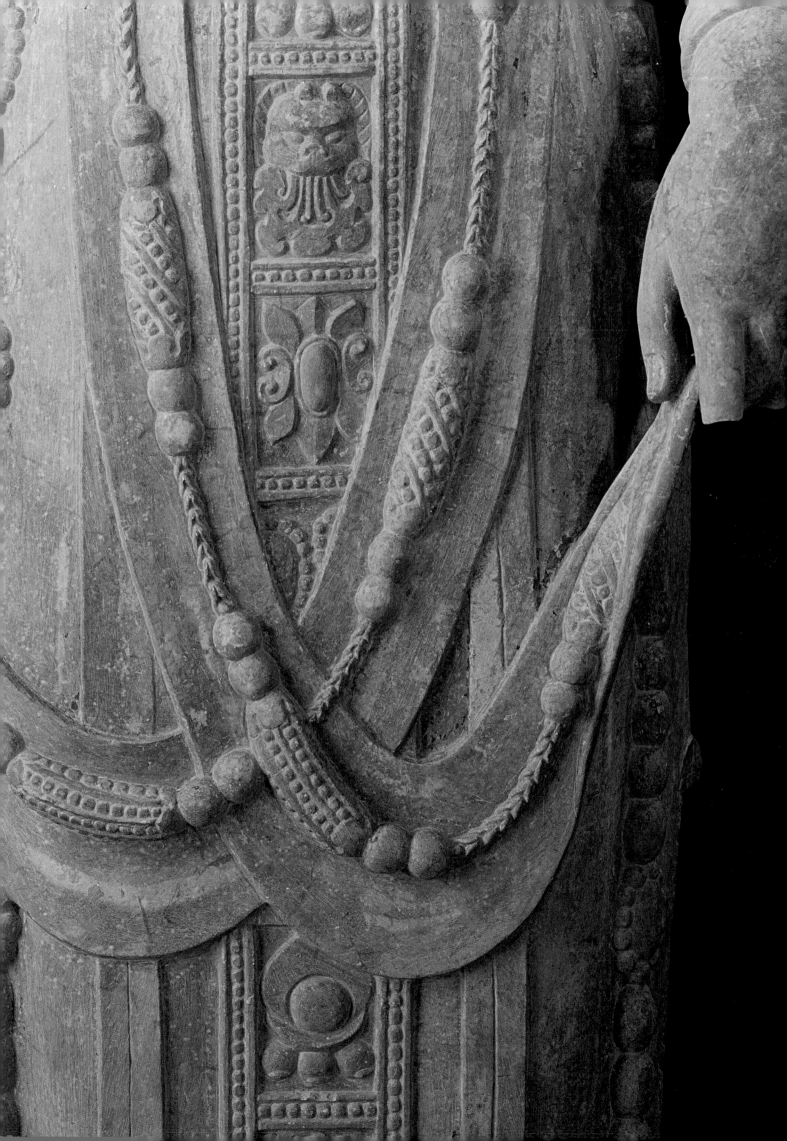

SPONSOR'S STATEMENT

This exhibition is supported by the RA Exhibition Patrons Group with additional generous donations from Mrs Arthur M. Sackler and two anonymous benefactors. The Royal Academy receives no public subsidy and is entirely reliant on self-generated income and charitable donations.

The RA Exhibition Patrons Group was set up in May 1997 to encourage the regular and committed support of individuals who believe in the Royal Academy's mission to promote the widest possible understanding and enjoyment of the visual arts. Patrons support the Academy's exhibition programme by making an annual tax-effective donation of £1,000 or more. They are encouraged to become directly involved in the artistic life of the Academy and gain a unique insight into the creative process through which each exhibition evolves.

The Royal Academy is extremely grateful to its Exhibition Patrons, Mrs Arthur M. Sackler and its anonymous benefactors for their generous support of this exhibition.

PREFACES

As representative of the State Administration of Cultural Heritage of the People's Republic of China, I would like to express my sincere congratulations and deep gratitude to the representatives of the three museums that are hosting the exhibition of Buddhist sculpture from Qingzhou: the Altes Museum in Berlin, the Museum Rietberg in Zürich and the Royal Academy of Arts in London.

In October 1996, more than 400 Buddhist stone sculptures were discovered in a pit on the grounds of the former Longxing Temple in Qingzhou, Shandong Province. In China, the discovery was hailed as a great archaeological sensation, but it also attracted the attention and the interest of scholars all over the world. The high artistic quality of the figures is evident in the flowing lines, the crisp carving of details, as well as in the graceful postures and the contemplative facial expressions of the images. On some of the sculptures, the original gilding and pigmentation have been preserved, making them extremely rare and of inestimable importance. The sculptures from Qingzhou show us the creativity and the skill of past generations of artists. They are of great historical and archaeological significance, and at the same time they enchant us aesthetically.

With this exhibition, the find of Qingzhou is to be shown for the first time in Europe. The thirty-five sculptures of this exhibition were selected with the greatest care to represent the full scope and variety of the discovery. I am convinced that the exhibition will attract great attention in Berlin, Zürich and in London, since these magnificent works of art will directly convey the magic of Chinese Buddhist art to the Western viewer too. It is my firm belief that the exhibition 'Return of the Buddha' will contribute to the mutual understanding and friendship between China on the one hand, and Germany, Switzerland and Great Britain on the other. I wish the exhibition much success.

Zhang Wenbin
Director-General, State Administration of Cultural Heritage
of the People's Republic of China

In October 1996, a large, subterranean deposit of Buddhist sculptures was found on a construction site south of the Qingzhou Municipal Museum in Shandong Province. In an emergency excavation, the staff of the Qingzhou Municipal Museum were able to salvage more than 400 figures ranging in date across seven dynasties: Northern Wei (386–534). Eastern Wei (534–550), Northern Qi (550–577), Northern Zhou (577–581), Sui (581–618), Tang (618–906) and Northern Song (960–1127). The oldest figure dated by an inscription was made in 529, the most recent dated figure bears the donation date of 1026. Many of the sculptures retain their original pigmentation and gilding to an astonishing degree. The shining lustre of the gold and the colourful pigmentation bring back to us much of the original beauty of these stone sculptures. Moreover, the carving is of the highest quality, and the variety of figure types is extremely large.

The sensational discovery has caused a stir domestically as well as abroad. In China, the find was among the ten most important archaeological discoveries of the year 1996. The images of the Longxing Temple of Qingzhou now belong to the one hundred most significant cultural monuments of the country, together with other great Buddhist monuments such as the cave temples of Dunhuang, Yungang and Longmen.

Since their discovery, the most spectacular pieces of the find have been shown in Beijing, Shanghai and Hong Kong. A small selection has also been exhibited in Japan and in the United States. Everywhere, the images from Qingzhou have been received with awe and admiration. Since art knows no frontiers, I am convinced that the unique magic of these Buddhist treasures from the East will cast its spell on people in Europe as well. Most certainly, this exhibition will further strengthen the cultural exchange between China and Europe.

Wang Huaqing
Director of the Qingzhou Municipal Museum

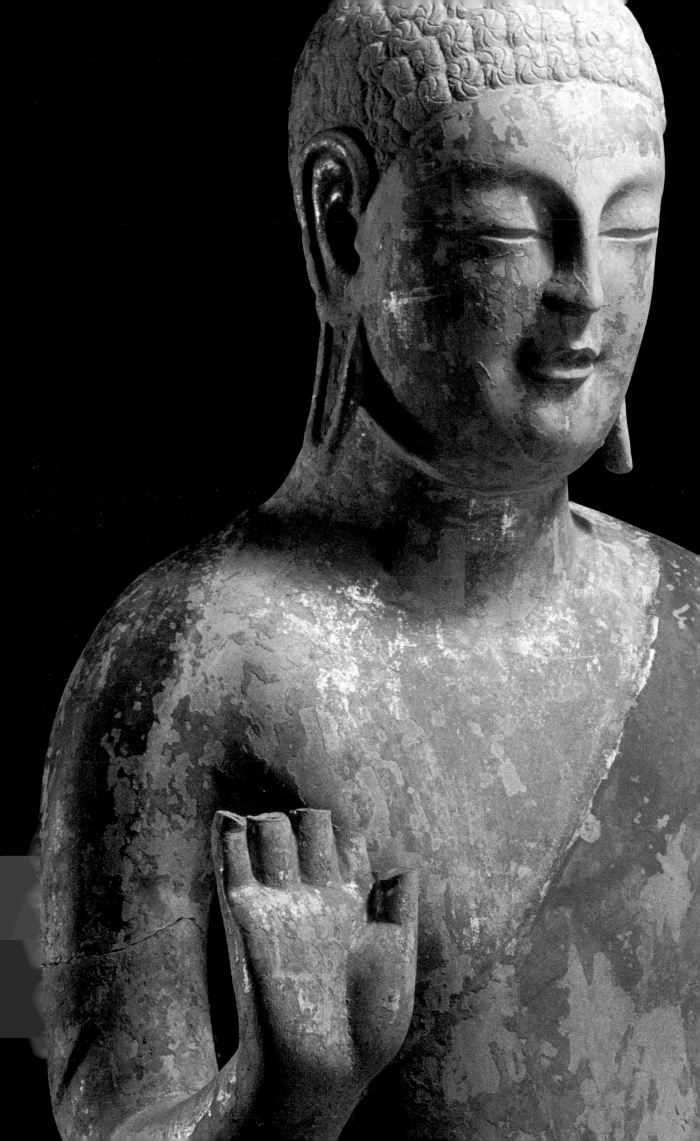

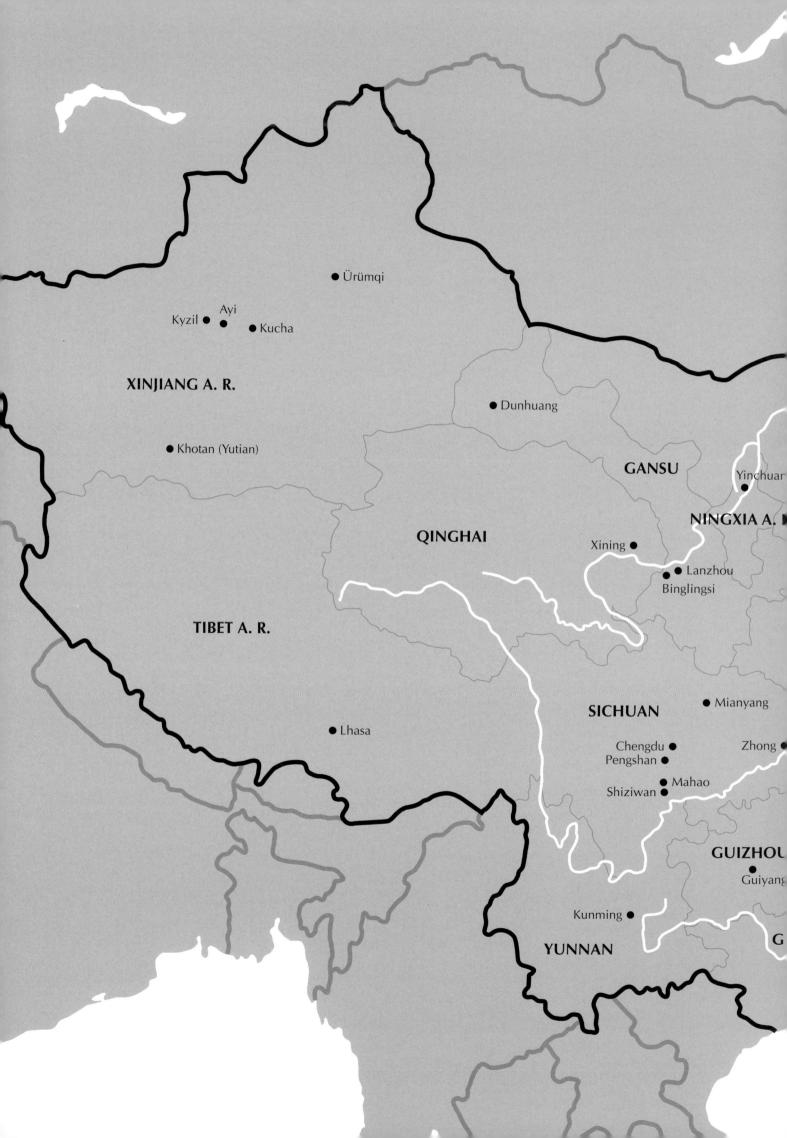

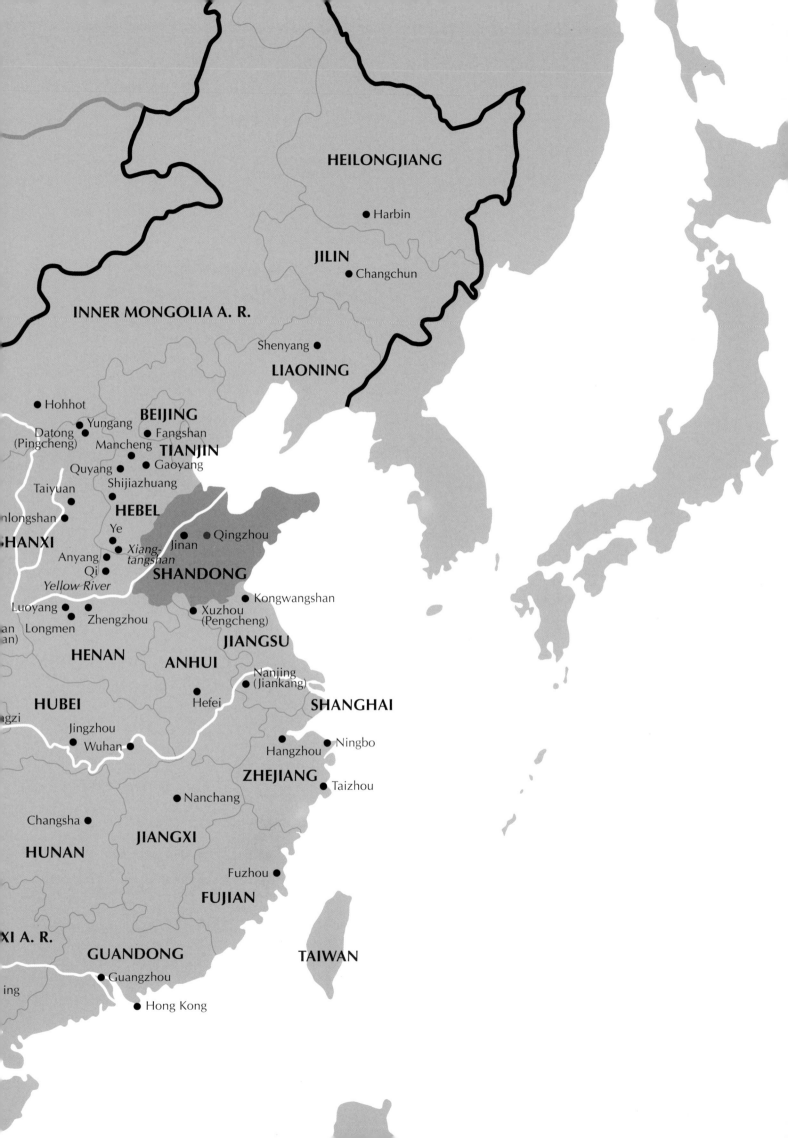

FOREWORD

In 1996 an extraordinary treasury of Buddhist stone sculptures was found in a pit in eastern China. The high quality of the sculptures, their large number and their deliberate burial raise many questions. These questions, mostly unanswered, make this one of the most intriguing discoveries of the last decade. Why should over 400 Buddhist figures, dating in the main to the sixth century, have been buried at some point in the twelfth century in a carefully constructed pit within the precincts of a temple situated in the eastern province of Shandong? We may never know the answer; but the sheer mastery of the sculptures, their high artistic quality, will continue to be provoking.

London is very fortunate that the Royal Academy has been able to bring a selection of the finest of these sculptures to Britain from the site at Qingzhou in north-eastern Shandong. Longxing Temple has long disappeared and the area is now home to a primary school. Little did the workers digging there in 1996 expect to fall upon a hoard of forgotten religious statues. Almost all the figures were broken, but we do not know how. They do not seem to have been wilfully smashed or disfigured. They appear to have been interred when already partly or completely broken. Long and careful restoration has had to be undertaken before the sculptures could be shown abroad.

Chinese Buddhist sculpture has rarely been exhibited outside China. Much more attention has been paid to Chinese bronzes, paintings and porcelain. In part, this reflects a natural concern with traditional Chinese arts. Buddhism, on the other hand, was introduced to China from the Indian subcontinent along the trade routes across Central Asia. Over several centuries, sculptural styles were developed that mixed foreign with Chinese qualities. These fascinating conjunctions are seen at their richest in the figures from Longxing Temple. Massive flame-like mandorlas embrace groups of figures, sometimes accompanied by characteristically Chinese dragons. Other sculptures have the grace and voluptuousness that we often associate with the Indian subcontinent and show the curves of the human body as if below a fine, almost transparent robe. The sculptures have other remarkable features, above all the extraordinary survival of painting on the stone, especially on the Buddha's garments. Gold also was used for the face, hands and feet of the figures. These glimpses of brilliant colour indicate that, when first made, all Buddhist sculpture in China was probably brightly painted and sometimes even gilded and bejewelled. These bright traces of a vanished past are only one of the remarkable revelations of the Longxing find.

This exhibition will fill a gap in our understanding of Chinese art and culture. A whole artistic tradition has long been invisible to western audiences. Buddhist sculptures are often large, difficult to transport and scattered at many different sites. Few of us can visit the distant mountain retreats favoured by Buddhist monks. We are most fortunate that the sculptures have now come to us.

Professor Jessica Rawson
Warden, Merton College, Oxford

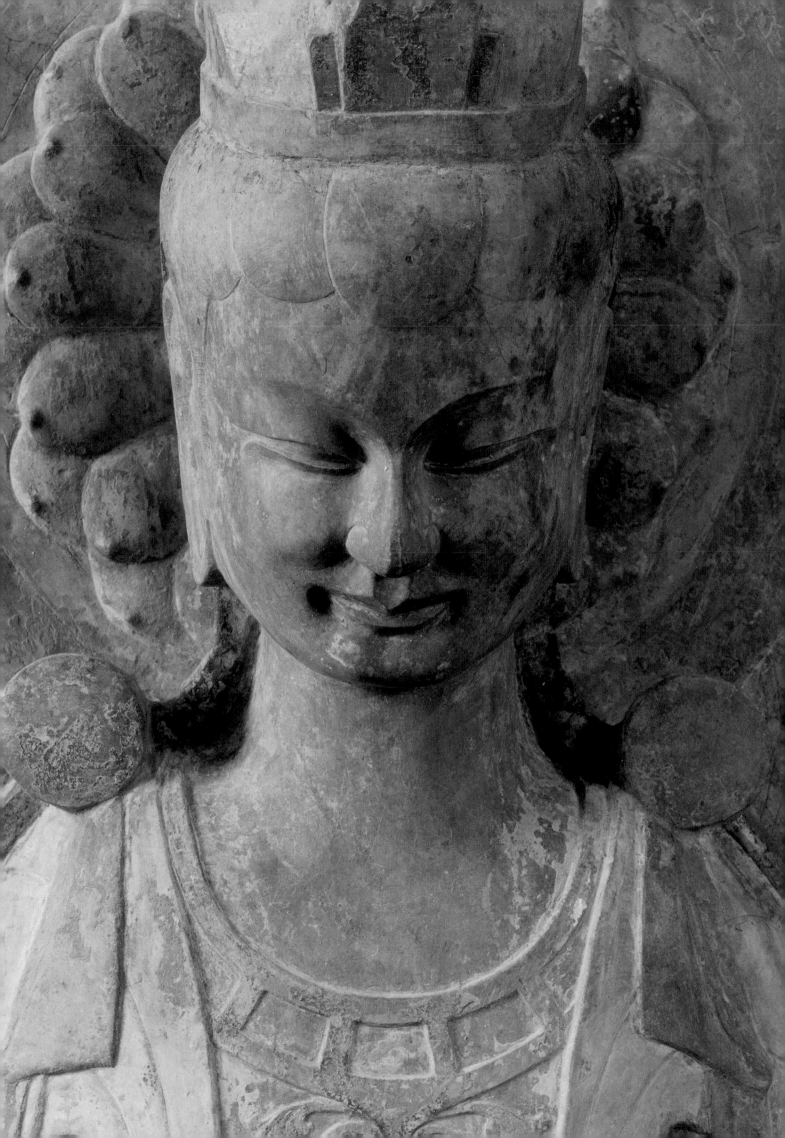

INTRODUCTION

ALBERT LUTZ

Ancient Buddhist sculpture in China was rediscovered during the first decades of the twentieth century by Europeans and Japanese who undertook research expeditions equipped with cameras and survey instruments. In their extensive reports these pioneers not only published the art of the great cave temples of Dunhuang, Yungang and Longmen; they also attempted to write the history of Chinese Buddhist sculpture, a topic previously of little interest to students of Chinese art and archaeology. Our knowledge has since been increased by many further discoveries and scholarly studies, although Chinese Buddhist sculpture still receives less attention than painting or archaeology. The list of new discoveries is long. Chinese scholars have returned to the great cave temples and found a large number of unknown caves. Moreover, intensive documentary study has deepened our understanding of the social dimension of Buddhist art. As Helmut Brinker reveals in his essay in the present volume, we now also know considerably more about the beginnings of Buddhist art in China. And a new facet of Buddhist creativity has been brought to light by numerous finds of cult objects in reliquary chambers beneath pagodas, including the hoard of Famen Temple at Fufeng, west of Xi'an.

The sixth-century sculptures presented here come from a hoard found in 1996 at Qingzhou in Shandong Province. Hundreds of fragments of Buddhist stone sculptures were lying in a pit two metres deep and sixty square metres in area. All had been broken at the time of their interment in the twelfth century. Buried Buddhist sculptures had been discovered before, notably in 1953 in the Temple of the Ten Thousand Buddhas (Wanfosi) in western Chengdu, Sichuan Province. As Su Bai shows in his essay, the sculptures in the Wanfosi hoard are an important stylistic point of reference for the Qingzhou works, which constitute the most significant find since that of 1953.

All experts who saw the Qingzhou figures at their first public presentation in Beijing in 1999 were astonished by their vivid colour and their artistic power. The excellent preservation of some of the painting and gilding serves as a forcible reminder that, like the sculptures of Greek antiquity and medieval cathedrals, all temple figures in China were polychrome. Scholars were also surprised to learn that large amounts of sixth-century sculpture had been found not only in Qingzhou itself, but also in its environs, indicating that Shandong must have been a major centre of Buddhist stone sculpture. In his essay Zhang Zong relates that, although most of these sculptures were unearthed during official excavations, some

were discovered on clandestine digs and have found their way on to the international art market.

The Qingzhou statues were discovered on a site once occupied by Longxing Temple. As Lukas Nickel reports in his essay, the extent and quality of the find suggest that this sparsely documented temple must have been an important institution, a supposition supported by the fact that the eminent Japanese monk Ennin (794–864) visited it in 840. Yet the size of the find should not seduce us into believing that our knowledge of Buddhist art in Shandong from the fifth to the seventh century is anywhere near complete. Not until an inventory has been drawn up of all the relevant sculptures, including those familiar before the recent discovery and those in the cave temples, will it be possible to establish their chronology and stylistic development. Furthermore, Longxing Temple has not been adequately researched. Preliminary excavations have been carried out on the site, now partly built on again, but they have not yielded information on the exact location and dimensions of the temple. Neither has the pigmentation of the sculptures been examined scientifically.

When and why the figures were destroyed is likewise unknown. Several records of natural disasters, wars and persecutions of Buddhists in the region of Qingzhou between the sixth and the twelfth century exist, yet none mentions the destruction of Longxing Temple. On the other hand, Zhang Zong draws attention to an inscription that may explain why damaged and old-fashioned sculptures were buried. The inscription, located a few dozen kilometres from Qingzhou, in the former Mingdao Temple, states that in 1004 two travelling monks interred 300 broken sculptures that they found in the temple, which had evidently been abandoned or neglected. To commemorate their pious deed, they had a pagoda erected on the burial site. Old cult images, perhaps damaged or outmoded, may also have been collected and interred at Longxing Temple, where restoration work is known to have been undertaken in 1037. The sculptures themselves offer no precise clues to the cause of their destruction. A number of figures show signs of violence, smashed to pieces or bearing traces of fire. Others are hardly damaged. Most faces are intact and many of the statues were evidently repaired carefully long before burial, only to be broken again and placed as fragments in the earth. All we can be sure of is that the sculptures were buried in the early twelfth century with a certain amount of ceremony and have survived more or less in the condition in which they were interred.

The Qingzhou sculptures were created over a fifty-year period. The stele of 529 (cat. 1) is the oldest piece; the most recent items were probably carved before 577, the end of the Northern Qi dynasty. The sculptures can be divided into two stylistic groups. The first consists of works dating to the late Northern Wei dynasty (386–534) and the Eastern Wei dynasty (534–550), the second of items made during the Northern Qi dynasty (550–577). The change in style accompanied the change in dynasties in 550 and, as Su Bai explains in his essay, was partly political in motivation. The Northern Wei, originally a nomadic people who had conquered China in 386, adapted quickly to their new environment, eagerly adopting Chinese customs and mores. They soon prohibited the equestrian attire typical of nomads and, following the example of their emperor, they took Chinese family names. This sinicisation had repercussions for Buddhist art. By the end of the fifth century, for instance, Buddha figures were shown wearing traditional Chinese, rather than Indian, robes (e.g. cat. 2).

The Northern Qi, another non-native dynasty, set about reintroducing non-Chinese values. The Qi aristocracy, headed by a military class of nomadic origin, was not only hostile to Chinese influence; it also had a predilection for the foreign and exotic, especially in art. Hence, a style influenced by the Gupta art of India acquired pre-eminence soon after the Northern Qi dynasty came to power. Northern Qi figures of the Buddha are clad in thin, clinging robes, like those in Gupta-period pieces from Mathurā and Sārnāth. Thus, an emphasis on the body replaced the decorative drapery characteristic of Buddha figures during the Wei dynasties. The Qingzhou torso (cat. 25) is a fine example of this development, the body depicted naturalistically with a hint of movement – a most unusual feature in Chinese Buddhist art of the sixth century. Emphasis on the body went hand in hand with increased three-dimensionality. Wei dynasty Buddhas and bodhisattvas form a relief with their body nimbuses, whereas Northern Qi sculptures stand free of their backgrounds. This does not mean that they were true free-standing statues intended to be viewed from all sides. On the contrary, individual figures were bound into the temple architecture by their pedestals and nimbuses and arranged hierarchically in accordance with cult requirements. Hence these statues, too, formed part of sculptural ensembles designed to be viewed from the front.

We hope that this first presentation of the Qingzhou sculptures in Europe will stimulate research into the Buddhist art of Shandong. Detailed inventories and art historical analyses of all known material would undoubtedly reveal the immense significance of the region for Chinese Buddhist art as a whole. Increased knowledge would also help to save future finds from illegal excavation and theft.

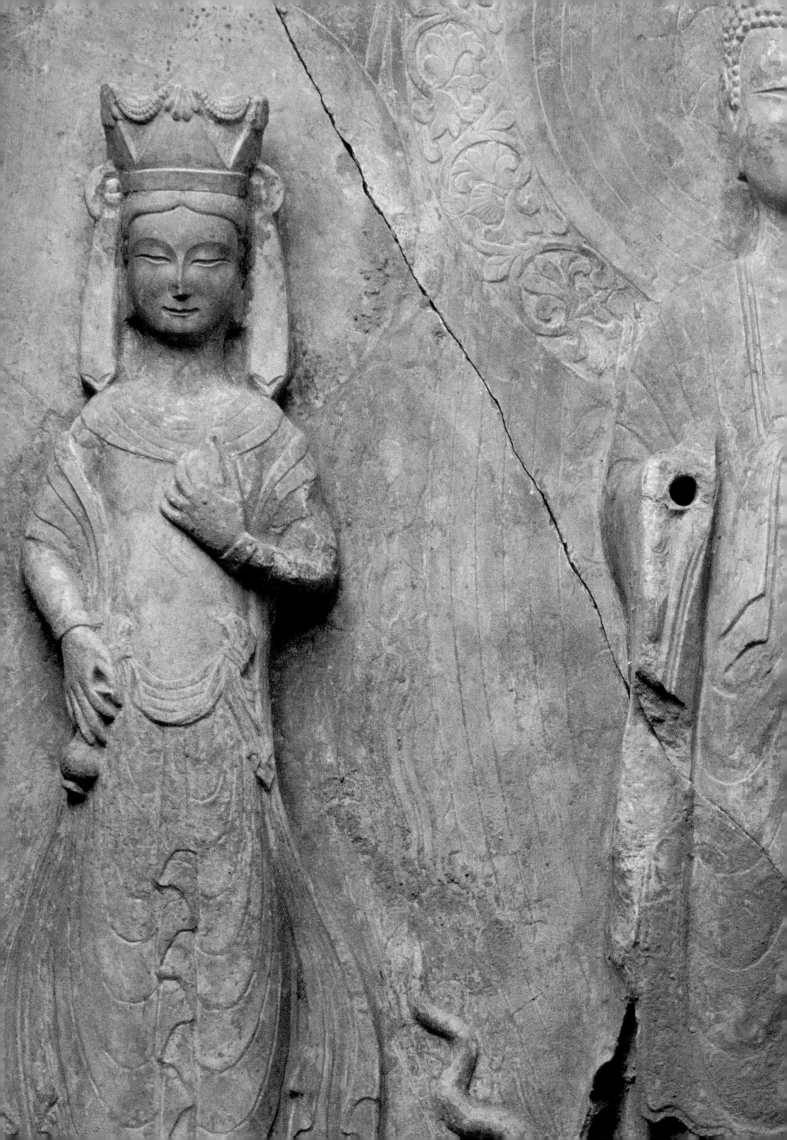

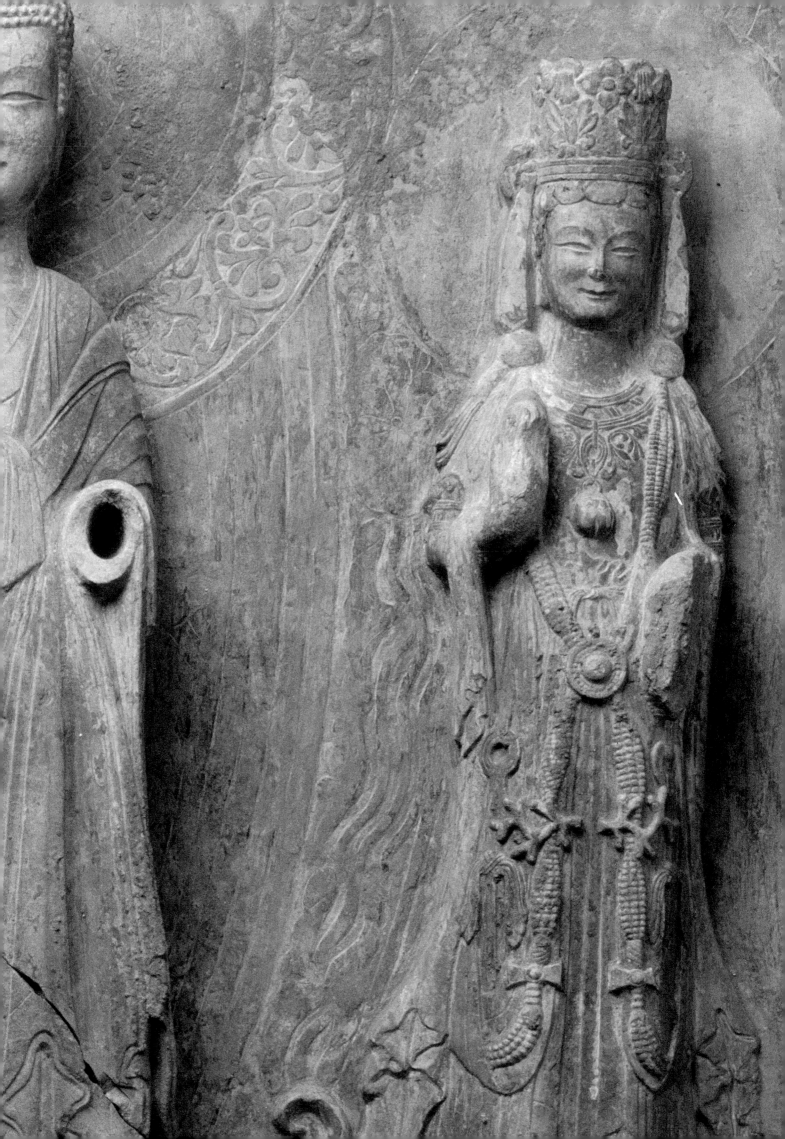

EARLY BUDDHIST ART IN CHINA

HELMUT BRINKER

When Buddhism reached China from India it encountered two philosophies, Confucianism and Daoism. For the first time, the Chinese were confronted with a foreign system of thought, with a dynamic religion promising eternal bliss and salvation that was so immediate in its appeal that it soon began to have an impact on people from all strata of society. The creative power of a people or an individual, a period or a region, manifests itself in the reinterpretations that emerge from a dialogue between new and established ideas and in the way these reinterpretations are incorporated into existing thought structures and imagery. Archaeological discoveries and traces of Buddhist influence in literature and the visual arts indicate that Buddhism was known in China during the Han dynasty in the second century BC, but it did not begin to gain a footing there until the first century AD.[1] The new religion, notable for its extensive use of images, finally flourished in China during the Tang dynasty (618–907).

The Theological Foundations of the Cult of Images

In discussing the origins of Buddhism and its early visible remains in China, we shall need to enquire into the origins and meaning of Buddhist figures and objects and into their textual basis. In other words, we shall have to establish an iconology of Buddhist art, discovering the religious, theological and artistic determinants of the works.

Buddhism was initially an aniconic religion, using symbols rather than fully fledged images to evoke the figures and beings central to its beliefs. The Buddha, for example, was represented by his footprints, by his wheel symbol or by the superstructure of his reliquary chamber – the stūpa, or pagoda.[2] On leaving this world and entering Nirvāna, Shākyamuni, the historical Buddha (c. 563–483 BC), transcended humanity and its imprisonment in the empirical perception of worldly phenomena. His essence was thought to be invisible and thus not capable of representation. Any attempt to depict the Buddha as a figure would therefore falsify his absolute nature.

'The highest truth is without image. Yet if there were no image there would be no possibility for the truth to manifest itself. The highest principle is without words. Yet if there were no words how could the principle be known?' This almost apologetic inscription appears on a sandstone Chinese Buddha figure dated 746 in the Museum für Ostasiatische Kunst, Berlin (fig. 1). The sculpture depicts the Buddha Amitābha, who rules the 'Pure Land' in the west. With legs crossed in the 'lotus position' (Skt. padmāsana) or 'diamond position' (Skt. vajrāsana), he is seated on a lotus throne resting on a rectangular pedestal. The partly damaged inscription names the donors and states that they made sacrifices, prayed and had the image carved in the hope of salvation, providing it with robes appropriate to a wondrous depiction of the highest truth.

Images of the Buddha had begun to appear in the late first century and early second century AD, the result of profound changes in religious practice and consciousness. Such images were intended to help believers longing to 'see the Buddha' (Chin. jian Fo) to reach their goal of salvation. An image cult took root in China in the fourth century, flourishing within the elaborate ritual structure of the fully developed Mahāyāna, the Buddhist doctrine of the Great Vehicle. Buddhist images served as visible manifestations of the beings described in the sacred scriptures. Veneration focused on the images: they were thought to be vessels in which deities were present either permanently or for the duration of a ritual dedicated to them, after consecration had imbued them with the force of life.

Prior to the establishment of such views, Buddhist theologians had promulgated the doctrine of the secret and holy non-duality (Skt. advaita, Chin. bu'er) of all existing things whatever their formal differences. They stressed the unity of exterior form and inner essence (Chin. li), i.e. the fundamental nature of things as illuminated by the wisdom of the transcendent (Chin. zhi). Lizhi bu'er was the watchword here – the 'non-duality of inner essence and transcendental wisdom'. The condition, degree and form of a deity's spiritual presence in an image made by human hands were the subject of endless debate. Yet the earliest canonical texts do not discuss the making and cultic use of images. Nowhere do they mention the transcendent existence or the manifestation of the Buddha in 'two bodies' (Chin. ershen) or 'three bodies' (Chin. sanshen) and nowhere do they refer to trikāya or trayah kāyāh – the later Mahāyāna doctrine that the Buddha exists simultaneously in three bodies.

The first of these bodies is the dharmakāya (Chin. fashen), the 'true body of the Dharma' or the 'body of essence', which denotes the Buddha's status as an absolute. He transcends all diversity of form and colour found in the world of phenomena. He cannot be represented in images or described in words and cannot be 'seen' by the unenlightened human mind: he is invisible. The second body is called the sambhogakāya (Chin. baoshen), the 'body of retribution', which the Buddha attained during his mutation from bodhisattva to

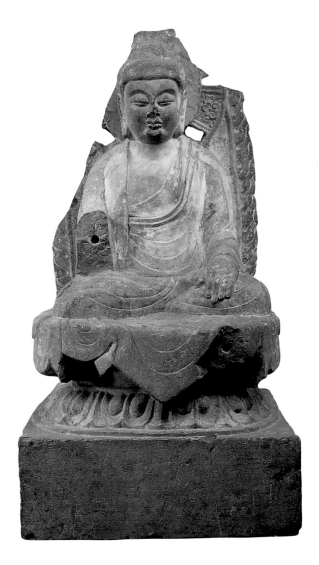

Fig. 1 Seated Buddha Amitābha, dated 746. Sandstone,
height 94 cm. Museum für Ostasiatische Kunst, Berlin

Practice of the Way of Perfect Wisdom Scripture (Chin. *Daoxing banruo jing*), reportedly completed by Lokakshema in 179, states that the spirit of the Buddha is *not* present in his image.[3] In this sermon the bodhisattva Dharmodgata discusses with a disciple, the bodhisattva Sadāprarudita, the nature and essence of the Buddha's body and the making of images:

> The Buddha's body is like the images which men make after the Nirvāna of the Buddha. When they see these images, there is not one of them who does not bow down and make offering. These images are upright and handsome; they perfectly resemble the Buddha and when men see them they all rejoice and take flowers and incense to revere them. O Noble One, would you say that the Buddha's spirit is in the image?
> *Bodhisattva Sadaprarudita replied:* It is *not* there. The image of the Buddha is made [only] because one desires to have men acquire merit.
> *Dharmodgata said:* You do not use one thing to make the image of the Buddha nor do you use two. There is gold and also a skilled artisan. If there is a man who has seen the Buddha in person, then after Nirvāna he will remember the Buddha and for this reason make an image, because he wants men in this world to revere the Buddha and receive the merit of the Buddha.
> *Bodhisattva Sadāprarudita said:* It is because of the Nirvāna of the Buddha that one makes images?
> *Dharmodgata replied:* It is just as you say, the constitution of the perfect Buddha's body is thus, you do not use one thing nor even two, but rather tens of thousands of things, including the practice of the bodhisattva and his original seeking for the Buddha [or Buddhahood]. If men constantly see the Buddha performing meritorious deeds, then they too will constitute a perfect Buddha body, and be endowed with wisdom, the [power of bodily] transformations, flying and in sum all the auspicious marks of a Buddha. The constitution of a perfect Buddha body is like this.[4]

This brief exchange makes it clear that early Buddhism addressed the nature and essence of the Buddha in relatively simple terms. Discussion of the concept of an image imbued with life, of the vital issues surrounding the presence of the deity in a work of art, the relationship between the real and the ideal, between form and spirit, had not reached the level of abstraction they were to attain a few centuries later. Huiyuan (334–416), a prominent figure in early Chinese Buddhism, wrote the following poem in praise of a Buddha statue purportedly completed in 375:

> Now form and principle are distinct, yet they pass one into the other as do steps into a highroad. The fine and the coarse are truly different, yet to the enlightened they also are interrelated. So it is that to represent a supernatural model prepares the heart for its final crossing [into salvation]. An iconographically-correct form divinely imitated opens the way to an understanding of all wisdom. It enables those who cherish the profound to discern the invisible root in the disclosure of a leaf, and those wrapped

Buddha by virtue of his vows, religious exercises and pious deeds. On this level, enlightened beings or meditators can see the Buddha in transfigured form. The third body is *nirmānakāya* (Chin. *yingshen*), the 'shadow body' or 'body of transformation', in which the Buddha incarnates himself for the good of all unenlightened beings. The Buddha either fashions this body in a suitable shape or releases it from within himself as one of the many forms inside Shākyamuni. The 'body of retribution' and the 'body of transformation' are also called *rūpakāya* (Chin. *seshen*), 'body of form' or 'body of colour'. According to fully developed Mahāyāna doctrine and the later *prajnāpāramitā* literature, images for veneration can be made only of these two bodies.

Sacred Scriptures and the Cult of Images
It is safe to assume that images of the Buddha were made long before the abstract concept of three bodies identical in their essential nature became established. The oldest extant translation of the

up in the near to construct for themselves a rewarding destiny for many aeons to come. Though the achievement was human, it is like Heaven's own art.[5]

Instructions for the Making and Consecration of Buddhist Images
Questions concerning the material transformation of a cult image through the spiritual presence of a deity still occupy Buddhists and scholars of Buddhism. From the outset, such issues were far too important for the making of images capable of granting salvation to be entrusted to the discretion and imagination of artisans. The craftsmen needed to be given a precise theological framework and iconographical guidelines if they were to create works of a metaphysical, magical potency.

This guidance was provided by sacred scriptures and by extensive compendia containing exact descriptions of sacred Buddhist figures and instructions for their depiction, with the deities themselves giving the instructions in some canonical texts. The need for information spawned a great number of textbooks for everything pertaining to the Buddhist cult and its rites. Making a sacred image was not primarily an artistic act, an interpretation of religious phenomena in visual terms; it was the realisation of a sacred commission. Buddhist rituals do not focus exclusively on the veneration of an image or of the being manifested in it, but rather on experiencing the mystic presence of a deity. The image serves as no more than a mental aid, as a visual bridge between the deity and the believer. 'In order to facilitate the "imaging" of the deity, to help it become an image . . . with full iconographical significance, texts concerning ritual nearly always provide an exact description (Skt. *sādhana*) of the figure and all its attributes. The extant collections of such texts thus often read like handbooks of iconography and can be used as such.'[6] Writings containing precise iconographical prescriptions and possibly sketches of members of the Buddhist pantheon arranged in hierarchical groups must have been available in China at an early date. At the same time, oral transmission in the sculptors' workshops and among the Buddhist missionary clergy will also have played an important part in disseminating such knowledge.

Some figures, especially the bodhisattvas, wear a large amount of jewellery. While the graceful appearance of the statues embodies transcendent mercy, the jewellery derives from vivid descriptions in spiritual texts and from the idea that such sumptuousness would endow the sculptures with unearthly, paradisal glory. In Chinese this embellishment of Buddhist images with crowns and precious stones, gold and silver, jewelled necklaces, earrings, armbands, lotus pedestals, flower garlands and so forth is called *zhuangyan* (Skt. *alamkāra*), a term that unites aesthetic and religious concerns by indicating that the display of splendour and mysterious beauty contribute to the sacred dignity of an image: in 'the meaning "sanctification by splendour",' the two characters *zhuangyan* 'became the embodiment of the most exalted numinous beauty.'[7]

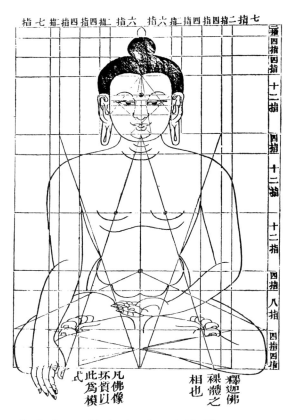

Fig. 2 Iconometric drawing of a seated Buddha.
From: *Zaoxiang* 2000

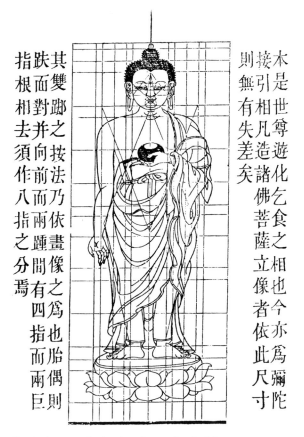

Fig. 3 Iconometric drawing of a standing Buddha.
From: *Zaoxiang* 2000

The classic Tibetan treatise *Pratimā māna lakshana*, based on a long oral tradition, did not appear in Chinese until 1742, when the Manchu prince Gongbu Chabu translated it as *Treatise on Measurement in the Making of Buddhist Sculptures* (Chin. *Zaoxiang liangdu jing*; fig. 2, 3).[8] Chinese documents have little to say about Buddhist iconometry, the 'science of measuring cult images' (Skt. *pratimā māna*), but from Indian sources we know that an elaborate canon of proportions prescribed different sets of measurements according to the level of existence of each member of the Buddhist pantheon. Chinese oral tradition speaks of *shi jiedu*, the 'ten outstanding length measurements'. The smallest unit is the breadth of a finger, *angula* (Chin. *zhiliang*). Larger modules are the width of a hand, *tāla* (Chin. *shouliang*); the span of a hand, which corresponds to the height of a face from the chin to the hairline; and the length of the arm from the elbow to the tip of the thumb (Chin. *zhouliang*). The height of a standing or seated Buddha or bodhisattva, a deity or a Buddha disciple, a patriarch or an ordinary human being, and the size and proportions of the various parts of the figure's body, were determined by various combinations of these units. This system of measurement does not use observation of the human body as a basis for establishing a unified, ideal canon of proportions. Rather, it consists of a set of normative symbolic modules with abstract origins in spiritual insights and metaphysical premises. A specific iconometric status denoted a particular type and category of figure, a particular level of existence or manifestation. Hence, Buddhas appear simply clothed, idealised, seated or standing in majestic serenity. Bodhisattvas are usually smaller, richly adorned, their pose indicating a slight movement. Buddha disciples, belonging to this world, are rendered more realistically and smaller than bodhisattvas, while donor figures, still caught up in the life cycle on earth, are smaller still. As in Western art, a hierarchy of size indicates relative importance.

Hierarchical status is also expressed in purely sculptural terms, by the degree of three-dimensionality accorded a figure (see cat. 5). In Buddhist votive steles, and in groups of images in cave temples, the central Buddha is usually carved almost as a free-standing figure, with the accompanying bodhisattvas in fairly high relief. Less important assisting figures and donors are represented in low relief or by engraved lines. A number of requirements had to be met to ensure the validity and efficacy of the images: volume and proportions, pose and movement, facial expression, attire and adornment, body marks, attributes and symbols all had to be correct if raw material devoid of form and life was to be transformed into a true, living cult image. As Huiyuan states in the poem quoted above: 'An iconographically correct form divinely imitated opens the way to an understanding of all wisdom'.[9] The biography of Huiyuan's teacher Dao'an (312–385), a famous translator of Buddhist texts into Chinese, touches on a similar question when mentioning that Dao'an once received a seven-foot-high gilt Buddha statue from abroad:

Whenever there was a lecture or assembly, the holy images would be set out. Banners and canopies would be hung up;

festoons of beads would swing; everywhere would be incense smoke and flowers; so that those who mounted the steps and crossed the threshold were awestruck and paid the utmost in devotion. The foreign bronze image was so archaic in form and workmanship that most people had no great respect for it. [Dao-]An said: 'The shape and the body-marks are excellent; the only fault is that the form of the *ushnīsha* [the protrusion on the crown of the head] is incongruous.' So he ordered a disciple to fire and remould the *ushnīsha*. At once a light flamed up with such brilliance that it filled the whole hall. On close inspection it was discovered that inside the *ushnīsha* there was a relic. The brothers were filled with consternation; but [Dao-]An said: 'The statue is already a wonder-working one, and will not be disturbed by recasting.'[10]

Buddhist writings often state that the material substance and the artistic form of an image are worthless, that it is only an inanimate object or a 'shadow image' (Chin. *yingxiang*), until it has been consecrated. Only when metamorphosed by consecration does the cult image cease to be a piece of wood, stone, clay or lacquer, an iconographically-correct 'form image' (Chin. *xingxiang*) depicting the external appearance of the deity, and become a sacred icon. This transformation may be achieved by ritual means or by incorporating relics or other holy treasures in the image. One of the most important ways of bringing a statue to sacred life is the ceremony of 'eye opening' (Chin. *kaiyan*), during which the pupils are painted on the eyes of the statue. The second Tang emperor, Taizong (r. 626–649), took part in a ceremony of this kind when the central Buddha statue at Hongfusi, the former Xingfu Temple, in Chang'an was consecrated. The emperor had dedicated this temple to the memory of his mother.[11] Documents give no further details of that particular 'eye opening', but records of the consecration of the Great Buddha at Tōdaiji in Nara in 752 reveal that such ceremonies were conducted with great pomp and widespread public participation. Consecration elevates a cult image to another level of existence: it becomes the 'main [object of] veneration' (Chin. *benzun*), a term that can be traced at least as far back as the Northern Wei dynasty (386–534).[12] Often the image is placed in a hall in the temple precinct that has been dedicated to it and frequently named after it. The faithful can now address their prayers to the image in the context of appropriate rituals.

The Introduction of Buddhist Images to China

Tradition has it that the first image of the Buddha was brought to China soon after the mid-first century AD. Emperor Ming of the Eastern Han dynasty (r. 57–75) had a dream in which he saw a 'divine figure' (Chin. *shenren*). Its body shone like gold and behind its head was a nimbus similar to the shining sun. On asking his advisers about this strange apparition, the emperor learned that in the West there was a deity known as the Buddha (Chin. *Fo*) who resembled the figure of his dream. In the opinion of his advisers, the emperor may have seen the Buddha. Emissaries were sent to India. They had sacred scriptures copied and a Buddha statue made, which

written accounts state was a standing image (Chin. *lixiang*) of Shākyamuni. This was put on display when the mission returned to China. The emperor ordered artists to produce copies of it and install them on the Terrace of Cooling Freshness (Qingliangtai) in the southern courtyard of the palace and in other prominent places in the capital, Luoyang. These Buddhist images were worshipped devoutly by the emperor, princes and other members of the aristocracy.[13]

The first known record of this story occurs in an early preface to the *Scripture in Forty-two Sections* (*Sishi'er zhang jing*), which dates from the Eastern Han dynasty (25–220) or slightly later.[14] Over time it was embellished in various ways and, in common with other legends of this type, acquired the status of established fact, often being cited as such by Chinese Buddhists. By the fifth century the image brought to China by the Mingdi mission was already being celebrated as the original 'true portrait' (or at least as an equally valuable, exact replica) of the historical Buddha, Shākyamuni, which had allegedly been commissioned by the young Indian king Udayana. Apocryphal though the story may be, it reveals how important Buddhist cult images were in transmitting religious ideas and concepts and indicates that such images probably travelled from India to China. The legend also shows how the Chinese respected the religion of a foreign people, its culture and its art.

Two Indian missionaries, Dharmaratna (Chin. Zhu Falan) and Kāshyapa Mātanga (Chin. She Moteng), supposedly accompanied the Chinese delegation on its return to Luoyang in the year 67. On the back of a white horse, they are said to have brought with them copies of the *Scripture in Forty-two Sections*, the first Buddhist text they had caused to be translated into Chinese. Legend has it that the emperor erected the Monastery of the White Horse (Baimasi) in Luoyang, the first Buddhist monastery on Chinese soil, in honour of the two monks. The origin and date of the *Scripture in Forty-two Sections* remain obscure, but in China the two missionaries from the West have been credited with its translation since the Middle Ages.

The first Buddhist communities in China were probably established in the commercial quarters of large cities, where foreign merchants lived. The poet and natural scientist Zhang Heng (78–139), a close observer of his surroundings, noticed foreign Buddhist monks (*sangmen*) in Chang'an at the beginning of the second century. Evidently recognisable by their physiognomy and tonsure, they enjoyed a reputation as steadfast, morally incorruptible ascetics immune to worldly temptations.[15] The indigenous population was initially reluctant to embrace the new religion, but from the fourth century on Buddhism and its culture left a deep mark on Chinese religious life. In 547 the military leader and chronicler Yang Xuanzhi stated in the preface to his *Record of Buddhist Monasteries in Luoyang* (*Luoyang qielanji*):

> There was an increase in the number of Buddhist converts and those who lectured on Dharma. Princes, dukes and ranking officials donated such valuable things as elephants and horses as generously as if they were slipping shoes from their feet. The people and wealthy families parted with their treasures as easily

as with forgotten rubbish. As a result, Buddhist temples were built side by side, and stūpas rose up in row after row. People competed among themselves in making or copying the Buddha's portraits. Golden stūpas matched the imperial observatory in height, and Buddhist lecture halls were as magnificent as the O-pang [the ostentatious Efang palaces of the Qin (221–207 BC)]. Indeed, [Buddhist activity was so intense] that it was not merely a matter of clothing wooden [figures] in silk or painting earthen [idols] in rich colours.[16]

Yang Xuanzhi reports that at the beginning of the fourth century there were 42 Buddhist monasteries in Luoyang and that the number was increasing rapidly. It has been estimated that by the end of the Wei dynasty in the mid-sixth century there were no fewer than 1,367 Buddhist temples in and around Luoyang. Early sources indicate that by the first half of the eighth century the Tang capital, Chang'an, contained 64 Buddhist monasteries and 27 nunneries. At this time only ten monasteries and six nunneries existed for the city's Daoists; two 'Persian' temples were used by Manichaeans and Nestorians; and four temples were dedicated to the cult of the Iranian god Ahura Mazda.[17]

The 'true portrait' of the Buddha, mentioned above, is first recorded in the *Scripture on the Production of Buddha Images* (*Zuo fo xingxiang jing*), one of the oldest Buddhist texts in China.[18] It was translated into Chinese in the first half of the third century; nothing is known of its origins or translators, but it was extremely popular during the Tang dynasty. This short text discusses in detail the miraculous rewards believers may expect in another life if they commission or make holy images in honour of the Buddha.

The Buddha in a Daoist Context

A century after the first Buddhist scripture and image had reached China a lavish ceremony in honour of Shākyamuni, Huangdi (the mythical Yellow Emperor from the remote beginnings of Chinese civilisation) and Laozi (traditional dates 604–531 BC) took place in Luoyang at the Palace of the Shining Dragon (Zhuolonggong), which belonged to the Han emperor Huan (r. 146–167). The astrologer, cosmologist and scholar Xiang Kai from Xiyin in the south of Shandong Province recorded the event in a memorandum that he presented to the emperor in 166. At about this time the belief seems to have been widespread that the Buddha was the deified form of Laozi, who, over time, had merged with Huangdi, a figure central to religious Daoism, to form the deity Huanglao. Accordingly, at the ceremony in Luoyang golden images of Huanglao and of Buddha, seated side by side on sumptuous thrones under canopies and garlands of flowers, were venerated in lavish rites accompanied by sacred music.[19]

In his memorandum Xiang Kai twice quotes from the *Scripture in Forty-two Sections* (sections 2 and 24), providing a *terminus ante quem* for the existence of that work. Prior to his period at the court in Luoyang, Xiang Kai had been the highly respected spokesman of Shandong's intellectuals and an esteemed connoisseur of the 'art of heavenly patterns of *yin* and *yang*' (*tianwen yinyang zhi shu*). The

interest he showed in Buddhism in one of the strongholds of Daoism is nothing less than striking.

Early Buddhist Rituals and Communities in China

Records show that a hundred years before the ceremony in Luoyang there existed in China a religious rite of confession, probably imported at about this time, that fused elements of Daoist and Buddhist ritual. In his official *History of the Later Han Dynasty* (*Houhanshu*) Fan Ye (398–446) tells the story of Prince Ying of Chu, son of Emperor Guangwu (r. 25–57) and half-brother of Han Mingdi, and how he had to confess various misdemeanours at a public ceremony. From 52 to 70 the prince lived in Pengcheng (now Xuzhou) on the main route from Luoyang to the south of the empire. Pengcheng was the capital of his realm, located in the north of present-day Jiangsu Province and in the south of Shandong and elevated to a kingdom in 52. At this time Pengcheng was already a flourishing commercial city. At the ceremony, the guilty prince offered silk as a sacrifice, and Emperor Ming, who was well disposed towards him, eventually granted absolution:

> The prince of Chu recites the obscure words of Huanglao, he does honour to the Buddha's temples [*Futu zhi renci*] of forbearance. Having purified himself and fasted for three months, he makes a vow to his deities [*shen*, i.e. Buddha and Huanglao]. Why should we doubt him? Why should we suspect him? He must have some regret. Let his ransom be returned, therewith to aid the elaborate feasts [*chengzhuan*] of the Buddhist lay followers [*yipuse*] and Buddhist monks [*sangmen*].[20]

This source, the reliability of which is beyond question, clearly indicates that Buddhist cultural concepts and rituals had taken root in the Han aristocracy by the mid-first century. It documents the use of Buddhist terminology, in however rudimentary a form: 'lay followers' (Skt. *upāsakas*), for example, are distinguished from 'monks' (Skt. *shramanas*). Moreover, it reveals that Buddhist communities existed in Luoyang and in the region around Pengcheng and that members of these communities worshipped their cult images in public, in 'the Buddha's temples', evidently without being stigmatised, obstructed or persecuted. In addition, believers confessed and made vows, they cleansed themselves in three months of fasting and participated in what were presumably vegetarian feasts.

The region of southern Shandong and northern Jiangsu seems to have been an early centre of Buddhism in China and it was probably here that the first images of the Buddha were made. Towards the end of the second century Ze Rong, supervisor of grain transport to the magistrate of Xuzhou, Tao Qian, made special efforts to establish Buddhism in and around Pengcheng. With the profits from his business Ze Rong built a 'large Buddhist temple complex' (*daqi futusi*) that included halls (*tang*), pagodas (*lougedao*) of several stories crowned by nine canopy-like bronze disks (*jinpan*), towers (*lou*) and pavilions (*ge*). He installed in the buildings 'gilt bronze statues of human shape' (*tong renshen shang tu shang huangjin*)

clothed in precious brocade. The grounds of the temple could accommodate some three thousand people. When the ritual bath of the Buddha (*yufo*) was re-enacted here each year on Shākyamuni's birthday – the eighth day of the fourth month – Ze Rong is said to have organised a great feast with ample supplies of food and drink. No less than ten thousand people purportedly took part in these Buddhist 'baptismal rites'.[21]

The Rock Reliefs of Kongwangshan

In northern Jiangsu, south of Lianyungang and less than 50 kilometres to the east of the region where Prince Ying and Ze Rong practised their Buddhist activities, lies Kongwangshan, 'The Mountain where Master Kong [i.e. Confucius, traditional dates 551–479 BC] Gazed'. In the 1960s, and during more thorough investigations in 1979–80, scholars discovered reliefs carved into the grey rock of the mountain. Notably archaic in style and often of monumental proportions, the reliefs depict narratives and single figures that seem to belong in a variety of religious contexts.[22] Some of the 105 figures at the western end of the cliff are undoubtedly Buddhist. Probably carved towards the end of the Han dynasty, between 150 and 200 (fig. 4), they are among the earliest Buddhist sculptures to have been found in China. They represent the Buddha, standing and seated, and various narratives, including a large depiction of the Buddha entering Nirvāna (Skt. *parinirvāna*). The reliefs with Buddhist content occur among images deriving from popular beliefs of the Han dynasty, especially those concerning Xiwangmu, the Queen Mother of the West, and Dongwanggong, Lord King of the East.[23] In the region of Shandong these two deities were thought to be interrelated

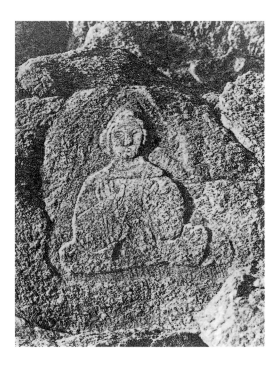

Fig. 4 Seated Buddha, second half of second century. Rock. Kongwangshan near Lianyungang, Jiangsu Province

manifestations of the complementary forces *yin* and *yang*, which had emerged from the primordial *dao* and which regulated the balance of the universe through their shifting interaction.

Before the advent of Buddhism, Chinese culture had been defined almost exclusively by the interaction of Confucian and Daoist traditions. Confucianism was proclaimed a kind of state doctrine under Emperor Wu (r. 141–87 BC). In 3 BC large numbers of Daoists left their homes in Shandong Province and migrated west in the hope of finding the area in which the Queen Mother of the West was to establish her kingdom on earth.[24] They settled in what are now Sichuan Province and southern Shaanxi Province, a region in which the second and third centuries AD saw the establishment of a religious form of Daoism referred to in later sources as *Wudoumi Dao*, 'Five Pecks of Rice Daoism'.[25]

The Dissemination and Assimilation of Buddhist Art

To many of the first Chinese to embrace the new faith from the West, the Buddha may have appeared as a kind of exotic guardian deity, as an immortal (*xianren*) or as an incarnation of Laozi. An early version of the story of Laozi converting the barbarians (*Laozi huahu*) states that 'Laozi went to barbarian lands and became the Buddha'.[26] Other Daoist texts borrow freely from Buddhist sources, and Laozi is even credited with introducing Buddhist images to China. In *Examining the Essay on Threefold Destruction* (*Xi sanpo lun*), for instance, recorded by the Liang monk Sengyou (445–518) in the eighth chapter of his *Collection on Propagating the Light* (*Hongmingji*), we read: 'The barbarians did not believe in emptiness [*xu*] and non-existence [*wu*]. Therefore Laozi had statues made of the [Buddha's] form [*xingxiang*] after he emigrated [to the west], and he converted [the barbarians with the help of these images]'.[27]

During the formative phase of Buddhist culture and art in China, the Buddha was generally depicted standing or seated in contexts deriving from indigenous systems of belief. Chinese artists and craftsmen employed modes of representation, styles and techniques with which they were familiar from Han tomb art.[28] Hence, the Chinese versions of Indian prototypes often appear like foreign bodies embedded in Confucian and Daoist surroundings.

The sacred scriptures of Buddhism were first translated into Chinese using Daoist terminology and metaphors along with certain words borrowed from the classics of Confucianism. Similarly, Buddhist imagery had to be 'translated' in terms of forms and motifs intelligible to the indigenous population. Along with descriptions and sketches, easily transportable objects no doubt played an important part in transmitting the new visual language: for example, small stone, clay, (sandal)wood or bronze reliquaries and portable cult images for private veneration, items of jewellery and coins. This is borne out by two Kushān coins, a famous gold stater coin of King Kanishka I (who seems to have reigned for approximately 23 years from shortly after 100) bearing the inscription *BODDO* and a copper didrachm inscribed *Sakamano Boudo* (fig. 5).[29] As one scholar has noted: 'the Kushān empire was located at the intersecting point of several cultures, and major . . . trade routes crossed its territory from the Roman Empire, Mesopotamia and Persia in the west to all lands

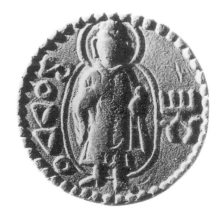

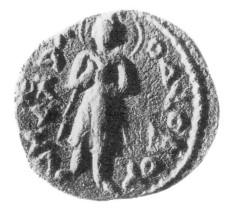

Fig. 5 Gold stater and copper didrachm of Kanishka I

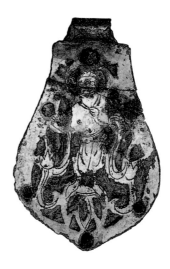

Fig. 6 Leaf-shaped ornament from the tomb of Peng Lu in Lianqi Temple at Wuchang, Hubei Province; before 262. Gilt bronze, height 4.9 cm. Hubei Provincial Museum

from India to China in the east, bringing it great wealth . . .
its culture, religion and art were therefore cosmopolitan from the
outset, especially in the north-western frontier regions'.[30] The Greek
inscriptions on the Kushān coins clearly identify the figures depicted
as the historical Buddha. He is shown from the front, standing with
his feet slightly apart and his right hand raised in the 'Fear not!'
gesture (*abhaya mudrā*). A round nimbus appears behind the heads
of both figures; the Buddha on the gold stater also has an oval
body aureole.

The figure engraved on a small, leaf-shaped piece of jewellery
made of gilt bronze and inlaid is less easily identifiable (fig. 6).
A Buddhist figure with an *ushnīsha* and a round head nimbus is
shown standing on a lotus pedestal from each side of which grows
a lotus flower. The figure wears a long robe, or a skirt, with flowing
stoles draped over its arms. Two parallel curved lines on the
exposed chest may depict a necklace. It has been suggested that
the image represents a bodhisattva rather than the Buddha.[31]
This attractive piece was once owned by Peng Lu, a military
commander of the *xiaowei* rank who was buried in 262 in Lianqi
Temple at Wuchang in Hubei Province (this can be inferred from
a dated document found in 1956 during the excavation of his tomb
[no. 475]). The small bronze object was probably an amulet, for if
a military leader of the Wu empire adorned himself with a Buddhist
figure it was no doubt in order to enjoy protection. If we accept the
identification of the figure as a bodhisattva, we may recognise it as
a precursor of the famous gilt bronze figure from the late third
century in the Fujii Yūrinkan in Kyoto, a key work of Chinese
Buddhist sculpture (fig. 7).[32]

In September 1997 four golden rings were found in tomb no. 6
of a burial compound at Nanchang in northern Jiangxi Province that
dates from the Eastern Jin dynasty (317–420) (fig. 8).[33] Each ring
bears a tiny Buddha figure seated cross-legged on a lotus throne in
front of triangular backgrounds reminiscent of mountain peaks or
stylised leaves. With the exception of the objects found in the tomb
of Peng Lu the rings would seem to be the only surviving Buddhist
images on private Chinese jewellery of this early period; but the fact
that an evidently wealthy Jin aristocrat chose to include them among
the precious jewellery he was buried with shows how strong
Buddhist influence was on the spiritual life of the time. Presumably,
he had prayed for the Buddha's protection while alive and wished
to be accompanied by him on his passage into the next world.

Images of the Buddha in Tombs

Images of the Buddha seem to have been used for a similar purpose
in Daoist tombs and temples. Daoists apparently hoped for
additional support from the new Indian saviour on their path to
eternal bliss. The tympanum above the door to the inner chamber
of Daoist tombs was often adorned with symbols and emblems of
permanent happiness and harmony, such as a ram's head. These
were now occasionally replaced by an image of the Buddha
showing some of his basic attributes and gestures – the round head
nimbus, the *ushnīsha*, the *abhaya mudrā* and the left hand grasping
the seam of his robe. He is depicted frontally with his legs

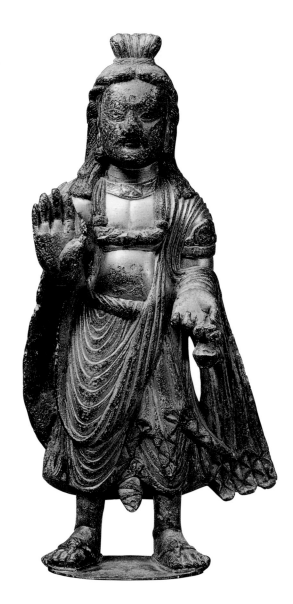

Fig. 7 Standing Bodhisattva, third century.
Gilt bronze, height 32.9 cm. Fujii Yūrinkan, Kyoto

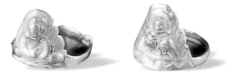

Fig. 8 Rings from a burial site at Nanchang, Jiangxi
Province; Eastern Jin dynasty (317–420).
Gold, height approx. 1.5 cm each

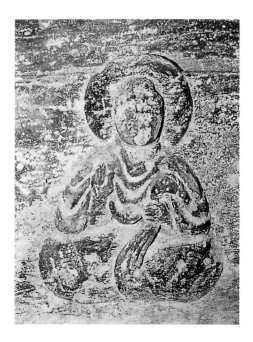

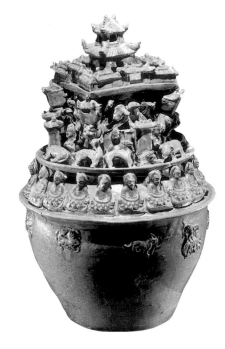

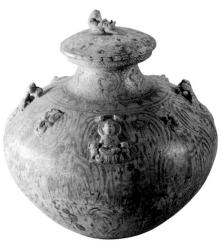

Fig. 9 Seated Buddha, second century. Rock.
 Cave tomb no. 9, Mahao, Sichuan Province

Fig. 10 Seated Buddha, second century. Rock.
 Cave tomb no. 1, Shiziwan, Sichuan Province

Fig. 11 Funerary urn, Jin dynasty (256–317). Yue ware,
 height 45.4 cm. The Metropolitan Museum of Art, Gift
 of Charlotte and John C. Weber, 1992. (1992.165.21)

Fig. 12 Funerary urn, State of Wu (222–280). Yue ware,
 height 32.1 cm. Changguangcun, Yuhuatai, Nanjing,
 Jiangsu Province. Nanjing Municipal Museum, Jiangsu

crossed (Skt. *nyashīdat paryankam ābhujya*), a pose also called the 'barbarian position' (Chin. *huzuo*) or the 'lotus seat' (Skt. *padmāsana*). This is how he appears in the second-century cave tomb reliefs of Mahao and Shiziwan on the east bank of the River Min opposite the old town of Leshan, which lies south of the capital of Sichuan, Chengdu (fig. 9, 10).[34] These figures occupy a prominent position above the entrance to the inner chambers of tombs that are otherwise decorated exclusively with Daoist legends and historical narratives.

Miniature Buddha figures of a comparable date are seen most frequently on Yue ware funerary urns (literally 'soul urns' [Chin. *hunping*] or 'granaries' [Chin. *gucang*]), which have been found

in great numbers in recent years.[35] These bulbous stoneware vessels, mostly with an olive-green, greyish or green-brown glaze, were produced in the south of Jiangsu Province and in the north of Zhejiang Province. The small Buddhas, probably made with moulds and then applied to the urns, sit cross-legged on a lotus pedestal often guarded on each side by a lion. They either occur singly on the body of the vessel in combination with animals, floral decorations or other figures in relief or they appear in a row like a garland around the shoulder of the vessel. A very well preserved example of the latter arrangement is in the Metropolitan Museum of Art, New York (fig. 11). Another, round-bellied funerary urn may be slightly older (fig. 12). Excavated in 1983

near Nanjing, Jiangsu Province, it has been claimed to date from the time of the Wu empire (222–280).[36] The pot is painted in brown with Daoist genies and immortals (some of them holding sceptres), stylised plants and animals. Small appliqué reliefs of the Buddha appear on the shoulder of the vessel amid the Daoist decoration. They are seated, with a nimbus behind their heads and two lions guarding their lotus pedestals. In this striking arrangement the funerary urn figures anticipate the image of the Buddha on the Lions' Throne, probably developed only slightly later in its classic form of three-dimensional cult images in gilt bronze and stone.

The Buddha in Money Trees

Further evidence of comparatively indiscriminate syncretism is provided by numerous bronze mirrors from the Han dynasty and the period of the Three Kingdoms (220–280), especially the mirrors with Buddhas and mystical animals (Chin. *Foshou jing*),[37] and by the so-called money trees (Chin. *qianshuzi*), also known as money-shaking trees (Chin. *yaoqianshu*). The latter's delicate bronze 'branches' bear 'foliage' consisting of coins pierced with a square, figures of immortals and images of mythical deities, human beings and animals. Here and there small seated Buddhas appear side by side with the Queen Mother of the West, as in the well-preserved example in the Asian Art Museum, San Francisco.[38] A bronze fragment from a money tree in the Kubosō Kinen Bijutsukan in Izumishi shows the Buddha in the lotus position with a nimbus behind his head.[39] He has a striking, mushroom-shaped *ushnīsha*, raises his right hand in the *abhaya mudrā* and grasps the seam of his robe with his left hand. The semicircular fold of the robe on the figure's chest is emphasised in a similar fragment, now in the Royal Ontario Museum, Toronto,[40] in which parallel hatching is used to denote the hair and moustache. Motifs and stylistic features of this kind are to be found especially in art produced during the Kushān period in Gandhāra, Swat and western Central Asia.

Fragments of a bronze money tree found in November 1989 in cave tomb no. 1 at Hejiashan in Mianyang County, Sichuan Province, display the same iconographical characteristics (fig. 13).[41] The arrangement of the tomb and the objects found in it – among them bronze mirrors, coins and clay figures – suggest that it dates from the Eastern Han dynasty (25–220). Five figures of the Buddha are attached to the 'trunk' (height 79 cm) of the money tree, which is crowned by a finely pierced image of the Queen Mother of the West. Four fragments of two further money trees, found in tomb no. 14 at Tujing in Zhong County, Sichuan Province, seem to have been made slightly later, during the Shu empire (221–263).[42]

In the same region, south-west of Chengdu, a ceramic base from a money tree was purportedly found in 1942 in a rock tomb (fig. 14).[43] The base, which dates from the late Han dynasty, has a brownish glaze and is decorated with reliefs of the Buddha figure and other motifs. It has long been regarded as one of the oldest extant examples of Buddhist art in China. The seated Buddha is

Fig. 13 Money tree from cave tomb no. 1 at Hejiashan, Mianyang County, Sichuan Province; Eastern Han dynasty (25–220). Bronze, height 76 cm. Mianyang Municipal Museum, Sichuan

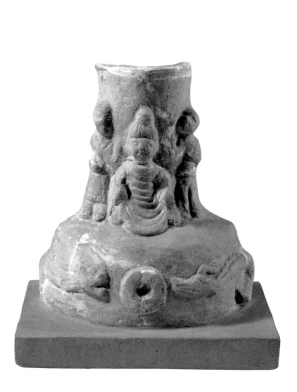

Fig. 14 Base of a money tree, from Pengshan, Sichuan Province;
Eastern Han dynasty (25–220). Clay, fired and glazed,
height 21.3 cm. Nanjing Municipal Museum, Jiangsu

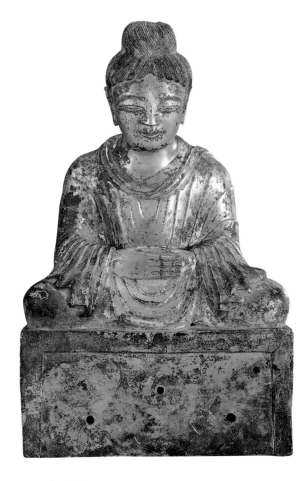

Fig. 15 Seated Buddha, dated 338. Gilt bronze, height 39.4 cm.
Asian Art Museum of San Francisco, The Avery Brundage
Collection, Chong-Moon Lee Center for Asian Art and Culture,
B60 B1034

flanked by standing figures, one possibly representing a Chinese,
one a foreigner. A tiger and a dragon, symbols of *yin* and *yang*
respectively, are moving around the foot of the pedestal towards
a *bi* disk. The animals also refer to the two points of the compass
involved in the spread of the foreign faith: the west, where
Buddhism originated, and the east, where it was now becoming
established. The Buddha's hairline is only slightly rounded; the
hair itself is depicted by incised parallel lines. His *ushnīsha* is
cone-shaped and unusually high. His robe is carved rather stiffly
in curved, parallel folds, arranged symmetrically at the chest and
legs, a feature that was to become a hallmark of stone and
bronze images over the following two centuries.

The Oldest Free-standing Sculptures of the Buddha

Two gilt bronze images of the seated Buddha, in the Tokyo
National Museum (height 13.5 cm)[44] and the Asian Art Museum
of San Francisco (fig. 15),[45] show how closely the early reliefs
were related to the first free-standing sculptures of the Buddha
in China. Here too, symmetrical folds dominate the drapery.
A fragmentary inscription on the back of the San Francisco piece
mentions the year 338, making this the oldest dated free-standing

Chinese Buddhist sculpture to have survived. The inscription
suggests that the image was made in the territory of the Later Zhao
(319–352, today's Hebei Province), who supported the missionary
activities of the unconventional miracle-working monk Fotu Cheng
(d. 349) from Kucha. This popular figure, whose name means
'clarification of the Buddha image', was made court 'chaplain'
by the Zhao.[46]

Earlier, undated examples of such images, which were set up
as objects of devotion in the halls of Buddhist temples, are no doubt
extant. The gilt bronze statue of a seated Buddha, purportedly
excavated at Shijiazhuang in Hebei Province and now in the
Grenville L. Winthrop Collection at Harvard University's Arthur
M. Sackler Museum, may be among them (fig. 16).[47] The figure
sits cross-legged on a lions' throne with a lotus vase in the centre.
The almond-shaped eyes, the elegant moustache, the straight
hairline and the *ushnīsha* resembling a tied-off knot are typically
Gandhāra in style, as is the drapery, its parallel folds sweeping
across the body and backwards over the shoulder. Flames rise
from around the shoulders. Like nimbuses, they symbolise the
light of enlightenment and may well derive ultimately from the
religion practised in Iran, which propagated a cult of light.

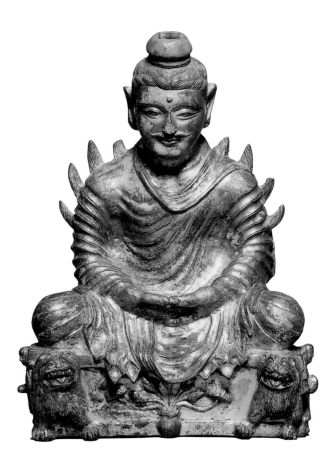

Fig 16 Seated Buddha, second or third century. Gilt bronze, height 32.8
cm. Arthur M. Sackler Museum of Art, Harvard University Art
Museum, Cambridge, MA, Bequest of Grenville L. Winthrop

Prototypes of this iconographical feature in Buddhist imagery
are found in sculptures of the Kushān period from Afghanistan,
Gandhāra and Mathurā.[48] The high quality of this work bears
witness not only to the technical skill of the bronze casters and
their familiarity with prototypes ultimately of western origin, but
also to the sophistication and religious commitment of the donors.
The date of the sculpture has long been the subject of dispute,
opinions ranging from the late second century to the early fifth.
Research undertaken recently by Marylin M. Rhie suggests a
date in the Eastern Han dynasty or the beginning of the third
century.[49]

Centuries later, Chinese sculptors were still using this exotic
style à la Gandhāra or Mathurā when reproducing imported
Buddha prototypes. These included the legendary Shākyamuni
image commissioned by the Indian king Ashoka (c. 273 – c. 232 BC)
and soon known in China as Ayuwang xiang. A polychrome gilt
sandstone example of this was excavated in May 1995 at the Xi'anlu
in the centre of Chengdu, along with eight other Buddhist sculptures
and a Daoist stele (fig. 52).[50] The inscription on the pedestal states
that the image was carved in 551, during the Liang dynasty, and
commissioned by one Du Sengyi.[51]

A Sixth-century Description of a Buddhist Temple

The Temple of Eternal Peace (Yongningsi) that once stood in the
centre of Luoyang near the imperial palace no doubt contained
images of this type and quality. Begun in 516 under imperial
patronage, it was one of the largest and most lavish Buddhist
temples in China.[52] Yang Xuanzhi's *Record of Buddhist Monasteries
in Luoyang* of 547 contains a description of the temple that conveys
a vivid impression of the splendour of this lost Buddhist architecture
of the early sixth century and its rich furnishings:

The Yongning Temple was constructed in the first year of the
Xiping era [516] by decree of Empress Dowager Ling, whose
surname was Hu. It was located one *li* south of the Changhe
Gate on the west side of the Imperial Drive [*yudao*], facing
the palace grounds[…]Within the temple's precincts was a
nine-storey wooden pagoda. Rising nine hundred feet above
the ground, it formed the base for a mast that extended for
another one hundred Chinese feet; thus together they soared
one thousand Chinese feet above the ground, and could be
seen as far away from the capital as one hundred *li*. In the
course of excavating for the construction of the temple, thirty
golden statues were found deep underground; this was
interpreted as an auspicious reward for the empress dowager's
conversion to Buddhism. As a result, she spent all the more
lavishly on its construction[…]

North of the pagoda was the Buddha Hall [Fodian], which
was shaped like the Palace of the Great Ultimate [Taijidian].
In the hall was a golden statue of the Buddha eighteen
Chinese feet high, along with ten medium-sized images –
three of sewn pearls, five of woven golden threads, and two
of jade. The superb artistry was matchless, unparalleled in
its day[…]

Luxuriant cypress, juniper, and pine trees brushed the
eaves of the building, while bamboo groves and aromatic
plants lined the courtyards and stairways[…]Chang Jing wrote
a stone inscription that reads [in part]: 'Even the grand
Treasure Hall on Mount Sumeru [*Xumi baodian*] and the
Palace of Purity in Tushita Heaven [*Doushuai jinggong*] are
no match for this.

Here were kept all the sūtras and Buddhist images
presented by foreign countries. The walls of the temple
[buildings] were all covered with short rafters beneath the
tiles in the same style as our contemporary palace walls.
There were gates in all four directions. The tower on the
South Gate rose two hundred Chinese feet above the ground,
had three storeys, each with an archway, and was shaped like
the present-day Duanmen [South Gate] of the palace grounds.
On the gate and latticed windows were paintings of patterned
clouds and colored fairies – all magnificent and beautiful.
Under the archway were images of the four guardian [kings]
and four lions, adorned with gold, silver, pearls, and rare
stones. Such an imposing and splendid scene could not be
found anywhere else.[53]

The Making of Buddhist Images in China

The 'Buddhist images presented by foreign countries' that graced these magnificent temple halls were probably brought to China by missionaries, pilgrims and merchants travelling overland along the Silk Roads and across the sea via South-East Asia. With Buddhism becoming increasingly independent of its Indian origins in the third and fourth centuries, such images doubtless began to be made in great numbers in China for both official and private purposes. A hoard discovered in September 1983 at Songdecun in Boxing County, approximately 90 kilometres north of Qingzhou, suggests that a major centre for the production of sculptures of this kind lay in what is now Shandong Province.[54] Most of the bronze images excavated on this occasion date to the second half of the fifth century and the first half of the sixth.

Daoxuan (596–667), a prodigious translator of sacred scripture and a founder of the Lü school of Buddhism, which stressed observance of monastic rules, reports that in 377 a monk by the name of Huihu had a golden image of Shākyamuni made for Shaoling Temple in Wujun. He notes that the statue was cast in a cave on the steep south side of the temple and was sixteen feet tall.[55] Unlike the painters of the time, bronze casters and sculptors did not stand in high regard: their social status was that of artisans and they generally remained anonymous. One of the first documented sculptors of Buddhist images was Dai Kui (d. 395). He is said to have made monumental groups of images in bronze, wood and lacquer for various temples. The beauty and artistic power of these works were felt to testify to their creator's inventiveness and technical skill. Daoxuan thought that Dai Kui's intense faith, paired with his genius, greatly contributed to the gradual sinicisation of Buddhist images.[56] Some of the sculptors may have been lay followers of Buddhism or loosely associated with the temples. Most of them, however, probably worked as professional artisans, organised in workshops in which technical knowledge and practical experience were passed down from generation to generation.

NOTES

1 Wu Hung 1986; Wu Hung 2000b; Rhie 1999.

2 Seckel 1976; Pal 1984, pp. 129–42.

3 *Taishō* 1960, vol. 8, no. 224, pp. 425a–78b.

4 Lancaster 1974, p. 289.

5 This passage comes from the fifteenth chapter of *Expanded Collection on Propagating the Light* (Chin. *Guang hongming ji*), compiled in 644 by the historian and monk Daoxuan (596–667). *Taishō* 1960, vol. 52, no. 2103, p. 198b–c; translated in Soper 1959, p. 16.

6 Goepper 1983, p. 11.

7 Seckel 1957, p. 189.

8 *Taishō* 1960, vol. 21, no. 1419, p. 951a; translated in *Zaoxiang* 2000.

9 Soper 1959, p. 16.

10 Soper 1959, pp. 15–16.

11 Wright and Twitchett 1973, pp. 256–6; Weinstein 1987, p. 22.

12 Goepper 1980.

13 Wei Shou (506–572) recorded the details of this legend in his *History of the Wei Dynasty* (*Weishu*). Another early source is cited by Daoxuan in his *Catalogue of Beneficial Influences of the Three Jewels on the Divine Continent* (*Ji Shenzhou sanbao gantong lu*). *Taishō* 1960, vol. 52. no. 2106, p. 413c. For translations and commentaries, see Soper 1959, p. 1ff., Tsukamoto 1985, vol. 1, p. 41ff., and Rhie 1999, pp. 14–15.

14 *Taishō* 1960, vol. 17, no. 784, pp. 722a–4a. For the various editions, see T'ang 1936 and, for a brief introduction to and translation of the text, Sharf 1996a.

15 At the end of the eleventh section of his *Rhapsody on the Western Capital* (*Xijing fu*) Zhang Heng gives some idea of these temptations when, in describing the entertainments in the palace, he says of the dancing girls: 'All together, bodies relaxed, they quickened the tempo, and returned just like a flock of startled cranes. Their vermilion slippers danced between plates and goblets, and they waved their long, dangling sleeves. With a curvaceous, cultivated bearing, their lovely dresses fluttered like flowers in the wind. Their eyes cast darting glances; one look could overthrow a city. Even Zhan Ji [Zhan Huo or Liuxia Hui, late seventh century BC, known for his integrity and moral rectitude] or a *shramana* [Buddhist monk] – no one – could not but be deluded.' See Knechtges 1982, p. 237; also Zach 1958, p. 16; Zürcher 1959, p. 29; Wright 1959, p. 21; and Tsukamoto 1985, vol. 1, p. 66.

16 *Taishō* 1960, vol. 51, no. 2092, p. 999a; translated in Wang 1984, pp. 5–6.

17 Schafer 1963, p. 139.

18 *Taishō* 1960, vol. 16, no. 692, p. 788b–c; translated in Sharf 1996b, pp. 261–7. Faure 1998, p. 782, tells the story as related by Huijiao (497–554) in his *Biographies of Eminent Monks* (*Gaoseng zhuan*). *Taishō* 1960, vol. 50, no. 2059, p. 860b. For a detailed account of the legend, see Soper 1959, pp. 259–65, and Carter 1990.

19 Soper 1959, p. 4; Zürcher 1959, pp. 37–8; Tsukamoto 1985, vol. 1, p. 67ff.; Sharf 1996a, p. 361; Rhie 1999, p. 18ff.

20 *Houhanshu*, section 42, biography no. 32, pp. 1428–9. Tsukamoto 1985, vol. 1, p. 60ff.; Bauer 1990, p. 212; Rhie 1999, pp. 17–18.

21 *Houhanshu*, section 73, biography no. 63, p. 2368; *Sanguozhi*, vol. 5: *Wushu*, biography no. 4 [Liu Yu], 1185. Soper 1959, p. 19ff.

22 Hall 1982; Wu Hung 1986, pp. 292–303, fig. 62–82; Rhie 1999, pp. 27–40, esp. p. 27, n. 43, and fig. 1.9–1.14, 1.16.

23 Rhie 1999, pp. 29–33, fig. 1.4a–b; Wu Hung 1987.

24 Schipper 2000, p. 40.

25 Stein 1979. For the culture and art of *Wudoumi Dao*, see Wu Hung 2000b.

26 Zürcher 1959, p. 37. For the various versions of *Laozi huahu*, see ibid., pp. 288–320, and Wu Hung 2000b, p. 91.

27 *Taishō* 1960, vol. 52, no. 2102, p. 52b. The *Hongmingji*, probably compiled between 515 and 518, collects in fourteen chapters documents concerning relations between Confucianism, Daoism and Buddhism. The work made an important contribution to the intellectual history of the Liang dynasty.

28 Wu Hung 1986; Wu Zhuo 1992, pp. 40–50, 67.

29 Rhie 1999, pp. 33, 40 and fig. 1.18 f–g. The hotly disputed issue of when exactly Kanishka I reigned need not concern us here.

30 Seckel 1962, p. 33.

31 *Fojiao* 1993, fig. 16; Rhie 1999, pp. 127–30, fig. 2.19.

32 Matsubara 1995, Zuhanhen 1, pl. 1, 2a–b; Rhie 1999, pp. 143–51, pl. 3, fig. 2.32a–g.

33 *Wenwu* 2001c, pp. 34 (fig. 78–81), 38–9, and colour plate 1(M6:2) on the final, unnumbered page.

34 Lim 1987; Tang Changshou 1997; Rhie 1999, pp. 47–56, fig. 1.21–4; Wu Hung 2000b, p. 90ff., fig. 24a–b.

35 *Fojiao* 1993, fig. 34ff.; Rhie 1999, pp. 112–19, fig. 2.2–8b, 2.10a.

36 Zhang Deqin 1993, no. 10; *Fojiao* 1993, fig. 38.

37 Wu Hung 1986, p. 257ff., fig. 23–42; *Chūgoku koshiki kondōbutsu* 1988, nos. 5–6, 9–11; *Fojiao* 1993, fig. 17–30; Rhie 1999, pp. 119–26, fig. 2.12–17a.

38 Little 2000, pp. 154–5, no. 25. For the significance and history of money trees, see Wiedehage 1996 and Chen Xiandan 1997.

39 *Chūgoku koshiki kondōbutsu* 1988, fig. 13–15.

40 Rhie 1999, p. 61, fig. 1.32.

41 He Zhiguo 1991, pp. 1–8, fig. 19–20, pl. 1:1–2; Rhie 1999, pp. 59–61, fig. 1.31a–d.

42 *Fojiao* 1993, fig. 9–12; Rhie 1999, p. 127, fig. 2.18a.

43 Wu Hung 1986, fig. 8; Wu Hung 1987, p. 33, fig. 12; Wu Hung 2000b, p. 91, fig. 25; *Fojiao* 1993, fig. 32; Rhie 1999, pp. 56–8, fig. 1.26a–b.

44 Matsubara 1995, Zuhanhen 1, pl. 5b–c; Rhie 1999, pp. 133–8, fig. 2.26a–c.

45 Matsubara 1995, Zuhanhen 1, pl. 6, 7a–b; Rhie 1999, pp. 133–8, fig. 1–48, 2.28a–b.

46 For Fotu Cheng (or Fotu Deng), see Zürcher 1959, p. 181ff., and Tsukamoto 1985, vol. 1, p. 249ff.

47 Matsubara 1995, Zuhanhen 1, pl. 3, 4a–b; Rhie 1999, pp. 71–94, pl. 1, fig. 1.44–5, 1.58, 1.61, 1.64–5a, 1.66–8.

48 Rhie 1999, fig. 1.49, 1.78–80.

49 Rhie 1999, p. 71ff., with a summary of the scholarly debate.

50 *Wenwu* 1998b, pp. 4–20, colour pl. 2:1–2, fig. 11, 14; Sofukawa and Okada 2000, pl. 248, 262, 456.

51 The archaeological report gives the name as Zhu Sengyi; *Wenwu* 1998b, p. 7.

52 *Luoyang Yongningsi* 1996.

53 *Taishō* 1960, vol. 51, no. 2092, pp. 999c–1000a; translated in Wang 1984, pp. 13–17.

54 *Wenwu* 1984a, pl. 2:1–5. See also Zhang Zong's essay in the present volume, p. 45.

55 *Ji Shenzhou sanbao gantong lu*, in *Taishō* 1960, vol. 52, no. 2106, pp. 416c–17a. See also Soper 1959, p. 18, no. 13.

56 Soper 1959, pp. 19–22.

LONGXING TEMPLE IN QINGZHOU
AND THE DISCOVERY OF THE SCULPTURE HOARD

LUKAS NICKEL

Fig. 17 The 'Giant Buddha of Qingzhou', a natural feature of the chain of mountains south-east of Tuoshan

Fig. 18 Standing Buddha, c. 520–30. Limestone, height of figure approx. 5m. Xitian Temple, Linzi, Shandong Province

Buddhism and its Physical Remains in Shandong Province

Qingzhou is located in what was once the state of Qi, not far from its capital, Linzi. The large expanse of flat land to the north-west of the town is still strewn with numerous tomb mounds from the first millennium BC, testifying to the former wealth and importance of the region.[1] The fertile land around Qingzhou is traversed by several rivers, which rise in the almost barren mountains to the south and the west. Only five kilometres from the edge of the town, these highlands, which are the end of a chain that includes far-off Taishan, contain the Buddhist cave temples of Yunmenshan and Tuoshan as well as the quarries that supplied the limestone for the sculptures in the temples in Qingzhou and its surroundings. Looking to the south-west from the terraces of Tuoshan, one sees a mountain chain about two-and-a-half kilometres long that is known popularly as the Giant Buddha of Qingzhou because, when viewed in a clear light, the silhouettes of the four mountains unite to form a horizontal profile of a face (fig. 17).[2]

Buddhism first flourished in Shandong in the late fifth and the sixth century, i.e. between the annexation of Qingzhou by the Northern Wei in 469 and its conquest by the Northern Zhou in 577. A considerable number of small Buddhist bronze sculptures have survived from the late fifth century. The inscription on a stone sculpture depicting a kneeling sheep and dated 508 mentions the construction of a Thousand Buddha Pagoda at Xingguo Temple east of Qingzhou,[3] yet intense religious activity in the region did not begin until c. 525. The oldest existing figure stele bears the date 523, while several steles dated 525 are extant.[4] Far more striking, though hardly examined by scholars, are several Buddhist statues more than five metres high that also date from the 520s and early 530s. At least seven of these limestone sculptures survive in the Qingzhou area. Like the statue in Xitian Temple in Linzi (fig. 18), each of them would seem to have been the chief image of a major temple.[5]

Archaeological finds lend weight to the theory that Buddhism flourished in Shandong until the demise of the Northern Qi dynasty, in 577,[6] but the extent to which religious images were produced in the area can only be conjectured. Wooden temple buildings vanished long ago, and wall paintings and images made of wood, clay and other perishable materials are lost. A few passages in documents, and scattered votive inscriptions, are all that remain to tell us of the local monastic communities and the piety of lay believers.

Buddhist sculptures of the fifth and sixth centuries have been unearthed in Shandong since the 1970s (see fig. 34), yet not until the discovery of the sculpture hoard at Qingzhou did scholars begin to concern themselves seriously with the widely scattered remains from this era. It is a legacy that permits at least a glimpse of a long-lost tradition of religious practice.

A Remarkable Discovery

In October 1996 construction workers levelling the sports field of the Shefan primary school in Qingzhou discovered a pit filled to the brim with broken Buddhist sculptures. The proximity of the school to the local museum saved the sculptures from illegal excavation and theft. The staff of Qingzhou Municipal Museum had the site protected and immediately set about salvaging the statues (fig. 19–22).[7] They divided the pit into nine sections of equal size, excavating and emptying each of them in turn. Within ten days, all the figures had been removed to a room in the museum. Although regrettable from an archaeological point of view, this haste was not unfounded, for in recent years many figures from comparable sites in the area have found their way onto the international art market and fetched high prices.[8] These pieces are now in Chinese and foreign collections, divorced from their historical context.[9]

The value of the Qingzhou hoard, apart from the outstanding artistic quality of its contents, lies in the wealth of information these sculptures yield about their original purpose, their destruction and the nature of their burial. The pit in which they were discovered, 8.7 metres long by 6.8 metres wide, lay only 1.5 metres below the surface and was approximately 2 metres deep.[10] Roughly in the middle of the south wall, halfway up, was a small earth ramp, which presumably facilitated the lowering of the figures into the pit. The figures and steles had been deposited in the pit in several layers, with the best-preserved items in the middle, surrounded by damaged pieces and by fragments. Some smaller sculptures were leaning against the walls of the pit in an upright position. Impressions of

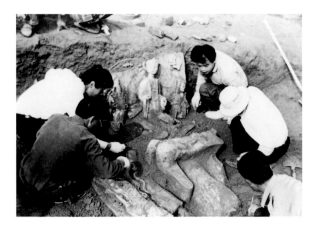

Fig. 20 Members of the excavation team at work in the pit

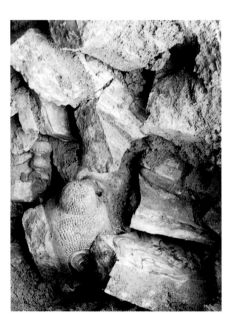

Fig. 21 Part of the find, showing the head of a
Buddha and fragments of a painted
mandorla

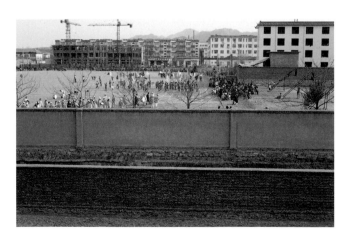

Fig. 19 The sports field of the Shefan school, photographed from Qingzhou
Municipal Museum in April 2001. The sculptures were discovered
directly behind the wall, between the two trees in the middle

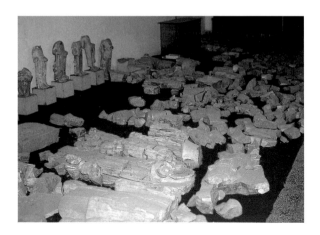

Fig. 22 The figures stored in Qingzhou Municipal Museum

coarse reed mats were found on the torsos of the top layer.[11]

Along with limestone, marble and granite sculptures, the pit contained figures made from cast iron, lacquered wood and clay, both low-fired and unfired. The poor condition of the figures made from perishable materials meant that they could not be salvaged and thus not investigated thoroughly, but 'numerous'[12] clay figures are known to have been brightly painted and some of them to have contained ash and burnt bones.[13] Other finds were a white porcelain bowl dating from the Northern Song dynasty (960–1127), remains of lacquer objects, 119 coins and fragments of three stone steles with sūtra inscriptions. Data on the exact position of the objects in the various layers was not published, but it is known that the coins were scattered at various points and that the porcelain bowl was found at the bottom of the pit, north-west of the earth ramp.

Before 1996 the pit and its contents had been disturbed only by the construction of a well in the south-west corner and by a shaft dug by illegal excavators near the centre. Glazed roof tiles found inside the well indicated that it was filled in during the Ming dynasty (1368–1644), but the dates of the well itself and of the excavation shaft could not be established.

Despite many unanswered questions, some conclusions may be drawn from the excavation data. The figures could not have been buried earlier than the Northern Song dynasty (960–1127), since the Northern Song porcelain bowl was found under the sculptures and thus cannot have been placed in the pit after them.[14] The most

recent coin in the hoard dates from the early twelfth century because it bears the inscription 'circulation coin [of the] Chongning [era]' (*Chongning tongbao*), which lasted from 1102 to 1107 in the reign of Emperor Huizong (r. 1101–1125).[15] As the pit did not contain objects later than the Northern Song dynasty, it can be assumed that it was sealed in the first half of the twelfth century.

The majority of the figures in the pit date from the sixth century, from the late Northern Wei, the Eastern Wei and the Northern Qi dynasties. The earliest year to appear in an inscription is 529 (fig. 23). Few objects in the find date from the period between the sixth century and the sealing of the pit.[16] The latest date on an inscription is 1026.

Almost all the figures were made locally. Approximately 95% of them were carved from the grey, fine-grained limestone that is still quarried around Qingzhou. A few fragments of Tang dynasty figures are made of

Fig. 23 Rubbing of the donor's inscription on the earliest dated piece of the Qingzhou hoard (529; see cat. 1)

granite. Granite does not occur in Qingzhou and was presumably imported from northern Shandong. According to Xia Mingcai, the marble figures, also dating from the sixth century, were imports from the neighbouring province of Hebei.[17]

The number of figures interred in the pit cannot be established. More than 200 virtually intact torsos, 144 Buddha heads and 46 bodhisattva heads were discovered. Since restorers could find no matching torsos for two-thirds of the heads, the pit must have contained fragments of at least 320 sculptures. Other estimates of the total number of figures exceed 400.[18] The excavation showed that most of them were already broken at the time of their interment.

The burial of the figures was evidently carefully planned. The walls of the pit were vertical and at right-angles to each other. Judging from the position of the ramp, the pit was filled from the south. The figures were placed in the pit in layers and interred beneath reed mats. This amount of care and the fact that coins were scattered over the site indicate that the statues were buried with a certain degree of ceremony.

The excavators surmised that the figures were buried in consecrated ground, i.e. within the precincts of the long-since demolished Longxing Temple (Dragon Rise Temple). In the 1980s archaeologists found objects belonging to palace-like buildings near the site of the figure hoard, but it could not be proved that they were from Longxing Temple.[19] The area around the hoard has not yet been examined thoroughly, but the location of Longxing Temple can be deduced from written sources and aerial photographs. Su Bai has investigated the historical documents pertaining to the temple;[20] the aerial photographs published here were provided by Song Baoquan of the Ruhr Universität in Bochum, who took official aerial photographs, digitally rectified their distortions and fitted them together to form a larger image.[21]

The Town of Qingzhou

Modern Qingzhou is divided into a northern and a southern town by the River Yang (fig. 25). Both parts of the town can look back on a long history. The museum building, begun in 1984,[22] and the site of the figure hoard are located in the north-western corner of the southern town, above the banks of the River Yang, which turns east here on its passage from the south (fig. 24).

Qingzhou was founded in 204 BC by General Han Xin (d. 196 BC) as 'Guangxian'. It did not achieve prominence until AD 410, when Dongyang (literally, East Yang), a precursor of modern Qingzhou, was founded on the north bank of the River Yang as the administrative centre of Linzi County in Qingzhou Prefecture. In 556, following a redrawing of county boundaries, Dongyang became the centre of the newly established Yidu County.[23] The diaries of the Japanese monk Ennin (793–864), who travelled in the region in 840, indicate that by then the town was surrounded by an earth wall.[24]

In the Tianhui era of the Jin period (1123–1137) Dongyang lost its function as the centre of prefectural administration. Conquered and pillaged several times during the wars of 1227–30, the town became 'a ground of ruins and shards'.[25] Subsequently, it was only sparsely inhabited and its walls decayed. Yet the arrangement of the

fields in the aerial photographs of 1975 clearly reveals the position of the thousand-year-old walls. The area occupied by Dongyang was the scene of extensive building in the 1980s and, largely built up again, forms the northern section of Qingzhou.

The settlement on the other side of the River Yang, called Nancheng (South Town) or Nanyang (South Yang) in early sources, acted as a residential suburb of Dongyang. It is first mentioned in the tenth century.[26] After the destruction of Dongyang in 1129 the prefectural administration was moved here.[27] Records do not indicate when Nanyang was surrounded by an earth wall, but a local chronicle of the Qing dynasty (1644–1911) states: 'Originally, [Nanyang] had earth walls. A brick wall was built in the third year of the Hongwu era of the Ming dynasty [1370] and reinforced during the Tianshun and Zhengde eras [1457–1464, 1506–1521]. It was repaired in the 47th year of the Qianlong era of the present dynasty [1782].'[28] At the time the aerial photographs were taken these brick walls were still largely intact. Only in the last two decades, as the town's population has grown to 890,000, have they been demolished in the course of construction work. The photographs

Fig. 24 Qingzhou Municipal Museum from the north

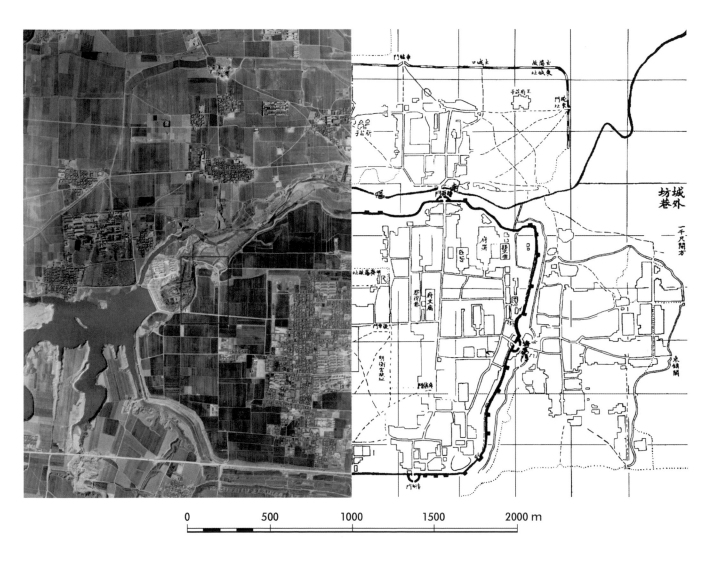

0 500 1000 1500 2000 m

Fig. 25 An aerial image of western Qingzhou aligned with a map published in 1906.
 The red rectangle marks the area containing Qingzhou Municipal Museum and the site of the find

37

show that in 1975 only the centre of the southern town, the almost rectangular administrative town of the Ming dynasty, was inhabited. The outer districts and the complete northern town consisted of farmland, with some smaller villages at former road junctions and town gates. The figure hoard was found in the north-western part of the southern town, at an exposed spot above the banks of the River Yang.

The Location of Longxing Temple

No above-ground traces remain of Longxing Temple. Written sources, however, give indications as to its location and enable us to establish beyond doubt that the sculpture hoard was discovered within the former temple precincts.

The earliest hint occurs in the *Chronicle of Qi (Qisheng)*, written in the first half of the fourteenth century.[29] This reproduces the inscription on the so-called Song stele (now lost), which was once housed at Longxing Temple: 'The temple is the [former] house [*zhai*] of Tian Wen'.[30] Tian Wen was a well-known aristocrat from the state of Qi in the Zhanguo period (475–221 BC) who was known posthumously as Prince Mengchang (Mengchang Jun). Although the opinion is expressed in the *Qisheng* that the building belonged not to Prince Mengchang, but to Liu Shanming in the fifth century AD,[31] the statement in the inscription was accepted until recently. The entry on Longxing Temple in the *Chronicle of Qingzhou Prefecture (Qingzhoufu zhi)*, written during the Ming dynasty, contains further information: 'The residence of Tian Wen was located in the north-west of the prefectural administration. During the [Liu-]Song dynasty [420–479], it was [confiscated] by Longxing Temple [and] relieved of its functions. . . . Today, the Temple of the City God [Chenghuangmiao] is on its premises.'[32] In its entry on the latter temple, the chronicle provides a further clue to the location of Longxing Temple: 'City God Temple: there are two. One is located inside the town [Nanyang] on the site of the old residence of Prince Mengchang. It had been built in the fourth year of the Wuping era of the Northern Qi [573] as Longxing Temple. It burned down during fighting at the end of the Yuan dynasty [1279–1368].'[33]

The identification of Longxing Temple with the Temple of the City God and the residence of Tian Wen has clear implications. Since we know that Tian Wen's residence was in the north-west of Nanyang, and since the location of the Temple of the City God was known at the time the chronicle was written also to have been in the north-west, Longxing Temple, too, must have been located there. Nevertheless, the information given in the *Qingzhoufu zhi* is not wholly accurate. Earlier texts state that Longxing Temple and the Temple of the City God stood side by side.[34] Evidently, knowledge of Longxing Temple 200 years after its destruction had become so vague that it was equated with the Temple of the City God, which was destroyed later.[35]

Older sources, written when Longxing Temple still dominated the town's appearance, help to provide more exact information. The earliest text is the inscription (originally of 1,635 characters) on the stele, dated 573, of Lou Dingyuan, magistrate of Qingzhou, who bore the honorary title King of Linhuai (fig. 26).[36] Most later authors refer to this inscription, which mentions the location of the temple, then known as Nanyang Temple, only briefly: '[The Nanyang Temple] in the east [of the empire] is a temple of the highest rank. To the left, one passes it on the way to the market place [*huanhui*]; on the right it clings to the river valley.'[37] Bearing in mind that in China maps were viewed and landscapes described from the north, this text indicates that the temple precincts were bounded in the west by the river bank and that a major road passed by it to the east.

Writing in the eleventh century, the scholar Xia Song (984–1050) had evidently seen the temple with his own eyes. In *Report Concerning the General Repair of the Central Buddha Hall of Longxing Temple of Qingzhou (Qingzhou Longxingsi chongxiu Zhongfodian ji)*, he refers to the site of the temple after some remarks in praise of the town: 'There [in Qingzhou] is a Buddha temple [*Fotu*] called in fact Longxing Temple. It used to be considered the [former] residence of Tian Wen. The precincts slope steeply to a hollow on the south bank of the Yang River. The buildings soar, as if they were floating above the double walls. To the east, a sharply descending road leads directly to the market. Looking west, one sees a great number of peaks, to the side of which is a broad plane. The twelve excellent things are all combined here.'[38] Thus Xia Song, too, notes that the temple was

Fig. 26 Stele of Lou Dingyuan, dated 573.
Limestone, height 440 cm. Sculpture Park, Qingzhou

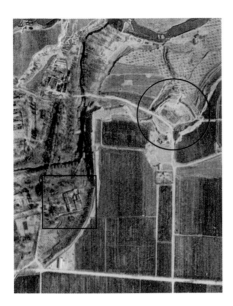

Fig. 27 Detail of fig. 25, showing the almost square temple precincts (the northern part of which is now occupied by Qingzhou Municipal Museum), the circular west gate of the town in the north-east and the Source of the Marquis Fan in the west

located beside the market road. His description of the view to the west suggests that there were no buildings in that direction, that the temple precincts lay on the edge of the town.

Another text of the Northern Song dynasty permits us to locate the temple in relation to a site still in existence: 'During the Huangyou era [1049–1054], when the Marquis Fan Wen pacified Qingzhou, a source of fresh water sprang from the valley of the River Yang, south-west of Longxing Monk's Inn.[39] The marquis had a pavilion erected above the source and commemorated the deed in an inscription in stone. Later, when the people of Qingzhou recalled the virtuous marquis, they referred to the place as Source of the Marquis Fan.'[40] The Marquis Fan pavilion and its inscribed steles have remained familiar to this day. The building was renovated in 1461.[41] Today, a small museum, clearly recognisable in the aerial photograph, marks the spot, which must have been next to the temple walls. The photograph shows a large rectangular area running from north to south and surrounded by roads and the town wall (fig. 27). To the north-east can be seen the circular shape of the 'west' gate of the town and to the south-west the Source of the Marquis Fan. The sculptures were found at a point near the centre of the rectangle. Examination of the photographs showed that the land had been levelled considerably for agricultural purposes, removing all traces of architecture.[42]

In their short descriptions of the temple the sixth- and the eleventh-century texts both refer to a *huanhui* – an encircled market place. This would therefore seem to have been the best-known feature of the region and was probably the reason why the west gate of the town lay so far north. A centuries-old landmark in the Yang valley, the market was doubtless a major traffic junction, so the west gate had to be situated near it. Longxing Temple thus occupied an excellent location. Protected in the north and west by the slopes of the river valley and, later, by the town walls, it stood close to an important market and to the gate through which people left town when travelling west (fig. 28). Moreover, it was immediately south of Qingzhou (then Dongyang) until the thirteenth century, when it found itself immediately north-west of the new administrative centre of the region in the southern part of the town (Nanyang).

The History of the Temple

Information on Longxing Temple and its history is sparse, scattered throughout the various sources. The only known dates in connection with the temple derive from inscriptions on the lost Song stele. In addition to that quoted above, the stele bore an inscription on its reverse that dated to the Jin period (1115–1234). This is quoted in the *Qisheng*: 'In the second year of the Yuanjia era [425] of the [Liu-]Song dynasty, [the temple] was called simply Buddha Hall [Fotang]. In the fourth year of the Wuping era [573] of the Northern Qi dynasty, it was given the name Nanyang Temple. In the first year of the Kaihuang era [581] of the Sui dynasty the name was changed to Changle or Daocang. In the second year of the Tianshou era [691] of [the empress Wu] Zetian the name was again changed to Dayun. Under emperor Xuanzong in the eighteenth year of Kaiyuan [730], the temple was called Longxing for the first time.'[43] The date given for the original 'Buddha Hall' is notably early. Xia Song, who in 1037 wrote the only extant description of the temple, mentions the same date:

In the temple there is a hall that was built in the second year of the Yuanjia era [425] during the [Liu-]Song dynasty. After ten times sixty years the pillars and gutters had fallen apart. The monk Zhoushu, having resided there for a long time, persuaded the people of Qingzhou to collect three million cash for the renovation of the building. It was strengthened by a stone terrace and fortified with lacquered bars. Behind, two

Fig. 28 Qingzhou Municipal Museum from the west, overlooking the River Yang on the site of the former Longxing Temple precincts

pavilions were added. The left one contains a [stone stele with an] engraved text. The right one contains a drum stand. According to tradition, the table companions of [Prince] Mengchang used the [beat of the] drum to mark time. Its stand is still extant. After so many years the wood and stone are worn. Even if [today's stand] with immortals [*feixian*] painted on it does not date from that ancient time, the monks of the temple consider it a treasure.[44]

Though marshalling their information differently, these two texts would seem to draw on a single source, possibly a stele inscription. The date 425 may well have been mentioned in the inscription that Xia Song notes as appearing in a prominent position in the temple, and the Jin period author might have been familiar with this.[45] At the very least, the sources indicate that the history of Longxing Temple reached back to the fifth century and that it was thus one of the oldest temples in Qingzhou.

Information on the appearance of the temple in subsequent centuries is scant. The inscription on the stele of Lou Dingyuan mentions a pagoda, but this does not appear in later records: it probably did not stand for long. Reporting in his diary on his sojourn at Longxing Temple in 840, Ennin names only two buildings: the Korean Hall (Xinluoyuan), in which he stayed,[46] and the Hall of the Summer Sacrifice (Xiagongyuan), to which he was invited to a supper with 50 other monks.[47] Further texts mention in passing a Hall of the Old Cypresses (Laoboyuan) in the northern part of the precincts, where there later stood a structure known as Heaven's Palace Hall (Tiangongyuan).[48] Such references cannot convey an adequate idea of the temple buildings, which, as we have seen, Xia Song described as seemingly 'floating above the double walls'; and the 573 stele inscription was said to be 'more magnificent than the Palace of Heaven [Huagong]'.[49] That the temple precincts were large can, however, be gauged from the walls and paths visible in the aerial photographs of 1975.

The temple lost its importance in the course of the Jin and Yuan dynasties. The decline seems to have been gradual: no source gives an exact date for its demise. One mentions fighting at the end of the Yuan dynasty (1279–1368), during which Longxing Temple (or the neighbouring Temple of the City God) burned down.[50] Another refers to building activity in the early Hongwu era (1368–1398) that involved demolishing the temple.[51] Moreover, its ruins may have been quarried for building material when the brick town wall was constructed in 1370.

Less than a century later, and some thousand years after its foundation, all traces of the temple seem to have vanished and its location to have been forgotten. This is clear from the entry for the Marquis Fan pavilion in the *Qingzhoufu zhi* of 1565, which quotes numerous poems inscribed in steles after the reconstruction of the pavilion in 1461. The poems describe the healing powers of the water and the idyllic location of the pavilion in the river valley, but none refers to Longxing Temple, which had stood only a few dozen metres away.[52] Neither is the temple listed in the section of the same chronicle entitled 'Si Guan' (Buddhist and Daoist

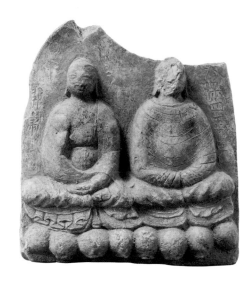

Fig. 29 Votive stele, dated 553. Clay, height 12.5 cm. Qingzhou Municipal Museum

Monasteries), which mentions only the stele of Lou Dingyuan (then housed in the Amitābha Temple [Mituosi] on the north side of the river). In the corresponding section of a local chronicle of the Jiaqing era (1796–1820) this last piece of information was misconstrued to mean that Longxing Temple had stood on the site of the Amitābha Temple.[53]

The Sculptures

The aesthetic appeal of the sculptures selected for inclusion here should not obscure the fact that the Longxing find contains figures of widely varying artistic quality. Some reveal no more than average skill on the part of their carvers or the limited financial means of their donors (fig. 29). Moreover, the figures differ so greatly in size, material and appearance that they could hardly have come from a single hall with specific ritual requirements. Simple clay items exist alongside figures made from iron or wood, and even the stone images shown here are too diverse in scale, sculptural finish and colour to have constituted a set.

The free-standing figures of the Northern Qi dynasty are a case in point. Extant cave temples of this period indicate that statues in cult spaces were arranged symmetrically.[54] The sculptures from the Longxing find thus have to be imagined as belonging to groups, such as triads showing the Buddha in the centre and bodhisattvas and other figures on either side. However, the free-standing bodhisattvas in the hoard did not form pairs, and it soon became obvious that the find represented the complete sculptural furnishing neither of a single hall nor of an entire temple. Rather, the figures are a random group of cult images that happened to have survived the 500 years from their creation to the sealing of the pit in which they had been deposited.

The number of figures unearthed is likewise surprising. Certainly, the making of cult images was determined not solely by the needs of a temple, but also by those who donated such

images; in other words, more than the required number of statues might be set up. Yet it is still difficult to imagine that the 400 sculptures represented by the fragments excavated, the missing bodhisattva pendants and the lost figures made of clay and wood were accommodated in a single temple. It seems safe to assume that the sculptures shown here were not all installed at Longxing Temple in the sixth century. Some of the pieces no doubt came from other temples, perhaps following their closure or destruction.

None of the figures excavated would seem have been the main image of the temple, the focal point of the other statues. The inscription on the Lou Dingyuan stele is evidently referring to this image when it reports: '[Lou Dingyuan] had a figure of Amitāyus [Wuliangshou-fo] made that measured three *zhang* and nine *chi*, and also two statues of Avalokiteshvara [Guanshiyin] and Mahāstāmaprāpta [Dashizhi], which were placed at his side.'[55] During the Northern Qi dynasty, one *zhang* measured 10 *chi* and corresponded to 3.02 m. If the inscription is to be believed, the Longxing Amitāyus was almost twelve metres tall, i.e. more than double the height of the colossal statues in Linzi, Boxing and Qingdao. An image of such huge dimensions has not survived.

Amitāyus, the 'Buddha of the immeasurably long life', is a manifestation of Buddha Amitābha. He is the main deity of the Pure Land school (*Jingtu zong*) of Buddhism, a relatively young movement at the time.[56] This school promulgated a simplified path to salvation, based not on the notion of Karma, which required life-long religious exercises, and still less on the intellectually demanding attainment of transcendent wisdom, but on the direct worship of Amitābha. Devotion to Amitābha and the repetition of his name were sufficient to gain entry to the Pure Land, or the Western Paradise, as it was also known.[57]

In the sixth century various forms of Buddhism might be practised in a single temple. It should not be assumed, therefore, that Longxing Temple adhered exclusively to the Pure Land teaching. Yet the simplified religious practices involved in the veneration of Amitābha were easily accessible to lay believers and no doubt contributed greatly to the flowering of Longxing Temple and of Buddhism in Shandong as a whole.

The Interment of the Sculptures

Study of the figure hoard of Longxing Temple has barely begun, but all scholars believe that the images were accorded a ritual burial. One of the few theories advanced to explain the interment suggests that the images were damaged in warfare in Qingzhou in 1127–9 and were buried thereafter.[58] This overlooks the fact that the pit contained almost exclusively items dating from the sixth century. Buddhist sculpture flourished during the Sui (581–618), Tang (618–907) and Song (960–1279) dynasties and works of these periods would certainly have existed at Longxing Temple. Hence, if the temple had been damaged and forced to remove its statuary in the twelfth century the hoard would have contained many more pieces from the period between the creation of the excavated sculptures and their interment.

The most frequently voiced opinion is that the figures were buried as a result of an anti-Buddhist edict issued in 1119 by the Song emperor Huizong (r. 1101–1125).[59] This decreed that Buddhist temples adopt Daoist names and that Buddhist monks wear Daoist robes and use their former Chinese family names. Adherents of this theory claim that the Longxing Temple images were destroyed in iconoclastic raids and that monks collected the fragments and buried them to protect them from further violence. China is no stranger to anti-Buddhist movements, and their often devastating consequences are well documented in historical sources. Yet no such excesses are recorded in connection with Emperor Huizong's edict and, since he revoked it the following year, its effects will have been fairly limited.

The broken figures themselves contain evidence suggesting that they were not destroyed in iconoclastic attacks. Such attacks often focus on the face of an image, since that is its most vulnerable part and damage to it is most likely to rob the image of religious efficacy. The faces and the arms and other protruding parts of some of the Longxing figures were indeed deliberately disfigured and broken (see cat. 6),[60] but this does not seem to have been the case with the majority of the sculptures, including virtually all the items shown here. Neither the delicate facial features and pronounced noses of some figures (see cat. 12, 31) nor the hand held away from the body

Fig. 30 Bodhisattva, detail from cat. 31

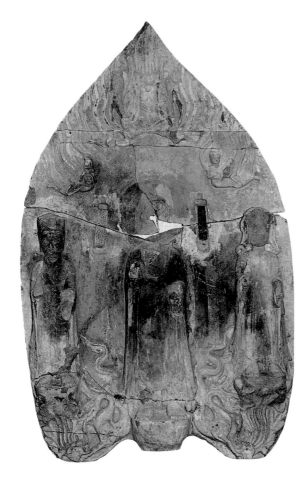

Fig. 31 Figure triad showing traces of fire, first half of the sixth century. Limestone. Qingzhou Municipal Museum

Fig. 32 Broken stele, first half of the sixth century. Limestone, height approx. 60 cm. Qingzhou Municipal Museum.

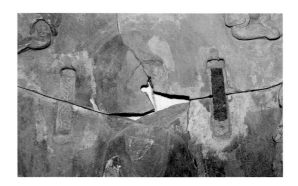

Fig. 33 Detail from fig. 31 showing an early repair by means of an iron clamp

of one bodhisattva (fig. 30) would have withstood a blow from a club or any other such implement.

The condition of the figures yields further information. Two sculptures included here (cat. 7, 12) must have fallen on their backs: though split in two across their width, their slightly protruding heads are undamaged. They may have been victims of an earthquake, especially since the bodhisattva (cat. 12) weighs 300 kg without the pedestal and is therefore difficult to topple.[61] Several statues betray clear evidence of damage by fire: some show soot stains (fig. 31 and the top of the mandorla in cat. 7), others appear to have broken into pieces owing to extreme heat (fig. 32). The collapse of a roof or damage done during the repair of a temple building are other ways in which the sculptures could have been harmed accidentally.[62]

As noted above, most of the figures found in the pit were damaged or incomplete at the time of their interment. Many had been repaired several times (fig. 33; cat. 5, 19). The monks possibly thought further repairs pointless, perhaps because the 500-year-old statues did not accord with Song dynasty styles or ritual requirements. Another feature points in the same direction. The fragments of one

Buddha statue display differing degrees of wear. No gilding remains on the shins, but it is intact on the feet, which were reattached after excavation. This suggests that the statue was broken and the two fragments exposed to different conditions long before their interment. A similar phenomenon can be seen on a bodhisattva where the paint on the torso is differently preserved from that on the head, which had been detached from the rest of the figure (cat. 32). It would seem that the damaged cult images were gradually withdrawn from their religious context and stored in rooms reserved for that purpose.

In Linqu, only a few kilometres from Qingzhou, an inscription states that in 1004 monks collected damaged figures from a temple and buried them ceremoniously in a pit. They built a pagoda on the spot and commemorated their deed in an inscription.[63] It is perfectly conceivable that the monks of Longxing Temple were following customary practice when, in the early twelfth century, they dug a pit in the precincts of their temple and reverently laid to rest the damaged remains of cult images that had long since performed no religious function.

NOTES

1 The archaeological sites of the Linzi region have been examined and mapped from the air by the archaeologist Song Baoquan: *Zhongguo Linzi* 2000.

2 In conversation with the author in April 2001, Xia Mingcai voiced the opinion that the mountain silhouette was retouched in the area of the 'mouth' in the sixth century.

3 Xia and Zhuang 1996, p. 61.

4 Dated examples known to the author are: the stele from Qingzhou in Shandong Provincial Museum (Sirén 1925, vol. 1, pl. 161), commissioned by Zhang Baozhu in 525; two steles of 525 and 523 respectively in the museum in Boxing; a stele of 527 from Zhuliang in Qingzhou Municipal Museum (fig. 55); and a sculpture of 524 from Zhongxing Temple in the Linzi museum. A number of undated pieces also exist.

5 Four such sculptures from Linzi have been in Qingdao Municipal Museum since 1945, following an unsuccessful attempt by the Japanese to take them out of the country (fig. 35). Two further statues still stand on the site of the former Xitian Temple in Linzi, now destroyed, while another, from the Boxing region, 90 kilometres north-west of Qingzhou, has been published in Matsubara 1995, p. 239.

6 Most finds were buried in the years following 577. See the essay by Zhang Zong in the present volume.

7 For a detailed account of the discovery, see Doar 1999.

8 A seated bodhisattva similar to cat. 32 was offered at auction by Christie's, London, in June 1999 (lot 25) with a lower estimated price of US$ 290,000. The figure is now in the Baoli Museum in Beijing. *Baoli cangzhen* 2000, pp. 159–60.

9 Some figures now in Taiwanese private collections and in the Baoli Museum in Beijing are said to have come from the site of Xingguo Temple in the eastern part of Qingzhou, a site that was plundered in the late 1980s and early 1990s. *Contemplation* 1997 and *Baoli cangzhen* 2000. One of the most beautiful sculptures from this region, a standing bodhisattva of the Eastern Wei dynasty with a large head nimbus, excavated in 1976 in Boxing County, north-west of Qingzhou, was stolen in the early 1990s and offered for sale in London in 1995, since when it has been in the Miho Museum in Japan. Chang and Li 1983, esp. pl. 5–3; Eskenazi 1995, no. 47; and *Miho Museum* 1997, no. 124. The Miho Museum now accords the figure the status of a Chinese loan.

10 Information on the discovery of the hoard has been drawn from the preliminary excavation report in *Wenwu* 1998a, pp. 4–15, from Xia Mingcai 1998, Xia Mingcai 1999 and Doar 1999, and from conversations in April 2001 with the director of Qingzhou Municipal Museum, Wang Huaqing, and his colleagues Xia Mingcai and Sun Xinsheng, all three of whom participated in the excavations.

11 Wang Huaqing 2001, p. 113, fig. 4.

12 *Wenwu* 1998a, p. 5. Exact numbers have not been published.

13 One such figure is illustrated in Wang Huaqing 2001, p. 66, fig. 3.

14 All those involved in the excavation whom I consulted agreed on this point.

15 *Wenwu* 1998a, p. 14, where the authors suppose that the coins were strewn over the figures.

16 The exact numbers could not be ascertained.

17 Conversation with the author, April 2001.

18 Xia Mingcai 1999, p. 9.

19 The finds included a 1.6m-long roof ridge tile and a stone pillar bearing a dragon relief, both dating from the mid-Tang dynasty. Su Bai 1999c, fig. 2, 3.

20 Su Bai 1999b and 1999c.

21 Song Baoquan is currently research fellow in the Department of Pre- and Early History at the Ruhr Universität. From 1996 to 1999 he participated in a German–Chinese research project by undertaking an archaeological survey of the Linzi region with the help of aerial photography and field research, which he documented in map form. The aerial photographs used here were taken from a height of 1000 metres in 1975 by the surveying authorities of Shandong Province to assist in the production of topographical maps.

22 Qingzhou Municipal Museum has been in existence since 1959. Work on the new building on the River Yang was partly completed by 1989. The southern wing, a section of which overlaps the site of Longxing Temple, was not finished until the late 1990s. *Weifang* 2000, pp. 291–2.

23 *Qingzhoushi zhi* 1989, pp. 103–25.

24 Entry for the third day of the fourth month, 840. Reischauer 1955, p. 200, and Su Bai 1999b, p. 48.

25 *Qisheng*, section 3, quoted in Su Bai 1999b, p. 49. The devastating battles are described in Su Jinren 2000.

26 *Wudai Shiji*, quoted in Su Bai 1999b, p. 49.

27 Su Jinren 2000.

28 *Da Qing yitongzhi* n.d., vol. 61, section 170, p. 2112.

29 The chronicle, written by Yu Qin, records events to 1316 and was furnished with a preface by Su Tianjue in 1339.

30 Quoted in Su Bai 1999b, p. 47. The inscription is known only from written sources, which do not give the date of the stele. The expression *Songbei* (Song stele) evidently refers to the Liu-Song dynasty (420–479) rather than the Northern Song dynasty (960–1127). See note 45.

31 Liu Shanming was governor during the Liu-Song dynasty (420–479). In the course of a terrible famine in the Yuanjia era (424–453) he provided the population of Qingzhou with grain produced on his own land. The *Qisheng* states that Liu Shanming's residence was later called Buddha Hall (*Fotang*) and was eventually

turned into a temple. Su Bai 1999b, p. 47.

32 *Qingzhoufu zhi* 1989, section 7, p. 23a.

33 *Qingzhoufu zhi* 1989, section 10, p. 11b. The accuracy of this account is open to doubt. The inscription on the stele of Lou Dingyuan (573), which was certainly the chronicler's source of information about the construction of the hall, does indeed mention building activity, but the temple was already in existence at this time.

34 According to these sources, the Temple of the City God stood east of Longxing Temple. Su Bai 1999c, n. 25.

35 The Temple of the City God was moved to the north side of the River Yang at the beginning of the Hongwu era (1368–1398) in the Ming dynasty. Su Bai 1999b, n. 25.

36 The stele has sustained heavy damage over the centuries. Sun Xingsheng 1999a and *Qingzhoushi zhi* 1989, p. 856. The inscription is printed in full in *Qingzhoufu zhi*, section 11, pp. 66b–8b.

37 *Qingzhoufu zhi* 1965, section 11, p. 68a.

38 Xia Song 1986, section 21, p. 8b.

39 The original text reads 'Xinglong sengshe', converting the characters for Longxing into Xinglong. The error has been corrected here in the interests of clarity.

40 *Shengshui yan tanlüe*, section 8; quoted in Su Bai 1999c, p. 37.

41 *Qingzhoufu zhi* 1965, section 7, p. 29b.

42 It is not known when the area was levelled, but the *Guangxu Yiduxian tuzhi* (section 13) reports that fields here were being farmed at the beginning of the Ming dynasty. Su Bai 1999c, p. 40. Final results of an examination of the site undertaken shortly after the discovery of the sculptures have not yet been published. Preliminary statements (for example, Xia Mingcai 1998, p. 41) do not agree with the description by Xia Song and are not substantiated by the aerial photographs.

43 *Qisheng*, section 4; quoted in Su Bai 1999c, p. 38. Since the temple still existed when the inscription was written, it may be assumed that the information was based on documents or on reliable oral tradition. Only the statement that in 573 the name of the temple was changed to Nanyang Temple seems incorrect. The chronicler certainly derived this information from the stele of Lou Dingyuan, set up that year and including the name Nanyang Temple in its inscription. No extant records refer to an official change of name, however, and Nanyang Temple may simply have been the traditional name of the temple because it stood near the bend in the River Yang, which was also called the River Nanyang. For the author of the inscription, the first half of the sixth century must have appeared very remote: he knows nothing worthy of mention from this glorious time in the temple's history and, as a result, we are not even familiar with its official name. Su Bai 1999c, n. 3.

44 Xia Song 1986, section 21, p. 8b. I am grateful to Klaas Ruitenbeek for providing help with the translation at very short notice.

45 It may be assumed that the stele in the pavilion was the Song stele. All knowledge of the temple's beginnings derives from the inscription on this stele and from that on the stele of Lou Dingyuan. The latter does not mention the year 425, so the date probably derives from the Song stele, which may have been erected in 425 in the new 'Buddha Hall' and thus came to be called 'Stele of the [Liu-]Song period' (the Liu-Song reigned from 420 to 479).

46 The Xinluoyuan served as the official quarters for travellers from various countries. Reischauer 1955, n. 695.

47 Reischauer 1955, pp. 195, 197.

48 Su Bai 1999c, p. 40.

49 *Qingzhoufu zhi* 1965, section 11, p. 68a.

50 *Qingzhoufu zhi* 1965, section 10, p. 11b.

51 *Guangxu Yiduxian tuzhi*, section 13; quoted in Su Bai 1999c, p. 40.

52 *Qingzhoufu zhi* 1965, section 7, pp. 28b–30b.

53 *Da Qing yitongzhi* n.d., vol. 61, section 170, p. 2112.

54 See the caves at Xiangtangshan in Hebei. Tsiang Mino 1996.

55 *Qingzhoufu zhi* 1965, section 11, p. 68a. Several expressions in the stele inscription, which states that the figures were made of stone, indicate that the new main image replaced an earlier figure of Amitāyus.

56 Shandao (613–681) is traditionally considered the founding father of the Pure Land school, which acquired great influence during the Tang dynasty; yet the real founder was Huiyuan (334–417), who in 402 is reported to have led a gathering of monks and laymen in worshipping Amitābha and the Western Paradise. Gernet 1982.

57 Until the Sui dynasty (589–618) the Buddha of the Western Paradise was generally called Wuliangshoufo (Amitāyus); he was later replaced by Emituofo (Amitābha). The terminology used in the inscription on the Lou Dingyuan stele follows the *Sukhāvatī* Sūtra, translated in 252 by Samghavarman. Among other pious deeds, this sūtra demanded of believers that they scatter flowers, burn incense and set up cult images. Soper 1959, pp. 142–3.

58 Su Jinren 2000.

59 Sun Xinsheng 1999b, 2001a and 2001b.

60 *Qingzhou yishu* 1999, fig. 18, 44.

61 The last earthquake recorded in Qingzhou prior to the sealing of the pit occurred in 1046. *Qingzhoufu zhi* 1965, section 5, p. 24b.

62 In the passage quoted above, Xia Song mentions that renovation work was carried out in the temple in 1037.

63 See also the essay by Zhang Zong in the present volume.

THE QINGZHOU REGION:
A CENTRE OF BUDDHIST ART IN THE SIXTH CENTURY

ZHANG ZONG

The Remains of Buddhist Art in Shandong

Three kinds of Buddhist object have been preserved in Shandong Province: cave temples, containing large figure groups; sūtra texts carved into rock; and single stone or bronze figures. The cave temples of Shandong Province are concentrated in three small areas[1] and contain figures from the Northern Wei (386–534) to the Song (960–1279) dynasty. The size of these cave temples renders them rather insignificant and only the seventh-century works they contain are of any artistic importance: the number and the quality of the images lag well behind those in the famous cave temples of Shanxi and Henan. Since cave temples have generally been viewed as the most important monuments of Chinese Buddhism, the Buddhist art of Shandong has received little attention.

Shandong's sūtra inscriptions are of greater interest.[2] In other parts of China such inscriptions are found mostly in cave temples.[3]

The fact that they were carved into rock outside the context of cave temples is a special feature of Shandong's Buddhist art. Most of the inscriptions date from the Northern Qi dynasty (550–577), i.e. from towards the end of the period of the Northern and Southern dynasties. Some appear on steles, yet most were carved in large characters directly into rock faces – a specifically Shandong tradition that was no doubt influenced by the Confucian and Daoist rock inscriptions of the Northern Wei dynasty in nearby Caizhou.[4]

Not until archaeological excavations uncovered large numbers of sculptures did Shandong's Buddhist art attract any serious scholarly attention. The hoard found at Longxing Temple alone brought to light more than 400 figures, mostly dating from the sixth century. The figures are of exceptionally high artistic quality, finely carved and with their polychromy unusually well preserved. Yet the Longxing Temple find was one among many in the Qingzhou area,

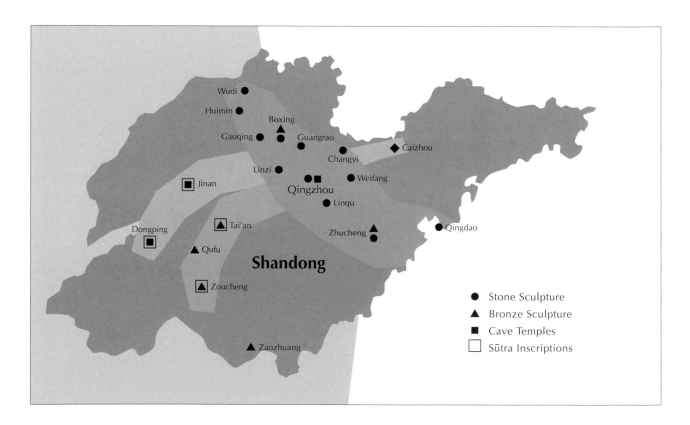

Fig. 34 Distribution of underground figure hoards, cave temples and sūtra inscriptions in Shandong Province

44

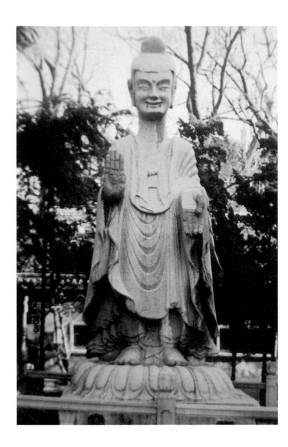

Fig. 35 Buddha from Longquan Temple in Zichuan,
Northern Wei dynasty (386–534). Stone,
height approx. 6m. Qingdao Municipal Museum

where more than one thousand Buddhist sculptures have been unearthed.[5] The only other major underground hoards of Buddhist figures to have been discovered in China are those of the former Xiude Temple in Quyang, Hebei Province, and the former Wanfo Temple in Chengdu, Sichuan Province. Neither the number of objects found at these two sites (which are also known by their historical names, Dingzhou and Yizhou respectively) nor their stylistic variety matches those of the Qingzhou figures, which are thus of prime importance for our knowledge of Buddhist art in China.

The Longxing discovery raises two main questions: why were there so many Buddhist sculptures in Qingzhou and its environs, and why were they buried?[6] Until the Ming dynasty (1368–1644) Qingzhou was the political centre of Shandong. Buddhist sculpture evidently flourished in this region: the map (fig. 34) shows that all three forms of Buddhist art mentioned above are represented here. The cave temples are located in an east–west band near the Yellow River. The sūtra inscriptions occur mainly in the region of Taishan and Yishan in the south-west of the province, although the inscriptions at Caizhou, which influenced those of Taishan and Yishan, are in the north near the coast. Single Buddhist figures have been found at a larger number of sites than have cave temples or sūtra inscriptions. The bronze figures, generally small and therefore easily transported, are scattered over a relatively large area, whereas

the stone sculptures all lie on a line stretching from the north-west to the south-east. The pieces found in the north show similarities with figures from the region of Dingzhou in neighbouring Hebei Province. One notes that it is at Qingzhou that the area with the cave temples overlaps that containing stone figures.

The Interment of Buddhist Images

Not all stone and bronze Buddhist sculptures in Shandong were found in underground hoards. As in other parts of northern China, many pieces survived – and indeed survive – in their original location (see fig. 35).[7] Such works were doubtless too large and too heavy to be moved. Thus the chronicle of Boxing County, *Boxingxian zhi*, could state: 'The temple is destroyed, but a stone image stands on the hill.' In addition, most local museums contain figures of unknown provenance.

Of the excavated items, some were not interred until the Qing dynasty (1644–1911)[8] and, although most were found in hoards, others had been lowered into wells, buried in the foundations of pagodas or deposited individually. They have frequently been discovered by accident during construction work.

The following list gives the most important finds of Buddhist sculpture in Shandong, some of them still unpublished:

– six bronze Buddhas dated 572 in an inscription, found in 1988 on the site of the former Shengguo Temple in Qufu;
– twenty bronze sculptures, four bearing dates between 553 and 601, found in 1978 near an old temple in Zaozhuang;[9]
– four bronze sculptures of the Bodhisattva Guanyin, dated between 533 and 562,[10] excavated in 1975 in Zoucheng;
– a nimbus and two pedestals of bronze figures, found between 1982 and 1984 in Tai'an County;[11]
– more than 70 stone or clay figures, nine dated in their inscriptions to between 547 and 570, and a bronze Buddha, found in 1976 on the site of the former Longhua Temple in Boxing County;
– more than 100 bronze figures, 77 complete, 44 bearing inscriptions dating all but four of them to between 478 and 603, found in 1983, again on the site of the former Longhua Temple, Boxing County;
– a hoard of bronze figures, found in 1983, also on the site of the former Longhua Temple, Boxing County;[12]
– stone sculptures at eight or nine other sites of former temples in Boxing County, temples not mentioned in local chronicles;[13]
– several bronze sculptures, found on the site of the former Qingyun Temple in Zhucheng;
– more than 300 stone sculptures, over twenty bearing inscriptions with dates between 545 and 556, excavated from 1988 to 1990 at sports grounds and other sites in Zhucheng;[14]
– 17 sculptures, dated 569, discovered in Zhucheng during the Qing dynasty;[15]
– more than 100 stone heads, torsos and pedestals, one bearing the date of commission, 573, found in 1981 near Fahai Temple in the Chengyang district of Qingdao;[16]

- a group of stone sculptures dating to between 546 and 568 and a bronze nimbus dated 495, found in 1976 in Gaoqing County;[17]
- a group of stone sculptures, some bearing dates from 554 to 567, found before 1983 in Wudi County;[18]
- 17 figures bearing dates between 537 and 570, found in 1997 near Yulin Temple in Huimin County;
- 32 stone sculptures and a ceramic figure bearing dates between 540 and 561, found in 1996 in a well on the site of the former Baogai Temple in Changyi County;[19]
- a number of figures, found in the 1960s on the site of the former Mingdao Temple at Yishan in Linqu County, followed in 1988 by 100 further pieces, nine of them bearing inscriptions with dates between c. 520 and 596;[20]
- almost 40 figures dated to between 537 and 544, found in 1981 near the site of the former Xingguo Temple in Qingzhou;
- fragments of sculptures with pigmentation and gilding in excellent condition, found later on the sites of the former Qiji and Longxing Temples in Qingzhou;
- a hoard of more than 400 figures, discovered in 1996 on the former site of Longxing Temple in Qingzhou.[21]

As this list shows, bronze objects have been discovered in Boxing, Tai'an, Qufu, Zhucheng, Zaozhuang and Zoucheng. The more than 100 bronze sculptures found in Boxing County had been placed in a terracotta vessel buried 40 centimetres below ground, while the other bronze figures excavated there were arranged in rows in a pit 50 centimetres deep. The sculptures discovered on the site of Qingyun Temple in Zhucheng had been put in a ceramic vessel and buried at a depth of one metre. The bodhisattva figures, the nimbus and the pedestal found in Tai'an are unlikely to have been deposited in a container or pit because they were discovered at different sites. The figures from Zoucheng were found 80 centimetres below ground and had probably been buried originally in an earth pit, like that one metre in depth in which the figures from Zaozhuang were discovered. The evidence of these finds suggests that bronze figures were often interred in ceramic vessels.

The stone sculptures had been deposited in old wells, earth pits or the foundations of buildings. Only the figures from Gaoqing County, found at a depth of 50 centimetres and scattered over an area approximately 100 metres long, certainly did not form a hoard. Apart from the Changyi figures, which were lying in an old well, most of the stone sculptures were found in underground pits, carefully distributed in several layers. The size of the pits and the number of figures they contained varied a great deal, as follows:

- The more than 400 figures found in the 50-square-metre pit in the northern part of the former precincts of Longxing Temple in Qingzhou had been buried in several layers. The lowest of these contained coins dating from the late Northern Song dynasty (960–1127).
- The sculptures discovered over the last two decades on the site of the former Xingguo Temple in Qingzhou, some of which have found their way abroad, probably come from various earth pits.

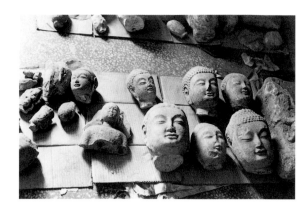

Fig. 36 Heads from stone statues of the Buddha, from the subterranean palace of the pagoda of the Mingdao Temple in Linqu County; sixth century. Mingdao Museum

- The items from Zhucheng County were all found in specially dug pits. Single figures, and fragments of bodies, heads and feet, had been distributed among several pits. One of the larger pits was examined by experts from the local museum. Its opening was rectangular, measured approximately nine square metres and lay on an east–west axis. The pit itself lay 50 centimetres underground and was one metre deep. Inside, 26 fragments of bodies had been placed on top of each other in two layers in a west–east direction, their fronts facing upwards.
- The sculptures from the Mingdao Temple south of Linqu had been deposited in a subterranean 'earth palace' (didong) in the foundations of the reliquary pagoda. This chamber was opened during the Cultural Revolution in the early 1970s, when some of the sculptures were used as building material. Not until 1984 did the local authority responsible for cultural affairs order a thorough examination of the finds. The chamber, circular in plan with a diameter of 210 cm, was three metres high and had a pointed ceiling. A total of more than 400 fragments from 100 Buddhist figures were found there (fig. 36). They had been deposited face down in three layers in what was obviously a careful arrangement.

The Interment of Figures: An Act of Piety

The Inscription on the Reliquary Pagoda of the Mingdao Temple at Yishan (Yishan Mingdaosi shelita biji), a memorial inscription dating from the Northern Song dynasty (960–1127), reports that in 1004 the monks Juerong and Shouzong from the prefectures Ba and Mo (in present-day Hebei Province) were passing by the temple. Seeing 'more than 300 broken Buddha figures', they vowed to erect a reliquary pagoda and bury the fragments beneath it. Among those representing the local authorities at the ceremony marking the completion of the pagoda was the regional commander of the Zhenhai army, Zheng Guichang. Numerous monks and nuns also took part, including, significantly, the monk Yiyong from Longxing Temple.[22] Longxing lay only a few dozen kilometres from Mingdao

and the two temples were undoubtedly in close contact. Of more general importance is that the inscription makes it clear that the itinerant monks buried the Buddhist sculptures as an act of piety. Deeds of this kind could look back on a long tradition, for Buddhist monks and laymen had always been careful to repair and preserve damaged statues of the Buddha.

Buddhists were persecuted four times in China during the first millennium AD, in 446 under the Northern Wei, in 574 under the Northern Zhou, from 842 to 845 under the Tang and in 955 under the Later Zhou. In all four instances the emperor issued edicts prohibiting the Buddhist religion and ordering the destruction of Buddhist images. In each case, the emperor's successor attempted to make good the loss. Thus Emperor Wen (r. 581–605) of the Sui dynasty issued an edict at the beginning of his reign promoting a revival of Buddhism and urging everybody to donate money for the copying of sūtras and the making of Buddhist images. Of particular interest in the present context is another event involving Emperor Wen, recorded in the biography of the monk Tanqian in *Further Biographies of Eminent Monks* (*Xu Gaoseng zhuan*). This tells how Yang Xiu, king of Shu, came upon a caved-in pit while pursuing an animal on a hunt in the Nanshan Mountains. The pit was filled with broken Buddha images that had been buried there after the ban on Buddhism proclaimed by Emperor Wu of the Northern Zhou dynasty. When Tanqian reported the incident to the emperor, Wen issued an edict ordering damaged Buddhist figures to be collected carefully in all administrative districts and taken to the nearest temple. He also decreed that the inhabitants of all counties and prefectures should donate money for the repair of the figures.[23]

There can be no doubt that the burial of Buddhist statues in Shandong relates to the persecutions suffered by Buddhists, but no precise chronological connections can be established. The time chart (fig. 37) reveals that the majority of the images deposited in pits date from the sixth century, especially its third quarter. The Longxing and Mingdao sculptures, although they were not interred until the Song dynasty, date from this period. The chart further shows that the figures were buried at three times: at the end of the period of the Southern and Northern dynasties, at the end of the Sui dynasty and during the Northern Song dynasty. The hoards with items dating from the end of the Southern and Northern dynasties – such as those found at Qingyun Temple in Zhucheng, where sculptures were buried in various pits according to size – may well have been interred at the beginning of the Sui dynasty as part of the efforts to revive Buddhism after the persecutions of 574. The bronze and stone objects found at Longhua Temple in Boxing County, which included figures dating from the late Sui dynasty, may have been buried when the temple fell into decline. The painting and gilding of the Longxing Temple figures, interred during the Northern Song dynasty, show evidence of retouching and repainting, yet it is not clear whether the figures had continued to be used for ritual purposes until the Song dynasty or whether they were removed from another hoard and reburied.

The Typology of the Longxing Temple Sculptures

The distinction customary in Western art between sculpture in the round and relief applies only in part to Chinese Buddhist sculpture. Many Chinese pieces possess features characteristic of both genres.

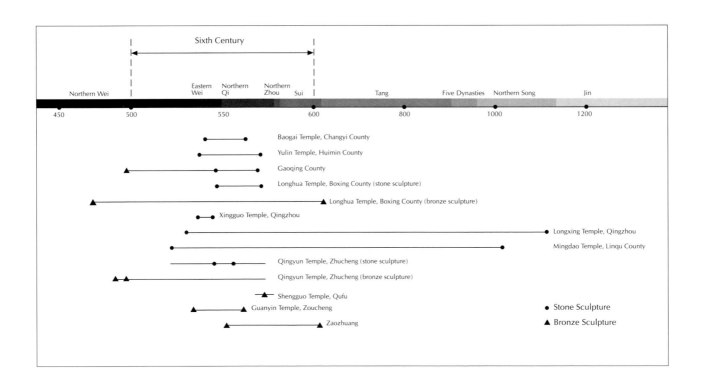

Fig. 37 Time chart showing finds of Buddhist sculpture in Shandong. Dynasties appear on the time line at the top, the individual finds below, with points marking the earliest and the latest dates inscribed on objects in the finds

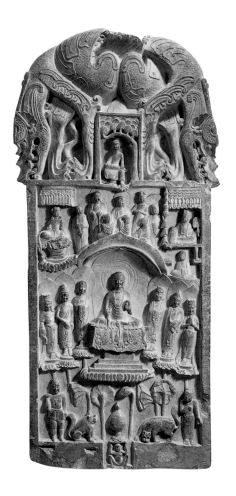

Fig. 38a Miniature pagoda, dated 532. Marble, height 41 cm.
Whereabouts unknown

Fig. 38b Votive stele of the family Yan, dated 557.
Stone, height 150 cm. Museum Rietberg Zürich

Figures may be sculpted in the round, for example, but also be attached to a nimbus behind the body or head. Furthermore, both the haloes and the figures may bear relief decoration (see cat. 26), which in turn may carry engraved ornamentation.[24] A more useful distinction in Chinese Buddhist sculpture is that between movable and unmovable works. The latter include the cave temples and the sculptures hewn into rock, the former items made from bronze, stone, clay, lacquer or wood. Movable sculptures may be divided into three groups: free-standing figures and groups of figures, figure steles and miniature pagodas decorated with figures. Each group has its own typological variants. The miniature pagodas are mostly embellished with figures in niches and have either a hemispherical roof (in the style of Indian stūpas) or a hipped roof (fig. 38a). Steles of the traditional Chinese shape (*bei*) usually have niches with figures on both sides and are crowned by a pair of entwined dragons (fig. 38b). Free-standing figures and figure groups are divided into works with body halos (*beiguang*), pieces with head halos (*dingguang*) and figures sculpted in the round, which occur in a variety of materials.

Very few miniature pagodas have been found in the Qingzhou region[25] and figure steles, too, are extremely rare.[26] On the other hand, free-standing figures and figure groups are well represented. All three types occur among the works from Longxing Temple included here: figures sculpted in the round, figures with a head nimbus and figures with a body nimbus. A triad over three metres high belongs in the last of these categories (cat. 5). Its giant nimbus is decorated with lotus flowers, flying heavenly beings (see cat. 7) and a small pagoda. Between the Buddha and the attendant bodhisattvas are two dragons. Such triads with a large, pointed mandorla are among the most important types of image in the Longxing find. They are also common in Wudi, Huimin and Guangrao counties, in other places in the Qingzhou region and indeed throughout northern China. The two dragons on either side of the Buddha, however, are peculiar to Qingzhou.

The type of figure with a round head nimbus is ancient – it occurs in Gandhāra among the earliest of all Buddhist images – and is very widespread. Many of the free-standing figures from Longxing Temple have a small hole or an iron hook at the back of the head for fastening the nimbus (cat. 19),[27] yet in other cases the nimbus was carved from the same piece of stone as the figure. This type was particularly common in the Northern Qi dynasty (550–577; see cat. 22), and it was during this era that a masterpiece of the

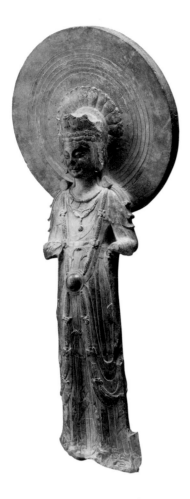

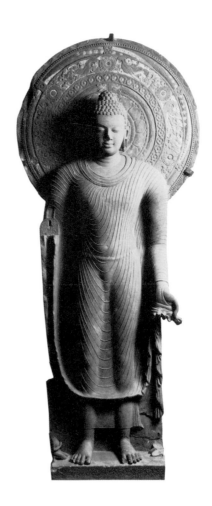

Fig. 39 Standing Bodhisattva, excavated at Longhua Temple,
Boxing County; first half of sixth century.
Stone, height 120 cm. Miho Museum, Japan

Fig. 40 Standing Bodhisattva, from Jamalpur/Mathurā, Uttar
Pradesh, India; fifth century. Sandstone, height 220 cm.
Archaeological Museum, Mathurā

genre was created: the bodhisattva excavated on the site of the
former Longhua Temple in Boxing and now in the Miho Museum in
Japan (fig. 39).[28] The bodhisattva wears a high-waisted lower
garment and a narrow chest cloth of thin material, worn diagonally.
His hair is separated into two strands by round pieces of jewellery
on his shoulders. A splendid pearl necklace of several strings hangs
down to his knees, held together at his stomach by a large jewel.
Both forearms are missing. The folds of the undergarment are finely
carved and its seam is turned back slightly to reveal the lining,
giving the figure a gentle dynamism. The head nimbus is decorated
with concentric circles and lotus petals. The figure is strongly
reminiscent of works at Mathurā from the Gupta period
(320 – c. 550; fig. 40).

The most popular type of sculpture during the Northern Qi
dynasty was the figure sculpted in the round. An especially fine
example included here shows just as meticulous detailing of the
robes and jewellery at the back of the figure as it does at the front,
where a date is inscribed in ink on the suspended section of the belt
(cat. 31). A great number of Buddhas and bodhisattvas are carved in
this way. In the West such figures would no doubt be classified as
free-standing sculptures, yet they are not intended to be seen from

all sides; rather, they were designed to be venerated from the front
in temples. It may therefore seem less surprising that even the backs
of some figures with a head nimbus are carefully worked.

Buddhas with Figurative Images on their Robes

Some sculptures carved in the round show paintings or reliefs of
Buddhist subjects on the figure's garments. Some ten statues of
this kind have been found in Qingzhou and its environs. For
conservation reasons, the three Buddhas from Longxing Temple with
painted figurative images have not been included in the exhibition
(see fig. 44, 45), but another Buddha bearing such depictions in
relief is on display (cat. 26).

About twenty Buddha statues bearing figurative images were
discovered some time ago in Xinjiang, Dunhuang, Henan and
Hebei. In western China they occur in painting (fig. 41),[29] while
sculptures of this type are found in northern China (fig. 42, 43).[30]
The small scenes on these Buddhas depict the five or six Realms of
Rebirth (Chin. *wu/liu dao*), sometimes also called the *Dharma* Fields
or Spheres of Existence (Skt. *dharmadhātu*, Chin. *fajie*): the realms
of the gods, of humans, of animals, of hungry ghosts, of hell and,
in some instances, of the *asuras* (fighting spirits). Sometimes the

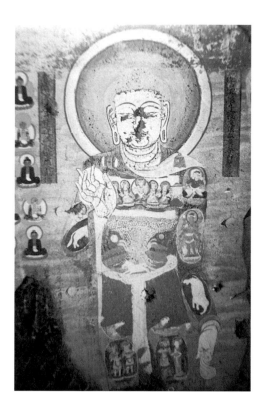

Fig. 41 Buddha Vairocana, Tang dynasty (618–906).
Wall painting. Cave temple of Ayi, Xinjiang

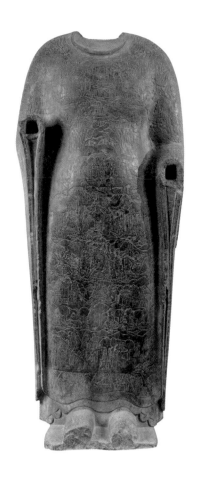

world mountain, Sumeru, occupies the centre of the image, which thus mirrors the Buddhist concept of the universe. Some Buddhas also show the Seven Treasures of a Cakravartin, Buddha's Sermon, the encounter of Vimalakīrti and Manjushrī, stories from the earthly life of Buddha or from one of his former lives, or heavenly flying beings carrying a treasure pagoda.

Buddhas with images on their robes have often been identified as Vairocana, the central Buddha of the Flower Garland Sūtra (Skt. *Avatamsaka* Sūtra, Chin. *Huayan jing*).[31] The school of the Flower Garland Sūtra (Chin. Huayan zong) grew in popularity during the Northern Qi dynasty and, with it, images of Vairocana. An inscription on a figure pedestal found on the site formerly occupied by Puzhao Temple in Jining, Shandong Province, shows that the Buddha Vairocana was indeed connected with the Realms of Rebirth at this time and that sculptures with such representations did exist. The inscription, which is quoted in Wang Chang's *Jinshi cuibian*, a compilation, published in 1805, of bronze and stone inscriptions from the Han to the Song dynasty, and in the book *On Stone Inscriptions* (*Yu shi*), reads: 'On the fifteenth day of the seventh month of the tenth year of the era Tianbao of the Great Qi dynasty [559] the monk Daofei, intending that all beings of the Spheres of Existence [*fajie*] to the outermost ends of space might attain enlightenment, humbly commissioned a figure of Vairocana with the Spheres of Existence on his body [*Lushena fajie renzhong xiang*].'[32] At the time this inscription was published, the pedestal belonged to Huang Yi, a specialist in bronze and

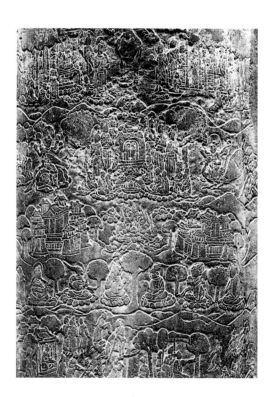

Fig. 42 Standing Buddha, Sui dynasty (581–618). Grey limestone, height 176.5 cm. Freer Gallery of Art, Smithsonian Institution, Washington, DC, purchase F1923.15

Fig. 43 Detail from fig. 42

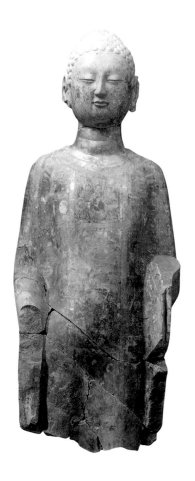

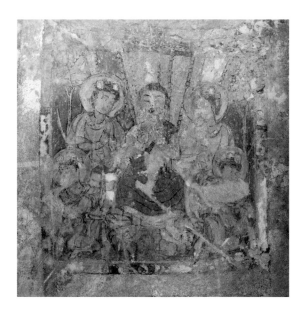

Fig. 44 Fragment of a standing Buddha, Northern Qi dynasty (550–577).
Limestone and pigment, height 121 cm.
Qingzhou Municipal Museum

Fig. 45 Buddha's Sermon. Detail from the chest area of fig. 44

stone inscriptions. He had it polished and used it as an inkstone, in which form it eventually passed to the well-known official and scholar Ruan Yuan (1764–1849). We do not know what type of figure stood originally on the pedestal.

Further evidence in support of the identification of Buddhas 'clothed' in Realms of Rebirth depictions as images of Vairocana is provided by the central Buddha in the Dazhusheng cave near Anyang, Henan Province, which is dated 589. Here, five Realms (those of the gods, humans, animals, hungry ghosts and hell) are engraved on the Buddha's garment and an inscription above the image identifies him as Vairocana. Another image of this type was found in 1999 in the cave temple of Ayi, near the well-known Kyzil caves, in Kuche (formerly Kucha) County, Xinjiang Province (fig. 41). This wall painting is accompanied by the inscription 'The faithful disciple of Buddha Kou Tingjun reverently erected [a figure of the] Buddha Vairocana'.[33]

It has recently been suggested that these images do not always represent the Buddha Vairocana, but could also depict the Buddha Shākyamuni in relation to the cosmological notions of Buddhism. Thus Angela F. Howard points out that the concept of the *Dharma* Fields and the six Realms of Rebirth also occurs in the Lotus Sūtra (*Saddharmapundarīka* Sūtra, Chin. *Fahua jing*). Accordingly, she calls the figures 'cosmological Buddhas' or 'cosmological Shākyamunis'.[34]

Depictions of the Realms of Rebirth from Qingzhou
The Buddhas from Qingzhou that bear figurative images on their garments are notable for the great variety of subjects depicted (fig. 44–46). One figure, for instance, shows Buddha's Sermon on the chest, several mortals from Central Asia on the shoulders, flying heavenly beings on the torso, and a pagoda and musicians on the stomach. On another statue Buddha's Sermon again appears on the chest, together with the sun and moon and flying heavenly beings on the shoulders and hungry ghosts and scenes from hell on the back.

A surprisingly large number of such figures have been found in the Qingzhou area. That from Zhucheng, which resembles an example now in a Taiwanese private collection (fig. 76), shows Buddhas, bodhisattvas, flying beings and so forth in rectangular fields. A figure in the Linqu museum is one of the finest of this type (fig. 46). Though it is relatively small, its painted images are almost completely intact and the colours have lost none of their luminosity. The shoulders bear depictions of the sun and the moon. On the chest the realm of heaven is represented by coiling dragons and a palace hall, above which hovers a flying heavenly being. A horse is shown *en face* on the stomach with four figures below it who are singing, dancing and playing music. Further down appears hell, with tormenting demons depicted with the heads of bulls and the faces of horses. Together, these easily identifiable scenes clearly represent the Wheel of Rebirth and the world mountain, Sumeru. Two groups of seated monks and laymen face each other on the sides and back of the statue, which also show people running and on horseback.

The images on a Sui dynasty Buddha in the Freer Gallery of Art in Washington are comparable in size and complexity to those of

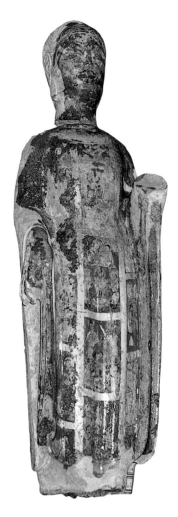

Fig. 46 Standing Buddha, Northern Qi dynasty (550–577).
Stone and pigment. Linqu Museum

Fig. 47 Stele of the nun Zhiming, dated 536, detail of the
polychromy. Stone and pigment, height 83 cm,
depth 18 cm. Qingzhou Municipal Museum

the Linqu figure, but are carved in low relief rather than painted (fig. 42). The depictions of the palace hall with the coiling dragons and of the front-on horse are almost identical in both pieces, and the scenes of hell at the bottom of the figures are similar (fig. 43).

The Wheel of Rebirth is also encountered in representations of the Bodhisattva Kshitigarbha (Chin. Dizang) and the Ten Kings of Heaven. Originally, the wheel comprised five realms in which people could be reborn; the Mahāyāna doctrine later added a sixth realm, that of the *asuras*. The oldest extant depiction of the Wheel of Rebirth in China occurs on a stele commissioned in 532 by Fan Nuzi of Fuping County in Shaanxi Province. Yama and the God of the Realms of Rebirth appear on the reverse of the stele, at the bottom.[35] Yama is seated under a cloth canopy; in front of the God of Rebirth can be seen the Wheel of Rebirth with the realms of the gods, humans, animals, hungry ghosts and hell. The images on the stele are far less complex than those on the Buddha in the Freer Gallery of Art, but both no doubt derive from the same source. Another comparable, engraved depiction of the five Realms of Rebirth occurs on the Buddha Vairocana in the Dazhusheng cave: flying beings represent the realm of the gods, mortals the realm of

humans, a horse the realm of animals and two demons the realms of hungry ghosts and hell. The same elements appear in the depiction of the Wheel of Rebirth on the Bodhisattva Kshitigarbha in the Bingyang cave at Lungmen.[36] On the other hand, six realms are shown in the Wheel of Rebirth that occurs at the end of several picture scrolls of the Ten Kings of Hell that were found in the sūtra cave at Dunhuang. Despite the inclusion of the realm of the *asuras*, the last King of Hell is described as 'King turning the Wheel of the Five Realms of Rebirth'. In other words, this King of Hell was originally the god of the *five* Realms of Rebirth.

As mentioned above, not all figures bearing images of the Realms of Rebirth necessarily represent the Buddha Vairocana, even if inscriptions sometimes indicate this to be the case. The sūtra *Da fangbian Fo shuo baoen jing*, for example, states: 'At that time, the Tathāgata Shākyamuni manifested on his body five bodies'.[37] This sūtra has often been depicted in paintings on silk (*baoen jing bian*). One of these, dating from the first half of the ninth century and now in the British Museum, London, shows Sumeru, the realm of the *asuras* and hell on the body of the Buddha.[38] Since the sun and moon appear on the Buddha's shoulders, Matsumoto Eiichi calls

him a Candra-sūrya-pradīpa (Chin. Riyue dengming fo; Buddha of the Light of the Sun and Moon), but this does not accord with the images on his body. Another painting based on the *Da fangbian Fo shuo baoen jing* is in the Baoding cave temple in Dazu, Sichuan Province. Here, the Buddha Shākyamuni is surrounded by depictions of his pious deeds in former lives; the six Realms of Rebirth appear beside his head. Although this figure dates from the Southern Song dynasty (1127–1279) and is thus much later than the others discussed here, it proves that representations of the six Realms of Rebirth did appear in conjunction with images of the Buddha Shākyamuni.

One further example may suffice to illustrate the complex relations between sculpture, painting and the written word in Buddhist art. As noted above, the Buddha Vairocana in the cave of Dazhusheng bears a depiction of the Wheel of Rebirth. Just inside the cave, opposite the Buddha, is an inscription from the *Mahāmāyā Sūtra* that mentions the five Realms of Rebirth. There may very well be a connection between this sūtra inscription and the Vairocana figure.

Other sculptures painted with figurative images in the Qingzhou hoard are less rewarding both artistically and in terms of their content. An example is the triad commissioned by the nun Zhiming in 536, in which nuns appear as donors on the sides of the nimbus (fig. 47). Such depictions are rudimentary compared to the complex compositions and meanings of the Buddhas bearing representations of the Realms of Rebirth. In these, sculpture and painting unite to give ideal visual expression to Buddhist notions.

NOTES

1 The Jinan region, with temples from the Northern Wei (389–534) and Eastern Wei (534–550) dynasties at Huangshiya and from the early Tang dynasty (618–907) at Qianfoya; the Qingzhou area with temples from the Sui (581–618) and Tang dynasties at Yunmenshan and Tuoshan; and Dongping County with caves from the Sui dynasty at Baifoshan and from the Tang and Song (960–1279) dynasties at Silishan.

2 The sūtra inscriptions in Zoucheng and Dongping and in the Taishan area are especially well known.

3 For example, at Xiangtangshan in the area of the old capital, Ye (Linzhang County, Hebei Province), where sūtra inscriptions were carved into the inside and outside walls.

4 The old name of Caizhou is Yexian. Two other important connections are the Upper Stele of Zheng Wengong at Tianzhushan and the Lower Stele of Zheng Wengong at Yunfengshan. The former is carved into a rock that already resembled a stele; only its front had to be smoothed slightly. The Lower Stele of Zheng Wengong, too, is carved into a flat section of rock. These two steles thus mark the transition from stele inscriptions to rock inscriptions in Shandong. Yu Shuting 1985, pp. 172, 174.

5 Buried Buddhist images made of bronze or stone have been found in Linqu, Zhucheng, Boxing, Zaozhuang, Qingdao, Changyi, Gaoqing, Wudi and Huimin.

6 For attempts to answer these questions, see Sun Xinsheng 1999b and Su Jinren 2000.

7 They include: a Buddha figure from Guangrao County, now in the museum in Dongying (Wang Sili 1958 and Zhao Zhengqiang 1996); a figure commissioned by Zhang Baozhu of Qingzhou, now in Shandong Provincial Museum; two Buddhas approximately six metres high and two bodhisattvas from Longquan Temple in Zichuan, now in Qingdao Municipal Museum (see fig. 35); two Buddhas approximately six metres high in the precincts of the former Xitian Temple in Linzi; and a Buddha of similar size on the site of the former Xingguo Temple in Boxing County.

8 For example, the figure stele donated in 547 to Jianxing Temple in Sishui County by the Chan master Gui. Since it is recorded in the *Shanzuofang beilu* (juan 17, p. 9090), a collection of stele inscriptions compiled by Fa Weitang during the Qing dynasty, the stele must have been buried later. It was excavated in 1972 and is now in the custody of the county authority responsible for cultural affairs.

9 *Kaogu* 1986a (two of these pieces are now in Xuzhou Municipal Museum); Wang Kai 1985.

10 *Kaogu* 1994.

11 Ji Yuanqin 1989.

12 Li Shaonan 1984; *Wenwu* 1984b.

13 Chang and Li 1983; *Kaogu* 1986b.

14 Han Gang 1986; *Kaogu* 1990; Du and Han 1994.

15 Lu Zengxiang n.d. records nineteen inscriptions containing this date.

16 The present author saw some of these pieces on display in Huayan Temple on Mount Lao.

17 Chang and Yu 1987.

18 *Wenwu* 1983.

19 *Wenwu* 1999; Wang Junwei 1999.

20 Sun and Gong n.d. I am grateful to the authors for permitting me to consult this unpublished manuscript.

21 Xia and Zhuang 1996; *Wenwu* 1996; *Wenwu* 1997; *Wenwu* 1998a.

22 Mentioning the monk Xianzhao from Huanghua Temple, the nun Faming from Weiyi Temple and other monks and nuns, the inscription indicates that people from four temples in Qingzhou participated in the ceremony.

23 *Gaoseng zhuan heji* 1991, p. 251.

24 In China bas-relief and engraved decoration derive from figure painting of the Han dynasty (206 BC – AD 220) and are therefore categorised as painting.

25 A fragment of a miniature pagoda decorated with figures was discovered in Jinan. Qiu Xuejun 1994.

26 Steles have been found only in south-west Shandong, near the towns of Juancheng and Chengwu. These few examples bear sūtra inscriptions as well as figures.

27 Such fastening devices are also found on two six-metre-high Buddhas from Xingguo Temple in Boxing, now in Qingdao Municipal Museum.

28 Li Li 2001.

29 Examples are a mural and a painting on wood from Hetian (Khotan, formerly Yutian) in Xinjiang Province, a mural in the cave temple of Kyzil and murals in the Mogao caves of Dunhuang.

30 One such stone sculpture exists at Gaohan Temple in Huaxian, Henan Province. Examples in museums are: an item elaborately carved with figurative images on the front and back in the Freer Gallery of Art, Washington, DC; a similar figure in the Asian Art Museum, San Francisco; a bronze sculpture in the Musée Guimet, Paris; and a figure in the Palace Museum in Beijing.

31 Aurel Stein was the first to address this issue, in his archaeological report on Yutian. Matsumoto 1937, vol. 1, 291–315, discussed the images in detail (see his fig. 91a [a painting on silk in the British Museum], 91b, 91c and 92a [Dunhuang, cave no. 135]). On the basis of the Flower Garland Sūtra, he interprets them as representations of the Buddha Vairocana. Mizuno 1968 identified the images on the rubbing taken from the figure from Gaohan Temple (the Seven Treasures, Buddha's Sermon, the three lower Realms of Rebirth, legends from Buddha's life, the encounter of Vimalakīrti and Manjushrī, and worshippers) and likewise concluded that the figure represented the Buddha Vairocana. Yoshimura 1959 compared seven inscriptions and nine extant works. He derived his choice of a Japanese term for the Buddha Vairocana bearing depictions of the *Dharma* Fields from the terminology used in the inscription on the pedestal from the Puzhao Temple in Jining.

32 *Jinshi cuibian*, juan 33, p. 7, and *Yu shi yitong ping*, juan 5, in Ye Changchi 1994, p. 327. For the difficulties involved in translating the concept *Lushena fajie renzhong xiang*, see Howard 1986, pp. 103–5.

33 *Chinese National Geography* 2000.

34 Howard 1986. Investigating in great detail the relation between the Flower Garland Sūtra and the depictions in the Dazhusheng cave at Anyang, Li Jingjie 1999 concluded that he had refuted once and for all the idea that the image of the figure with images on his garments might be 'Shākyamuni as ruler of the cosmos'. This assertion seems too categorical to me, particularly as Li Jingjie bases his argument chiefly on the *Flower Garland Sūtra in 60 Sections* (thereby limiting the scope of his study considerably in comparison to Matsumoto 1937) and ignores both the inscription in the cave temple of Ayi and the relevant sculptures from Qingzhou.

35 Many rubbings have been taken of the Fan Nuzi stele, but scenes on the reverse have generally been ignored. Zhang Zong 2001.

36 Cave no. 217 at Dunhuang, which dates from the mid-Tang dynasty, also contains images of the God of the Realms of Rebirth and of the Wheel of Rebirth as visual expressions of the contents of the Lotus Sūtra.

37 *Taishō* 1960, vol. 3, no. 156, juan 2, p. 127.

38 Whitfield 1982, fig. 11, 11.3.

SCULPTURE OF THE NORTHERN QI DYNASTY AND ITS STYLISTIC MODELS

SU BAI

Buddhist sculpture from Qingzhou during the Northern Qi dynasty (550–577) is notably different in style from the works found there during the late Northern and the Eastern Wei dynasties (386–550). This abrupt change in style in the mid-sixth century is the subject of this essay.

Many free-standing Buddha figures from the Northern Qi dynasty share certain characteristic features. They are generally approximately one metre in height, with a not very pronounced protrusion on the crown of their head (the *ushnīsha*, the sign of transcendent wisdom) and their eyes are almost closed, expressing contemplation. They raise their right hand in the 'Fear not!' gesture (*abhaya mudrā*) and lower their left hand in a gesture indicating 'Your wish is granted' (*varada mudrā*) (see cat. 17).

The most striking differences between the sculpture of the Northern Qi dynasty and that of the Northern and Eastern Wei dynasties occur in the garments depicted and in the treatment of the body. In the first half of the sixth century the Buddha wears a monk's robe with a sash, and a mantle of a thick material. In the second half of the century this typically Chinese attire, inspired by the robes of Confucian officials, is replaced by a close-fitting monk's garment of thin, light material, clearly influenced by Indian dress. This garment appears in two variants. In the first, the drapery falls in a series of narrow, U-shaped folds, either completely covering the body or leaving the right shoulder and the chest exposed. The folds are represented either by double lines in intaglio or by ridges (see cat. 20). In the second variant the garment clings to the body, the smoothness of the material disturbed only at the collar, the ends of the sleeves and the hem, where arc-shaped lines indicate a slight bunching of the cloth (see cat. 24). Traces of polychromy on many of these figures show that the robes were often painted with squares denoting patchwork, with figurative images occupying some of the squares. The bodies of the figures in Chinese dress are static and restrained in treatment. In contrast, the figures of the Northern Qi dynasty emphasise the three-dimensional fullness of the body and sometimes appear with a slight indication of movement (see cat. 25).

In 1976 Northern Qi figures of this type were found near the ruins of Longhua Temple in Boxing County, Shandong Province. This was followed by the discovery of stylistically similar pieces during excavations carried out from 1988 to 1990 in the precincts of a temple in Zhucheng, Shandong. Yet widespread interest was not aroused until the sculpture hoard at Longxing Temple in Qingzhou was unearthed in 1996.[1]

The stylistic origins of both variants of the figure with smooth drapery lie in Mathurā and Sārnāth in northern India, the two great centres of Buddhist art during the Gupta period in the fourth and fifth centuries. The drapery in some examples clings so tightly to the body that this type of robe was likened in China to a wet cloth taken 'out of the water' (*chu shui*; see fig. 48).[2] In statues from Sārnāth, which lies on the River Ganges and became an artistic centre slightly later than Mathurā, the Buddha often wears a smooth robe

Fig. 48 Torso of a standing Buddha from Jamalpur, Mathurā; mid-fifth century. Sandstone, height 112 cm. Archaeological Museum, Mathurā

Fig. 49 Standing Buddha from Sārnāth, c. 500.
Sandstone, height 39 cm.
Indian Museum, Calcutta

Fig. 50 Standing Buddha, c. 420. Clay and pigment,
height 105 cm. Bingling cave temple,
Yongjing County, Gansu Province,
cave no. 169, niche no. 9

almost completely free of folds. Only at the collar, the ends of the sleeves and the hem do some curved incised lines indicate the presence of clothing (fig. 49).

Figures of the Buddha wearing thin robes existed in India before the fourth century, in the north-west and in Gandhāra. From about the fourth century the Buddhist art of these regions influenced the style of the sculpture made in cave temples on the Silk Roads in central Xinjiang. By the beginning of the fifth century Buddhist sculpture with stylistic traits from northern India and Gandhāra was to be found even further east, in the heartland of China. The earliest known large-scale sculptures in China to have been inspired by Indian models are some figures in cave no. 169 in the temple at Bingling in Yongjing County, Gansu Province. The seated figure in niche no. 6 in the north wall dates from 420, and the standing Buddhas in niches no. 7 and 9 in the eastern wall are roughly contemporaneous (fig. 50, 71).

This 'Indian' mode prevailed in Chinese Buddhist sculpture until c. 480. A change in style occurred between 480 and 490, in the reign of Emperor Xiaowen (r. 471–499) of the Northern Wei dynasty. Marked by the introduction of the Chinese Buddhist attire described above, this change is especially noticeable in figures of the Buddha, the best-known of which is that in cave no. 6 at Yungang near Datong in Shanxi Province (fig. 51).[3]

Some 50 years later, in the mid-sixth century, sculpture in places further east in China, particularly Qingzhou, Shandong Province, and Quyang, Hebei Province, once more began adopting and adapting stylistic traits from Indian models. I believe that these Northern Qi figures with their thin robes were influenced directly by contemporary, Gupta-period images of the Budda in India. How did this come about? One reason is certainly that the Northern Qi rulers, originally members of a non-indigenous, nomadic people belonging to the Xianbei culture, admired all things foreign and are said to have treated even humble Indian monks with deference. Unlike the emperors of the late Northern Wei dynasty, who, although also of non-native, 'barbarian' origin, enthusiastically adopted a policy of sinicisation, the Northern Qi rulers emphasised

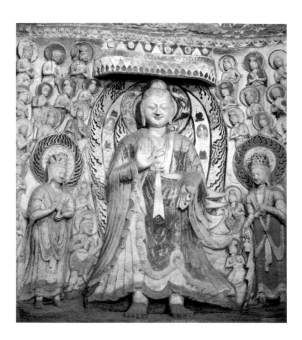

Fig. 51 Standing Buddha, before 494. Stone, height 305 cm.
Yungang cave temple, near Datong, Shanxi Province,
cave no. 6

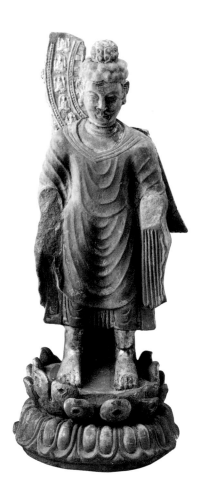

Fig. 52 Standing Buddha from Chengdu, Sichuan Province,
commissioned by Du Sengyi; dated 551.
Stone with gilding, height 48 cm

their Xianbei traditions and were sympathetic towards everything
non-Chinese.

Indian Influence on the Art of Southern China

Before Buddhist art flourished in Shandong during the Northern Qi
dynasty, regions further south in China were in contact with South-
East Asia and India. These territories of the Southern Dynasties,
centred on Jiankang (now Nanjing), enjoyed some 50 years of peace
under Emperor Wu (r. 502–549) of the Liang dynasty. At this time
many monks left South-East Asia and India travelled by sea to Liang.
Numerous Buddhist temples were built, and Indian-style images of
the Buddha seem to have been greatly admired. Chronicles written
in the early Tang dynasty (618–906), for example, report that
Emperor Wu had received Buddha figures from India.[4]

The early Buddhist images imported from India and worshipped
at the court of Emperor Wu are not extant, yet works based on them
have survived. A standing Buddha in the so-called Ashoka style was
found, for instance, in Chengdu, Sichuan Province, and bears an
inscription recording that it was commissioned in 551 by a certain
Du Sengyi (fig. 52).[5] Or again, the Seiryōji Temple in Kyōto contains
a wooden sculpture in the Udayana style that was carved by the

brothers Zhang Yanjiao and Zhang Yanxi and taken from Taizhou
to Japan in 985 by the Japanese monk Chōnen (fig. 53).[6]

No early Buddhist figure in the Indian style is known to have
survived from the Nanjing area, on the lower reaches of the Yangzi
River. On the other hand, since the early twentieth century standing
Buddhas with thin, Indian-style garments from the period of the
Northern and Southern dynasties (420–589) have repeatedly been
found on the upper reaches, near Chengdu, Sichuan Province, in
what used to be Yizhou Province. The earliest of these have narrow,
vertical folds on the left half of the body and curved folds cascading
in arcs down the right half. One of them (fig. 54) bears the
inscription: 'In the first year Zhongdatong [529], a Jupiter year with
the cyclical characters *jiyou*, Ji Mu and Dao You, with Jing Guang
and his mother Jing Huan as witnesses, all from the entourage of the
crown prince of Poyang, have donated a figure of the Buddha
Shākyamuni to the Anpu Temple[7] on their way west.'[8] The king of
Poyang, Xiao Hui, was the ninth younger brother of the Liang
emperor Wu, whose son Fan was governor of Yizhou Province.
Hence, the members of the entourage of Xiao Fan will have come
from the capital, Jiankang, probably bringing the model for this new
form of statue with them. The free-standing sculptures from Chengdu

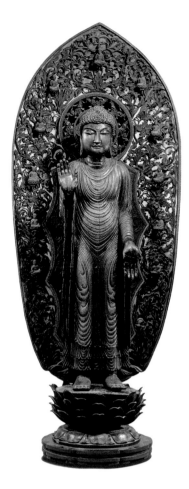

Fig. 53 Standing Buddha, before 985.
Wood, height 162.6 cm.
Seiryōji Temple, Kyōto

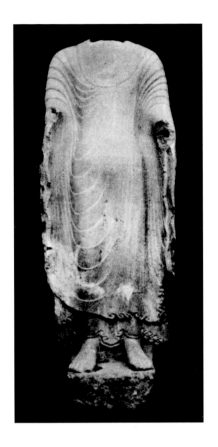

Fig. 54 Standing Buddha Shākyamuni from Wanfo
Temple, Sichuan; dated 529. Stone, 158 cm.
Sichuan Provincial Museum

with thin drapery are all relatively late in date – a further indication that this style reached Sichuan via Jiankang. Two dated examples have survived: the Ashoka-style figure of 551 (fig. 52) and one commissioned by Zhao Yuwen, chief administrator in the town of Yizhou from 562 until 565.[9]

The Chengdu figures are comparable in style to the Northern Qi sculptures from Qingzhou. The Northern Qi dynasty is known to have been in contact with the Liang dynasty in the south. The rites and ceremonies of the Northern Qi, for instance, were influenced by the Liang, and perhaps this influence extended to Buddhist images. Buddha statues with almost completely smooth drapery have been found in China only in the Qingzhou region. As noted above, this figure type derived ultimately from the art of Sārnāth, yet a lack of suitable comparative material makes it impossible to tell how it reached Qingzhou. Southern China should certainly not be ruled out as the route of transmission.

Influence from Peoples on Both Sides of the Pamir Plateau and from Indian Monks

At the end of the fifth century the nomadic Hephthalites invaded Sogdiana and Bactria, lands on the western side of the Pamir

plateau. As a result, various ethnic groups fled eastwards to central China, where they engaged in commerce and crafts. Before the division of the Wei empire in 534 most of them had settled in the capital, Luoyang, but when General Gao Huan (496–547) moved the capital further east, to Ye in south Hebei, many of them followed.[10] Historical records contain numerous stories of the favours shown descendants of the Pamir peoples at the courts of northern China because of their dancing, musical and acrobatic skills. People from the regions west of the plateau, including the bearers of the well-known Nine Family Names of Sogdiana, were highly esteemed by the rulers of the Northern Qi dynasty.

Many of these foreigners were raised to the nobility and became high-ranking government officials. This is confirmed by recent excavations in the provinces of Shanxi and Shaanxi. In May 2000, for example, a tomb dating from the first year of the Daxiang era of the Northern Zhou dynasty, i.e. 579, was found in the village of Kangdi north of Xi'an in Shaanxi Province. The tomb inscription gives the name of the deceased, An Jia, and states that he came from Changsong in Guzang Prefecture. He was the leader of the Zoroastrian community and an army officer. The stone panels of his funerary couch bear gilt reliefs with subject matter relating to the

customs and mores of the Sogdians: a ride in the country, a hunt, scenes of dancing, music-making and everyday domestic life.[11] In July 1999 another tomb was discovered in Wangguo Village, south of Taiyuan in Shanxi Province. The inscription dates the tomb to 592, the twelfth year of the era Kaihuang of the Sui dynasty. The buried man, Yu Hong, came from the state of Yuguo (Fish Land) in eastern Turkestan and was an official at the imperial court during the dynasties of the Northern Qi, Northern Zhou and Sui. Under the Northern Zhou, he was in charge of Zoroastrian and foreign affairs. The polychrome reliefs on the inside and outside of his sarcophagus depict scenes similar to those on An Jia's funerary couch.[12] They reveal quite clearly how immigrants from Central Asia remained rooted in the culture of their origins: the facial features of most of the figures, with their deep-set eyes and long noses, are not Chinese and, as in the tomb of An Jia, scenes showing the exuberant dances and amusements of Central Asian people are placed in very prominent positions.

The painter Cao Zhongda, too, came from a Sogdian family. Active during the Northern Qi dynasty, he was renowned for Buddhist figures based on Indian prototypes. Indian paintings of the Buddha seem to have made their way to China prior to this: a Buddhist history from the early seventh century, the *Catalogue of Beneficial Influences of the Three Jewels on the Divine Continent* (*Jishenzhou sanbao gantonglu*) by Daoxuan (596–667), mentions that Indian monks brought a representation of the 'Buddha Amitābha in his Pure Land, surrounded by 50 bodhisattvas' to Luoyang before the Wei-Jin period (220–420).[13] Subsequently, knowledge of such images was lost, until Cao Zhongda revived the style by producing faithful copies of Indian originals. The ninth-century connoisseur Zhang Yanyuan included a short biography of Cao Zhongda in the eighth section of his *Reports on Famous Painters from All Ages* (*Lidai minghua ji*): 'Cao Zhongda was originally from the state of Cao. During the Northern Qi dynasty he was especially esteemed. A skilful painter of Buddhist subjects, he was of the fifth rank [*Dafu*] at court. The monk Daoxuan of our dynasty mentions the beauty of [Cao's] Buddha images in his work [*Jishenzhou*] *sanbao gantonglu*. The paintings are wondrous and inspired.'[14]

In the second section of *Lidai minghua ji* Zhang Yanyuan claims that Cao Zhongda initiated a new style: 'Cao founded a school in Buddhist subjects. In painting Buddhas there are the Cao school pattern, the Zhang school pattern [of Zhang Sengyao], and the Wu school pattern [of Wu Daoxuan]. . . . Wu Daoxuan learned from Zhang Sengyao.'[15] Hence, it would appear that two traditions of Buddhist painting existed from the period of the Southern and Northern dynasties to the Tang dynasty: the Cao style and the Zhang–Wu style (as teacher and pupil, Zhang and Wu can be said to represent the same tradition). In the eleventh century Guo Ruoxu defined the salient features of the two schools in the essay 'Concerning the Characteristics of the Cao and Wu Schools', included in the first volume of his *Reports on Experiences with Painting* (*Tuhua jianwenzhi*): 'The styles of Cao and Wu served as models for the scholars [of later dynasties]. . . . The graceful pose of the Buddhist figure in the Wu style is true to life and the robes

flutter in the air. The drapery in the Cao style hangs down in folds and the robes cling tightly to the body. For this reason, the people of later times said: the shawl in the Wu style flutters in the wind and the robe in the Cao style is like [a wet cloth taken] out of the water. . . . These two styles existed in Buddhist sculpture as well.'[16] It may therefore be concluded that, as the example of Cao Zhongda shows, the kind of Buddha image with thin, close-fitting drapery encountered during the Northern Qi dynasty in Qingzhou was also preferred by Sogdian artists active in China.

The great cave temples on the trade routes from India to China were important centres of Buddhist art. The Northern Qi dynasty entertained close relations with the oasis town of Kucha on the Silk Roads in what is now Xinjiang. The Qi rulers were attracted not only to the dancing and music of their neighbours, but also to the cave temple architecture of Kucha. The *Annals of the Northern Qi Dynasty* (*Beiqishu*) mention a Buddhist temple called Queli in the centre of the capital, Ye.[17] This had been modelled on the renowned Queli Temple in Kucha, which the Buddhist history *Chusanzang jiji* of 515 calls the Great Temple of Queli (Queli dasi)[18] and which the Chinese monk Xuanzang visited on his pilgrimage to India in the seventh century.[19] Comparing Buddha images from the Northern Qi dynasty with those of Kucha and nearby Kyzil (Baicheng), where many wall paintings, wooden sculptures and woodblock prints from the fourth to the seventh century have survived, one again finds certain similarities. Neither Sogdian art nor that of the temples in Kucha and Kyzil could have been the immediate source of inspiration for the new style of sculpture practised during the Northern Qi dynasty, but persons from these western regions occupied high-ranking posts at the court of the Northern Qi and will no doubt have influenced artistic matters.

During the Northern Qi dynasty, Buddhist monks and laymen also came to China directly from India. The *Xu gaoseng zhuan*, a compilation of Buddhist monks' biographies written by Daoxuan (596–667), tells the story of Narendrayashas:

> Narendrayashas, which means 'the venerable' in Chinese, came from Udyāna in northern India. . . . When he was seventeen years old, he wanted to enter a monastery. He had visited the famous masters and heard everything about the true teaching. . . . In the seventh year of Tianbao [556], he was in the capital Ye and was received and venerated by Emperor Wenxuan. . . . Thereafter he worked in the Tianping Monastery and was asked to translate the Tripitaka. . . . The emperor esteemed the Buddhist teachings highly and worshipped the original Sanskrit texts. . . . Sometimes, Narendrayashas recited divine prayers which helped the emperor achieve successes. In this way he [Narendrayashas] attained great merit. Later he served as an official in the Bureau for Religious Affairs [*Zhaoxuandu*] and soon became its chief.[20]

The example of Narendrayashas shows that during the Northern Qi dynasty Indian monks not only worked as translators, but could also become high-ranking court officials responsible for religious affairs.

The biography is doubtless stating nothing less than the truth when it claims that the emperor 'received and venerated' Narendrayashas.

The Indian orientation of Northern Qi sculpture distinguishes it not only from the Buddha images popular under the Northern Wei emperor Xiaowen (r. 471–499), with their Chinese-style attire, but also from the art of the Liang and Chen dynasties in the south and the Northern Zhou dynasty in the west. Indeed, there is clear evidence to suggest that the Northern Qi aristocracy had none too high an opinion of the Han Chinese. Historical records repeatedly indicate as much. The *Annals of the Northern Qi Dynasty*, for instance, have this to say about the wife of Emperor Wenxuan and her son:

> The wife of Emperor Wenxuan, with family name Li, was the daughter of Li Xizong from Zhaojun prefecture. . . . When the emperor wanted to build an Inner Palace, [the prince] Gao Longzhi and [the minister] Gao Dezheng warned him: 'A Chinese lady cannot serve as the mother of the country. Your Majesty should take another beautiful woman.'[21]

The deposed Emperor Yin was the oldest son of Emperor Wenxuan. His mother was the empress Li. In the first year of Tianbao [550] he was appointed crown prince. . . . The emperor often said: 'In character, the crown prince is more Chinese than of my culture.' That is why the emperor wanted to depose this crown prince.[22]

Another report concerns Han Feng, a high-ranking official under the last emperor of the Northern Qi dynasty, who made no secret of his contempt for those fellow officials of his who were Chinese: 'Han Feng stood at the centre of power and hated Chinese officials. At every meeting on official business, Chinese officials were not allowed to look him straight in the face. If they did, he would abuse them: "I've had enough of you, you Chinese dogs! You should all be executed."'[23] Such attitudes among the Northern Qi aristocracy may well have lain behind their preference for foreign artists and styles, helping to explain the Indian aesthetic apparent in sculpture from Qingzhou at this time.

NOTES

1 Chang and Li 1983; Du and Han 1994; *Wenwu* 1998a, pp. 4–15.
2 See the quotation from Guo Ruoxu's *Tuhua jianwenzhi* on p. 58.
3 *Yungang* 1988, fig. 47, 58. This cave was completed before the capital was moved to Luoyang in 494.
4 The *Annals of the Liang Dynasty* (*Liangshu*) record that an Indian Buddha image reached Liang from South-East Asia, while the *Guang hongming ji* states that Emperor Wu personally received a Buddha image in the 'Ashoka style' in Jingzhou and sent embassies to India to bring back such images. *Taishō* 1960, vol. 52, no. 2103. According to *Further Biographies of Eminent Monks* (*Xu gaoseng zhuan*), in *Gaoseng zhuan heji* 1991, the emperor received a Buddha image in the 'Udayana style'.
5 *Wenwu* 1998b.
6 Tradition has it that this image was carved in Bianliang, the eastern capital of China, on the basis of an Indian sculpture. Japanese sculptors at the end of the Heian period (794–1184) used it as a model, and the style remained popular in Japan until the Kamakura period (1185–1333). Records indicate that there were almost 100 faithful copies of the figure in Kyōto and Nara alone. Shimizu 1978, fig. 23–35.
7 Anpusi (Temple of the Peaceful Shore) was an earlier name of the Wanfosi (Temple of the Ten Thousand Buddhas) in Chengdu.
8 Gao and Gao 1990.
9 Liu and Liu 1958, fig. 9.
10 'Enxing zhuan' and 'An Tugen zhuan', in Li Yanshou.
11 *Zhongguo Wenwubao*, 13 August 2000; *Wenwu* 2001a.
12 *Zhongguo Wenwubao*, 24 October 1999; *Wenwu* 2001b.
13 *Jishenzhou sanbao gantonglu*, in *Taishō* 1960, vol. 52, no. 2106.
14 Zhang Yanyuan 1966, p. 253; translated in Acker 1974, part 1, p. 193.
15 Zhang Yanyuan 1966, p. 63ff.; translated in Acker 1954, pp. 165–6.
16 Guo Ruoxu 1963, vol. 1, p. 7a–b.
17 *Beiqishu* 1972, vol. 13, p. 173.
18 'Biography of Kumārajīva', in *Chusanzang jiji*, written by the monk Sengyou (445–518). *Taishō* 1960, vol. 55, p. 100b.
19 Ji Xianlin 1985, pp. 60–1.
20 *Taishō* 1960, vol. 50, p. 432a–c.
21 *Beiqishu* 1972, vol. 9, p. 125.
22 *Beiqishu* 1972, vol. 5, p. 73.
23 *Beiqishu* 1972, vol. 42, p. 693.

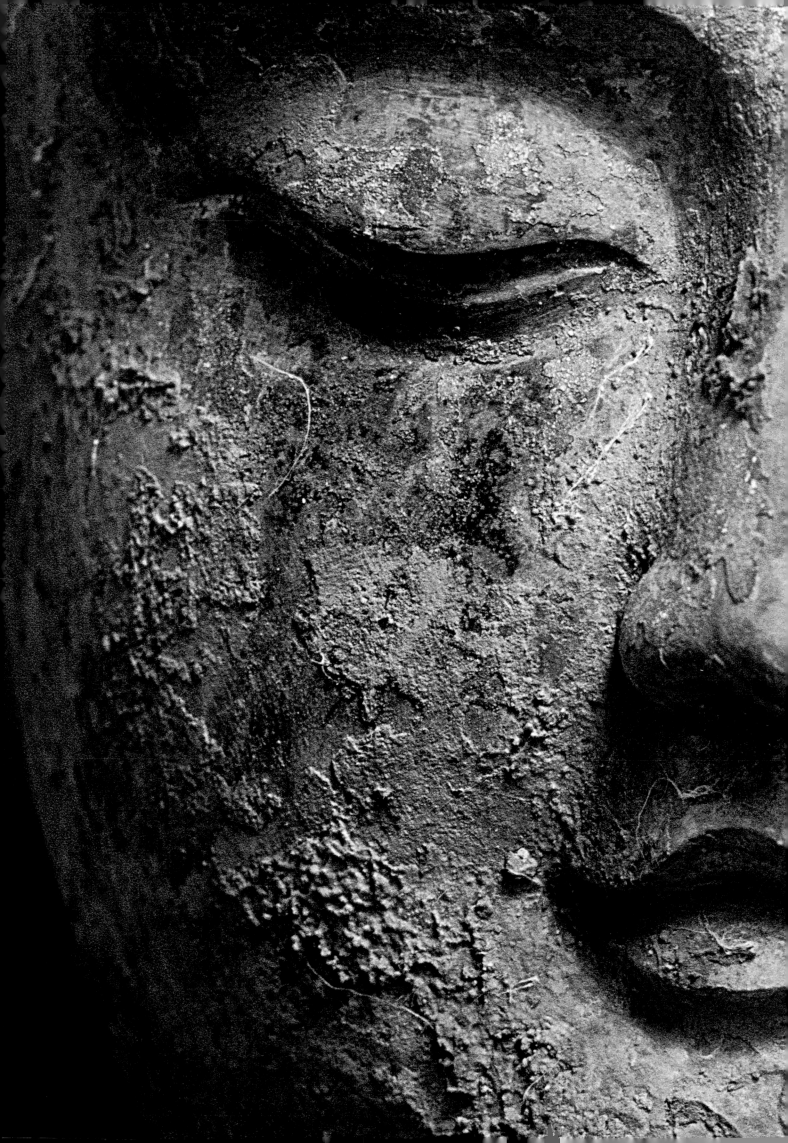

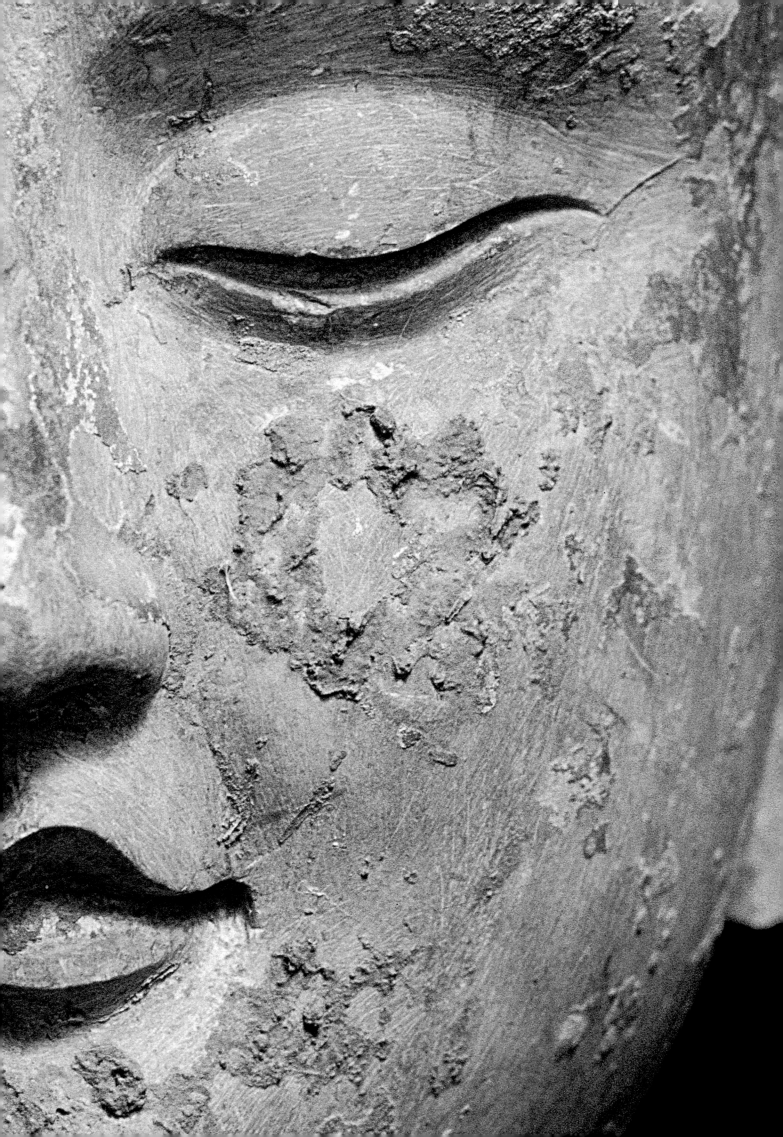

1 STELE OF HAN XIAOHUA

Northern Wei dynasty, dated 529
Limestone, height 55 cm (B 2)

Published: Wang and Shou 2001, p. 49; Wang Huaqing 2001, pp. 128–31; *Chugoku kokuhō ten* 2000, p. 187; *Masterpieces* 1999, pp. 40–1; *Qingzhou yishu* 1999, pp. 3–6

Fig. 55 Stele from Zhuliang, Shandong Province, dated 527.
Stone. Qingzhou Municipal Museum

This stele, commissioned by Han Xiaohua, is the earliest dated piece among the sculptures of the Longxing hoard. The donor's inscription on the right side of the stele reads: 'On the fourth day of the second month of the second year Yong'an [529] the lay follower Han Xiaohua humbly had a Maitreya statue made for her deceased husband Le Chou'er and her deceased descendants Youxing and Huinu, as well as for her surviving child, Ahu; she also vowed to serve and worship the Buddha rebirth after rebirth and generation after generation after traversing this lower existence' (fig. 23). The base of the stele is engraved with a figure on a lotus flower carrying a bowl with an incense burner on its head. The figure is flanked by two lions, beside each of which kneels a donor. The inscriptions at the far left and right of the base read 'Le Chou'er, in reverence' and 'Han Xiaohua, in reverence' respectively. The stele resembles an altar platform supporting a triad.

The Buddha is smiling and has a high *ushnīsha* (the protrusion on the crown of his head, one of his 32 bodily characteristics, which symbolises his transcendent wisdom). He raises his right hand in the *abhaya mudrā* ('Fear not!' gesture) and lowers his left in the *varada mudrā* (the gesture indicating 'Your wish is granted'). Iconographically, he differs very little from many other Buddha figures included here: only the inscription enables him to be identified as Maitreya, the Buddha of the Future. The two bodhisattvas flanking him are almost identical. Their damaged topknots must have been of about the same shape and size as the Buddha's *ushnīsha*. Each holds in his right hand a lotus bud and in his left a small, heart-shaped fan (see cat. 9). Characteristic features of the Northern Wei style are the pointed pieces of drapery protruding sideways towards the bottom and the raised hems forming lozenge-shaped folds at the ankles. The three figures stand on pedestals with inverted lotus petals; their haloes take the form of two layers of lotus petals. Barely visible engraved lines in the mandorla behind the triad depict a head and body nimbus surrounding the Buddha between flickering flames and three Buddha figures seated with their legs crossed in the 'lotus position' (Skt. *padmāsana*).

Two deities are depicted at the top, in the two areas between the mandorla and the edge of the stele. Each holds a disk, representing the sun and the moon respectively, and each has a roundish face, a broad smile and a *ushnīsha*. Traces of black and red pigment can be seen on the hair and lips. The deity on the right wears a bracelet. This is the only sculpture from Longxing Temple with sun and moon disks, although several steles bearing the motif have been found in the Qingzhou area, all roughly contemporaneous with the present example but for the most part unpublished.[1] Such figures holding the sun or moon may be divided into two groups. The first, rarer type, represented here, has a *ushnīsha* and can thus be identified as a deity in the broadest sense of the word. The second type wears a long beard and a pointed cap (fig. 55). The present deities cannot be precisely identified. Since the Han dynasty (206 BC – AD 220) the sun and the moon had been depicted in connection with pairs of indigenous Daoist deities, such as Fuxi and Nüwa, Changxi and Xihe, and the Queen Mother of the West (*Xiwangmu*) and the Lord King of the East (*Dongwanggong*). In such instances a three-legged bird is often painted on the sun disk and a toad on the moon disk. As Buddhism spread, the sun and moon became Buddhist deities belonging to the heavenly sphere of the *asuras* (fighting spirits).[2] They were no doubt traditional symbols of great power in China. In Buddhist votive steles from the first quarter of the sixth century, including the present example, they must therefore have formed part of an attempt to combine old concepts harmoniously with the new ideas of Buddhism. In some examples, such as the steles found in Shaanxi, Daoist and Buddhist ideas are blended so completely that the works cannot be assigned definitively to either religion.[3] Not until the Tang dynasty (618–907) did Buddhism reject ancient indigenous traditions as heterodox. Henceforth, the sun and moon symbolised non-Buddhist faiths, which needed to be overcome.[4] CW

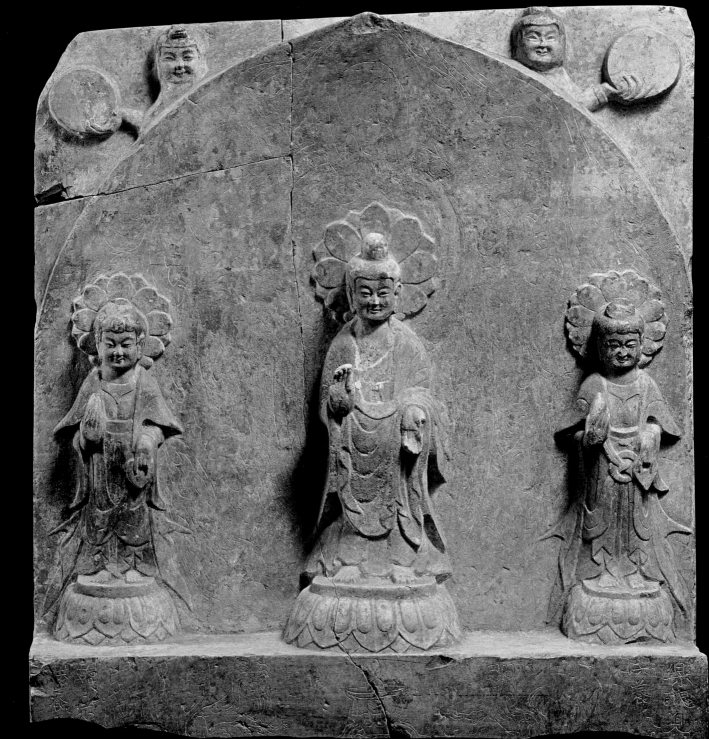

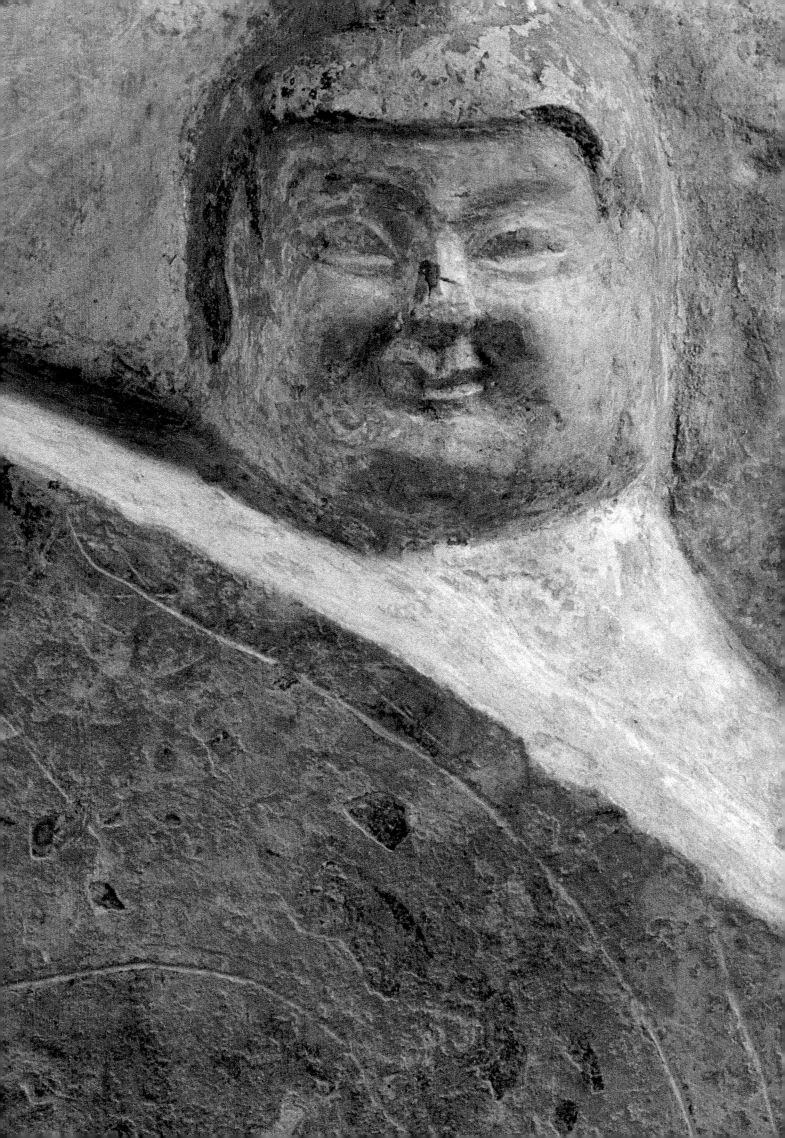

2 TRIAD WITH MANDORLA

Late Northern Wei dynasty (386–534)
Limestone, height 95.5 cm (B 40)

Published: Wang Huaqing 2001, pp. 122–3; Xia and Wang 2000, pp. 50–1;
Masterpieces 1999, p. 46; *Qingzhou yishu* 1999, pp. 11–13

The Buddha and the two bodhisattvas flanking him, all facing the
viewer and carved in high relief, stand on pedestals in front of a
mandorla, the top of which is missing. The pedestal of the Buddha
functions as a conical tenon to be inserted into a corresponding
cavity in a larger stone base. The Longxing Temple hoard contained
only fragments of bases, but intact examples are known from other
finds in the region. Such bases consist of a square or round stone
slab with a ring of lotus leaves pointing downwards around the
cavity designed to take the tenon. The pedestals of the bodhisattvas,
somewhat higher than the Buddha's, are carved in the shape of lotus
seed pods, attached to stems issuing from the central pedestal.
All three figures have almond-shaped eyes and are smiling slightly.
The Buddha has a high *ushnīsha* and his hair is dressed in spirals
and wave-shapes.

The Buddha wears monk's robes. The undergarment ends in
graceful, wave-like forms around his feet. A chest cloth, laid over the
left shoulder and knotted under the right arm, runs diagonally across
the chest and is held in place by a sash tied at the front. The outer
robe, laid over both shoulders, is visible only as a narrow strip
around the neck and chest, between the chest cloth and the top
garment, the mantle. The mantle, too, is laid over both shoulders;
draped over the arms, it covers the stomach and legs, but leaves the
chest open. This type of clothing is characteristically Chinese: Indian
monks drape the right half of the mantle over the left shoulder,
covering the chest.[1]

Each of the boddhisattvas wears a long lower garment tied
together at the waist by a sash. A long, narrow stole covers both
shoulders. At the knee, it crosses the body and continues up over
the opposite arm. Unlike the Buddha, the bodhisattvas wear
necklaces and bracelets. Their topknots are held together by simple,
band-shaped diadems. Each holds in his raised hand a lotus bud and
in his lowered hand a heart-shaped fan (see cat. 9).

Each of the three heads is framed by a nimbus consisting of
lotus petals in relief inside concentric circles. The Buddha is also
surrounded by an oval body nimbus, divided into concentric bands
of different colours. The innermost band shows a pattern of stylised
leaves. The mandorla is broken, leaving only four flying heavenly
beings (see cat. 7) engraved in the surface. They hover with
billowing garments, their faces and torsos turned towards the Buddha.

A triad with mandorla dated 534 in the Metropolitan Museum of
Art in New York (fig. 56) is comparable in style to the present piece.[2]
The nimbuses, the faces of the figures, the hair of the Buddha and

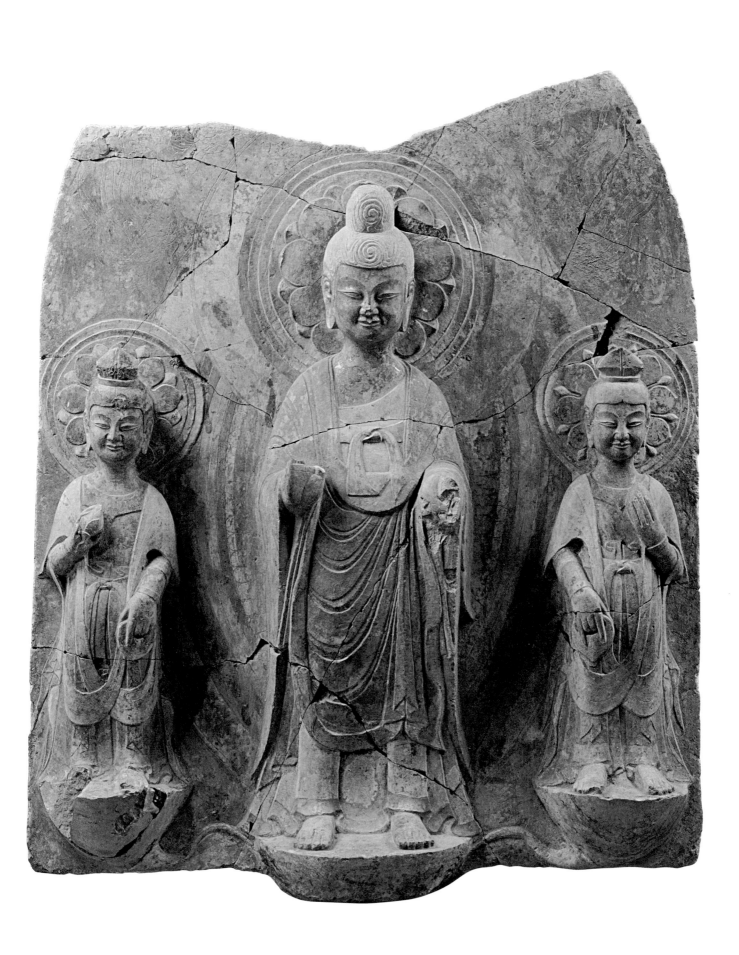

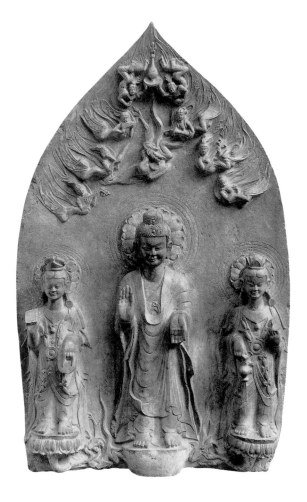

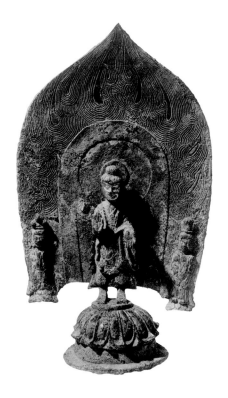

Fig. 56 Triad with mandorla, Wei dynasty, dated 534. Limestone, height 155 cm. Metropolitan Museum of Art, New York, Rogers Fund, 1919 (19.16)

Fig. 57 Buddha Shākyamuni with two bodhisattvas, dated 482. Gilt bronze, height 27 cm. Fujita Museum, Ōsaka

the bodhisattvas, and the drapery are very similar in both sculptures, although the folds of the Buddha's garments in the New York triad are less flat and stylised. It seems safe to assume that the sculpture of undocumented provenance in the Metropolitan Museum comes from the region of Qingzhou.

In the West such Buddhist stone sculptures with a mandorla and often carrying an inscription are generally called steles. In China they are termed 'statue' (zaoxiang) or 'Buddha statue' (foxiang), in contradistinction to steles bearing inscriptions (bei). The characteristically Chinese form of stele consists of a rectangular stone slab with straight or rounded top, sometimes adorned with two intertwining dragons. This type was developed during the Han dynasty (206 BC – AD 220) and later came to be used for Buddhist

images; Indian influence resulted in figurative reliefs being added to the inscriptions (see cat. 1).

Stone figures shown in front of a mandorla seem to derive from bronze votive figures, a type of sculpture already popular in China in the fifth century AD.[3] A bronze Buddha Shākyamuni with two bodhisattvas dated 482 (Fujita Museum, Ōsaka) shows a similar arrangement (fig. 57). The round base of the Buddha here resembles the tenon base of the Qingzhou triad: it, too, fits in a cavity surrounded by lotus petals pointing downwards.[4] The shape of the mandorla, the two bodhisattvas at the edges and the broad bands indicating the head and body nimbuses all recall the Qingzhou triad. Such bronze sculptures probably served the stone-carvers as models. NT

68

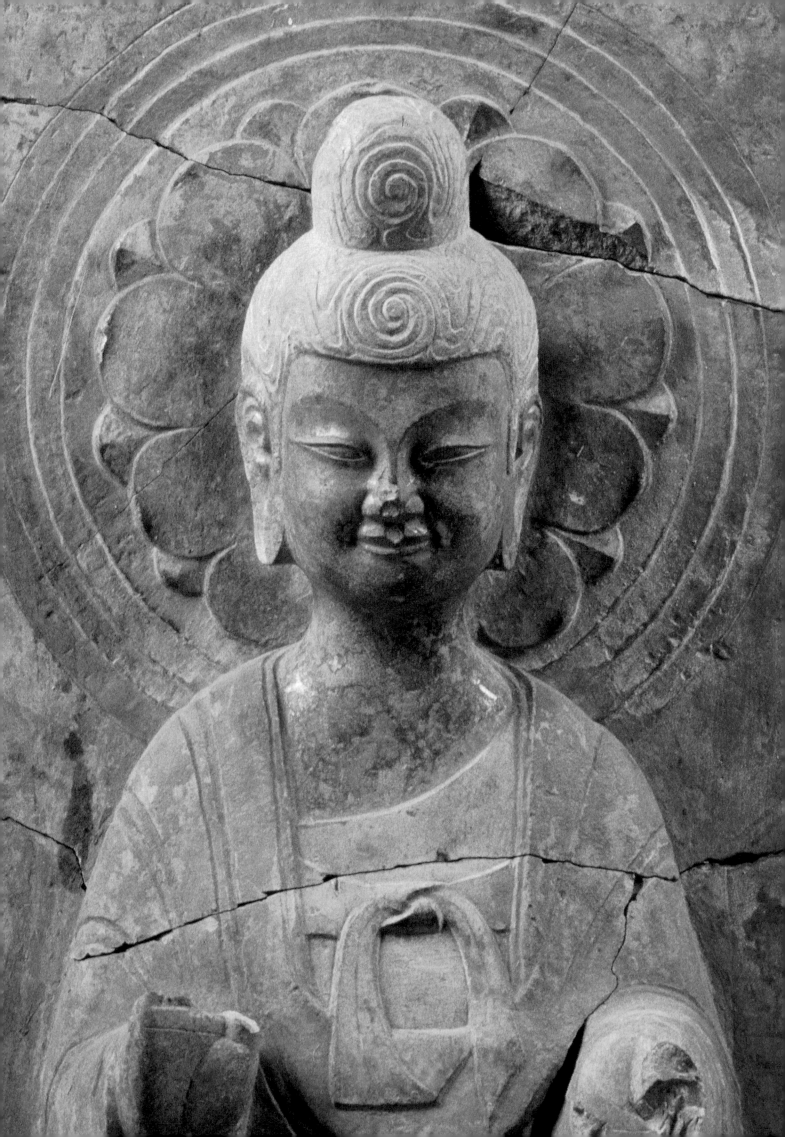

3 TRIAD WITH MANDORLA

Late Northern Wei (386–534) or Eastern Wei dynasty (534–550)
Limestone, height 121.5 cm (B 76)

Published: Wang Huaqing 2001, pp. 132–3; Wang and Zhuang 2000, p. 47;
Dewar 1999, p. 95; *Masterpieces* 1999, pp. 62–3; *Qingzhou yishu* 1999, pp. 19–21

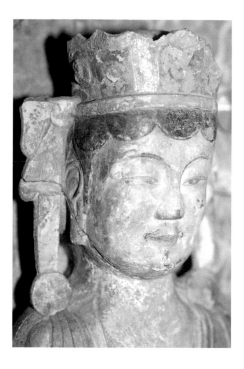

Fig. 58 Head of the bodhisattva on the right, showing
the gilded and engraved crown

With its exceptionally well preserved painting and gilding, this triad approximates to its original appearance more closely than any other image shown here. The Buddha and two flanking bodhisattvas stand in front of a mandorla, the upper section of which is lost. The forearms of the figures and the tenon beneath the base of the Buddha have been broken off. Three of the stumps have holes drilled in them, which probably facilitated repair by the attachment of new forearms. The other breakage points show no signs of repair, so these parts must have been broken after the repair.

All three figures have wide, open eyes and are smiling slightly. Their facial expressions are more serious and less childlike than those in cat. 2. The broad, squarish heads are notably large in relation to the narrow, delicate bodies. The head of the Buddha has the high *ushnīsha* typical of the Wei period and is covered with dense rows of small curls. The hems of his monk's robes form three rows of stylised folds, partly arranged diagonally, at the bottom of his legs. The mantle covers both shoulders and is draped over the left forearm. It leaves the chest open, revealing the chest cloth tied with a sash.

Each boddhisattva wears a long lower garment with the chest cloth tucked into it. These robes are held in place at the waist by a sash. Long stoles cover the shoulders and, crossing below the knees, are draped over the forearms. The bodhisattvas wear diadems from which ribbons hang down to the shoulders. The gilt crowns are adorned with an engraved pattern of circles and spikes (fig. 58). The hair is dressed in semicircles at the front, while two strands fall over the shoulders and upper arms. On the shoulders appear two round gilded discs – clasps for fastening either the strands of hair or the ribbons. The bodhisattva on the left wears a double-banded necklace with floral pendant; otherwise the two figures are virtually identical.

The bodhisattvas stand on lotus flower pedestals, the stems and leaves of which issue from the mouths of two dragons. The dragons' eyes, teeth, horns, scales and claws are carved and painted in great detail. With their hind legs widely spread, and their body and tail writhing in a snake-like motion, they contrast strongly with the static figures of the triad.

Above the bodhisattva on the right appears the damaged body of a flying heavenly being (see cat. 7) with billowing garments and the foot of a second such being. The Buddha is surrounded by a body and head nimbus consisting of variously coloured concentric bands; the outermost band of the head nimbus bears a floral design.

That part of the mandorla between the Buddha and the bodhisattvas is filled with flames or clouds painted in white with some black. The white leaf motifs at the edges of the mandorla are especially well preserved. The Buddha's red mantle shows the characteristic patchwork design with broad white stripes. The hem of the left bodhisattva's chest cloth bears a stylised floral pattern, while traces of a black moustache can be seen on the face of the other bodhisattva. The black pupils, painted on or inserted in the eyes during the 'eye-opening ceremony' (Chin. *kaiming* or *kaiguang*) held to consecrate an image, are preserved on all three figures. The meticulous painting on the dragons even includes the individual hairs of their beards.

This is among the few sculptures from the Longxing hoard to carry inscriptions. There are three, on either side of the Buddha and to the right of the right-hand bodhisattva. The short, vertical rows of engraved text are not complete. They list the names of eleven lady donors in brief, formulaic sentences: 'The nun Zhiyan ['Words of Wisdom'] awaits the time of the Buddha', 'The nun Fashi ['Dharma Realm'] waits for the time of the Buddha', 'The nun Jinghui ['Quiet Lustre'] awaits the time of the Buddha' and so forth.[1] Remains of engraved images of the eleven nuns can still be seen. Not only monks and nuns, but also individual believers and groups of Buddhist laymen donated such images in order to accumulate merit and to acquire a good karma. Inscriptions often mention the desire of the donor to be reborn in the paradise of the Buddha Maitreya or Buddha Amitābha. NT

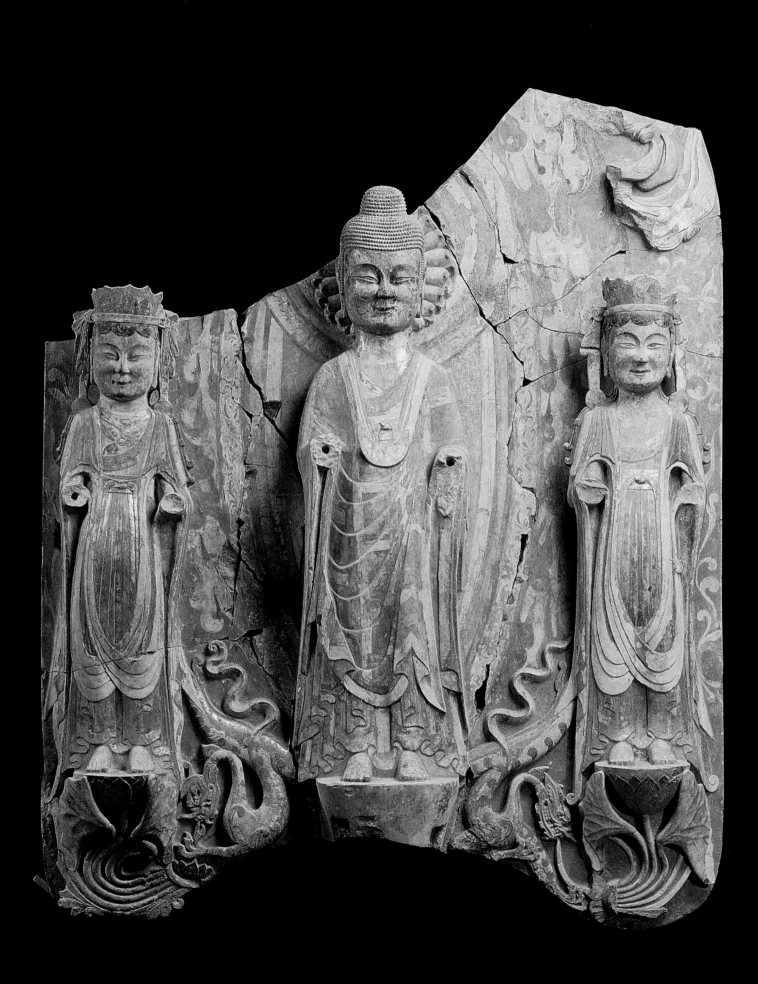

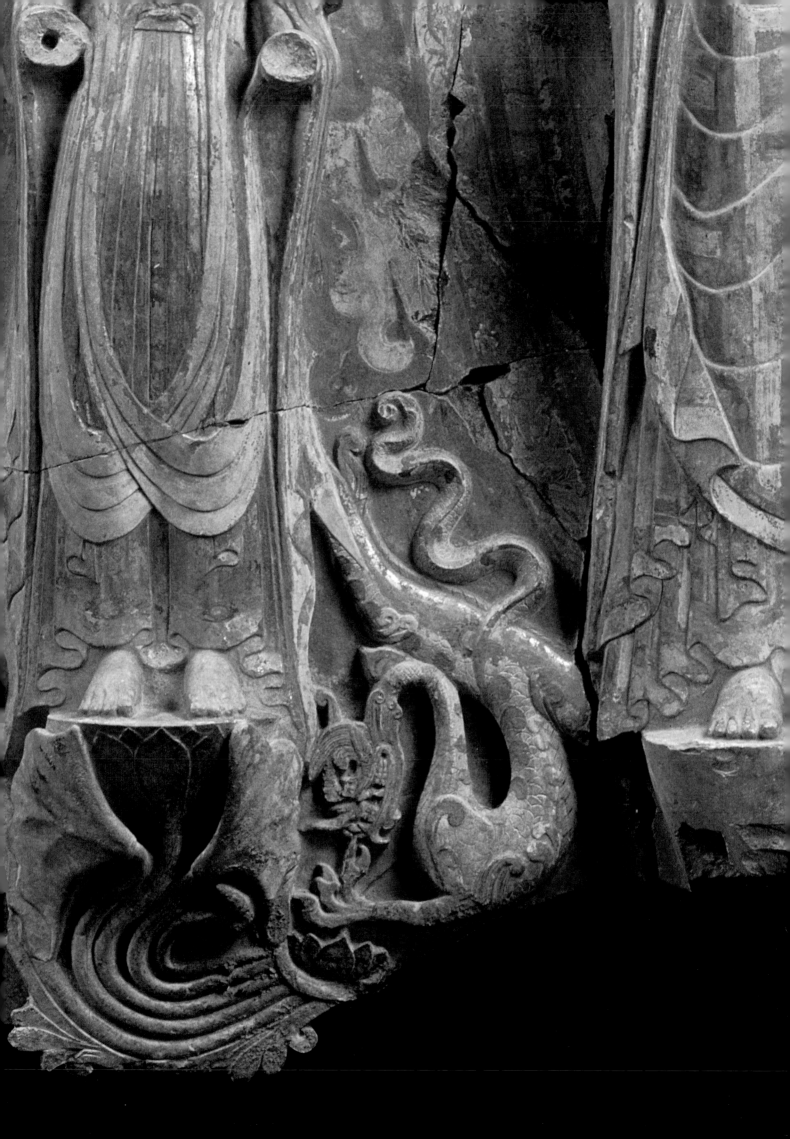

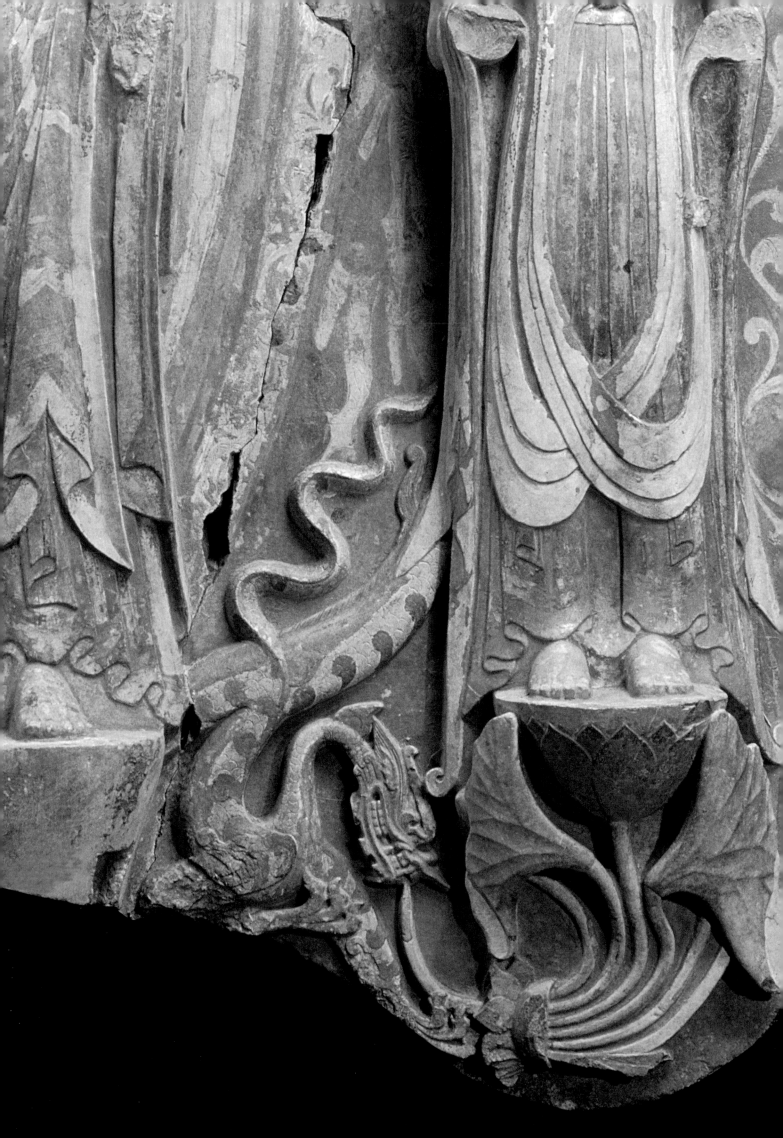

4 TRIAD WITH MANDORLA

Eastern Wei dynasty (534–550)
Limestone, height 134 cm (B 7)

Published: Wang Huaqing 2001, pp. 146–8; *Chugoku kokuhōten* 2000, p. 191;
Wang and Zhuang 2000, p. 49; *Masterpieces* 1999, pp. 58–9;
Qingzhou yishu 1999, fig. 34–7

A Buddha and two bodhisattvas are carved out of the mandorla in such high relief as to be almost free-standing. The mandorla is broken above the heads. Also missing is the tenon under the Buddha figure, used to anchor the image to the base.

The frontal figures have oval faces with almond-shaped eyes and elegantly arched brows. All three are smiling slightly (fig. 59). They emanate an other-worldly calm and child-like innocence. Each has a head nimbus consisting of a lotus flower in relief surrounded by concentric bands of various colours. The Buddha also has a body nimbus. His hair is dressed in hemispherical curls and his *ushnīsha* is high. Remains of gold leaf can be seen on his face, chest, hands and feet. His right hand, missing its fingertips, is raised in the *abhaya mudrā*, the left lowered in the *varada mudrā*. The hands are carved in great detail: the finger joints and nails, even the palm lines, are clearly visible. The combination of *abhaya mudrā* and *varada mudrā* occurs frequently in sixth-century representations of the Buddha Shākyamuni and Maitreya. Judging by the dated images in the cave temples of Longmen,[1] these were probably the most popular deities of the time.[2] Both were often shown flanked by bodhisattvas, and it seems safe to assume that the main figure in the present sculpture is either Shākyamuni or Maitreya.

The Buddha is clothed in the traditional monk's attire of undergarment, outer robe and mantle. The mantle's upper seam hangs to the waist in a U-shape, revealing a diagonally draped chest cloth. The red squares of the patchwork mantle were originally surrounded by bands of green, remains of which can be seen at the shoulders (fig. 60). The painting rarely coincides with the lines engraved beneath it.

Each bodhisattva wears a lower garment that falls to the ankles in parallel folds. Tucked into it is a chest cloth that leaves the right shoulder uncovered. A stole descends from the shoulders to the stomach, where it crosses through a perforated disk to the other side of the body. A many-stringed chain of pearls lies over the stole and shoulder ribbons are fastened to it with round clasps. Both bodhisattvas wear necklaces with spoke-like members. Their black hair is dressed in five circular locks at the front and adorned with a crown. Holes in the arm stumps show that the forearms were attached with tenons, but it is not possible to tell whether this was a feature of the original construction or the result of a repair.

As in almost all triads from Longxing Temple, the two bodhisattvas stand on pedestals in the shape of lotus flowers. The stems, buds and leaves of the lotus issue from the mouths of two

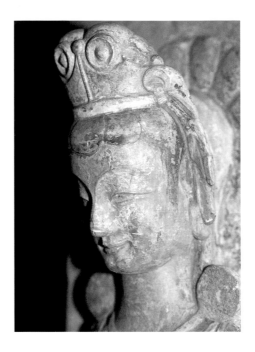

Fig. 59 Head of the bodhisattva on the left

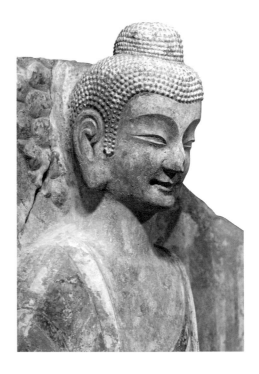

Fig. 60 Head of the Buddha

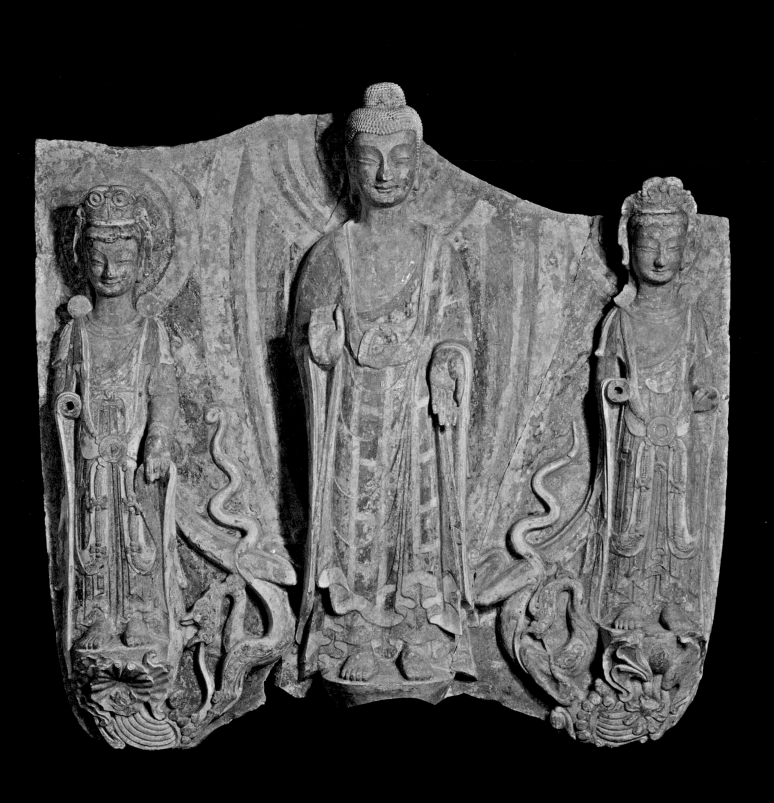

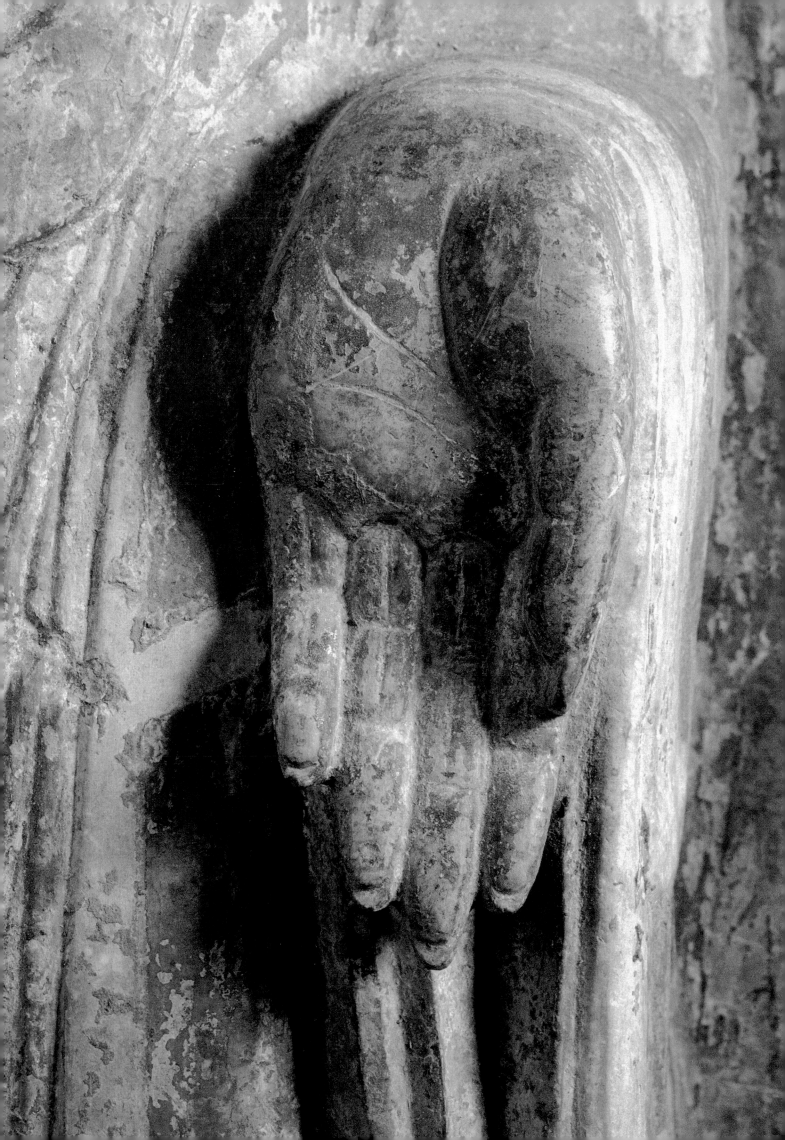

dragons shown vertically in a crouching position between the Buddha and the bodhisattvas, one hind leg stretched out and the other at an angle, the tail coiling in the air and their claws holding the lotus stems. Dragons spitting forth and grasping lotus thrones can be seen on images from Zhucheng, in the same region as Qingzhou, two of which are dated 545 and 546 respectively.[3] Earlier examples, dating from the late Northern Wei dynasty, have been found in the provinces of Henan and Hebei. A stone triad with mandorla from Qi County in Henan, for instance, datable to the early sixth century on stylistic grounds, shows the motif in a less developed form, with only the heads and necks of the dragons represented (fig. 61). The dragons on a bronze altar from Gaoyang County in Hebei, commissioned in 522,[4] resemble those of the Longxing sculptures, although the medium of bronze makes them seem even more crisp and alive. The dragon motif may therefore have been brought to Qingzhou by artisans from Hebei,[5] but it became extremely popular in Qingzhou during the Eastern Wei dynasty and was given an individual, highly decorative form there. AB

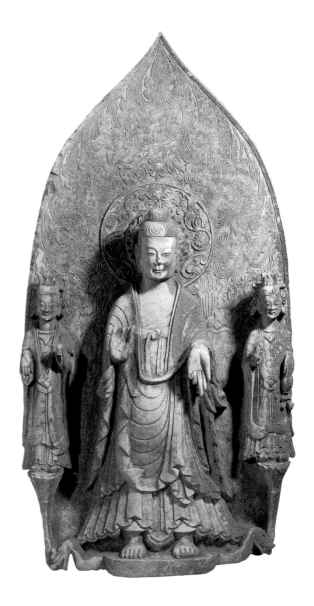

Fig. 61 Triad with mandorla from Qi County, Henan Province, early sixth century. Stone, height 96 cm. Henan Provincial Museum, Zhengzhou

5 TRIAD WITH MANDORLA

Eastern Wei (534–550) or Northern Qi dynasty (550–577)
Limestone, height 310 cm (B 164)

Published: Wang Huaqing 2001, pp. 149–51; Tsiang 2000, p. 46;
Masterpieces 1999, pp. 56–7; *Qingzhou yishu* 1999, pp. 32–3

The largest image from Longxing Temple, this sculpture weighs
about one ton, but its maximum thickness is only 35 centimetres,
which is no doubt why it broke into several pieces (fig. 62). Traces
of early repairs are the broken-triangular indentation at the upper left
break, below the lowest flying heavenly being, and the four holes
drilled in the head nimbus of the Buddha. The three figures are
carved in high relief. The Buddha stands directly on the tenon used
to anchor the image. The gaze of the tall, slender Buddha is serious;
his hair consists of hemispherical curls and his *ushnīsha* is high.

The difference in size between the Buddha and the bodhisattvas
is far greater than in other triads from Longxing Temple. On the
other hand, the dragons, diving headlong, and the lotus plants
issuing from their mouths are relatively large. Carved in great detail,
the dragons have spiral-shaped relief decoration on their bodies;
scales, now barely visible, were once painted in ink on the gilding.
Both bodhisattvas, their stomachs notably convex (fig. 62), wear
the customary lower garment and stole. The left hand bodhisattva
also wears a body chain. His pendant on the right bears a butterfly-
shaped, open-work plaque on his stomach; his facial expression
is serious and aloof.

The composition of the image and the Buddha's dress belong in
the tradition of Wei dynasty sculpture. On the other hand, the robust
figure of the Buddha and his almost completely smooth mantle, the
slightly rounder face of the right hand bodhisattva and the fact that
the upper parts of the bodhisattvas' bodies are naked and that they
wear tightly fitting lower garments anticipate the style cultivated
during the Northern Qi dynasty.

The Buddha's head and body nimbuses are surrounded by a
further, leaf-shaped nimbus decorated with painted flames. A stūpa
is carved in high relief at the top of the mandorla. Four flying
heavenly beings (see cat. 7), their heads carved almost in the round,
are related to it on each side; the two immediately flanking the stūpa
proffer votive gifts, the others dance and play music, their scarves
flutter towards the edge of the mandorla. The stūpa, one of its
corners facing the viewer, hovers on a lotus flower pedestal. It is
cubic, with a stepped base, a door on each side and tiered lintels.
Gable-like elements at the corners of the roof bear acanthus
decoration. A main mast rises from the cupola, branching into three
side masts with canopies. This kind of stūpa is without known
precedent in India or Central Asia. The motifs at the corners of the
roof, however, recall Ancient Greek acroteria, and this may point to
influence from Gandhāra, where Hellenistic architectural ornament

Fig. 62 The sculpture before restoration

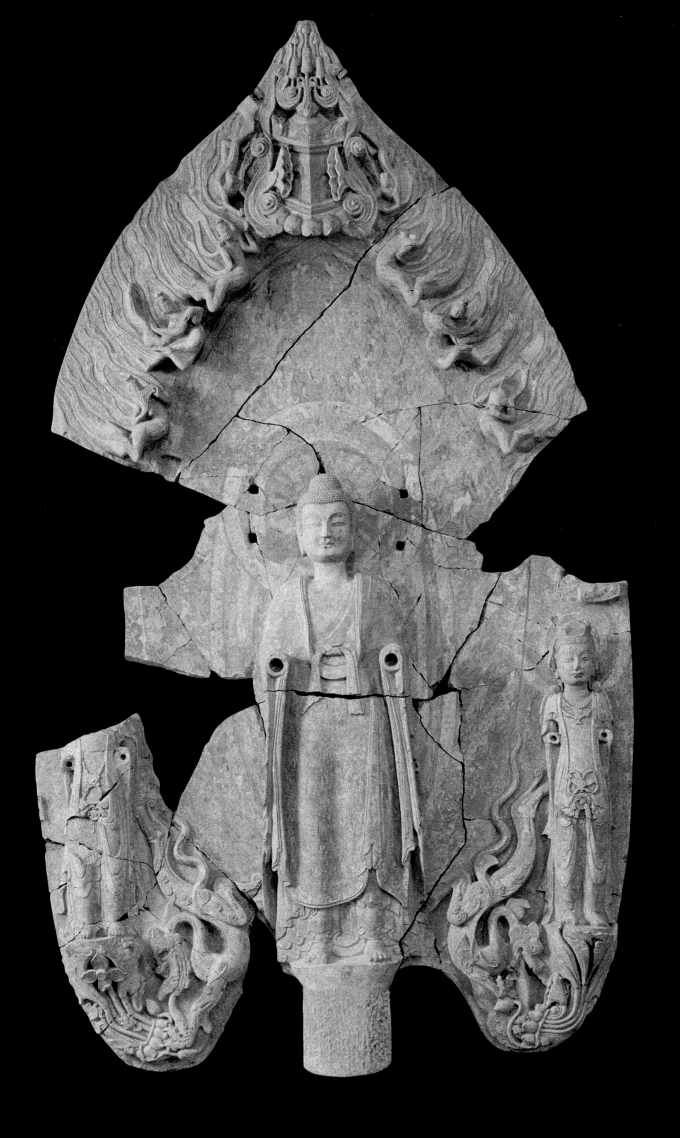

Fig. 63 The Four Door Pagoda (Simenta) of Shentong
Temple near Jinan, Shandong Province, 544

was popular. From the mid-sixth century until the middle of the Tang dynasty (618–907) such stūpas were often depicted on bronze altars, steles and mandorlas. They also existed as buildings, as witnessed by the Four Door Pagoda (Simenta) of Shentong Temple in Shandong (fig. 63), built in 544.[1]

The symbolic meaning of the flying stūpa has not been established beyond doubt. It may relate to the chief message contained in the Lotus Sūtra, one of the most important Mahāyāna sūtras and extremely popular in sixth-century China.[2] This tells the story of a Buddha named Prabhūtaratna who, in the mists of time, had vowed that, after entering Nirvāna, he would appear in his stūpa wherever the Lotus Sūtra was preached. When Buddha Shākyamuni was making good his promise on Vulture Peak, the stūpa suddenly rose and hovered in the air surrounded by heavenly beings. Shākyamuni ascended to the stūpa and sat beside Prabhūtaratna.[3] This tale was intended to show believers that the Buddhahood was subject to neither temporal nor spatial limitations. The two Buddhas sitting side by side were a popular subject on bronze altars and steles from the late fifth to the late sixth century.[4] Some images show two Buddhas seated in a flying stūpa, but no inscriptions identify the figures.[5] AB

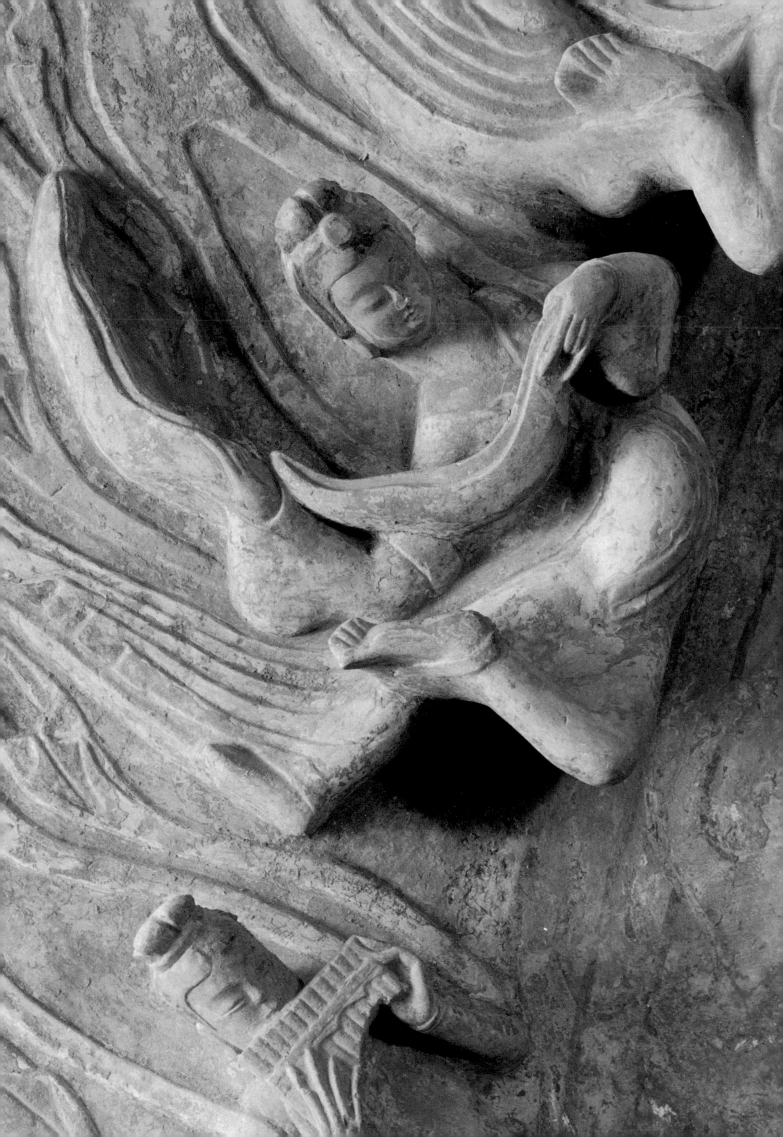

6 TRIAD WITH MANDORLA

Late Northern Wei (386–534) or Eastern Wei dynasty (534–550)
Limestone, height 76 cm (B 421)

Published: Wang Huaqing 2001, pp. 135–7; Tsiang 2000, p. 45;
Masterpieces 1999, pp. 66–7; *Qingzhou yishu* 1999, pp. 16, 170

A Buddha and two bodhisattvas are carved in high relief in front of a mandorla, the tip and the lower left section of which are missing. The Buddha's hair and high *ushnīsha* are without curls. Traces of gilding remain on his face, chest, hands and feet. The robes of the two bodhisattvas differ only in the draping of the stole. The concentric rings, once coloured, and the partly floral decoration of the Buddha's head and body nimbus are just recognisable in the weathered surface of the mandorla.

Eight flying heavenly beings appear above the triad in *mezzo rilievo*. The two at the top carry a stūpa, the others worship the Buddha by making music, a form of veneration described in many sūtras. The instruments played here are (in clockwise direction) a *konghou* (harp), a *sheng* (a wind instrument with a mouthpiece and several pipes arranged like those of an organ), a *jiao* (horn), a *paixiao* (Pan flute), *bo* (cymbals) and, possibly, a *yaogu* (hip drum).

The perspective of the stūpa at the tip of the mandorla is inconsistent: the base recedes, but the roof seems to tilt forward. Several other attempts to make the stūpa appear a distant building, some of them more successful, can be seen on mandorlas from the Longxing find (e.g. cat. 5).[1] A flying stūpa or one carried through the sky can be interpreted as an allusion to the Lotus Sūtra (see cat. 5). As Katherine Tsiang has pointed out, it may also represent one of the 84,000 stūpas which, according to legend, the Indian king Ashoka had erected all over the world in the third century BC for the mortal remains of the Buddha Shākyamuni.[2] Ashoka embodied the Buddhist ideal of a world ruler (Skt. *cakravartin*) and reports of the Buddha sculptures and stūpas donated by him were circulating in China as

early as the fourth century. According to Tsiang, many Chinese rulers wished to attain the status of a *cakravartin* and for that reason may have commissioned images representing an 'Ashoka stūpa'. The Buddhist historian Daoxuan (596–667) called a reliquary in the King Ashoka Temple (Ayuwangsi) at Ningbo an Ashoka stūpa. A reliquary still preserved there strongly resembles the flying stūpa motif, but it is not clear whether Daoxuan's description refers to this reliquary. No inscriptions are known that explicitly connect a flying stūpa on a mandorla to an Ashoka stūpa.

In support of her theory that the motif of the flying stūpa was political motivated Tsiang quotes a report probably written by Gao Huan (496–547), the founder of the Eastern Wei dynasty.[3] This concerns the famous nine-storey pagoda of the Yongning Temple (erected by imperial decree in the Northern Wei capital) and relates how, shortly after it burned down in 534, people living on the Shandong coast saw the pagoda appear above the sea. The traveller who brought this news to the court interpreted it as a harbinger of the Northern Wei's demise. He stated further that the Yongning pagoda had vanished in the Eastern Sea, thus sanctifying the coastal region of Bohai in what is now Hebei Province.[4] Gao Huan had been granted Bohai as a fief, and these events thus helped to serve as legitimisation when he later became regent. Not long after the destruction of Yongning Temple, Gao moved the capital from Luoyang to Ye. It is at this time that flying stūpas began appearing in sculptures, and the motif may well have symbolised the new ruler's authority. AB

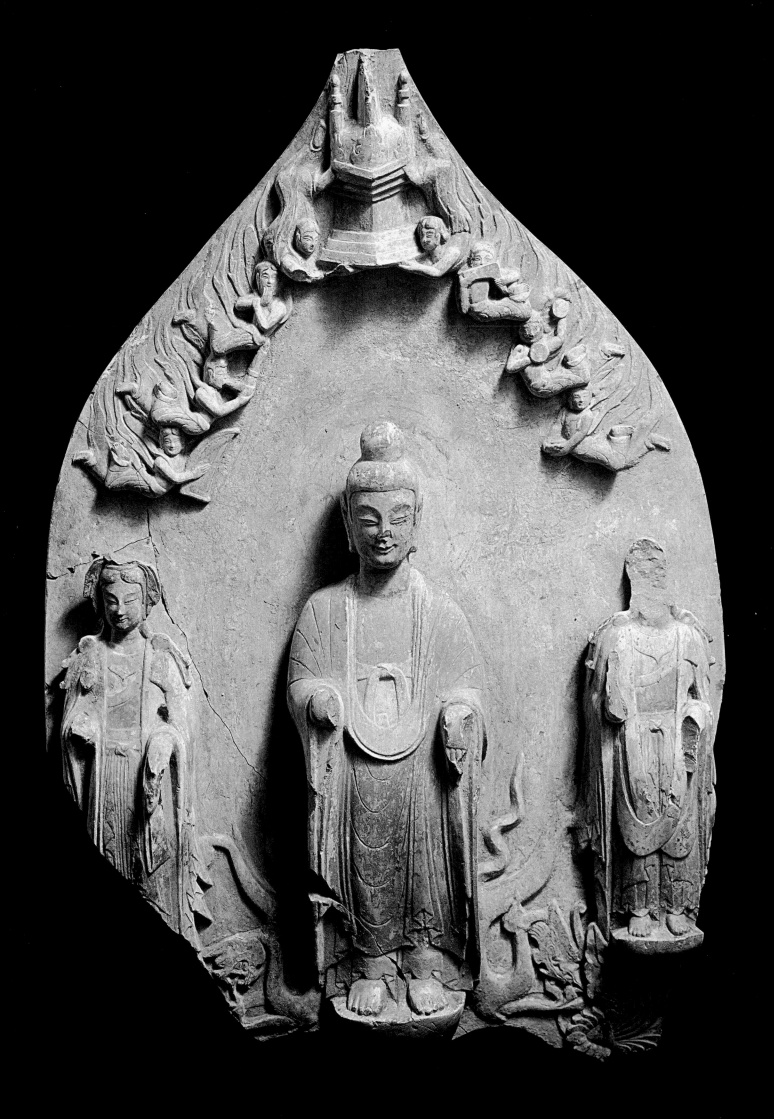

7 BUDDHA WITH MANDORLA

Late Northern Wei dynasty (386–534)
Limestone, height 121.5 cm (B 1)

Published: Wang Huaqing 2001, pp. 166–7; *Chugoku kokuhō ten* 2000, p. 188;
Dewar 1999, p. 97; Jin Weinuo 1999, p. 20; *Masterpieces* 1999, pp. 44–5;
Wenwu 1998a, p. 17, fig. 1; Xia Mingcai 1998, p. 43, fig. 4

In contrast to most figures with mandorlas from the Longxing hoard, this Buddha lacks flanking bodhisattvas. His head, tilted forwards slightly, is detached from the mandorla (fig. 64). The image was broken in two at the Buddha's knees, and a piece at the lower right is missing. Two large holes drilled into the stumps of the forearms derive from a repair carried out before the figure was buried: an iron nail driven into the hole from the side still exists in the right arm (fig. 65). The edges of the breaks at the knees are sharp and show the original colour of the stone.

The broad face shows the open almond-shaped eyes and the gentle smile typical of Northern Wei dynasty Buddhas. The red mantle covers both shoulders and is draped in Chinese fashion over the left forearm, leaving the chest free. The face and the neck of the Buddha show traces of gilding. His head nimbus consists of a double row of lotus petals carved in low relief and surrounded by concentric bands of various colours. The outermost band shows a painted floral design; in contrast to other sculptures from Longxing Temple, its outlines are traced in ink, not engraved. An oval body nimbus with the same floral motif on the outer band merges into the head halo.

Six flying heavenly beings appear in high relief around the top of the mandorla, their upper bodies and faces turned towards the viewer. They wear long, undulating robes and billowing stoles, creating a flame-like pattern at the edge of the mandorla. Their hair is piled high in topknots, and they are wearing pointed necklaces and narrow bracelets. The two upper heavenly beings hold a tray bearing an offering of a long-necked vase, a similar motif to that on a triad with mandorla dated 534 in the Metropolitan Museum of Art, New York (fig. 56).[1] The other heavenly beings dance and make music.

Flying heavenly beings are low-ranking deities or semi-deities who worship the Buddha and the bodhisattvas in song and dance or offer them votive gifts, such as flowers and incense. They originated in Indian mythology and belong among the Eight Supernatural Beings (Chin. *babuzhong*) in the Buddhist pantheon. In China and Japan the term *feitian* (Jap. *hiten*) now denotes various kinds of heavenly being, including *apsaras*, *gandharvas* and *kimnaras*.

According to the Lotus Sūtra, flying heavenly beings are the protectors of the Buddha and of doctrine.[2] Early instances of their appearance on Chinese Buddhist images are the body nimbus of a Buddha Amitābha dated 420 in the cave temple of Binglingsi[3] and a bronze triad of the early fifth century from Hebei Province with additional lateral figures and a mandorla, now in the Idemitsu Museum, Tōkyō.[4] NT

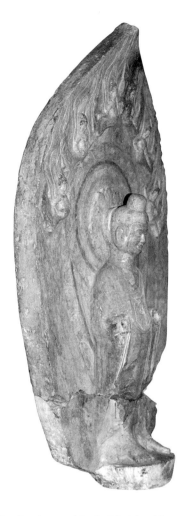

Fig. 64 The detachment of the Buddha's head from the mandorla is apparent in side view

Fig. 65 The right arm, showing the nail driven in from the side when the piece was repaired at an early date

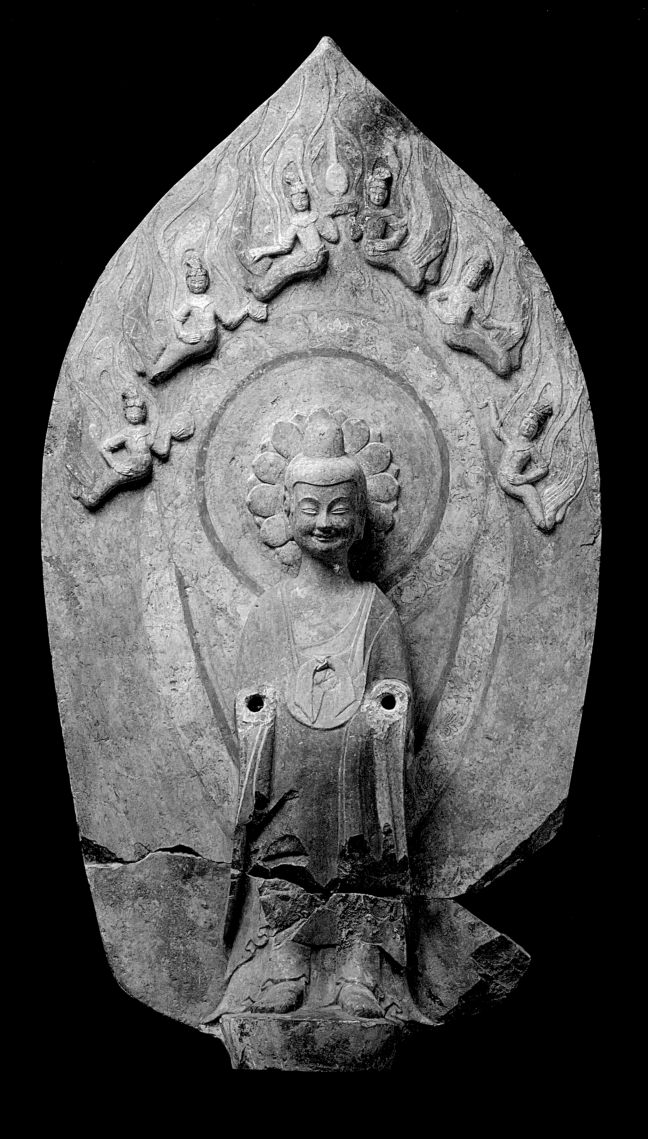

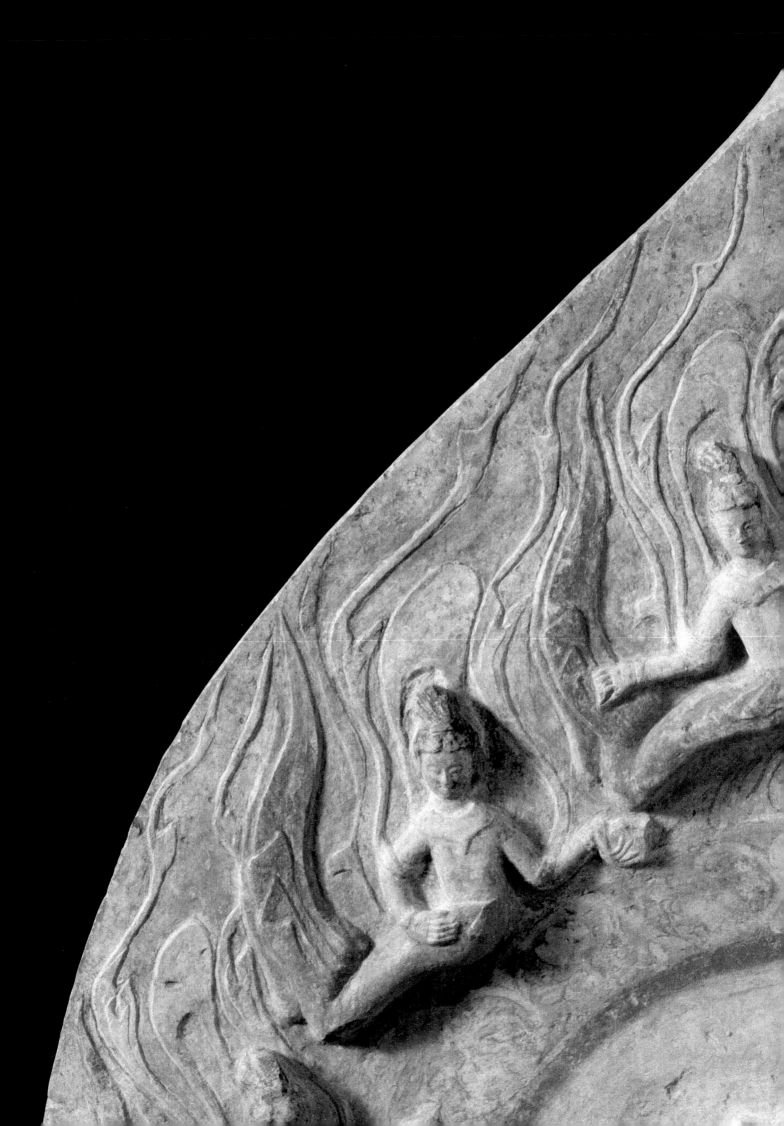

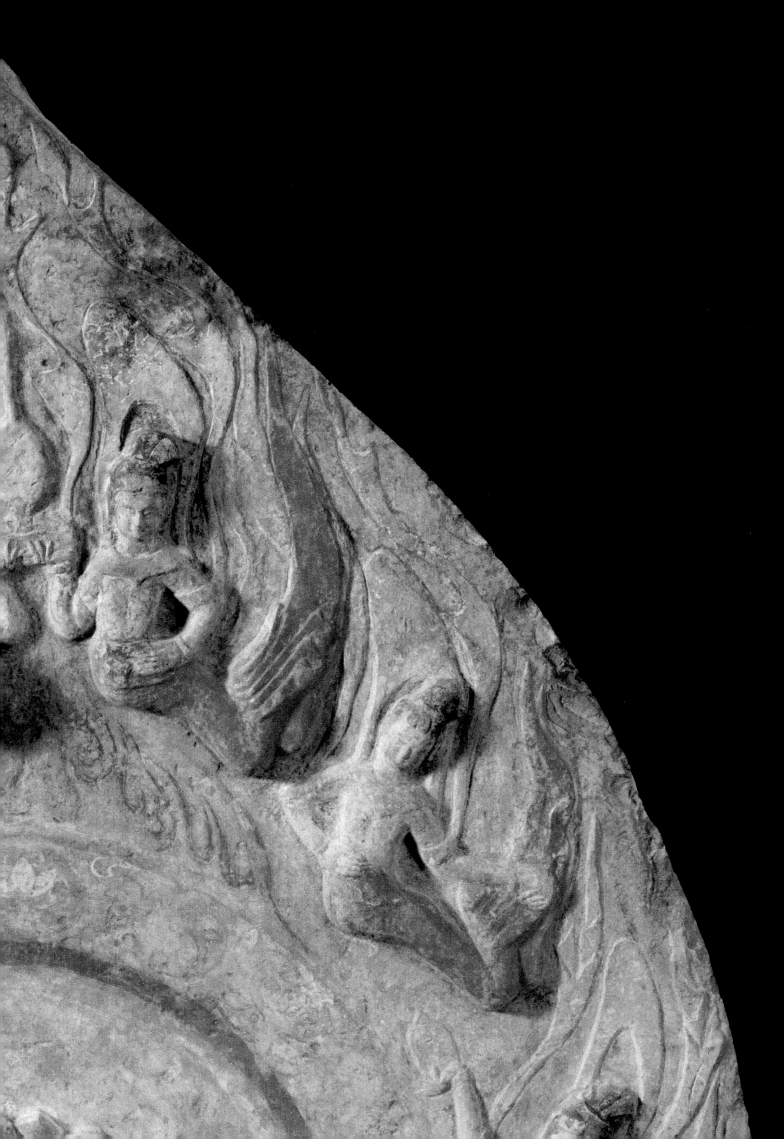

8 TRIAD WITH MANDORLA

Eastern Wei dynasty (534–550)
Limestone, height 45 cm (B 418)

Published: Wang Huaqing 2001, pp. 152–3; *Masterpieces* 1999, pp. 60–1; *Qingzhou yishu* 1999, pp. 22–4

The three figures, carved in high relief, stand in front of a mandorla, the upper part of which is lost. The Buddha is surrounded by a head nimbus bearing a floral design in low relief around the edge and by an engraved body nimbus. The bodhisattvas have simple head nimbuses, indicated by an engraved circle. The bodhisattva on the right wears a tall crown with a floral relief and ribbons falling to his shoulders from both sides. His hair is arranged in circular locks on his forehead. A necklace with a large, spherical pendant hangs on his naked chest. He holds a lotus bud in his right hand and a fan in his left (see cat. 9). His loose lower garment is fastened with a sash at the waist. The ends of his stole, which falls from both shoulders with strings of beads or pearls and corals, crosses through a disk at the waist and descends to the knees in two loops, seem to fall from the forearms and dangle in a lozenge pattern at the knees; but these ends may belong to a second sash, since drapery falls to below the base and across the right forearm to the waist.

The bodhisattva on the left holds a lotus bud in his left hand and a flask in his right. His hair is parted in the middle and he wears a tall crown with ribbons. His robes are unusual. A stole is wrapped around his neck like a collar and is probably to be thought of as crossing at the back before reappearing on the upper arm and descending on both sides of the body, billowing in a gentle curve at the knees and ending below the base. The depiction of the lower garment is inconsistent. Similar striking folds in the centre, reaching from the stomach to the feet, occur on another sculpture from the Longxing hoard, dated 536.[1] They probably represent the seam of the wrap-around lower garment, but they may possibly belong to a kind of waist sash. Likewise, neither the function of the sash on the stomach nor the manner of its fastening is clear. AB

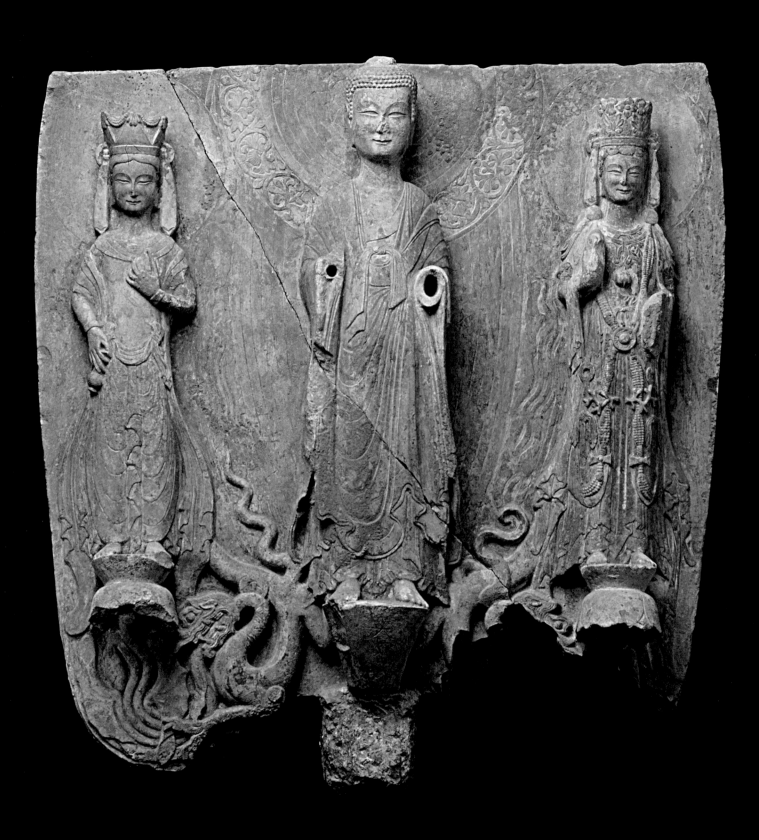

9 BODHISATTVA FROM A TRIAD WITH MANDORLA

Late Northern Wei (386–534) or Eastern Wei dynasty (534–550)
Limestone, height 110 cm (B 60)

Published: Wang Huaqing 2001, pp. 262–3; *Masterpieces* 1999, p. 80;
Jin Weinuo 1999, p. 17; *Qingzhou yishu* 1999, p. 25

The large head, small shoulders and short legs give this bodhisattva
a child-like appearance. The hair is covered with a cloth and tied in
a topknot, ribbons dangling to the temples. The strands of hair fall
to the shoulders and down the upper arms. Especially striking is the
heavy jewellery lying on the stole. It consists of strings of gilt pearls
held together by clasps of precious stones and twigs of coral.
Together with gold, silver, lapis lazuli, crystal, agate and beryl, coral
was one of the Seven Precious Materials, which were favourite
Buddhist votive gifts.[1] The branching corals in the present piece are
especially large and, unlike other bodhisattva sculptures in the
Longxing find, bear clear traces of deep red pigment.

In his left hand the bodhisattva holds a heart-shaped object
frequently encountered in such images and often referred to in
Chinese texts as a 'peach-shaped object' (*taoxingwu*). This has
recently been identified by Diana P. Rowan as a peacock feather fan
fastened to a wicker frame.[2] An aperture in the frame serves as a
handle. Early depictions of the fan, dating from the first to third
century AD, occur in reliefs from Gandhāra showing court scenes,
in one of which a servant fans Prince Siddhārta. The shape of the fan
was probably based on earlier Indian models; its construction and
materials can be seen particularly clearly in a wall painting in cave
no. 175 at Kyzil (fourth to early seventh century), where it is held
by a Vajrapāni (a deity grasping a thunderbolt, or *vajra*; fig. 66).
The painting appears to the left of the main niche, which contains
an image of the Buddha; on the right another deity holds a flywhisk.
According to Rowan, flywhisks were used in India to honour deities
or high-ranking persons, and the fan served the same purpose.[3]
A Northern Wei bronze relief dated 460 (Asian Art Museum, San
Francisco) shows a Buddha worshipped by two bodhisattvas holding
a flywhisk and a peacock feather fan, a rare depiction in China. By
the sixth century the flywhisk and fan were no longer represented
together, and the fan is always shown pointing downwards, like a
little bag (see cat. 1, 2), perhaps because the original nature of the
object had been forgotten.

The floral ornaments engraved in and painted on the mandorla,
the fine detailing of the dragon and the almost naturalistic rendering
of the lotus leaves with their engraved veins testify to the high
quality of the triad to which this bodhisattva belonged. The triad is
preserved almost in its entirety, but the dozens of fragments have
not yet been completely reassembled (fig. 67). AB

Fig. 66 Vajrapāni holding a peacock feather fan,
fourth to early seventh century. Wall painting.
Kyzil, Xinjiang Province, cave no. 175

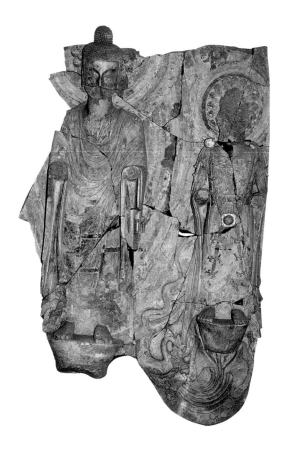

Fig. 67 Other parts of the triad to which cat. 9 belongs,
reconstructed in Qingzhou Municipal Museum

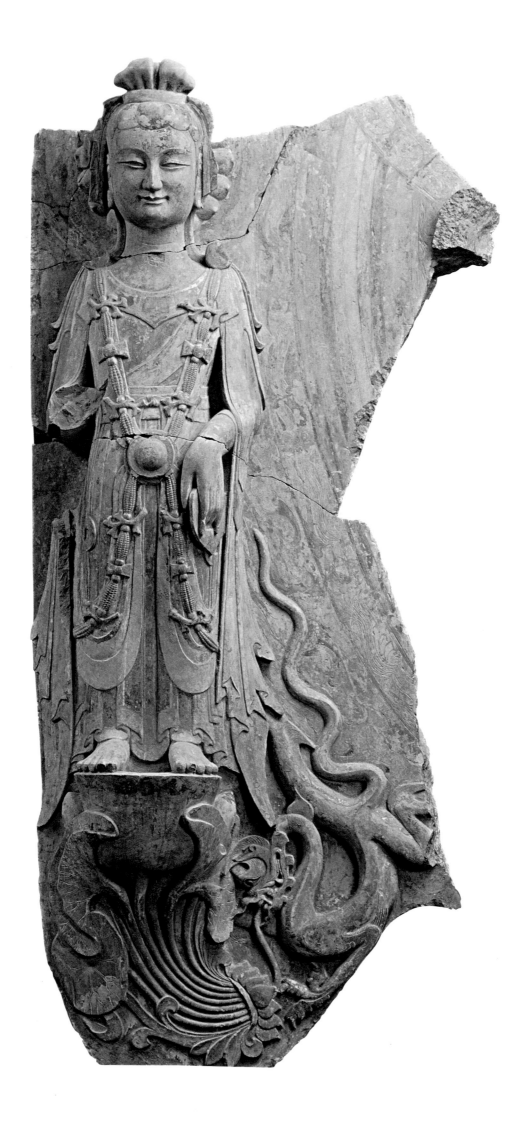

10 FRAGMENT OF A BODHISATTVA

Late Northern Wei dynasty (386–534)
Limestone, height 36 cm (B 212)

Published: Wang Huaqing 2001, pp. 256–7; Jin Weinuo 2000, p. 387;
Masterpieces 1999, p. 52; *Wenwu* 1998a, p. 17; Xia Mingcai 1998, p. 44

This image originally belonged to a triad with mandorla (see cat. 2–6, 8). The surviving section of the mandorla bears parts of the bodhisattva's head nimbus, consisting of two layers of lotus buds, some flames in low relief and traces of paint. Many more fragments of this triad were found, but they have not yet been reassembled (fig. 68). The bodhisattva shown here stood on the Buddha's left. The remaining parts of the figure resemble others included here (cat. 3, 4).

The small chin, the wide, narrow eyes and the high forehead give the face a youthful appearance. The hair is combed into fine strands, which lie in loops on the forehead and fall to the shoulders at the sides, where they are held by disk-shaped clasps. The topknot is damaged, but the diadem with three lotus buds at the front and ribbons at the sides is well preserved.

Traces of black pigment are visible on the stole and in the recesses of the necklace; remains of gilding can be seen on the jewellery and on the flames of the mandorla. The carving of the hair, the lotus buds hanging from the diadem, the ribbons at the side of the head and the flames is unusually fine. NT

Fig. 68 The splintered remains of the triad to which cat. 10 belongs

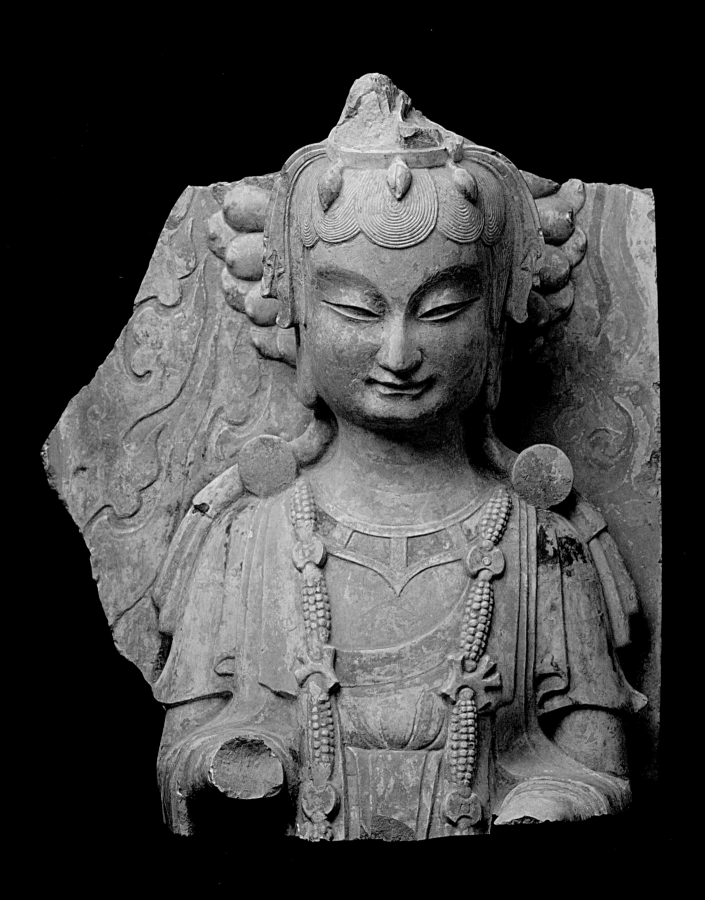

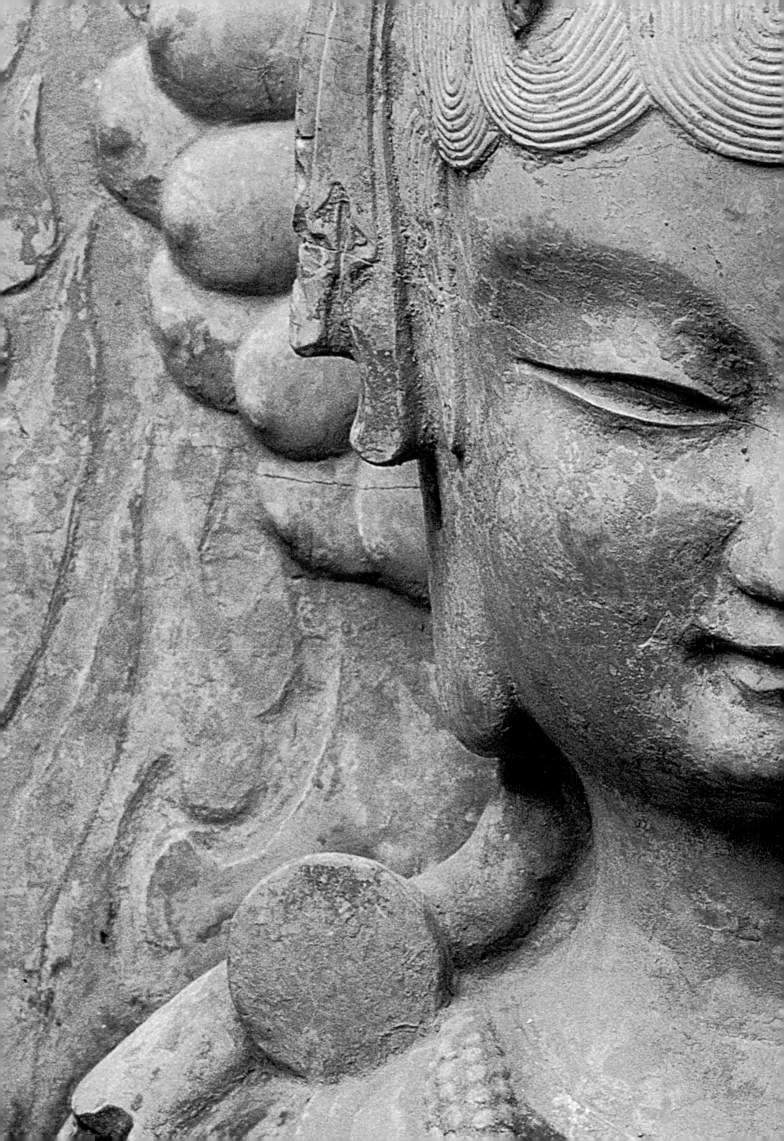

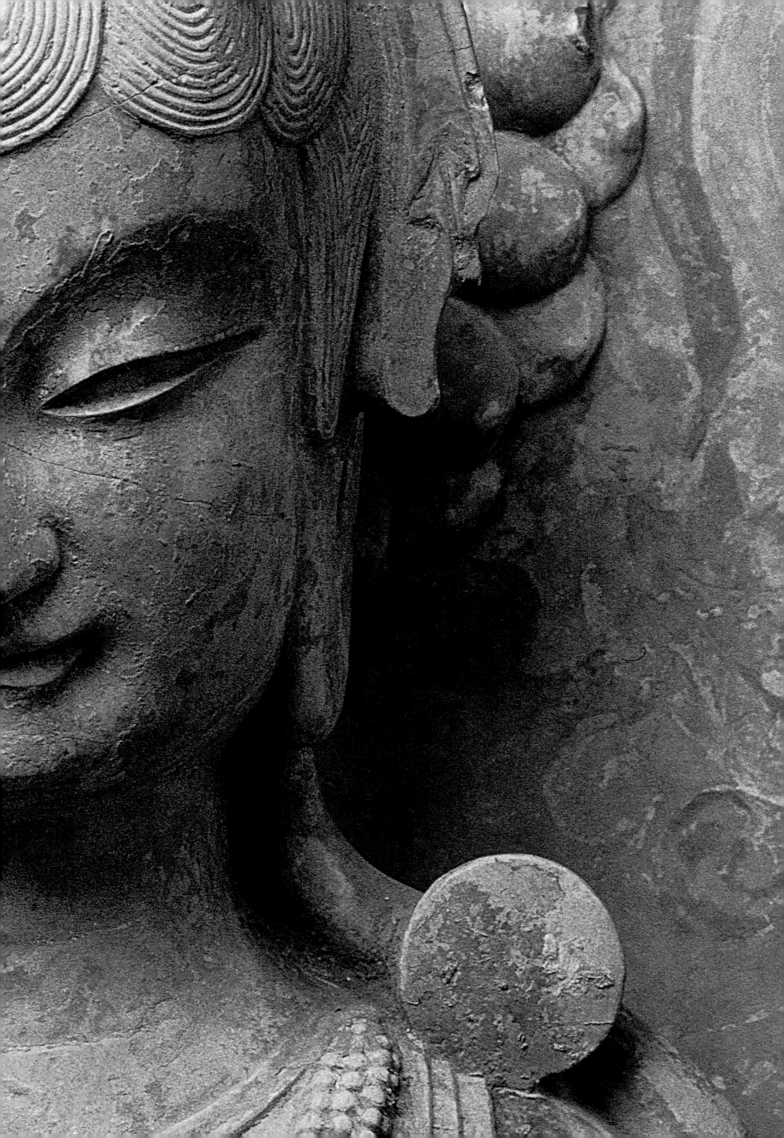

11 STANDING BODHISATTVA

Late Northern Wei (386–534) or Eastern Wei dynasty (534–550)
Limestone, height 82 cm (A 10)

Published: Wang Huaqing 2001, pp. 254–5; Jin Weinuo 1999, p. 16;
Liu and Jia 1999, p. 29; *Masterpieces* 1999, p. 55;
Qingzhou yishu 1999, p. 133; *Wenwu* 1998a, p. 9

The bodhisattva has a delicate, crisply carved face bearing a gentle
smile. The smooth modelling of the body and the narrow shoulders
and waist give him a youthful, almost feminine appearance.

Although only traces of the original polychromy remain, the
elaborate working of the robes and the jewellery indicates that this
was a figure with particularly lavish decoration. The diadem and
the hair cap, the shoulder-length hair with the disk-shaped clasps,
the necklace and the robes, are all carved in great detail and with
consummate skill. The ornamental arrangement of the hems, the
elegant curves of the stole and the way in which ends of the lower
garment and the stole are pressed back onto the mandorla as
if blown by the wind add to the striking effect of the sculpture.

The figure is carved in high relief with a slightly inclined head
and protruding stomach. The shape of the relief as a whole is
coextensive with the body and head nimbuses. This is unique
among images from Qingzhou: in all other cases either the nimbuses
form part of the mandorla behind a triad or the statue is a free-
standing figure carved in the round. The back of the sculpture is
polished smooth. On the reverse of the head nimbus, seven figures
with nimbuses and seated on lotus flowers or tiered bases are
incised in fine, hardly visible lines. Only two are complete: the
others are cropped by the edge of the stone, with only the base of
the uppermost figure preserved. The bodhisattva was evidently cut
from a larger image without regard to the engraved images on the
reverse. A detail on the front confirms this supposition. An S-shaped
line in relief can be seen beside the billowing end of the stole at the
lower right edge. Although the bodhisattva is almost completely
symmetrical, this line is not repeated on the left side and is not
connected with the figure. It evidently represents the end of a
dragon's tail. Dragons often appear in triads between the Buddha
and the bodhisattvas (e.g. cat. 3–6, 8, 9). Hence, the figure was
probably cut from a triad, perhaps after the other parts of the image
had been damaged beyond repair. LN

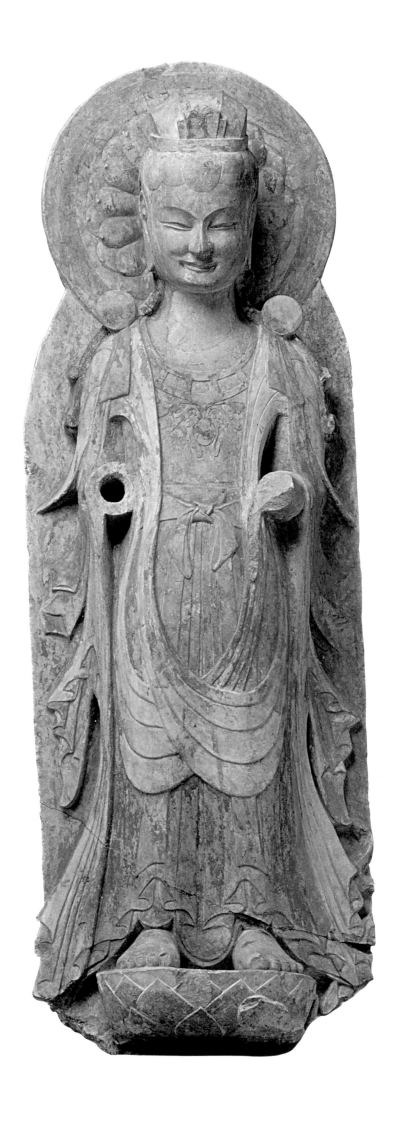

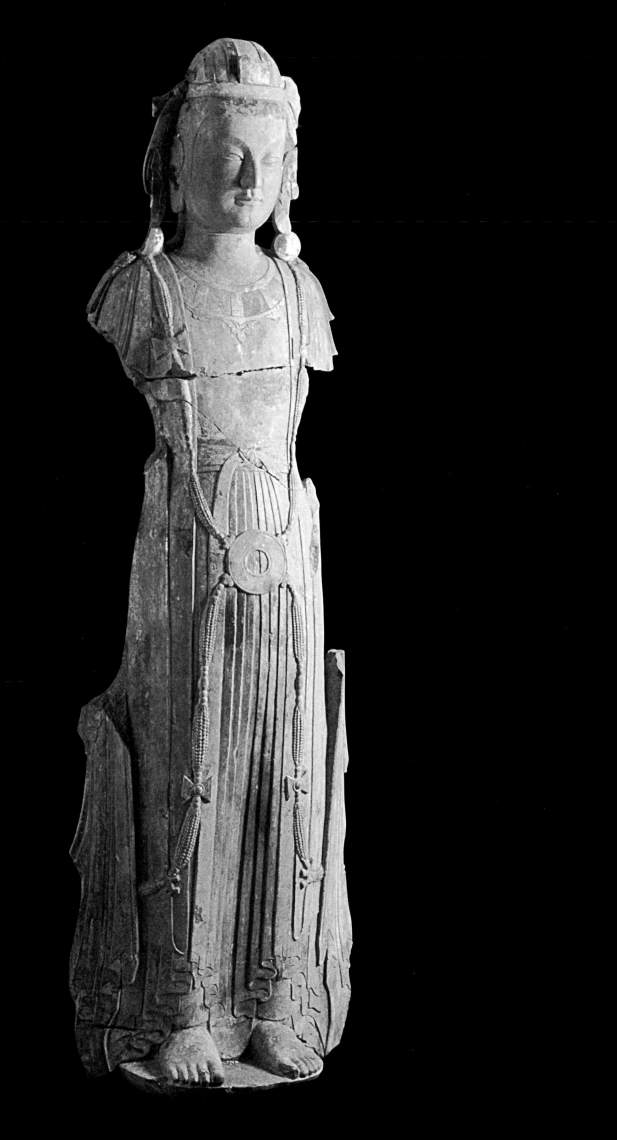

12 STANDING BODHISATTVA

Eastern Wei (534–550) or Northern Qi dynasty (550–577)
Limestone, height 164 cm (A 37)

Published: Wang Huaqing 2001, pp. 260–1; Jin Weinuo 2000, p. 385;
Chugoku kokuhō ten 2000, p. 194; Jin Weinuo 1999, p. 16;
Masterpieces 1999, pp. 78–9; *Wenwu* 1998a, colour plate 1, fig. 1

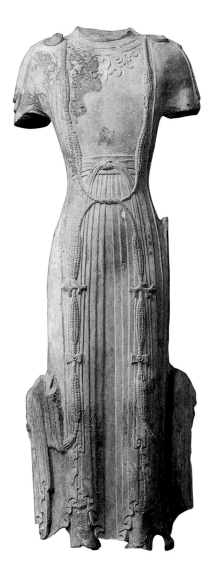

Fig. 69 Bodhisattva from the sculpture hoard of Longxing Temple,
Northern Qi dynasty (550–577). Limestone, height 77 cm.
Qingzhou Municipal Museum

This life-size bodhisattva was intended to be seen from the front.
Hence, the folds at the back are indicated only by engraved lines.
The jewellery chain, however, which passes from both shoulders,
via a disk at the stomach, to the calves, continues on the back of
the figure, where the area beneath the shoulders is slightly concave.
Two L-shaped metal hooks preserved at the back of the head were
used for attaching a nimbus of the kind seen in a similar, somewhat
smaller sculpture of comparable date from Boxing, Shandong
Province (fig. 39).[1] There are traces of red, green, blue and black
pigment on the figure and of gilding on the necklace and shoulder
clasps.

Chinese scholars date this bodhisattva to the late Northern Wei
dynasty (386–534),[2] while Japanese art historians[3] consider it a work
of the Eastern Wei (534–550) or the Northern Qi dynasty (550–577).
Comparisons with other figures from Longxing Temple support the
latter dating. A mid-sixth-century bodhisattva, for example, 39
centimetres high and missing its head,[4] wears the same garments as
the present figure and their treatment is highly similar, with narrow,
parallel folds, tiered hems above the ankles and spreading stole
ends. The robes and their depiction in another bodhisattva, 77
centimetres high and dating from the Northern Qi dynasty, are again
very close to our sculpture (fig. 69), but the emphasis placed on the
form of the body (the lower garment fits more tightly and the waist is
slimmer than the chest and hips) points to a somewhat later date.
Moreover, the face of the present bodhisattva is rounder, the chin
more oval and the expression more serious than in bodhisattvas
of the Northern Wei dynasty (see cat. 2, 10).

Its size and fine carving make this one of the most striking
pieces included here. It also bears witness to the transition during
the sixth century from sculpture bound to an architectural or other
background to free-standing figures carved in the round. NT

13 STANDING BUDDHA

Late Northern Wei dynasty (386–534)
Limestone, height 133 cm (B 200)

Published: Wang Huaqing 2001, pp. 162–3; *Chugoku kokuhō ten* 2000, p. 189;
Jin Weinuo 1999, p. 15; *Masterpieces* 1999, pp. 48–9; *Qingzhou yishu* 1999, p. 47

The Buddha, with an almost angular head that is flattened at the
back, lowers his left hand in the *varada mudrā*; the right hand was
no doubt raised in the *abhaya mudrā*. The head nimbus is carved
from the same piece of stone as the figure. Traces of red, green and
black pigment indicate that the robes were colourfully painted. A
pattern of rectangles is discernible on the mantle and a section of
the brocade pattern on its lining is visible at the stomach (fig. 70).
Remains of gilding can be seen on the face and neck.

The figure displays all the salient stylistic characteristics of
sculpture from the Northern Wei dynasty. These include the high
ushnīsha, the large, open eyes, the gentle smile, the tiered lower
hems and drapery that flares slightly into points at the bottom on
either side. Furthermore, the shape of the body is concealed by the
drapery and linear forms dominate, emphasising the stylised folds
and the ornamental appearance of the robes.

This is an unusually early example of a stone Buddha carved
in the round without accompanying bodhisattvas. Japanese scholars
have therefore surmised that it originally formed part of a triad and
was reworked as a single image following damage done to it during
persecutions of Buddhists.[1] No precise evidence has been adduced
in favour of this supposition, which is difficult to substantiate, since
the figure bears no traces of reworking. NT

Fig. 70 Knot tied in the sash fastening the chest cloth,
with a painted brocade pattern visible on the
mantle lining between the ends of the sash

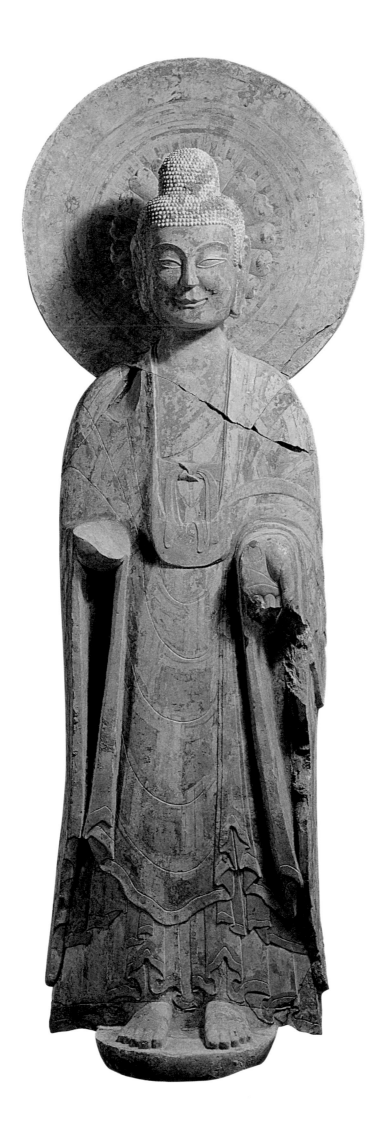

14 STANDING BUDDHA

Northern Qi dynasty (550–577)
Limestone, height 125 cm (A 41)

Published: Wang Huaqing 2001, pp. 208–9; Wang and Shou 2001, p. 44;
Chugoku kokuhō ten 2000, p. 195; Dewar 1999, p. 97;
Masterpieces 1999, pp. 94–5; *Qingzhou yishu* 1999, p. 52; Su Bai 1999a, p. 11;
Wenwu 1998a, p. 11, fig.13

With their emphasis on the body, on volume and on modelling, Qingzhou sculptures from the Northern Qi dynasty (550–577) differ markedly from those produced during the Northern Wei dynasty (386–534; cat. 1–13). The difference is revealed primarily by drapery: in contrast to the heavy, stiff Northern Wei robes, which conceal the body, the Northern Qi figures wear thin, light garments that fit the body more closely.

Over an undergarment and an outer robe, the Buddha shown here wears a fairly tight-fitting, calf-length mantle. The folds, denser at the shoulders, where they look like appliqué ridges, reveal the gentle curves of the body. The centre fold begins at the left shoulder near the neck, passes across the stomach and straight down to the hem. On either side, the folds fall in a series of parallel U-shapes that give expression to the suppleness of the material. This drapery scheme, found in a number of statues from Qingzhou, seems to have been a standard pattern. Variations in detail exist – the folds are sometimes rendered as single or double engraved lines (cat. 20), sometimes as a combination of engraved lines and low relief (cat. 16) and sometimes as fully modelled protrusions, as in the present image – but this probably represents nothing more than different sculptors interpreting the same prototype (possibly a drawing) in different ways.

The mantle is draped over the shoulders in such a way that a small strip of the outer robe is exposed between the bared chest and the mantle. Similarly, part of the ankle-long undergarment can be seen below the mantle at the bottom of the figure. Groups of engraved parallel lines suggest the texture of the material. Such indications of texture are rare among the Northern Qi figures of the Longxing find, in which, if anything, painting is used to depict the decoration and texture of generally plain drapery (see cat. 17, 21, 24). Another unusual feature of the piece is that the painting follows the structure of the folds at least in part. Whereas in other statues the patchwork pattern painted onto the mantle disregards the forms of the sculpted drapery (e.g. cat. 16), here the light-toned bands separating the rectangular red patches conform to the arrangement of the folds in the central area, where the two rows of U-shaped folds meet.

The Buddha's strong facial features include downward-looking eyes, which indicate, on the one hand, that he is in a state of profound introspection and, on the other, that the figure originally stood in an elevated position. The head and chin also reflect this raised location: the slight inclination of the head presses the chin

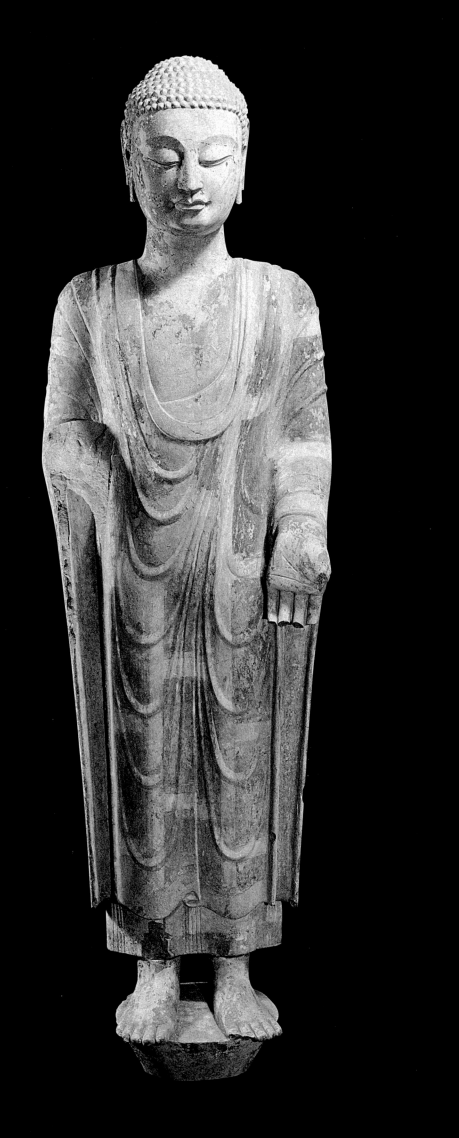

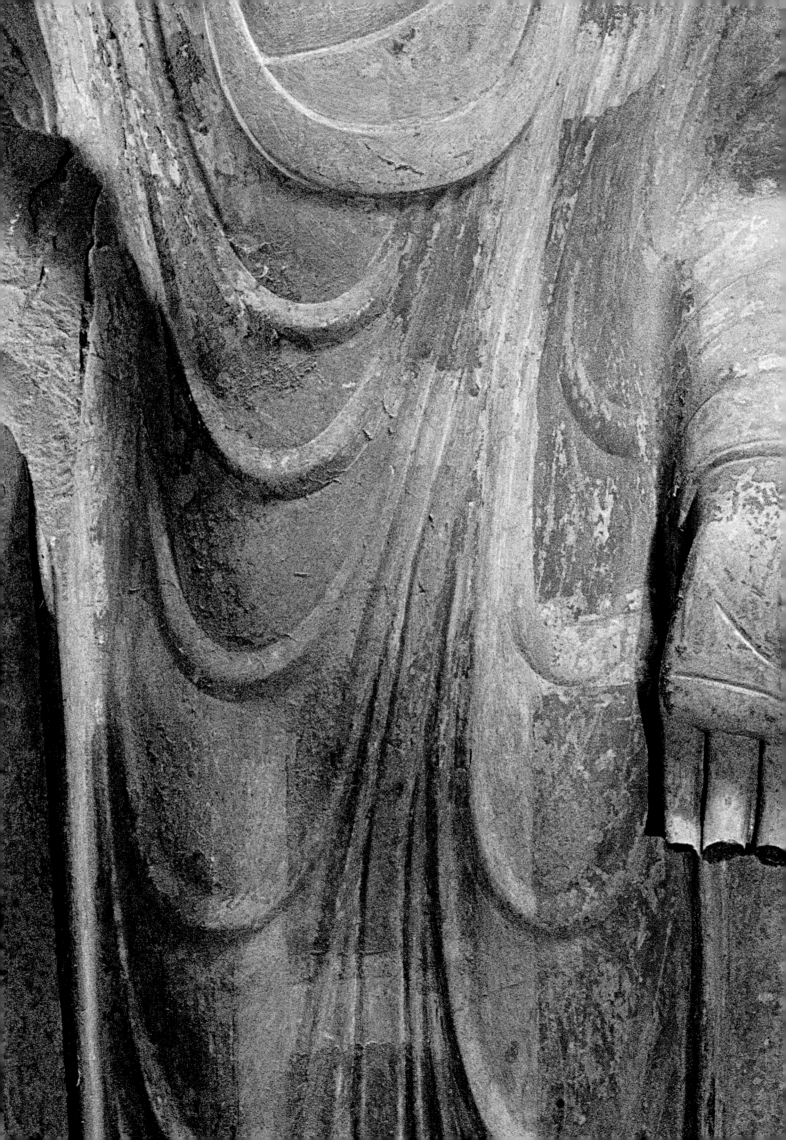

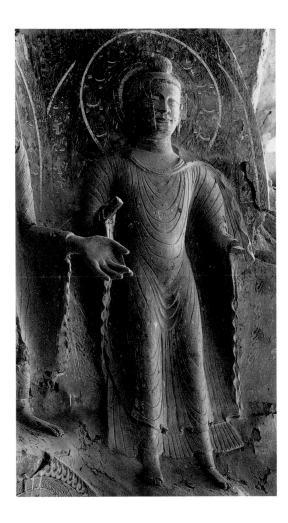

Fig. 71 Standing Buddha, *c.* 420. Painted clay, height 245 cm.
Binglingsi, Gansu Province, cave no. 169

Fig. 72 Standing Buddha Shākyamuni with mandorla, from
Mancheng County, Hebei Province, dated 475.
Bronze, height 35.2 cm. Hebei Provincial Museum

against the throat, almost turning it into a double chin. The hair is
dressed in even rows of small curls, which also cover the *ushnīsha*,
the sign of transcendent wisdom. As in most Northern Qi sculptures,
the *ushnīsha* is much less pronounced than in Northern Wei pieces.

The characteristic U-shaped folds cascading down the figure in
two rows were inspired by Chinese or Central Asian models. The
drapery of figures at the Great Stūpa of Rawak in Central Asia,
dating from the fourth or fifth century, is depicted in a comparable
way.[1] There the folds seem to be naturalistic in intent, whereas in
the Qingzhou pieces they appear ornamental, their stylisation
transfiguring the figure by removing it from the context of a common
human body. The mantle of another Buddha figure, a sculpture of
c. 420 in cave no. 169 at Binglingsi, Gansu Province, hugs the body
as in a gust of wind (fig. 71). The legs are shown almost in the round
and the U-shaped folds underscore the modelling. A small bronze
figure from Mancheng County in Hebei Province, bearing an
inscription with the date 475, has a wing-like mantle typical of the
Northern Wei dynasty, but it too shows a row of U-shaped folds
clinging tightly to each leg (fig. 72). Su Bai has supposed that many

artisans from Hebei moved to Qingzhou during the Northern Qi
dynasty.[2] It is therefore possible that the characteristic Qingzhou
folds derived from such bronzes rather than from stone sculptures.

Examples of raised drapery folds can be found in Indian
sculpture of the Gupta period (320 – *c.* 550; e.g. fig. 48).[3] There,
the ridges look like lines, far less strongly modelled than in the
present sculpture. Although the surface of the Mancheng bronze
image, which is only 35.2 centimetres high, is articulated mainly
in terms of line, the effect of the mantle folds is almost as powerfully
three-dimensional as in the Qingzhou image.

Scholars have suggested that a new wave of Indian or South-East
Asian influence is reflected in Northern Qi sculpture from
Qingzhou.[4] Although its drapery may have been the result of
indigenous developments, the pronounced modelling of the body
does seem to have been based on Indian models. This emphasis on
the body was the prerequisite for a major change in sculpture that
took place in Qingzhou during the Northern Qi dynasty – the
change from the triad relief typical of the Northern Wei dynasty to
free-standing images sculpted in the round. SG

15 STANDING BUDDHA

Northern Qi dynasty (550–577)
Limestone, height 78.5 cm (A 855)

Published: Wang Huaqing 2001, p. 172; *Masterpieces* 1999, p. 93

This Buddha, missing its head and right hand, wears Chinese monk's
attire, a far cry from the simple, strictly regulated forms of its Indian
model. The outer robe is draped from the left shoulder, across the
chest (where it becomes visible as a diagonal line) and under the
right arm, leaving the right shoulder bare. This outer garment has a
wide trimming bearing floral motifs. The undergarment is fastened
by a rope-like belt. Such belts were usually hidden, but here it has
been pulled out from under the mantle and falls to the waist with its
golden tassels. Yijing, a Chinese master of monastic discipline in the
seventh century, would hardly have approved of such extravagance.
He recommended cutting belts that were too long.[1] The hem of the
undergarment can be seen at the bottom of the figure.

The mantle, covering both shoulders, hangs loosely over the
chest in the Chinese fashion. Its wide border is turned back like a
collar. The right side of the mantle is fastened with a large button
at the left armpit, raising the seam of the garment on that side. The
drapery is thus asymmetrical: a few dense, almost exactly vertical
folds on the left curve towards the right in a series of wide, parallel
arcs. The mass of material on the left is bunched along the forearm
to prevent it sliding. Remains of faded red pigment on the mantle
show that it was depicted as patchwork fabric. The arrangement
of the drapery is the logical consequence of the way the robes are
worn and thus underscores the naturalism of the sculpture as a
whole, noticeable above all in the representation of the material
qualities of the cloth. CW

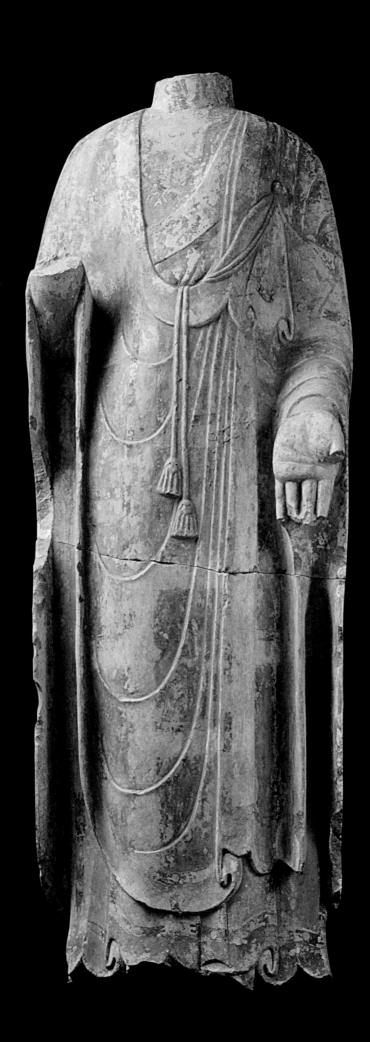

16 STANDING BUDDHA

Northern Qi dynasty (550–577)
Limestone, height 125 cm (A 41)

Published: Wang Huaqing 2001, pp. 174–5; Wang and Shou 2001, p. 45;
Meishu yanjiu, no. 3 (2000), cover; *Qingzhou yishu* 1999, p. 53;
Masterpieces 1999, pp. 96–7

The composition of this statue resembles that of several other
Buddhas included here, but there are differences in execution.
Thus, although the arrangement of the mantle drapery corresponds
to that in other figures (e.g. cat. 14), the folds are represented by
narrow ridges with an engraved line on either side, making them
less emphatically three-dimensional.

Clinging to the body, the drapery reveals the shape of the body
beneath, yet the sculpture appears relatively stiff. This is mainly due
to the painting. The bands indicating the patchwork pattern of the
mantle are arranged in strict vertical and horizontal lines,
irrespective of the delicately modelled drapery and the forms
of the body.

As usual in Northern Qi sculpture, the *ushnīsha* is not very
pronounced. The hair is dressed in even rows of curls, sculpted
as clockwise spirals along the hairline only. Since the head is not
inclined, the face, with its faint double chin, appears slightly
elongated. The polychromy is so well preserved that the thin
lines of a moustache can still be seen. SG

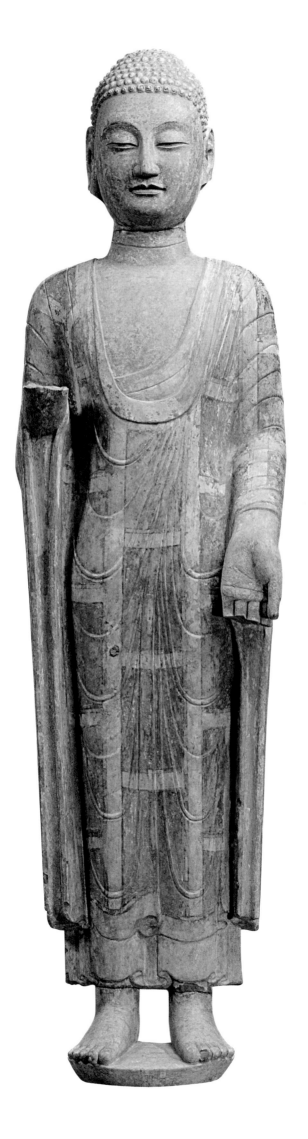

17 STANDING BUDDHA

Northern Qi dynasty (550–577)

Limestone, height 97 cm (23)

Published: Wang Huaqing 2001, pp. 212–13; Jin Weinuo 2000, p. 385;
Chugoku kokuhō ten 2000, pp. 198–9; Wang and Liu 1999, p. 37;
Masterpieces 1999, p. 103; Yang Xiaoneng 1999, cover and pp. 444–6;
Wenwu 1997, inside back cover

Unlike most sculptures included here, this free-standing Buddha
image was not found buried in the northern part of the Longxing
Temple precincts, but was excavated in 1987 near the Tuoshan
Road, east of the temple, together with a bodhisattva image (cat. 33).
Both sculptures differ in treatment and style from contemporaneous
figures from Qingzhou.

Like the majority of Buddhas from the Longxing hoard, this
figure raises the right hand in the *abhaya mudrā* and lowers the left
in the *varada mudrā*. The mantle is tight at the neck, so that in
contrast to most Buddha statues shown here the chest is covered. A
second robe, underneath the mantle, can be seen at the ankles. The
garments cling to the body, revealing its gentle shapes. Excepting the
forearms, the figure is symmetrical about its vertical axis.

The hair of the Buddha consists of a series of spiralling curls
culminating in a conical *ushnīsha*. The round, softly modelled face
with its low forehead and full cheeks appears youthful. The lips are
half opened in a benevolent smile. Although the eyelids are lowered
slightly, the Buddha is gazing straight at the viewer. The elongated
earlobes signal renunciation of the world.

The original pigmentation is relatively well preserved. In
accordance with the established canon of Buddha images, the skin
was originally gilt and the hair painted sapphire blue. Traces of blue
can also be seen around the neck and, on the back of the sculpture,
on the border of the mantle. The hem resting on the Buddha's feet is
painted with a band of ochre. Following the gently curving surface
of the body, a network of vertical and horizontal green bands
denotes the patchwork characteristic of a monk's mantle. Along one
side of these bands runs a narrow, continuous pattern of golden
triangles and lozenges, bordered by thin gilt stripes.[1] The elaborate
decoration of the mantle is continued on the reverse, where the
painter indicates how the vertical edge of the robe falls in gentle
curves. White priming can be seen in places where the pigment
has disappeared. SG

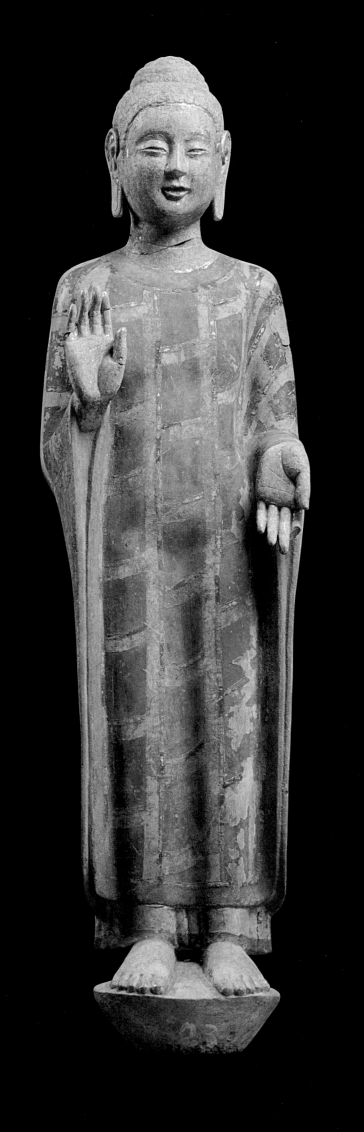

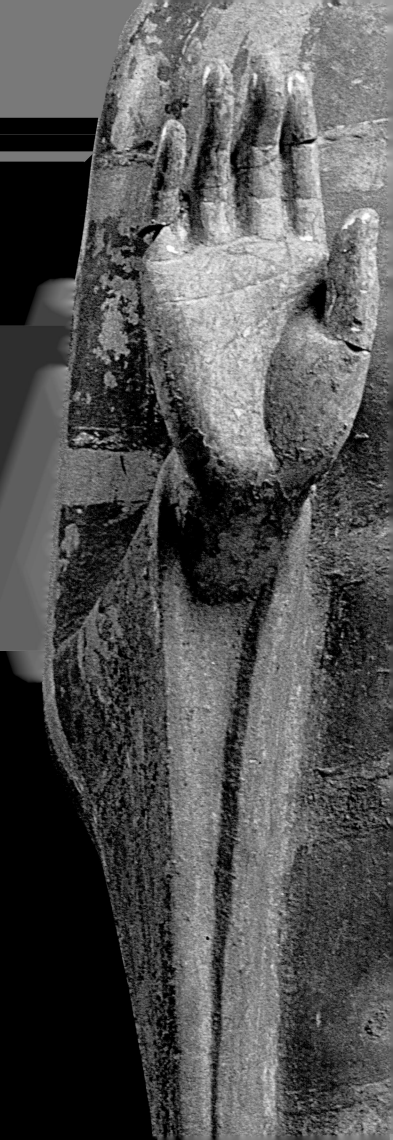

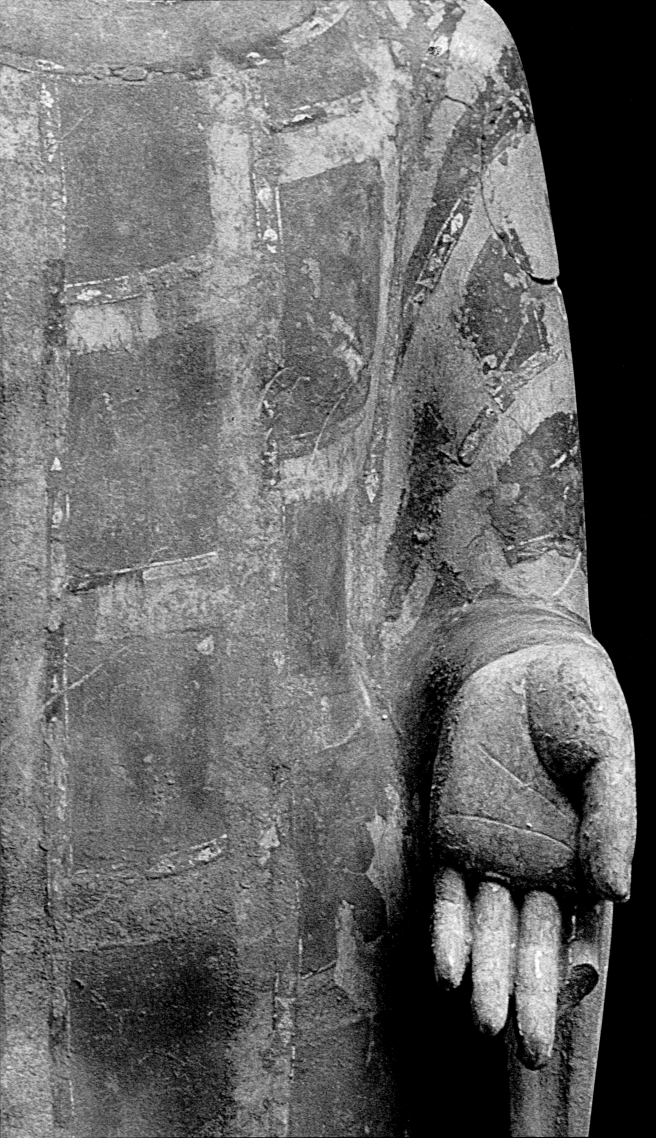

18 SEATED BUDDHA

Northern Qi dynasty (550–577)
Limestone, height 64 cm (A 884)

Published: Wang Huaqing 2001, pp. 206–7; *Masterpieces* 1999, p. 123;
Qingzhou yishu 1999, p. 82

Few sculptures from Qingzhou show the Buddha seated cross-legged, a pose frequently encountered in Chinese cave temples. The Buddha sits on a round base with two layers of lotus petals. The left leg is crossed over the right, with the toes of the right leg showing under the left knee and the left foot resting sole upwards on the right knee. The Buddha is meditating: his eyelids are half lowered and he smiles gently. The full, oval face has strongly three-dimensional eye sockets, eyes, nose and lips, whereas the eyebrows are each rendered with a single engraved line. Only traces remain of the gilding that originally covered the areas of exposed skin. The hole drilled in the middle finger of the left hand derives from a repair carried out before the figure was interred. The hand is lowered in the *varada mudrā*; the right hand was presumably raised in the *abhaya mudrā*.

Draped over the left shoulder, the red robe falls in diagonal folds across the youthful, well-rounded body onto the base, where it spills over the edge. In style, the drapery, with its clearly modelled, overlapping folds, resembles that of a number of figures included here (e.g. cat. 14, 19); but it also recalls that of images in the Buddhist caves of Southern Xiangtangshan in neighbouring Hebei Province,[1] in which the volumes of the hands and the feet are similarly pronounced. Su Bai has suggested that a number of artisans from Hebei Province were active in Qingzhou during the Northern Qi dynasty and this may explain the correspondences in the modelling of sculptures from these two regions.[2] SG

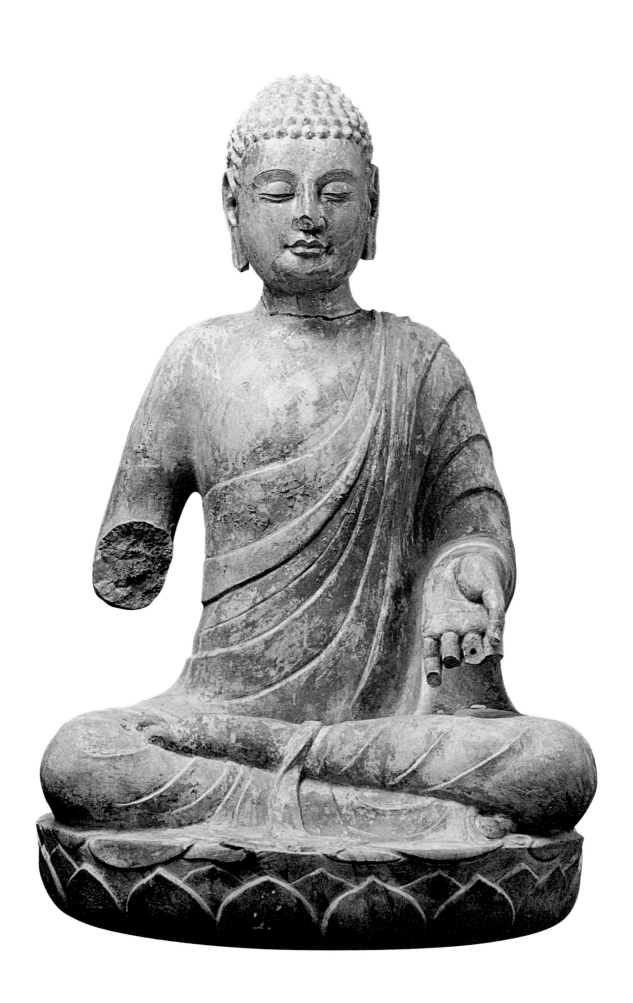

19 SEATED BUDDHA

Northern Qi dynasty (550–577)
Limestone, height 64 cm (A 885)

Published: Wang Huaqing 2001, pp. 198–9; *Masterpieces* 1999, p. 119;
Qingzhou yishu 1999, p. 84

This figure, originally seated on a throne, was broken into three
pieces: the head, the main part of the body, and the legs from the
middle of the thighs downwards. The forearms, feet and throne were
missing, as was the nimbus, which had been attached to the head
with an iron hook (fig. 73). A large hole had been drilled into each
arm stump and the area of the breakage smoothed – both indications
that the figure had been repaired prior to burial.

The carving of the facial features, the eyes half closed in
meditation, is exceptionally fine, with the bridge of the nose notably
high and the curve of the upper lip remarkably bold. The *ushnīsha*
is barely visible under the spiral-shaped curls and thus scarcely
disrupts the harmonious proportions of the head.

The Buddha wears only two of the customary three monk's
garments. The wave-like upper edge of an undergarment is partly
visible at the waist. The outer robe forms a kind of loop around the
right arm, leaving the bulging chest, right shoulder and right arm
free.[1] This form of drapery is common in China, but it is unusual for
the Buddha not to wear a mantle and thus leave his chest almost
completely exposed.[2] This may have been done here in order to
show more gilding. The leaves of gold, each measuring
approximately 2 x 3 centimetres, can still be seen on the chest.
A swastika, a symbol of good fortune, is painted in ink on the
gilding. CW

Fig. 73 The head, showing the iron hook
for attaching the nimbus

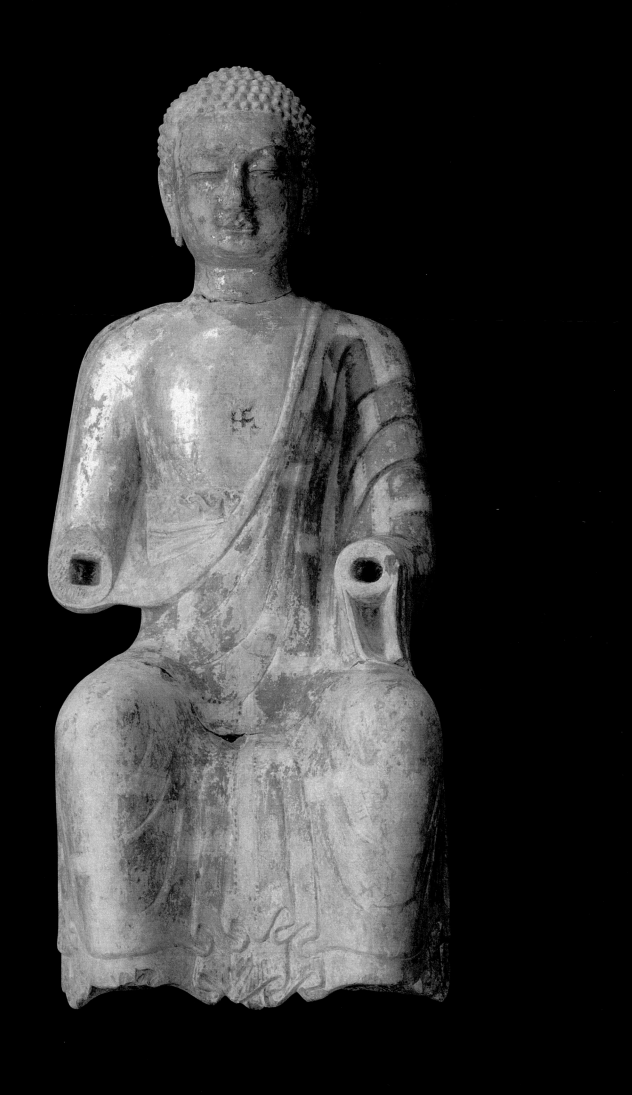

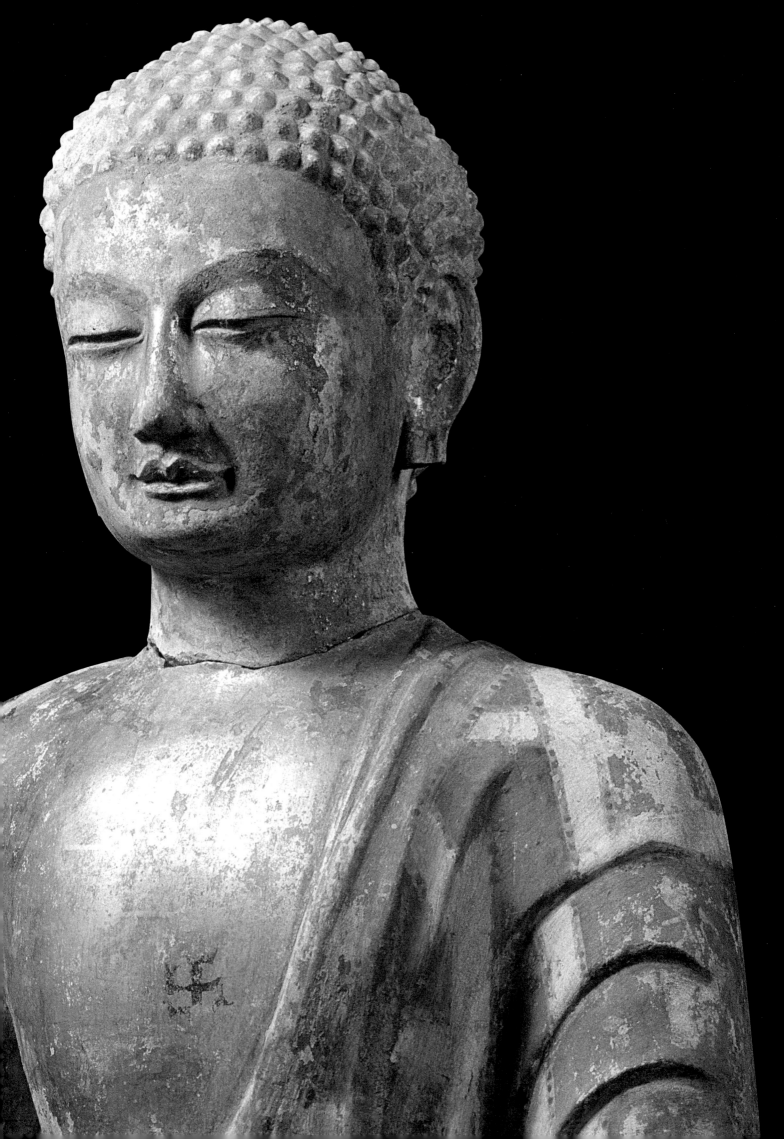

20 STANDING BUDDHA

Northern Qi dynasty (550–577)
Limestone, height 120 cm (A 1012)

Published: Wang Huaqing 2001, p. 176; *Masterpieces* 1999, p. 98

This sculpture is notably well preserved, even though the right arm, the left hand and the feet – those parts that protruded from the mass of the body – are missing and the edges of the robes have flaked off in places. The Buddha's expression is serious and dignified, his half-closed eyes seeming to gaze at the viewer. In the traditional Chinese manner, the robe obscures rather than reveals the shape of the body. Engraved double lines depict the folds, which fall in a regular series of U-shapes from below the chest, underscoring the dignified austerity of the figure. A few traces of crimson red on the robe are all that remain of the original polychromy. CW

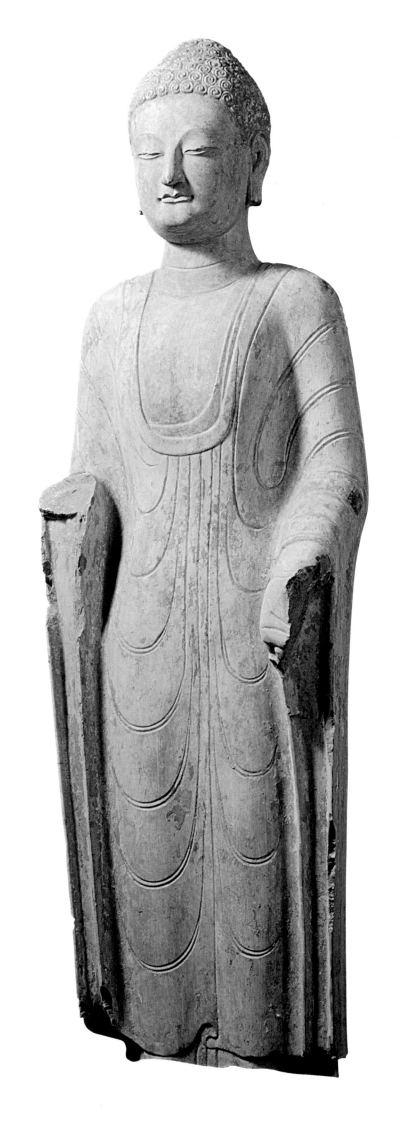

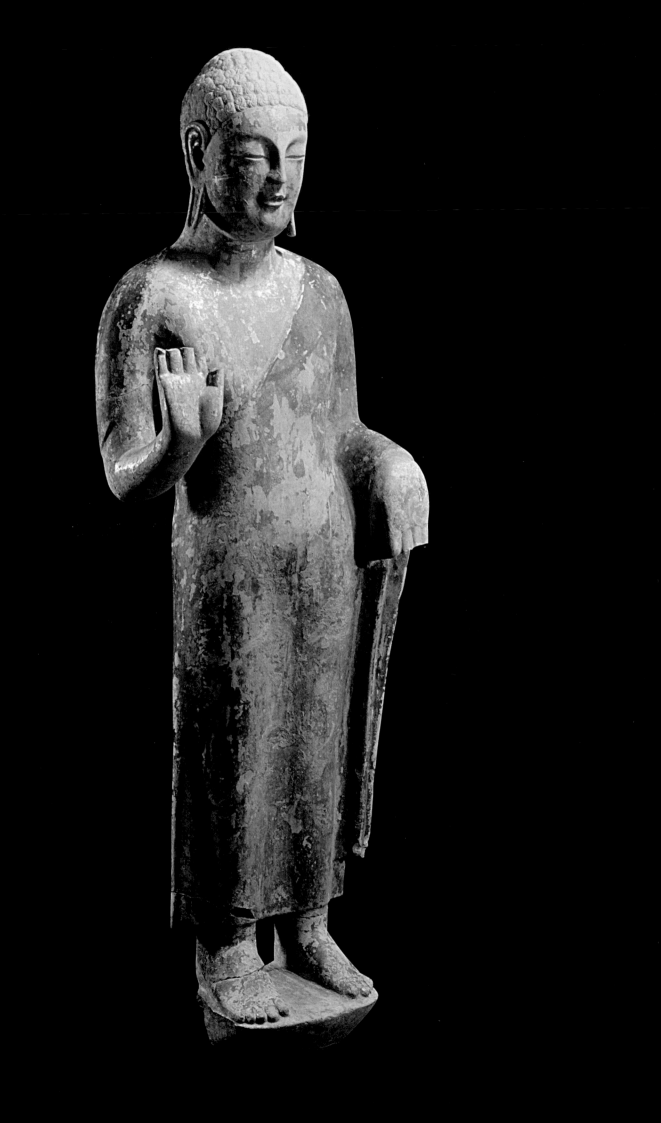

21 STANDING BUDDHA

Northern Qi dynasty (550–577)
Limestone, height 116 cm (A 47)

Published: Wang and Shou 2001, p. 48; Wang Huaqing 2001, pp. 192–3; Dewar 1999, p. 95; *Masterpieces* 1999, p. 110; *Qingzhou yishu* 1999, p. 59

Fig. 74 Detail of a Buddha from Longxing Temple, showing strips of green that have partly turned black. Qingzhou Municipal Museum

This is one of several images from Qingzhou in which the figure wears only a simple, tight-fitting mantle. The Buddha raises his right hand in the *abhaya mudrā*. His left forearm outstretched, he holds the seam of his ankle-long garment with the index finger and thumb of his lowered hand, the back of which faces the viewer. The mantle is draped diagonally across the chest from the left shoulder and loops back up over the right shoulder and the upper arm.

All exposed areas of the body were originally gilded. The mantle now appears to have been black only. The intensity of the black pigment as preserved varies, which may be either an indication that the mantle was decorated or a consequence of the statue's long interment. Other figures from the Longxing hoard show traces of black (e.g. cat. 10, 28),[1] and in some cases this would seem to be the result of green pigment changing colour owing to environmental influences (fig. 74).[2] Silver can also turn black over time. Although we cannot therefore be certain that the Buddha's robes in the present statue were originally black, we do know from the *Chronicle of Buddhas and Patriarchs (Fozu tongji)* and the *Biographies of Eminent Monks (Gaosengzhuan)* that some monks wore black robes in the territories of the Southern Dynasties (429–589).[3] SG

22 STANDING BUDDHA WITH HEAD NIMBUS

Northern Qi dynasty (550–577)
Limestone, height 116 cm (A 2)

Published: Wang and Shou 2001, p. 42; Wang Huaqing 2001, pp. 186–7; *Meishu yanjiu*, no. 3 (2000), p. 43; Dewar 1999, p. 79; *Masterpieces* 1999, p. 107; *Qingzhou yishu* 1999, p. 49; *Wenwu* 1998a, p. 11

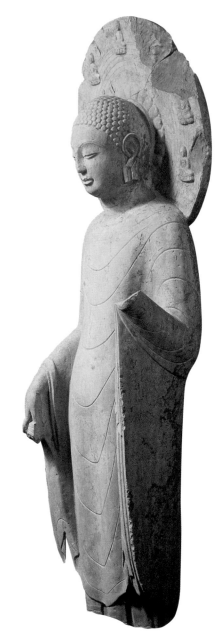

Fig. 75 The nimbus of this Buddha is only three centimetres thick.

This free-standing image is notable for its head nimbus. Such nimbuses were usually attached by means of iron hooks (fig. 73),[1] but here the entire sculpture was carved from one block of stone.

The Buddha stands in a relaxed pose. He leans back slightly from the waist, pulling the closely clinging garments over the gentle contours of his stomach and legs. The mantle, covering the body up to the neck, falls in bunched folds from the arms to the ankles, where the hem forms a lozenge-shape. Its other folds and its border are indicated by parallel arcs cut into the stone. Painting would have compensated for such plainness, but only a few traces of polychromy remain. An inner garment can be seen below the hem of the mantle.

The Buddha extends his right forearm slightly, holding the tip of his mantle in his hand. Enough of his left arm remains to indicate that his hand was raised. The full, round face, the eyes, nose and mouth, all appear relatively naturalistic. The upper eyelids are lowered; the lower lids protrude. Other parts of the head are more stylised. The eyebrows, for example, are each represented by an engraved line that describes a broad arc from the nose to the temple. The large ears end in elongated lobes that are perforated, and the hair is dressed in even rows of spiral-shaped curls.

The halo, only 3 centimetres thick, was excavated in three pieces. Its centre lies approximately between the eyes of the Buddha. The head of the Buddha is surrounded by two layers of lotus petals in relief, which in turn are surrounded by an engraved pattern of pointed motifs. Five concentric circles, no doubt representing the light emanating from the halo, are arranged at regular intervals around the pattern. The outermost band contains palmette-like motifs. Seated Buddhas are carved in high relief around the edge of the nimbus.

Small Buddhas in head nimbuses are often identified as Nirmāna-Buddhas (Manifestation Buddhas, Chin. *hua fo*), in reference to the notion that the Buddha can manifest himself in different visual forms in order that his message may reach every living being. This belief is expounded in the first section of the *Lankāvatāra* Sūtra (Chin. *Lengjia abaduoluo baojing*), which was translated into Chinese for the first time in 443.[2] The *Guanwuliangshoufo jing* (Skt. *Amitayurdhyāna* Sūtra, translated 424) states that innumerable Nirmāna-Buddhas appear in the haloes of the Buddhas Amitābha and Shākyamuni and in those of the Bodhisattva Avalokiteshvara.[3] Scholars have related the occurrence of seven Buddhas in a nimbus (one is destroyed in the present piece)

to the Seven Buddhas of the Past (Skt. *Sapta Buddha*, Chin. *Qushifo*) and to the Seven Buddhas of Medicine and Healing (Skt. *Bhaishajyaguru*, Chin. *Yaoshifo*). Hayami Baiei suggests that, as Nirmāna-Buddhas, these Buddhas were thought to be the historical Buddha transformed in appearance.[4]

Body and head nimbuses in images of the Buddha and of bodhisattvas may also show three, five, nine or more such Buddhas, generally in the meditation pose. In figures with body and head nimbuses the Buddhas are usually placed in the area of the body nimbus that surrounds the head nimbus. This is how they appear, again seated in meditation on lotus pedestals, on a Qingzhou stele dated 536.[5] As the present example shows, the motif survived the Northern Qi preference for free-standing statues, the small figures taking their place in the head nimbus. SG

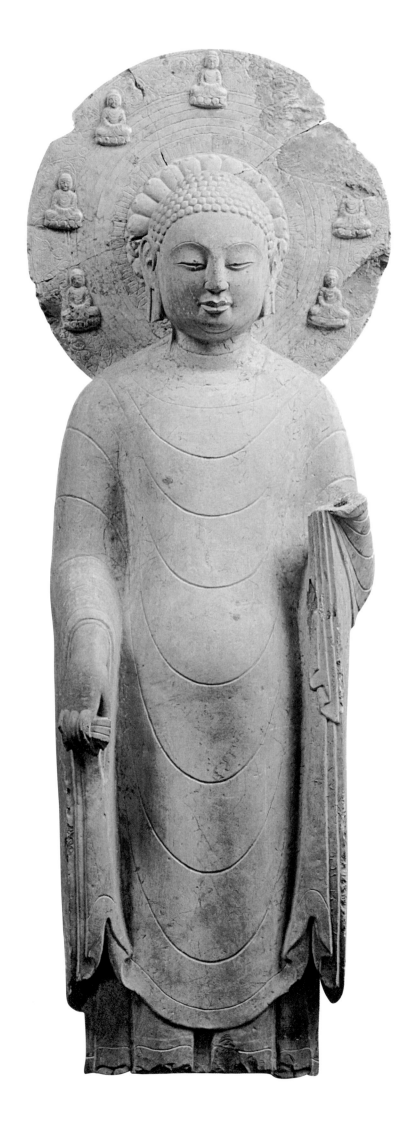

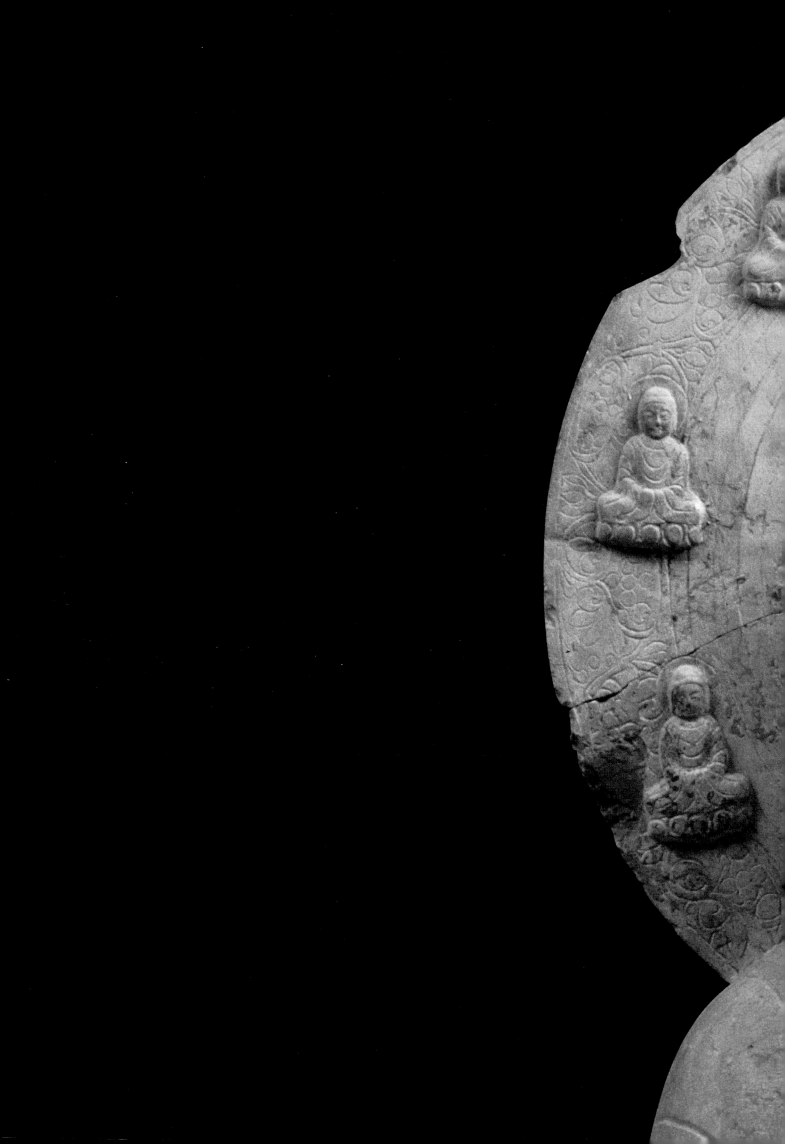

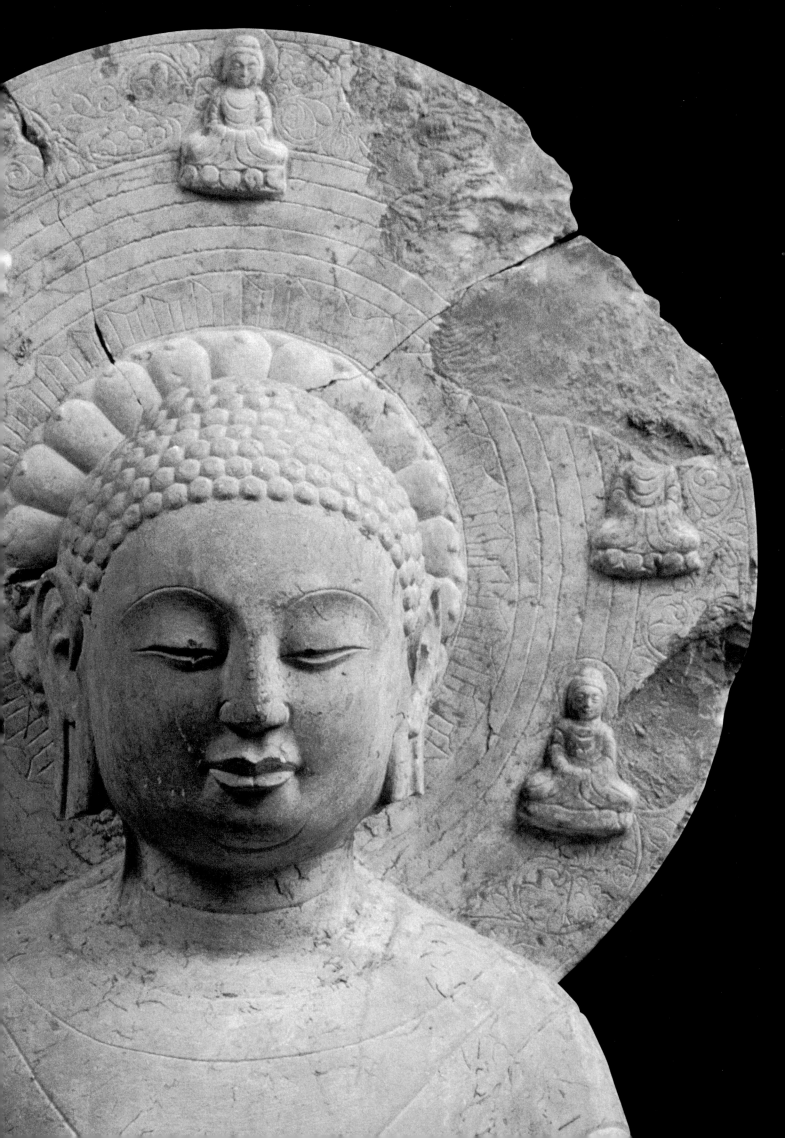

23 STANDING BUDDHA

Northern Qi dynasty (550–577)
Limestone, height 150 cm (A 484)

Published: Wang Huaqing 2001, pp. 204–5; *Chugoku kokuhō ten* 2000, p. 200; *Masterpieces* 1999, p. 102; *Qingzhou yishu* 1999, p. 54

The slightly opened eyes and the gentle, benevolent smile give this Buddha an almost dreamy appearance. His hair, its curls resembling rows of pearls, bears traces of blue pigment. The slender body, doll-like in its perfect regularity, contrasts strongly with the head. The robe is draped tightly over the body, exposing the right shoulder and the left arm from the shoulder downwards. Monastic regulations stipulated that such robes, and occasionally also mantles, be worn 'open', leaving the right shoulder uncovered. Nevertheless, statues clothed in this manner are unusual in China, and exposed left arms are encountered extremely rarely. The folds of the garment are no less striking: carved as rounded ridges, they pass diagonally across the body in long, even curves, imbuing the figure with an almost fashionable elegance. CW

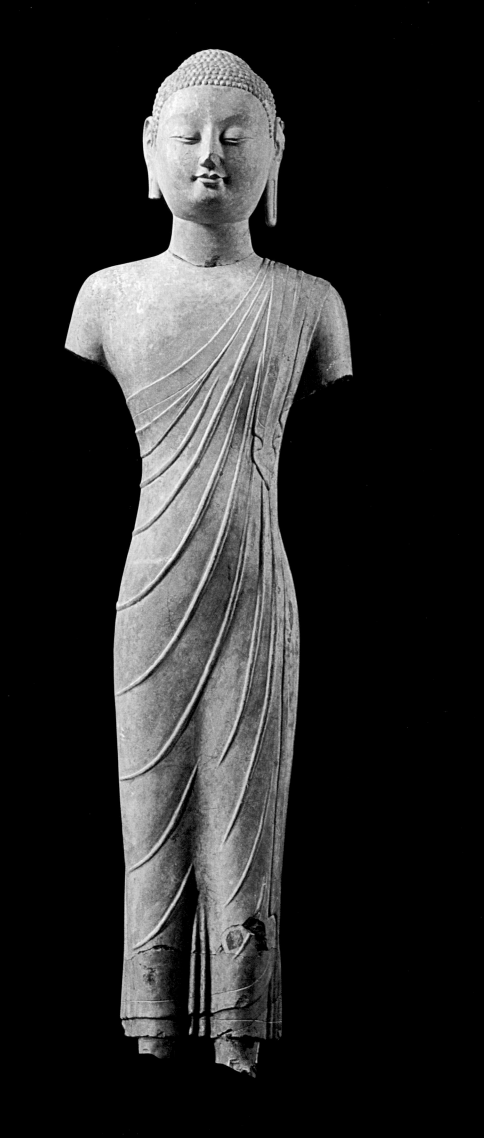

24 STANDING BUDDHA

Northern Qi dynasty (550–577)
Limestone, height 108 cm (A 38)

Published: Wang Huaqing 2001, pp. 202–3; Wang and Shou 2001, p. 43;
Chugoku kokuhō ten 2000, p. 201; *Masterpieces* 1999, p. 99;
Qingzhou yishu 1999, p. 57

Vertical cavities carved into the arm stumps of this figure and horizontal holes drilled into them are evidence of early repairs. The head was reattached after excavation. Traces of gilding remain on the face and the neck.

The full, oval face of the Buddha is smiling gently, and the eyes, lowered beneath finely engraved, arching brows, create a contemplative mood. With broad shoulders, a slightly curved chest and a slim waist, the body is finely proportioned. The soft curvature of abdomen and thighs lends the figure a restrained sensuality, which is underscored by the thin monk's robe clinging to the body like a wet cloth and leaving the chest and the right shoulder free. Traces of red pigment in these areas indicate that an undergarment was painted directly on the stone. The folds, engraved as single or double lines and beginning at the left shoulder, fall across the stomach in parallel arcs and between the legs in a series of U-shapes, the ends of which curl like volutes on the thighs. On the back of the figure, the hem of the outer robe falls in an elegantly wavy line from the left shoulder to the waist.

Indian influence is evident in the emphasis on the shape of the body, achieved by suppressing the material character of the robes. In thus reflecting the influence of Gupta art, the figure is typical of sculpture produced during the Northern Qi dynasty. CW

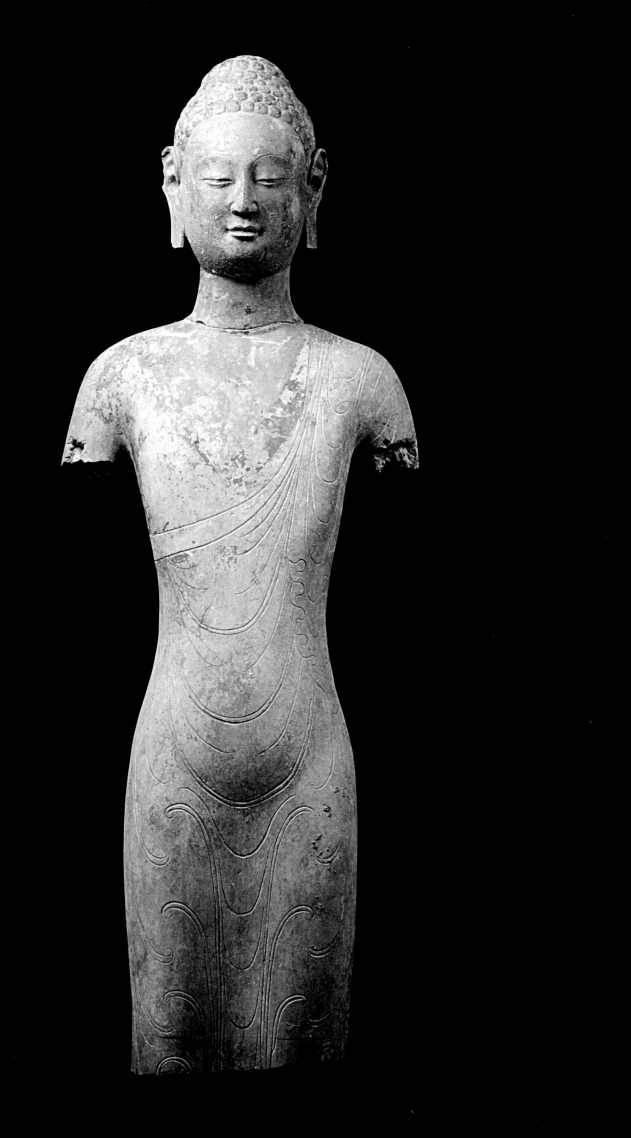

25 STANDING BUDDHA

Northern Qi dynasty (550–577)
Limestone, height 128 cm (A 548)

Published: Wang Huaqing 2001, pp. 210–11; *Qingzhou yishu* 1999, p. 70

The fact that the head, arms and feet of the Buddha are missing focuses attention on the smoothly carved body. The material of the robe is so thin and so tight-fitting that the volumes of the body emerge almost in their entirety. Not a single fold has been carved or engraved into the stone. Detailing was produced by colour alone, of which traces remain only in the form of ring-shaped folds around the left knee. It is therefore impossible to tell if the robe covered both shoulders and lay around the neck or if it left the right shoulder exposed, as the diagonal line faintly visible on the chest might suggest. An undergarment is indicated by a painted red seam above the ankles.

There may be iconographical reasons for the transparency of the robe, models for which existed in Indian art of the fourth and fifth centuries in Mathurā and Sārnāth. Among the 32 bodily characteristics (*lakshana*) traditionally ascribed to the Buddha is the golden lustre emanating from his person. A tight-fitting, transparent robe would be a suitable solution to the problem of representing this *lakshana* in sculptural terms.[1]

The depiction of the body would seem to testify to an interest in the human body unique in Chinese Buddhist sculpture of the sixth century. Contrasting with the standardised curves and generalised contours of other figures, the proportions of the shoulders and hips are here related to each other in a harmonious way and the chest and abdomen are strikingly naturalistic. One is astonished to note that the right knee is bent slightly, i.e. that an attempt has been made to depict a varied distribution of weight between the two legs. Although not entirely convincing – the hips are straight, so the *contrapposto* movement does not suffuse the whole figure – the attempt as such has no known precedents in China. CW

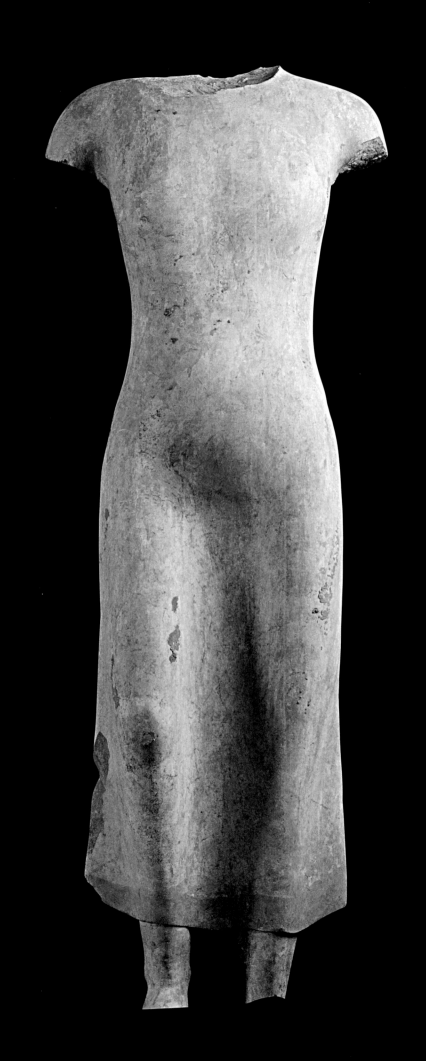

26 STANDING BUDDHA

Northern Qi dynasty (550–577)
Limestone, height 115 cm (A 477)

Published: Wang Huaqing 2001, pp. 234–7; Wang and Shou 2001, p. 47; *Qingzhou yishu* 1999, pp. 123–5; *Masterpieces* 1999, pp. 112–13

The characteristic patchwork mantle worn by the Buddha is here marked by thirteen rectangular fields formed by engraved double lines. Each rectangle contains a figurative Buddhist image carved in low relief. Images of this type, with the individual scenes painted or carved, were long known in central and northern China (see fig. 41–3), but examples have been discovered only recently in Shandong (fig. 44–6, 76).[1] The Longxing Temple find contained five sculptures of this type, two of which (one is shown here) display the scenes in relief.[2]

The raised parts of the reliefs, the result of stone removed from around their contours, are smooth. Only occasionally – in the upper right corner of the central rectangle on the chest, for instance – have details been engraved in these areas. Hence, the reliefs are considerably less finished than the finely modelled and proportioned body of the figure. One wonders whether the reliefs were combined with painting, as comparison with sculptures from the Longxing find that show painted images suggests.[3] The flying heavenly beings (see cat. 7) and the bodhisattvas with their billowing ribbons and swaying bodies bear a particularly strong resemblance to paintings. Perhaps the scenes were painted on the sculpted figure, at least in outline, and then made into reliefs. The few engraved lines may have been added later, after the original painting had disappeared. Since the images cannot be identified without the polychromy, it seems more likely that the engraved lines are contemporaneous with the reliefs. This could be taken as evidence that all the individual images were meant to be supplemented with engraved lines and that the figure was never completed.[4]

The present state of the sculpture makes it difficult to determine which images are depicted in the reliefs. The scenes on other statues of this type have been identified and they suggest that the present piece shows the Realms of Rebirth (the realms of the gods, of human beings, animals, hungry ghosts and hell). Caution is required here, however, since regional variations may have been considerable. Neither do texts necessarily form a reliable basis for identifying images, which were often indebted to pictorial tradition and popular notions rather than simply representing verbal content in visual terms.

A number of standing or flying figures with head nimbuses appear in the upper part of the sculpture (fig. 77). The uppermost rectangle in the centre shows two triads on lotus pedestals. In the upper triad a Buddha sits under a canopy on a lotus throne, flanked by two standing bodhisattvas.[5] These figures may belong to the realm of the gods. The next vertical rectangle depicts worshippers

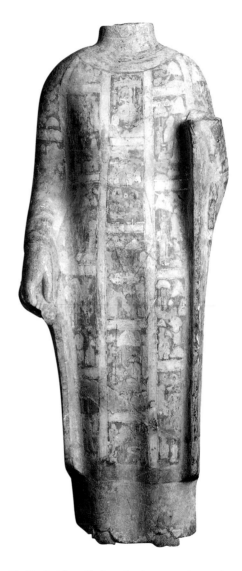

Fig. 76 Buddha with figurative images on its mantle, Northern Qi dynasty (550–577). Limestone, height 66 cm. Aurora Foundation (Zhendan Wenjiao Jijinhui), Taibei

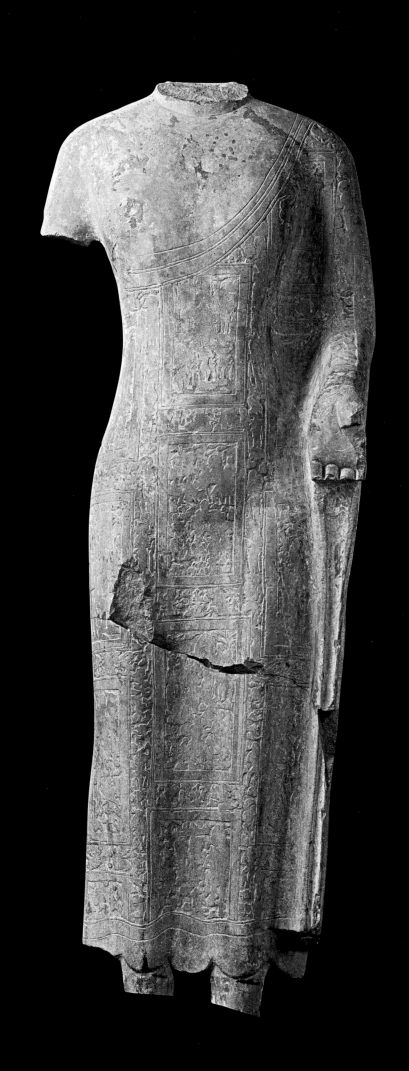

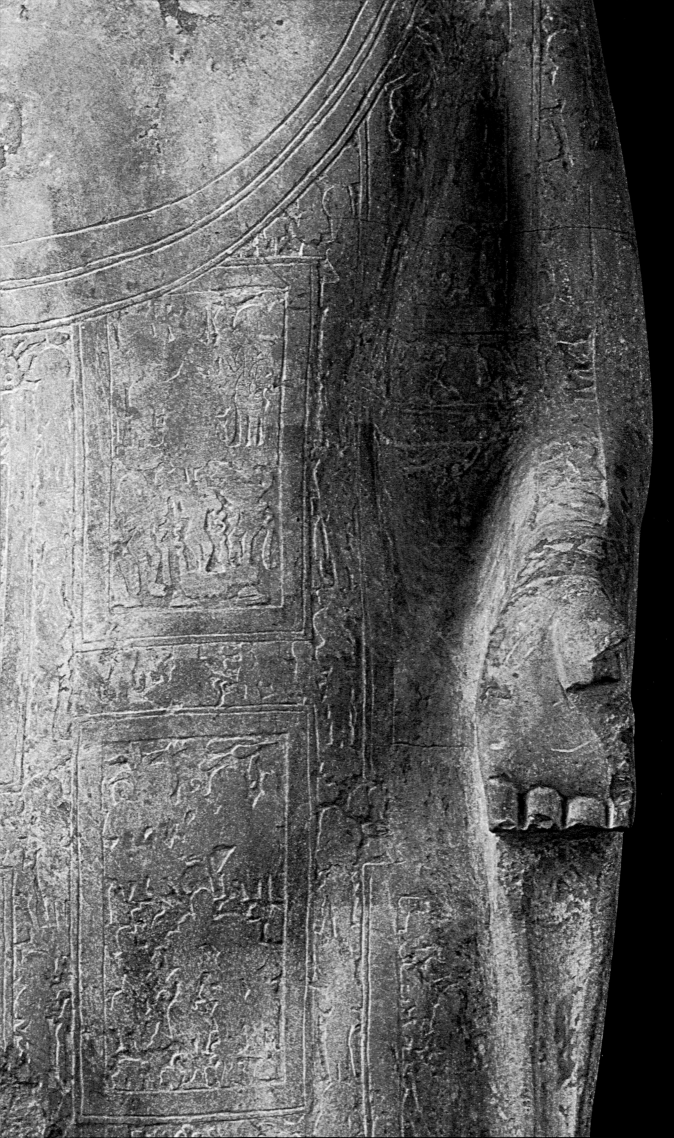

27A THREE BUDDHA HEADS

Eastern Wei dynasty (534–550)
Limestone, height 22 cm

B Northern Qi dynasty (550–577)
Limestone, height 27.2 cm

C Northern Qi dynasty (550–577)
Limestone, height 23.2 cm

Published: A: Wang Huaqing 2001, p. 217; *Masterpieces* 1999, p. 91; *Qingzhou yishu* 1999, p. 95
B: Wang Huaqing 2001, p. 218; *Masterpieces* 1999, p. 122; *Qingzhou yishu* 1999, pp. 100–1
C: Wang Huaqing 2001, p. 219; *Masterpieces* 1999, p. 121

The pit in the former precincts of Longxing Temple contained 144 heads that were evidently detached before burial because they could not be matched with any bodies in the find. The heads were deposited around the edges of the pit, the complete figures in layers in the middle.[1] The faces of all three heads were originally gilded and the hair painted blue. This blue is preserved well only on the first of the heads shown here (cat. 27A). This has a relatively long, narrow face, a small mouth deeply carved at the corners, a faint smile and a finely cut nose, characteristics that point to a date in the late Eastern Wei dynasty. The hair is dressed in small curls resembling rows of pearls, which form a pointed arch at the forehead and continue on both sides of the ears. The *ushnīsha* rises clearly from the head, less so than in earlier Buddha figures (e.g. cat. 1–3), but more so than in figures from the Northern Qi dynasty.

The two Northern Qi heads (cat. 27B,C) show not only a flat *ushnīsha*, but also curls that are larger and more pointed. Other features distinguishing the style of this dynasty from that of its predecessor are the fuller faces, which are broader at the cheeks and chin; the more emphatic modelling of eyes, mouth and nose; and the stronger curves of the eyes, which, especially in the third head, seem to be looking down.

The striking differences in style between the two Northern Qi heads are characteristic of the Longxing Temple sculptures from this dynasty. Barely two images of the Buddha are alike in their proportions, attire, treatment of the body and quality of execution. Perhaps the sculptures came from various temples in Qingzhou, and Longxing acted as a collecting point for the damaged or unused images, which were interred in a 'deposit for old Buddha images' (Chin. *gushenku*) out of respect for the deities represented.[2] PR

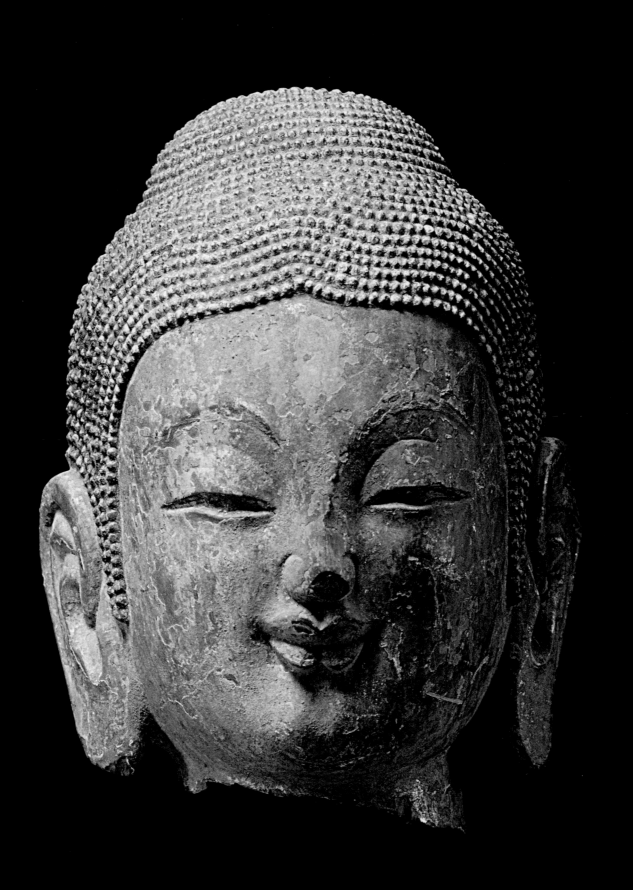

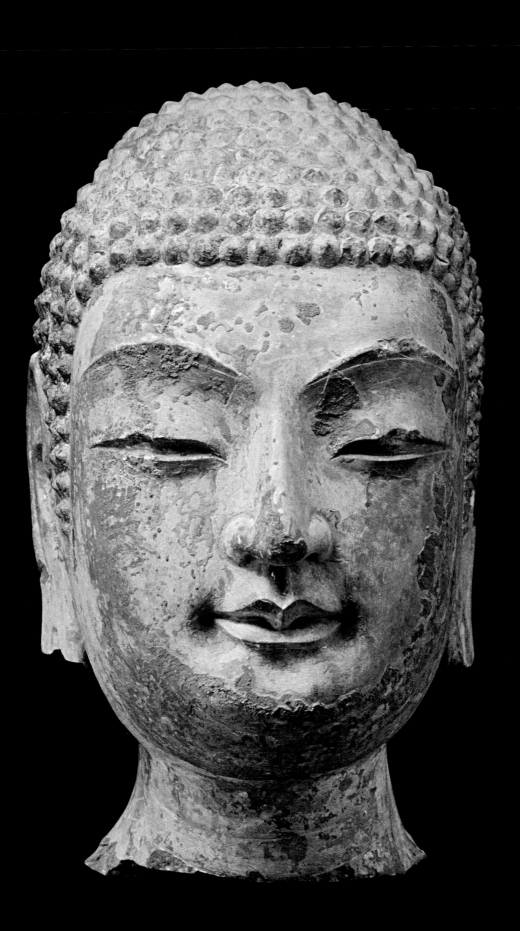

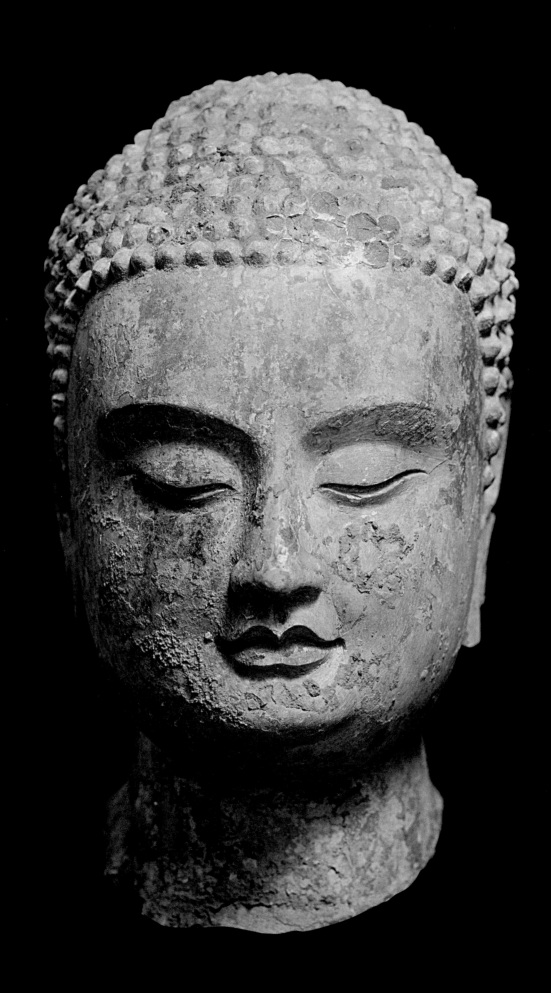

28 STANDING BODHISATTVA

Northern Qi dynasty (550–577)
Limestone, height 84 cm (A 875)

Published: Wang Huaqing 2001, pp. 278–9;
Qingzhou yishu 1999, p. 153; *Masterpieces* 1999, p. 131

The rounded shapes of the body visible under the drapery, and the gentle folds towards the bottom of the statue, are typical features of sculpture during the early Northern Qi dynasty. The squat stature of the figure and its 'square' head, with weak chin and broad forehead, distinguish this bodhisattva from the others of the same dynasty in the Longxing find (cat. 29–31).

Two hems above the ankles show that the figure is wearing a double lower garment. This kind of robe has no precedent in India or Central Asia, but is familiar from such Chinese images as the bodhisattvas in cave no. 427 at Dunhuang, which date from the Sui dynasty (581–618).[1] The lower garment reaches from the waist, where it is fastened by a sash only the ends of which are visible (just above the knees), to the ankles, where a series of parallel engraved arcs denote the folds. The chest cloth, draped diagonally from the left shoulder to beneath the right arm, is tucked into the lower garment. A stole with heavy strings of pearls draped on it passes round the shoulders, crosses at the navel, where it is held by a bejewelled clasp, and loops down to the knees. A further string of pearls, ending in a large tassel, hangs from the clasp. The strings of pearls are not symmetrical: on the right side of the chest the chain consists of four long elements, on the left of round pearls. The bodhisattva also wears a one-string necklace, round earrings and a diadem, which is adorned with two jewels and a large, leaf-shaped medallion. The hair below the diadem shows the original blue painting, while the gilding on the jewellery and on the hem of the chest cloth is particularly well preserved. The hair is stylised as a series of regular locks curling outwards from the centre of the forehead. This type of hair, and the strings of pearls crossing through a central clasp, can be traced to Central Asian models. They are to be seen, for example, in wall paintings in cave temples along the Silk Roads, including cave no. 22 at Kumtura near Kucha, Xinjiang Province, and in sculptures from Gandhāra.[2] PR

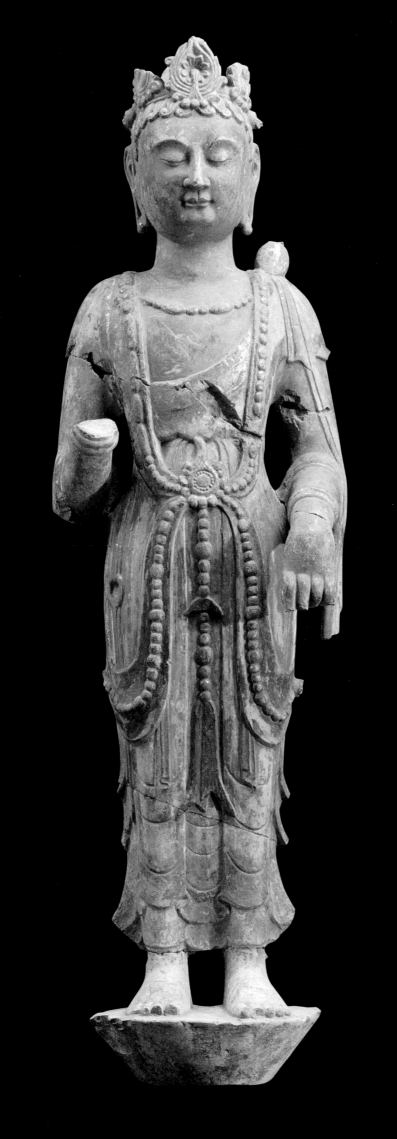

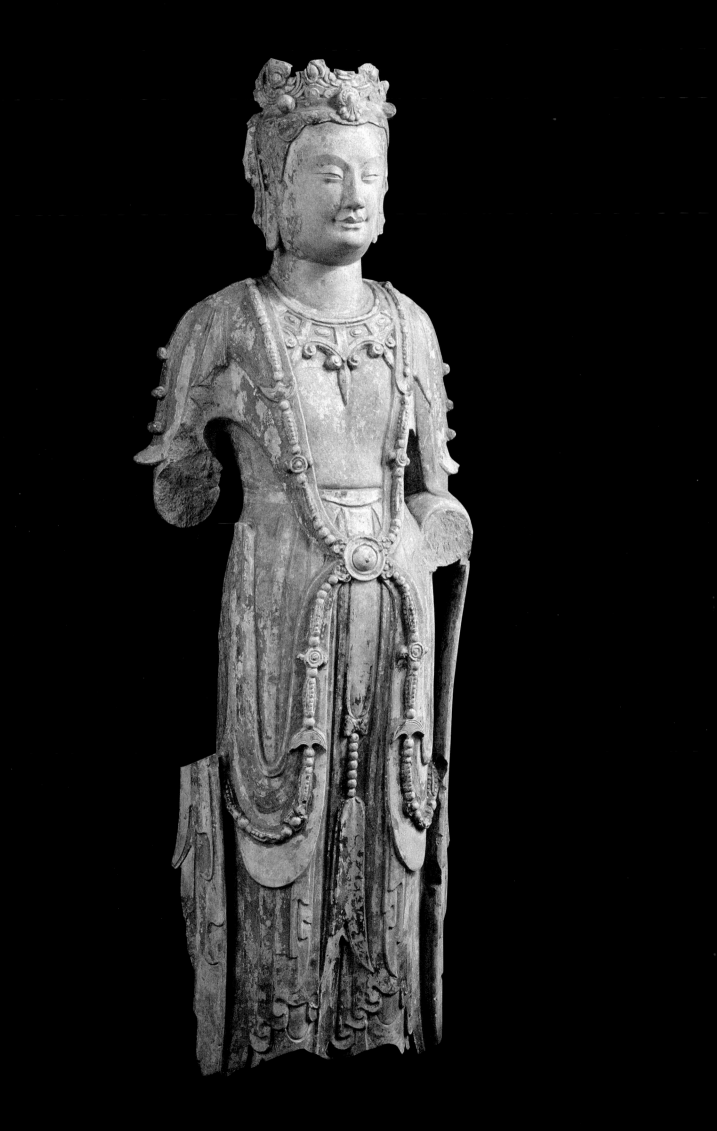

29 STANDING BODHISATTVA

Northern Qi dynasty (550–577)
Limestone, height 101 cm (A 609)

Published: Wang Huaqing 2001, pp. 280–1; *Masterpieces* 1999, p. 134; Xia Mingcai 1998, p. 44; *Wenwu* 1998a, p. 12

This standing bodhisattva shows many stylistic features typical of sculpture throughout northern China in the second half of the sixth century. They include attempts to represent the volumes of the body, evident here in the stocky upper body and the convexity of the stomach. The rather stiff pose occurs in other Northern Qi sculptures in the Longxing find (e.g. cat. 26) and in a Bodhisattva Avalokiteshvara in the Museum of Fine Arts, Boston.[1]

The figure has a strikingly thick neck and full face, with a high forehead, a slight double chin and pronounced cheeks. The head was originally crowned by hair in a topknot and a richly decorated diadem with side ribbons. Although only partly preserved, these elements still serve to focus attention on the large, gently smiling face. A medallion, decorated with pearls, is attached to the front of the diadem, other embellishments to its sides. Crossed legs are all that survive of a small figure seated on a lotus throne that once appeared above the pearls of the medallion (see cat. 30, 31).

The hair falls in two strands on the shoulders and ends in three curled locks on each upper arm. It is so strongly stylised as to be almost indistinguishable from the stole on which it lies, the edges of which also protrude from the arms. The striking necklace consists of two bands connected by spoke-like members that continue beyond the outer band to end in tips resembling arrow-heads. The spaces between the tips are spanned by arcs with volutes at either end. This kind of necklace probably represents a Chinese variation on Indian and Central Asian models, which are comparably wide in diameter[2] and which, in examples from Gandhāra, are decorated with jewels in settings.[3] PR

30 STANDING BODHISATTVA

Northern Qi dynasty (550–577)
Limestone, height 93 cm (A 3)

Published: Wang Huaqing 2001, p. 282; *Masterpieces* 1999, p. 136;
Qingzhou yishu 1999, p. 154

This slim, elegant bodhisattva raises his right hand in the *abhaya mudrā*; the left hand is missing. An iron peg, driven into the stump of the left forearm, stems from an early repair.

As stipulated by iconographical rules, the bodhisattva wears large amounts of jewellery, which derives from that of Indian noblemen.[1] This symbolises not only worldly wealth, but also the divine nature of the bodhisattva.[2] The string of jewels draped across the body consists of lengths of pearls separated by brooches and coral twigs. Unlike the strings of jewels worn by other bodhisattvas included here, this does not cross at the same point on the stomach as the stole. Rather, it is held together by a jewel below the knot in the stole, which in turn is positioned below the knot in the sash fastening the lower garment. The inside of the elaborate necklace is bordered by a string of beads or pearls of varying sizes. From the main part of the necklace, which consists of rectangular sections containing jewels, hangs a floral pendant comprising two acanthus leaves ending in a trefoil in the centre. Rather disparate in character, the necklace may well combine motifs from several, partly misunderstood models (cf. cat. 29).

The ornate diadem, held together by a band of pearls, supports jewels and floral motifs at the sides and a small figure sitting cross-legged on a lotus flower at the front. Bodhisattvas with such Manifestation Buddhas (Chin. *huafo*) in their diadems are often identified as Avalokiteshvara.[3] The Bodhisattva Avalokiteshvara (Chin. Guanyin) is considered the most important attendant of the Buddha Amitābha, residing with him and the Bodhisattva Mahāsthāmaprāpta in the Western Paradise. Believers in Amitābha wished to be reborn in that Paradise, also called the Pure Land. According to Buddhist calculations, the End of the Law (Chin. *mofa*) would begin in the year 552, ushering in a period in which chaos would reign and the teachings of the Buddha would no longer be understood. Since worship of Amitābha, which included veneration of the Bodhisattva Avalokiteshvara, promised a quick passage to salvation, the Pure Land school (*Jingtu zong*) of Buddhism became increasingly popular at this time.[4] The headgear of Avalokiteshvara often contains a figure of the Buddha Amitābha, usually with his hands in the meditation gesture (*dhyāna mudrā*).[5] Although the Buddha on the present diadem is seated in the meditation position, he seems to be raising his right hand in the *abhaya mudrā*, a gesture characteristic of many Buddha images, not just those of Amitābha.[6] PR

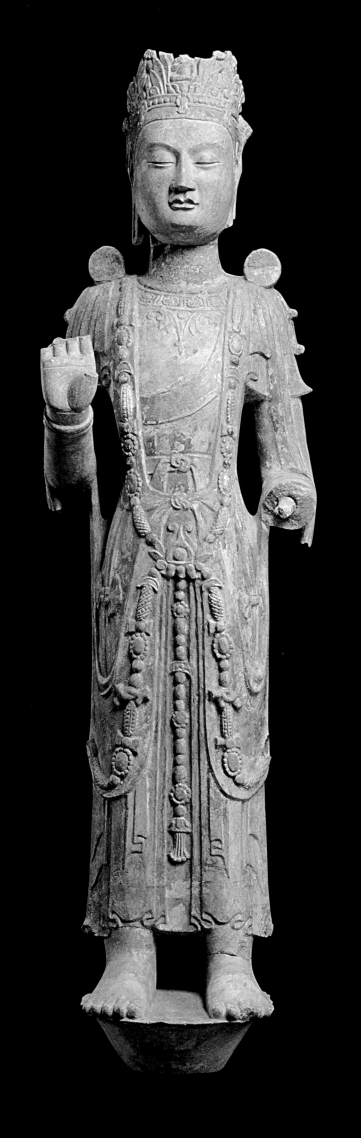

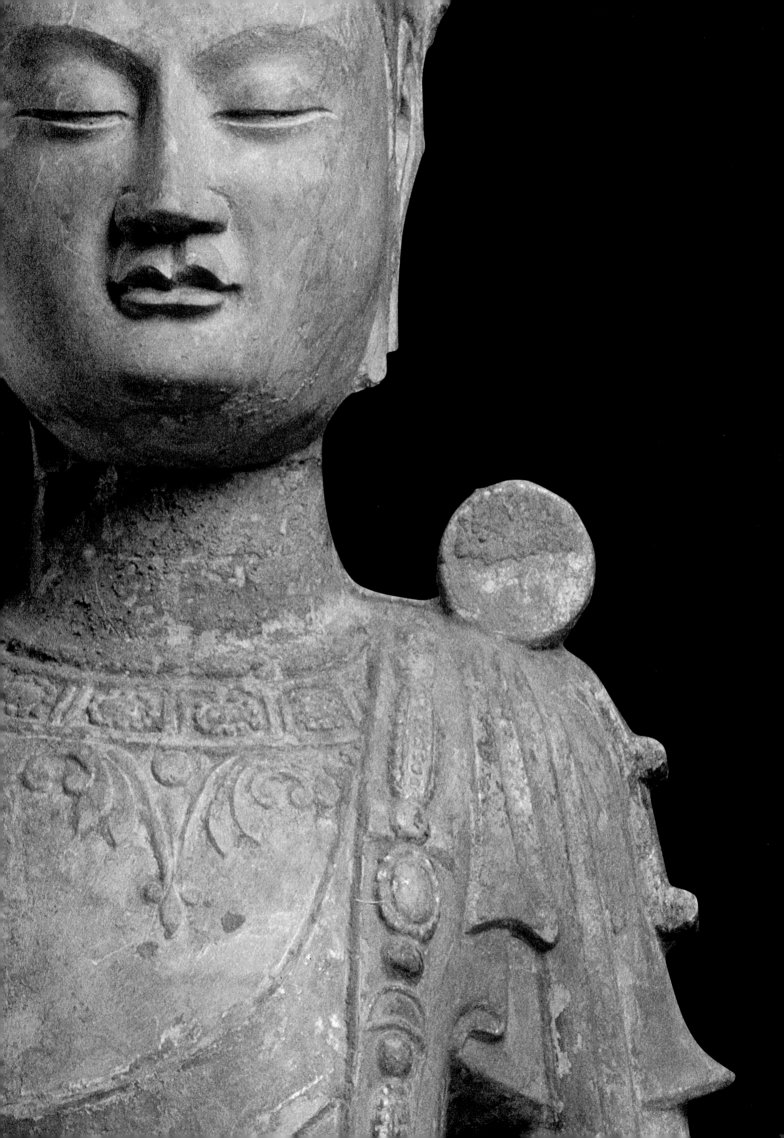

31 STANDING BODHISATTVA

Northern Qi dynasty (550–577)
Limestone, height 136 cm (A 895)

Published: Wang Huaqing 2001, pp. 274–7; *Qingzhou yishu* 1999, pp. 143–7;
Jin Weinuo 1999, pp. 16–17; Xia Mingcai 1998, pp. 48–9; *Wenwu* 1998a, pp. 13–14

With its harmonious proportions and finely detailed carving, this bodhisattva belongs among the outstanding works of Northern Qi sculpture. The figure combines in a particularly felicitous manner a tendency towards naturalistic representation with the strict idealisation typical of the sixth century. The naturalism characteristic of Northern Qi art is especially evident in the fleshy hand and in the full, oval face with its meticulously modelled mouth, strong nose and slightly curved, downward-looking eyes.

The shoulders of the bodhisattva are covered by a stole that falls in a broad band across the back of the figure. The ends of the stole cross in front of the knees. One end is then draped over the raised right forearm; the other loops around the lowered left forearm and is lifted gently by the left hand. Chest and hips bulge slightly; the narrow waist is wrapped in a bodice-like cloth. The volume of the shin bones is suggested beneath the lower garment, which falls to the feet accompanied by ribbons.

The back of the figure is comparatively flat, but carved in relief with great attention to detail. The lower garment, embellished by a double sash in the centre, falls over the base. Carved in high relief, the string of pearls contrasts with the rest of the back and passes through a pierced disk.

The bodhisattva wears a magnificent string of pearls, a richly decorated diadem, a lavish neck ornament and an ornate sash that falls from the waist to between the feet.[1] Rows of pearls form the borders of the sash and divide it into nine rectangles (to view) containing reliefs. The uppermost relief depicts a figure seated on a lotus throne, its hands joined in prayer. The next relief shows an animal mask like that on the chest of the bodhisattva. The remaining reliefs represent jewels and a Buddhist treasure flask (Skt. *kundikā*). Sashes of this kind occur not only on other sculptures in the Longxing Temple find, but also in the cave temples of Yunmenshan near Qingzhou[2] and at Xiude Temple in Quyang, Hebei Province,[3] where the rectangles, sometimes smaller, contain comparable motifs. It would seem that these sashes, favoured particularly in bodhisattva figures bearing large amounts of jewellery, were popular in Hebei and Shandong, the heartland of the Northern Qi dynasty.

The unusual necklace consists of a band of large set pearls with a jewel in the centre. A pendant in the shape of an animal mask is attached to the jewel. Five strung pearls hang from the mask's mouth and a further string of jewels passes through it. As neck and border decoration, the motif of pearls issuing from the mouth of an animal mask occurs in two other bodhisattva images from the Longxing

Fig. 78 The flatness of this figure's back is apparent in side view

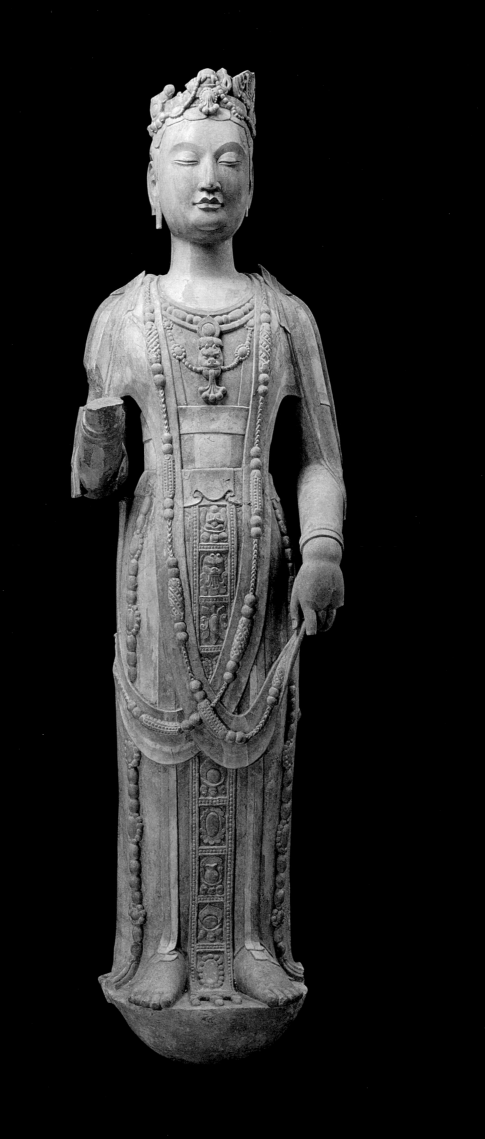

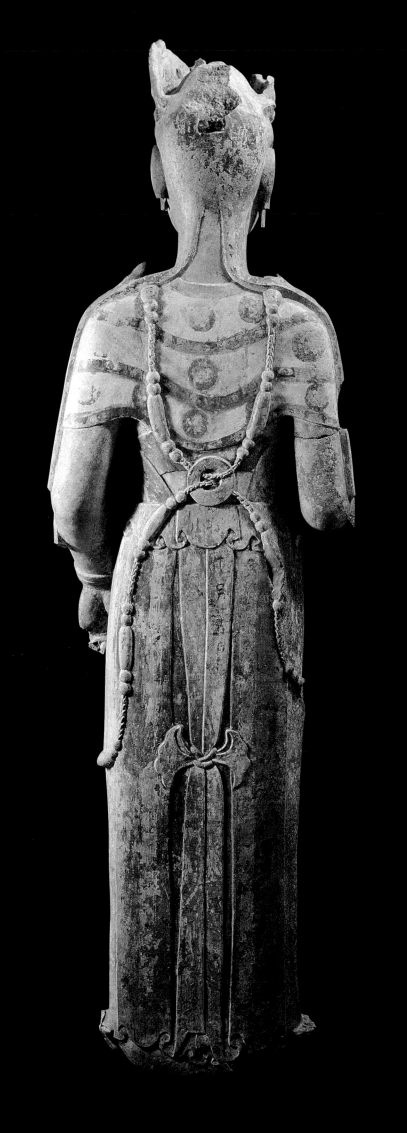

Fig. 79 Triad from Sahri-Bahlol, Gandhāra,
 second or third century AD. Schist, height 63 cm

hoard.[4] In addition, animal masks are frequently encountered as
body decoration in bodhisattvas from the second half of the sixth
century. The string of jewels in an example from Zhucheng in
Shandong, for instance, is held together by a clasp in the shape of
an animal mask.[5] Perhaps such masks on the garments and jewellery
worn by bodhisattvas derived from the grotesque masks with strings
of pearls that appear in the canopy above, or at the feet of, some
Buddha figures. As Wai-Kam Ho has shown, this motif can be traced
to Hindu models; its purpose in China seems to have been primarily
decorative.[6]

The bodhisattva wears a bejewelled diadem, partly damaged,
with open-work floral motifs at the sides and a plaque in the front.
The plaque shows a seated figure holding a string of pearls that
passes round the entire diadem. Chinese scholars identify this figure
as the Buddha Amitābha (although strings of pearls are unusual in
his iconography) and hence believe the image as a whole represents
the Bodhisattva Avalokiteshvara (see cat. 29, 30).[7] However, figures
carrying festoons or garlands are also found on headdresses in
images from Gandhāra in Central Asia,[8] where they seem to have
originated in a different context. A triad relief from Sahri-Bahlol,
Gandhāra, for example, shows a figure worshipping the Buddha by
holding a garland in both hands like a canopy above him (fig. 79).
The figure in the diadem of the Longxing bodhisattva may also be
a worshipper, carrying jewellery.

Except for the missing right hand and damage to the diadem
and the fingers of the left hand, the image is preserved in its entirety.
An iron bolt found in the back of the head was probably used to
attach a halo. The upper part of the vertical sash on the reverse of
the image is inscribed with characters written with a coarse brush:
'[made on the] 25th day of the 9th month'.[9] The four missing
characters indicating the year would normally appear to the right
of the extant line, but no traces of ink are to be found there. PR

32 SEATED BODHISATTVA

Eastern Wei (534–550) or Northern Qi dynasty (550–577)
Limestone, height 80 cm (C 103)

Published: Wang Huaqing 2001, pp. 286–7; *Baoli cangzhen* 2000, p. 159;
Wang and Zhuang 2000, pp. 48–9; *Masterpieces* 1999, p. 135;
Qingzhou yishu 1999, pp. 151–2; Xia Mingcai 1998, pp. 47–8

Fig. 80 Seated bodhisattva from the Longxing
Temple hoard, Northern Qi dynasty
(550–577). Limestone.
Qingzhou Municipal Museum

This bodhisattva in the 'pensive position' (Chin. *siwei*) sits on an
hour-glass-shaped throne with a band round the middle. His left foot
rests on a lotus capsule pedestal issuing from the mouth of a dragon.
Since this motif is common in triads with mandorlas until the early
Northern Qi dynasty (see cat. 3, 5, 8, 9), the sculpture may date
from the mid-sixth century.

There are notable stylistic differences between this figure and
another of the same type in the Longxing Temple find (fig. 80).
Here, the lower garment covering the legs has carefully modelled,
rounded folds, and hangs from the leg in a smooth arc. Although in
this second figure the position of the right foot on the left leg is
anatomically incorrect, the left hand and the right leg appear more
natural and the face is more finely modelled. It would therefore
seem that this bodhisattva is somewhat later in date.

Comparisons with dated bodhisattvas in the 'pensive position'
confirm that the present figure is earlier than other images of this
type. An example in the Shanghai Museum, 52 centimetres high,
is stylistically similar to the second bodhisattva from Qingzhou and
is dated 553 (i.e. in the early Northern Qi dynasty) in an inscription
on its base.[1] This figure, in turn, is comparable in size and style to
one dated 562 that was discovered in Boxing County, Shandong
Province, in 1976.[2] The Shanghai and Boxing sculptures evince a
similar treatment of the body, noticeable especially in the left hand
resting on the left knee and in the naturalism of the right leg, and
they both make use of U-shaped folds in the lower garment. Such
features distinguish these figures from our bodhisattva, which is still
indebted stylistically to the Eastern Wei dynasty.

The term *siwei* was already being used to describe seated
bodhisattvas in the early sixth century, as inscriptions at Dunhuang
show.[3] Yet it is not clear which bodhisattva is represented, for the
inscriptions are vague, often calling the image simply 'sculpture of
the Prince' (*taizi xiang*). Today, the figures are generally identified as
Bodhisattva Maitreya, waiting in Tushita Heaven for his descent as a
future Buddha, or Prince Siddhārta, i.e. Buddha Shākyamuni before
his enlightenment. The Ten Steps School (*Dilun zong*) of Buddhism
established itself in the capital, Ye, in the second half of the sixth
century. This school focused on the ten stages of enlightenment that
a bodhisattva passes through on his way to Buddhahood.[4] Since
many sculptures of pensive bodhisattvas date from this time, they
may belong within the orbit of the Ten Steps School. If so, they
represent bodhisattvas waiting in paradise for their rebirth as
Buddhas.[5] PR

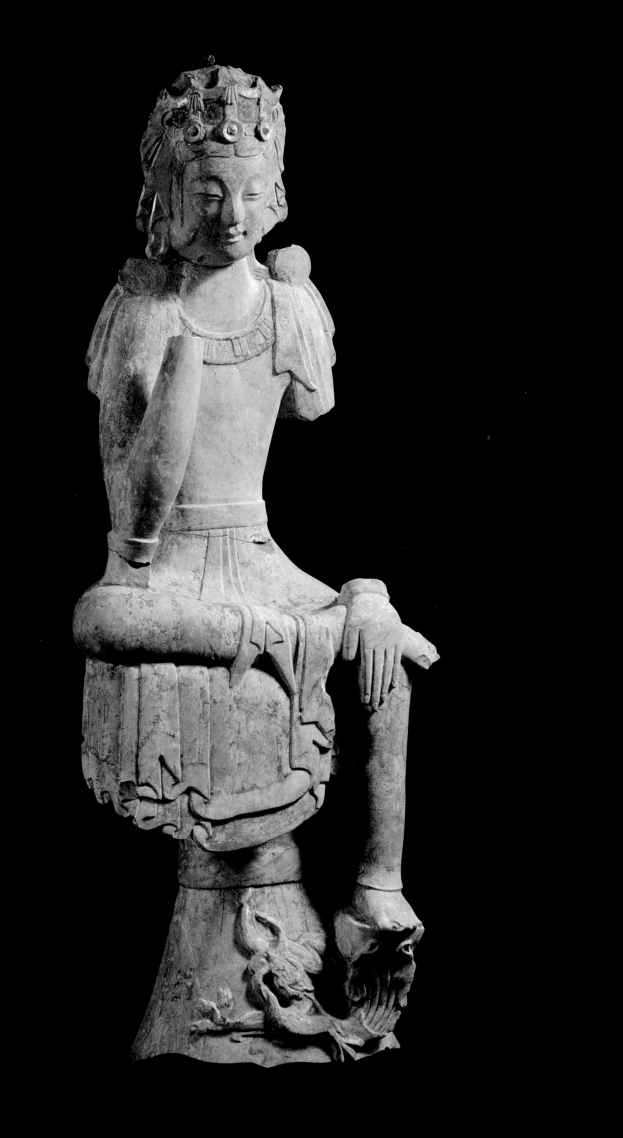

33 STANDING BODHISATTVA

Eastern Wei (534–550) or Northern Qi dynasty (550–577)
Limestone, height 95 cm (B 24)

Published: Wang Huaqing 2001, pp. 292–3; *Chugoku kokuhō ten* 2000, pp. 196–7; *Masterpieces* 1999, p. 88; Wang and Liu 1999, pp. 36–7; *Wenwu* 1997, cover, pp. 80–1

This bodhisattva, barely one metre high, was excavated in 1987 to the east of the Longxing Temple site, together with a standing Buddha (cat. 17).[1] It differs markedly from the sculptures of the Longxing hoard, most notably in the rounded forms of the body and drapery and in the cloud-shaped ornaments on the necklace and diadem. These characteristics may indicate that it did not originate from the Qingzhou region. The facts that the body's volume is indicated under the robes and that the lower garment and facial features show relatively little stylisation suggest a date in the Eastern Wei or Northern Qi dynasty.

The figure is missing both its right hand, which may have held a lotus bud, the symbol of Buddhist doctrine and purity (see cat. 1, 2, 8), and the round clasps that fastened the hair or ribbons on the shoulders (see cat. 30). The polychromy, however, is well preserved. Flesh-coloured paint is applied over white priming in the areas of exposed skin. The pupils of the eyes are painted black, while the eyebrows and the moustache are outlined in black and filled in with blue. Vertical bands of pearls are painted on the lower garment, which bears decoration in a variety of colours on a red ground. The diadem, the necklace and the bracelets are gilded.

Two holes appear in the back of the head. These were no doubt used for attaching a nimbus. PR

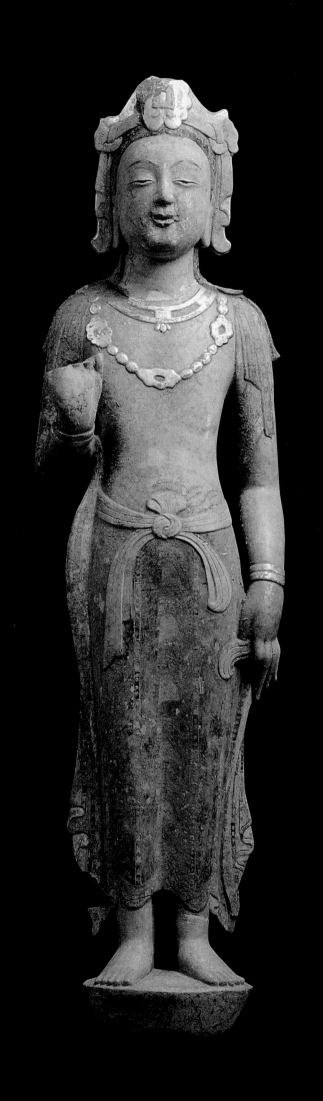

NOTES TO THE CATALOGUE ENTRIES

CAT. 1

1 Yang Hong mentions two figure steles over 2.5 metres high from Guangrao County, Shandong Province, with the sun and moon each appearing next to one or three figures. Yang Hong 1999, p. 41, fig. 4 and 5. Qingzhou Municipal Museum contains two further examples.
2 Zhang Zong 2000b, p. 61.
3 James 1989, pp. 71–2; Little 2000, p. 168, no. 30.
4 Zhang Zong 2000b, pp. 62–3.

CAT. 2

1 Klein-Bednay 1984, pp. 54–5.
2 Jin Shen 1994, p. 198, no. 143; Sirén 1925, pl. 143.
3 A very early bronze example shows a Buddha, three bodhisattvas, a Buddha disciple, *apsaras* and seven Mutation Buddhas (Chin. *huafo*) in front of a mandorla (Idemitsu Museum, Tōkyō). This piece was excavated in Shijiazhuang, Hebei Province, and is thought to date from the early fifth century. As in the triad from Qingzhou, lotus stems issue from the throne in the centre and end in two pedestals in the shape of lotus seed pods. Jin Shen 1994, no. 6.
4 Matsubara 1966, no. 45 a, b; *Fujita Museum* 1972, pp. 59–60, fig. 206.

CAT. 3

1 The characters *dai* and *shi* used in the inscription differ by only one stroke and both can mean 'to wait for'.

CAT. 4

1 Jin Shen 1994, fig. 120, 121, 137, 142, 145, 149, 152, 177, 236 and 243, all bearing inscriptions giving the date and subject of the image.
2 Ch'en 1964, p. 172.
3 Du and Han 1991, part 2, pp. 76, fig. 3, and 77, plate 3.
4 Jin Shen 1994, fig. 114.
5 Zhang Zong 2000b, p. 58.

CAT. 5

1 Franz 1978, p. 54.
2 Davidson 1954.
3 Hurvitz 1976, pp. 183, 187–8.
4 Jin Shen 1994, fig. 50, 53, 102, 127.
5 Jin Shen 1994, fig. 114, 121, 167.

CAT. 6

1 Wang Huaqing 2001, pp. 141, 307, 311.
2 Tsiang 2000, p. 51.
3 Tsiang 2000, pp. 52–3.
4 Biography of Gao Huan, in *Annals of the Northern Qi Dynasty* (*Beiqishu*), quoted in Tsiang 2000, p. 52.

CAT. 7

1 Jin Shen 1994, p. 198, no. 143; Sirén 1925, pl. 143.
2 Frédéric 1995, pp. 258–9; Malalasekera 1966, pp. 38–9.
3 *Heireiji sekkutsu* 1986, fig. 21.
4 Matsubara 1966, no. 45a, b; *Fujita Museum* 1972, pp. 59–60, fig. 206.

CAT. 8

1 Wang Huaqing 2001, p. 139.

CAT. 9

1 Ancient Chinese lists of the Seven Precious Materials vary in content. Klein-Bednay 1984, p. 119.
2 Rowan 2001.
3 Rowan 2001, p. 34.

CAT. 12

1 Chang and Li 1983, pl. 5.3; *Eskenazi* 1995, no. 47; *Miho Museum* 1997, pp. 243–6.
2 *Masterpieces* 1999, p. 78; Wang Huaqing 2001, p. 260.
3 *Chugoku kokuhō ten* 2000, p. 194.
4 *Qingzhou yishu* 1999, p. 142, fig. 157.

CAT. 13

1 *Chugoku kokuhō ten* 2000, p. 189.

CAT. 14

1 Stein 1907, vol. 2, fig. 15a.
2 Su Bai 1999d, p. 17, and the same author's essay in the present volume.
3 Su Bai 1999d, p. 17.
4 Su Bai 1999d; Jin Weinuo 1999; and the essay by Su Bai in the present volume.

CAT. 15

1 Griswold 1963, p. 123.

CAT. 17

1 *Wenwu* 1997, p. 81.

CAT. 18

1 *Zhongguo diaosushi tulu* 1983–87, vol. 2, p. 789.
2 Su Bai 1999d, p. 16.

CAT. 19

1 Klein-Bednay 1984, p. 23.
2 Griswold 1963, p. 121.

CAT. 21
1 See also *Qingzhou yishu* 1999, p. 68.
2 The ribbons hanging from the diadem worn by bodhisattvas are usually green,
 for instance, but in one such figure from the Longxing find they are black,
 as are parts of the sash. Wang Huaqing 2001, p. 273.
3 Zhipan (1220–1275), *Fozu tongji*, in *Taishō* 1960, no. 2035, section, p. 347a;
 Huijiao (497–554), *Gaosengzhuan*, in *Taishō* 1960, no. 2059, section 50, p. 378b.

CAT. 22
1 Xia Mingcai 2001, p. 49.
2 By Gunabhadra (Chin. Qiunabaluo, 394–468). *Taishō*, no. 670, section 16,
 p. 481b.
3 *Taishō* 1960, no. 365, section 12, p.343b,c.
4 Hayami Baiei 1970.
5 *Masterpieces* 1999, p. 87. The stele has only two Nirmāna-Buddhas
 because its tip is missing.

CAT. 25
1 Griswold 1963, p. 113.

CAT. 26
1 See the essay by Zhang Zong in the present volume, pp. 44–53, and Peng Jie
 2001, Li Jingjie 2000 and Zhang Zong 2000a, pp. 70–1.
2 The other example, mentioned in Zhang Zong 2000a, p. 71, awaits full
 publication.
3 Significantly, the sequence of reliefs on the other Qingzhou figure of this type
 continues on the back of the statue with painted scenes. Zhang Zong 2000a, p. 71.
4 *Qingzhou yishu* 1999, p. 123.
5 A similar scene can be seen on the chests of two painted sculptures, one from
 Qingzhou and one, in a private collection, that was shown in 1987 at the Palace
 Museum in Taibei. Xia Mingcai 1998, p. 46.
6 Howard 1981 and 1986.
7 They include Matsumoto 1937; Mizuno 1950; Banerjee 1972; Howard 1986;
 Li Jingjie 2000; Zhang Zong 2000a; and Peng Jie 2001. See also the essay by
 Zhang Zong in the present volume, pp.49–53.
8 Howard 1981, pp. 217–19.
9 Peng Jie 2001, p. 74, and the essay by Zhang Zong in the present volume,
 pp. 49–50.
10 Zhang Zong 2000a, pp. 70–2.

CAT. 27
1 Xia Mingcai 1999, p. 9.
2 Wang Huaqing 2001, pp. 28, 42–3.

CAT. 28
1 Klein-Bednay 1984, p. 93 and fig. 97.
2 Jin and Luo 1995, pp. 03, 07; Kurita 1990, p. 177, fig. 13.

CAT. 29
1 Klein-Bednay 1984, fig. 354; Leidy 1998, fig. 8, 8a.
2 Klein-Bednay 1984, pp. 236–49.
3 Kurita 1990, fig. 13.

CAT. 30
1 Klein-Bednay 1984, pp. 40–1.
2 Seckel 1957, pp. 187–91.
3 This identification has also been proposed for cat. 29 and 31. *Wenwu* 1998a,
 p. 14; Xia Mingcai 1998, p. 49.
4 Ho 1968–69, p. 8.
5 See, for instance, two sculptures in the Harvard University Museum
 and the Boston Museum of Fine Arts respectively. Leidy 1998, fig. 4, 8.
6 Saunders 1985, pp. 64–5.

CAT. 31
1 Klein-Bednay 1984, p. 293.
2 Tokiwa and Sekino 1976, vol. 7, fig. 77, 79.
3 *Chugoku kokuhō ten* 2000, p. 143.
4 *Qingzhou yishu* 1999, pp. 176, 178.
5 Du and Han 1994, fig. 5.1, 5.2.
6 Ho 1968–69, p. 26, fig. 27–9. See also Mizuno and Nagahiro 1937, fig. 36A.
7 *Qingzhou yishu* 1999, p. 146; Xia Mingcai 1998, p. 49.
8 Kurita 1990, fig. 175.
9 'Jiu yue nian wu ri [zao]'.

CAT. 32
1 *Shanghai Museum* 1996, fig. 30.
2 Chang and Li 1983, fig. 6.1.
3 Lee 1984, p. 66.
4 Leidy 1986, pp. 73–4.
5 Leidy 1986, p. 72.

CAT. 33
1 Wang and Liu 1999.

DYNASTIES AND PERIODS OF IMPERIAL CHINA

Qin (221–206 BC)

Western Han (206 BC – AD 8)

Interregnum of Wang Mang (9–23)

Eastern Han (25–220)

Period of the Three Kingdoms (220–280)

Western Jin (265–316)

SOUTHERN CHINA **NORTHERN CHINA**

Eastern Jin (317–420) Period of the Sixteen Kingdoms (317–439)

[Liu-] Song (420–479) Northern Wei (386–534)

Southern Qi (479–502)

Liang (502–557) Western Wei (535–557) Eastern Wei (534–550)

Chen (557–589) Northern Zhou (557–581) Northern Qi (550–577)

Sui (581–618)

Tang (618–906)

Period of the Five Dynasties and Ten Kingdoms (907–960)

Northern Song (960–1127)

Southern Song (1127–1279) Jin (1115–1234)

Yuan (1260–1368)

Ming (1368–1644)

Qing (1644–1911)

A NOTE ON THE PRONUNCIATION
OF SANSKRIT AND CHINESE WORDS

In the interests of readability, diacritical marks have been largely omitted from transliterated Sanskrit terms. Only long vowels are marked with a macron, although *e* and *o* have not been marked thus because they are always long. An *h* after a consonant indicates a strong aspiration. Both palatal and cerebral *s* are rendered here as *sh* and should be pronounced *sh*, as in *ship*. *C* should be pronounced *ch*, as in *chip*. As a rule, the third syllable from the end is stressed (*mandala*), but the penultimate syllable is stressed if it includes a long vowel (*nirvāna*) or a double consonant (Bodhi*satt*va).

The *pinyin* system has been used for the transliteration of Chinese characters. Most consonants are pronounced as in English. There are exceptions. *Q* denotes a light, aspirated *ch* sound, as in *chip*. Thus the *Qi* dynasty is pronounced *chee*. *X* indicates a thin *sh* sound, something like *ti* in *meditation*. The pronunciation of Long*xing* thus approximates to Long*shing*. *S*, *c* and *z* form three pairs with *sh*, *ch* and *zh*. *S* is pronounced as in English, but *c* denotes a light *ts* sound, as in *its*, and *z* a harder *dz* sound, as in *beds*. To pronounce *sh*, *ch* and *zh*, start by saying *s*, *c* or *z*, then slide your tongue back along the roof of your mouth (the 'retroflex position') until the sounds resemble a thick *sh*, *ch* or *zh*. Thus *Qingzhou* would sound like *ching-joe* with the *j* swallowed. *R*, also retroflex, is pronounced *jr*, rather like the French *je*. *W* is pronounced more or less as in English. *Wen*, for example, resembles *when*.

Pinyin a is pronounced as in *father*. *E* resembles no English pronunciation of this vowel, but has a grunt-like *uh* sound. Hence, *de* sounds like a cross between *duh* and *der*, close to the *de* in French. *I* is pronounced *ee*. After *s*, *c*, *z*, *sh*, *ch* or *zh*, it denotes a very short guttural sound. *O* is pronounced as in *portent*, but like *u* in *put* when it appears in the combination *ong*. Thus *Long*xing is pronounced not like the English *long-*, but as *lung-* (with the *u* as in *put*). *U* is pronounced as in English, except after *j*, *q*, *x* and *y*, when it resembles the French *u*. *Ei* is a long *a*. The *Wei* dynasty, for example, is pronounced *way*.

Phillip Newell

163

ICONOGRAPHIC ILLUSTRATIONS

BODHISATTVA

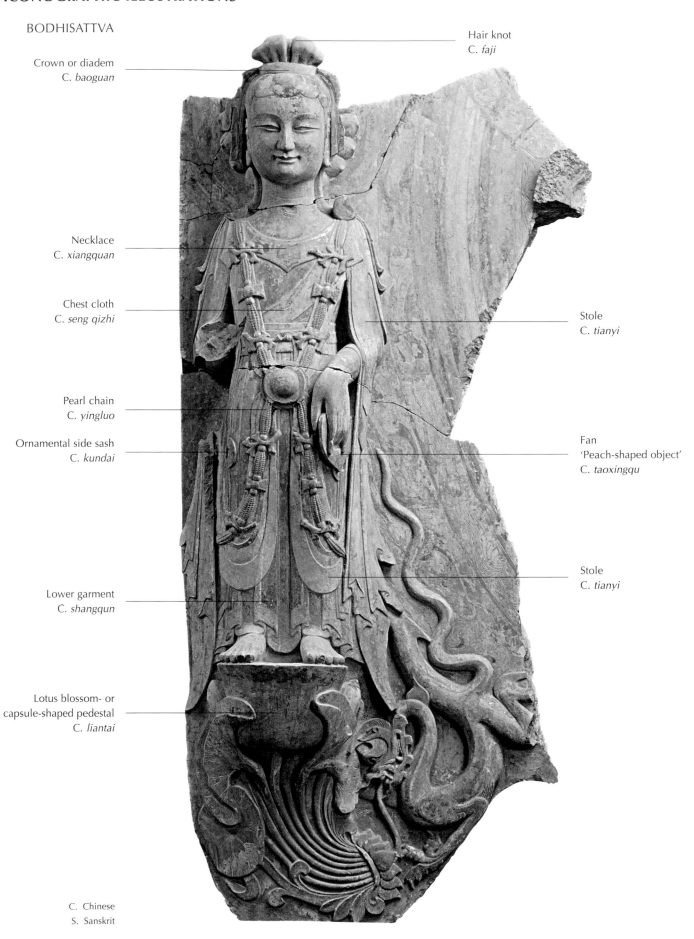

Hair knot
C. *faji*

Crown or diadem
C. *baoguan*

Necklace
C. *xiangquan*

Chest cloth
C. *seng qizhi*

Stole
C. *tianyi*

Pearl chain
C. *yingluo*

Ornamental side sash
C. *kundai*

Fan
'Peach-shaped object'
C. *taoxingqu*

Stole
C. *tianyi*

Lower garment
C. *shangqun*

Lotus blossom- or
capsule-shaped pedestal
C. *liantai*

C. Chinese
S. Sanskrit

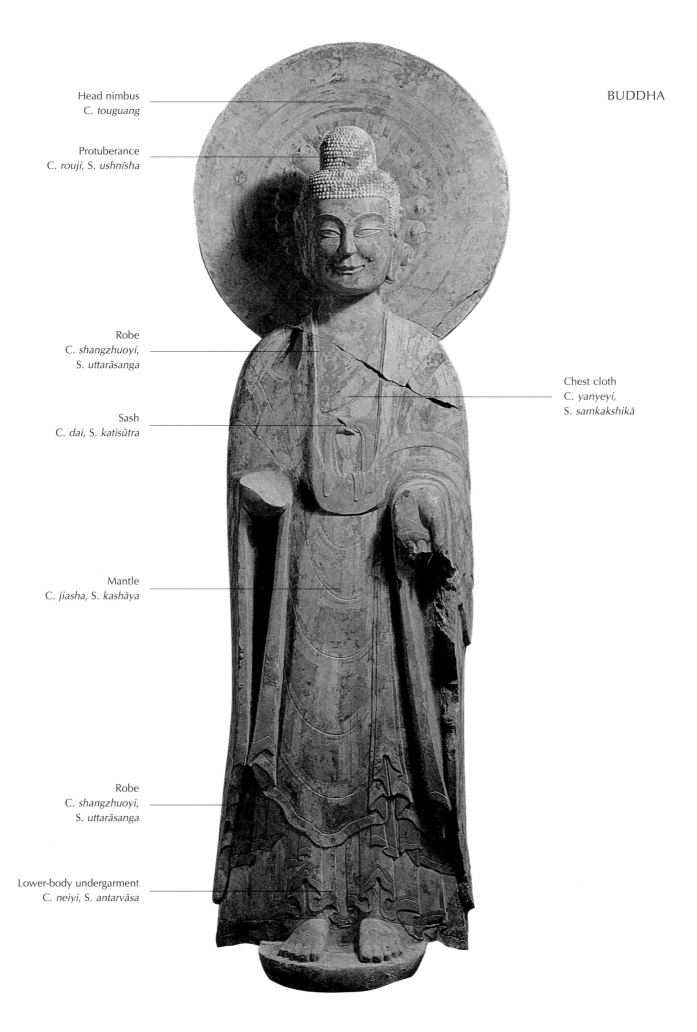

Head nimbus
C. *touguang*

Protuberance
C. *rouji*, S. *ushnīsha*

Robe
C. *shangzhuoyi*,
S. *uttarāsanga*

Sash
C. *dai*, S. *katisūtra*

Chest cloth
C. *yanyeyi*,
S. *samkakshikā*

Mantle
C. *jiasha*, S. *kashāya*

Robe
C. *shangzhuoyi*,
S. *uttarāsanga*

Lower-body undergarment
C. *neiyi*, S. *antarvāsa*

BIBLIOGRAPHY

Acker 1954
William Reynolds Beal Acker (trans. and ed.), *Some T'ang and Pre-T'ang Texts on Chinese Painting*, [vol. 1], Leiden, 1954.

Acker 1974
William R[eynolds]. B[eal]. Acker (trans. and ed.), *Some T'ang and Pre-T'ang Texts on Chinese Painting*, vol. 2, Leiden, 1974.

Banerjee 1972
P. Banerjee, 'Vairocana Buddha from Central Asia', *Oriental Art*, vol. 18, no. 2 (Summer 1972), pp. 166–70.

Baoli cangzhen 2000
Baoli cangzhen: Baoli yishu bowuguan cang shike fojiao zaoxiang jingpin xuan / *Selected Works of Sculpture in the Poly Art Museum*, Guangzhou, 2000.

Bauer 1990
Wolfgang Bauer, *Das Antlitz Chinas: Die autobiographische Selbstdarstellung in der chinesischen Literatur von ihren Anfängen bis heute*, Munich and Vienna, 1990.

Beiqishu 1972
Beiqishu [Annals of the Northern Qi dynasty], Li Delin (531–591) and Li Baiyao (565–648) (comps), Beijing, 1972.

Binglingsi 1988
Binglingsi deng shiku diaosu [Sculpture of the Binglingsi and other caves], Zhongguo meishu quanji, diaosubian, vol. 9, Beijing 1988.

Carter 1990
Martha L. Carter, *The Mystery of the Udayana Buddha*, Naples, 1990.

Chang and Li 1983
Chang Xuzheng and Li Shaonan, 'Shandong sheng Boxing xian chutu yipi Beichao zaoxiang [A group of Northern Dynasties sculptures excavated in Boxing County, Shandong Province]', *Wenwu*, no. 7 (1983), pp. 38–44.

Chang and Yu 1987
Chang Xuzheng and Yu Fenghua, 'Shandong sheng Gaoqing xian chutu fojiao zaoxiang [Buddhist sculpture excavated in Gaoqing County, Shandong Province]', *Wenwu*, no. 4 (1987), pp. 31–5.

Ch'en 1964
Kenneth Ch'en, *Buddhism in China: A Historical Survey*, Princeton, 1964.

Chen Xiandan 1997
Chen Xiandan, 'On the Designation "Money Tree"', *Orientations*, vol. 28, no. 8 (September 1997), pp. 67–71.

Chinese National Geography 2000
'Guici hanfeng shiku: Ayi shiku bihua [A cave temple in Chinese style in Kyzil: The wall paintings of the cave temple of Ayi]', *Chinese National Geography*, no. 9 (2000), pp. 82–5.

Chūgoku kokuhō ten 2000
Chūgoku kokuhō ten / *Treasures of Ancient China*, Tōkyō, 2000.

Chūgoku koshiki kondōbutsu 1988
Chūgoku koshiki kondōbutsu to Chūō, Tōnan Ajia no kondōbutsu [Gilt Buddhist bronzes from Chinese antiquity and gilt Buddhist bronzes from Central and South-East Asia], Izumishi, 1988.

Contemplation 1997
The Art of Contemplation: Religious Sculpture from Private Collections, Taipei, 1997.

Da Qing yitongzhi
Da Qing yitongzhi: Qingzhou fu [Complete chronicle of the great Qing dynasty: Qingzhou Prefecture], in Wang Yunwu (ed.), *Jiaqing chongxiu yitongzhi*, vol. 4, Taipei, n.d., pp. 2105–53.

Davidson 1954
J. LeRoy Davidson, *The Lotus Sutra in Chinese Art: A Study in Buddhist Art to the Year 1000*, New Haven, 1954.

Dewar 1999
Susan Dewar, '"Returned to Light: Buddhist Statuary from the Longxing Temple Site, Qingzhou", *Zhongguo Lishi Bowuguan*, Beijing, 9 July – 9 November 1999', *Orientations*, vol. 30, no. 7 (September 1999), pp. 95–7.

Doar 1999
Bruce Doar, 'Returned to Light: Buddhist Statuary from Longxing Temple in Qingzhou', *China Art and Archaeology Digest*, vol. 3, no. 1 (April 1999), pp. 5–12.

Du and Han 1991
Du Zaizhong and Han Gang, 'Santōshō Shojō shutsudo no sekibutsu zō ni tsuite / Buddhist Sculptures Unearthed in Shandong Province', *Kobijutsu*, no. 99 (July 1991), pp. 78–85; no. 101 (January 1992), pp. 75–89; no. 102 (May 1992), pp. 91–105.

Du and Han 1994
Du Zaizhong and Han Gang, 'Shandong Zhucheng fojiao shi zaoxiang / Buddhist Stone Images in Zhucheng, Shandong', *Kaogu xuebao*, no. 2 (1994), pp. 231–62.

Eskenazi 1995
Eskenazi: Early Chinese Art, 8th Century BC – 9th century AD, London, 1995.

Fa Weitang 1979
Fa Weitang (Qing), 'Shanzuofang beilu', in *Shike shiliao xinbian* [New material concerning stone inscriptions], part 2, vol. 12, Taipei, 1979.

Faure 1998
Bernard Faure, 'The Buddhist Icon and the Modern Gaze', *Critical Inquiry*, vol. 24, no. 46 (Spring 1998), pp. 768–813.

Fojiao 1993
Fojiao chuchuan nanfang zhi lu [The southern route in the early transmission of Buddhism], Beijing, 1993.

Franz 1978
Heinrich Gerhard Franz, *Pagode, Turmtempel, Stupa: Studien zum Kultbau des Buddhismus in Indien und Ostasien*, Graz, 1978.

Frédéric 1995

Louis Frédéric, *Buddhism*, Flammarion Iconographic Guides, Paris, 1995.

Freer Gallery n.d.

The Freer Gallery of Art, vol. 1: *China*, Tōkyō, n.d.

Fujita Museum 1954

Illustrated Catalogue: Masterpieces in the Fujita Museum of Art, Ōsaka, 1954.

Fujita Museum 1972

Fujita bijutsukan meihin zuroku / Catalogue of Masterpieces in the Fujita Museum, Tōkyō, 1972.

Gao and Gao 1990

Gao Wen and Gao Chenggang, *Sichuan lidai beike* [Historical steles in Sichuan], Chengdu, 1990.

Gaoseng zhuan heji 1991

Gaoseng zhuan heji [The collected 'Biographies of Eminent Monks'], Shanghai, 1991.

Gernet 1979

Jacques Gernet, *A History of Chinese Civilization*, J.R. Foster (trans.), Cambridge, 1982.

Goepper 1980

Roger Goepper, 'Some Thoughts on the Icon in Esoteric Buddhism of East Asia', in *Studia Sino-Mongolica: Festschrift für Herbert Franke*, Wolfgang Bauer (ed.), Münchener Ostasiatische Studien, vol. 25, Wiesbaden, 1980, pp. 245–54.

Goepper 1983

Roger Goepper, *Das Kultbild im Ritus des esoterischen Buddhismus Japans*, Rheinisch-Westfälische Akademie der Wissenschaften: Geisteswissenschaften, Vorträge, G 264, Düsseldorf, 1983.

Griswold 1963

A. B. Griswold, 'Prolegomena to the Study of the Buddha's Dress in Chinese Sculpture with Particular Reference to the Rietberg Museum's Collection', *Artibus Asiae*, vol. 26, no. 2 (1963), pp. 85–131; vol. 27, no. 4 (1965), pp. 335–40.

Guo Ruoxu 1963

Guo Ruoxu (2nd half 11th century), *Tuhua jianwen zhi* [Reports on Experiences with Painting], Huang Miaozi (ed.), Beijing, 1963.

Hall 1982

Dickson Hall, 'Sculpture at Kongwangshan', *Orientations*, vol. 13, no. 3 (March 1982), pp. 50–5.

Han Gang 1986

Han Gang, 'Shandong Zhucheng chutu Beichao tongzaoxiang [Bronze figures of the Northern Dynasties, excavated in Zhucheng, Shandong]', *Wenwu*, no. 11 (1986), pp. 95–6.

Hayami Baiei 1970

Hayami Baiei, *Butsuzō no keishiki* [The shape and style of Buddha images], Azuma, 1970.

He Zhiguo 1991

He Zhiguo, 'Sichuan Mianyang Hejiashan yi hao Donghan yamu qingli jianbao [Excavation of the Eastern Han cliff tomb no. 1 at Hejiashan in Mianyang]', *Wenwu*, no. 3 (1991), pp. 1–8.

Heireiji sekkutsu 1986

Heireiji sekkutsu [The cave temple of Binglingsi], Chūgoku sekkutsu, Tōkyō, 1986.

Ho 1968–69

Wai-kam Ho, 'Notes on Chinese Sculptures from Northern Ch'i to Sui, Part 1: Two Seated Stone Buddhas in the Cleveland Museum', *Archives of Asian Art*, vol. 22 (1968–69), pp. 6–45.

Howard 1981

Angela F. Howard, 'The Imagery of the Cosmological Buddha', Ph.D. diss., New York University, Ann Arbor, 1981.

Howard 1986

Angela Falco Howard, *The Imagery of the Cosmological Buddha*, Studies in South Asian Culture, vol. 13, Leiden, 1986.

Hurvitz 1976

Leon Hurvitz (trans.), *Scripture of the Lotos Blossom of the Fine Dharma (The Lotus Sūtra)*, trans. from the Chinese version by Kumarajiva, New York, 1976.

James 1989

Jean M. James, 'Some Iconographic Problems in Early Daoist-Buddhist Sculptures in China', *Archives of Asian Art*, vol. 41 (1989), pp. 71–6.

Ji Xianlin 1985

Ji Xianlin, *Datang xiyu ji jiaozhu* [Commentary on 'Report on the Western Regions [created] under the Great Tang Dynasty'], Beijing, 1985.

Ji Yuanqin 1989

Ji Yuanqin, 'Tai'an Dawenkou chutu beichao tongliujin lianhuazuo deng wenwu [A gilt bronze lotus throne of the Northern Dynasties and other works excavated at Dawenkou, Tai'an]', *Kaogu*, no. 6 (1989), pp. 568–9.

Jin Shen 1994

Jin Shen, *Zhongguo lidai jinian foxiang tudian* [Handbook of dated Buddhist images of the Chinese Dynasties], Beijing, 1994.

Jin Weinuo 1999

Jin Weinuo, 'A Brief Discussion of the Artistic Style of the Statues Unearthed in Qingzhou', *China Art and Archaeology Digest*, vol. 3, no. 1 (April 1999), pp. 13–22.

Jin Weinuo 2000

Jin Weinuo, 'Artistic Achievements of Buddhist Sculpture from the Longxingsi in Qingzhou: On the Qingzhou Style and the Northern Qi "Cao School"', in Wu Hung 2000a, pp. 377–96.

Jin and Luo 1995

Jin Weinuo and Luo Shiping, *Zhongguo zongjiao meishu shi* [The history of religious art in China], Nanchang, 1995.

Kaogu 1986a

'Zaozhuangshi chutu fanwen tongjing he beichao tongxing [Bronze images of the Northern Dynasties and bronze mirrors with Sanskrit inscriptions excavated at Zaozhuang]', *Kaogu*, no. 6 (1986), pp. 511–13.

Kaogu 1986b

'Shandong Boxing Longhuasi qingli jianbao [Preliminary report on the excavation at Longhua Temple in Boxing, Shandong]', *Kaogu*, no. 9 (1986), pp. 813–21.

Kaogu 1990

'Shandong Zhucheng faxian Beichao zaoxiang [Northern Dynasties figures discovered in Zhusheng, Shandong]', *Kaogu*, no. 8 (1990), pp. 717–26.

Kaogu 1994

'Shandong Zouxian faxian de Beichao tongfo zaoxiang [Bronze Buddha sculptures of the Northern Dynasties discovered in Zhou County, Shandong]', *Kaogu*, no. 6 (1994), pp. 569–70.

Kijiru sekkutsu 1985

Kijiru sekkutsu [The cave temple of Kyzil], vol. 3, Chūgoku sekkutsu, Tōkyō, 1985.

Klein-Bednay 1984

Ildiko Yolantha Klein-Bednay, 'Schmuck und Gewand des Bodhisattva in der frühchinesischen Plastik', Ph.D. diss., Rheinische Friedrich-Wilhelms-Universität, Bonn, 1984.

Klimburg-Salter 1995

Deborah E. Klimburg-Salter, *Buddha in Indien: Die frühindische Skulptur von König Asoka bis zur Guptazeit*, Vienna, 1995.

Knechtges 1982

David R. Knechtges (trans. and ed.), *Wen Xuan or Selections of Refined Literature*, vol. 1: *Rhapsodies on Metropolises and Capitals by Xiao Tong (501–531)*, Princeton, 1982.

Kurita 1988

Kurita Isao, *The Buddha's Life Story*, Gandhāra Art, vol. 1, Tōkyō, 1988.

Kurita 1990

Kurita Isao, *The World of the Buddha*, Gandhāra Art, vol. 2, Tōkyō, 1990.

Lancaster 1974

Lewis R. Lancaster, 'An Early Mahāyāna Sermon about the Body of the Buddha and the Making of Images', *Artibus Asiae*, vol. 36, no. 4 (1974), pp. 287–91.

Lee 1984

Lee Junghee, *The Contemplating Bodhisattva Images of Asia, with Special Emphasis on China and Korea*, Ann Arbor, 1984.

Leidy 1986

Denise Patry Leidy, *Northern Ch'i Buddhist Sculpture*, Ann Arbor, 1986.

Leidy 1998

Denise Patry Leidy, 'Avalokiteshvara in Sixth-century China', in Janet Baker (ed.), *The Flowering of a Foreign Faith: New Studies in Chinese Buddhist Art*, Mumbai, 1998, pp. 88–103.

Li Jingjie 1999

Li Jingjie, 'Lushena fajie tuxiang yanjiu / Images of the Lo-She-Na-Fa-Chieh', *Fojiao wenhua zengkan*, no. 11 (1999).

Li Jingjie, 2000

Li Jingjie, 'Lushena fajie tuxiang yanjiu jianlun [Short treatise on representations of the Dharmadhātu world of Vairocana]', *Gugong bowuyuan yuankan*, no. 3 (2000), pp. 53–63.

Li Li 2001

Li Li, 'Shizong guobao huijia [A lost national treasure returns home]', *Zhongguo wenwu bao*, 14 January 2001.

Li Shaonan 1984

Li Shaonan, 'Shandong Boxing chutu baichujian Beiwei zhi Suidai tongzaoxiang [More than one hundred bronze figures of the Northern Wei to Sui Dynasties, excavated in Boxing, Shandong]', *Wenwu*, no. 5 (1984), pp. 21–31.

Li Yanshou 1974

Li Yanshou (7th century), *Beishi* [History of the Northern Dynasties], Beijing 1974

Lim 1987

Lucy Lim, 'The Mahao Cave Tomb at Leshan', in *Stories from China's Past*, San Francisco 1987, pp. 194–99.

Little 2000

Stephen Little with Shawn Eichman, *Taoism and the Arts of China*, Chicago and Berkeley, 2000.

Liu and Jia 1999

Liu Huaguo and Jia Guangzhi, 'Buddhist Statues Discovered in a Hoard at Longxing Temple in Qingzhou, Shandong', *China Art and Archaeology Digest*, vol. 3, no. 1 (April 1999), pp. 29–34.

Liu and Liu 1958

Liu Zhiyuan and Liu Tingbi, *Chengdu wanfosi shike yishu* [Sculptures of the Wanfosi in Chengdu], Beijing, 1958.

Lu Zengxiang n.d.

Lu Zengxiang (1833–1889), *Baqiongshi jinshi buzheng* [Additions and corrections to the collection of stone and bronze inscriptions from the Baqiong Hall], Beijing, n.d.

Luoyang Yongningsi 1996

Bei Wei Luoyang Yongningsi [The Yongning Temple in Luoyang from the Northern Wei dynasty], Beijing, 1996.

Malalasekera 1966

G. P. Malalasekera (ed.), *Encyclopedia of Buddhism*, vol. 2, fascicle 1, Colombo (Sri Lanka), 1966.

Masterpieces 1999

Shandong Qingzhou Longxingsi chutu fojiao shike zaoxiang jingpin / Masterpieces of Buddhist Statuary from Qingzhou City, Beijing, 1999.

Matsubara 1966

Matsubara Saburō, *Chūgoku bukkyō chōkoku kenkyū / Chinese Buddhist Sculpture: A Study Based on Bronzes and Statues other than Works from Cave Temples*, Tōkyō, 1966.

Matsubara 1995

Matsubara Saburō, *Chūgoku bukkyō chōkoku shiron* [Historical survey of Chinese Buddhist sculpture], Tōkyō, 1995.

Matsumoto 1937

Matsumoto Eiichi, *Tonkō ga no kenkyū* [A study of the paintings at Dunhuang], Tōkyō, 1937.

Mattos 1988

Gilbert Mattos, *The Stone Drums of Ch`in*, Nettetal, 1988.

Miho Museum 1997

Miho Museum: South Wing, n.p., 1997.

Mizuno 1950

Mizuno Seiichi, 'A Stone Statue of the so-called Vairocana in the Hua Yen World', *Tōhō Gakuhō*, vol. 18, no. 3 (1950).

Mizuno 1968

Mizuno Seiichi, 'Iwayuru kegon kyōshu rushana-butsu no ritsuzō ni tsuite [On the standing statues of Vairocana-Buddha of the Kegon School]', in *Chūgoku no bukkyō bijutsu* [Buddhist art of China], Tōkyō, 1968, pp. 135–55.

Mizuno and Nagahiro 1937

Mizuno Seiichi and Nagahiro Toshio, *Kyōdōsan sekkutsu: The Buddhist Cave Temples of Hsiang-T'ang-Ssu on the Frontier of Honan and Hopei*, Kyōto, 1937.

Pal 1984

Pratapaditya Pal, *Light of Asia: Buddha Sakyamuni in Asian Art*, Los Angeles, 1984.

Peng Jie 2001

Peng Jie, 'Xinjiang Kuche xin faxian de Lushena foxiang chuyi [Some thoughts on the Buddha Vairocana images recently discovered in Kucha]', *Gugong bowuyuan yuankan*, no. 2 (2001), pp. 73–7.

Qingzhou yishu 1999

Qingzhou Longxingsi fojiao zaoxiang yishu [The art of the Buddhist sculptures of Longxing Temple in Qingzhou], Jinan, 1999.

Qingzhoufu zhi 1965

Qingzhoufu zhi [Chronicle of Qingzhou Prefecture], in *Tianyige zang Mingdai fangzhi xuankan*, Shanghai, 1965.

Qingzhoushi zhi 1989

Qingzhoushi zhi [Chronicle of Qingzhou City], Tianjin, 1989.

Qiu Xuejun 1994

Qiu Xuejun, 'Jinan shi chutu Beichao shizaoxiang [A Northern Dynasties stone sculpture excavated at Jinan]', *Kaogu*, no. 6 (1994), pp. 568–71.

Reischauer 1955

Edwin O. Reischauer (trans.), *Ennin's Diary: The Record of a Pilgrimage to China in Search of the Law*, New York, 1955.

Rhie 1999

Marylin Martin Rhie, *Early Buddhist Art of China and Central Asia*, vol. 1: *Later Han, Three Kingdoms and Western Chin in China and Bactria to Shan-shan in Central Asia*, Handbuch der Orientalistik / Handbook of Oriental Studies, part 4, vol. 12, Leiden, Boston and Cologne, 1999.

Rowan 2001

Diana P. Rowan, 'Identifying a Bodhisattva Attribute: Tracing the Long History of a Small Object', *Oriental Art*, vol. 46, no. 1 (2001), pp. 31–6.

Sanguozhi 1975

Sanguozhi [The history of the Three Kingdoms], Chen Shou (233–297, comp.), Beijing, 1975.

Saunders 1985

E. Dale Saunders, *Mudrā: A Study of Symbolic Gestures in Japanese Buddhist Sculpture*, Princeton, 1985.

Schafer 1963

Edward H. Schafer, 'The Last Years of Ch'ang-an', *Oriens Extremus*, vol. 10, no. 1 (April 1963), pp. 133–79.

Schipper 2000

Kristofer Schipper, 'Taoism: The Story of the Way', in Little 2000, pp. 33–56.

Seckel 1957

Dietrich Seckel, *Buddhistische Kunst Ostasiens*, Stuttgart, 1957.

Seckel 1962

Dietrich Seckel, *Kunst des Buddhismus: Werden, Wanderung und Wandlung*, Kunst der Welt, Baden-Baden, 1962.

Seckel 1976

Dietrich Seckel, *Jenseits des Bildes: Anikonische Symbolik in der buddhistischen Kunst*, Abhandlungen der Heidelberger Akademie der Wissenschaften, Philosophisch-historische Klasse, Jahrgang 1976, 2. Abhandlung, Heidelberg, 1976.

Shanghai Museum 1996

Shanghai Bowuguan: Zhongguo gudai diaosuguan / The Shanghai Museum: Ancient Chinese Sculpture Gallery, Shanghai, 1996.

Sharf 1996a

Robert H. Sharf, 'The Scripture in Forty-two Sections', in Lopez 1996, pp. 360–71.

Sharf 1996b

Robert H. Sharf, 'The Scripture on the Production of Buddha Images', in Lopez 1996, pp. 261–7.

Shimizu 1978

Shimizu Zenzō (ed.), *Kyōto Seiryōji* [The Seiryōji in Kyōto], Koji junrei, Kyōto, 1978.

Sirén 1925

Osvald Sirén, *La Sculpture chinoise du Ve au XIVe Siècle*, Paris and Brussels, 1925.

Snellgrove 1978

David L. Snellgrove (ed.), *The Image of the Buddha*, New Delhi et al., 1978.

Sofukawa and Okada 2000

Sofukawa Hiroshi and Okada Ken (ed.), *Sekai bijutsu taizenshū* [New history of world art], *Tōyōhen 3: Sangoku – Nanbokuchō* [The Three Kingdoms – Northern and Southern Dynasties], Tōkyō, 2000.

Soper 1959

Alexander C. Soper, *Literary Evidence for Early Buddhist Art in China*, Artibus Asiae, suppl. 19, Ascona, 1959.

Stein 1907

Sir Marc Aurel Stein, *Ancient Khotan*, Oxford, 1907.

Stein 1979

Rolf A. Stein, 'Religious Taoism and Popular Religion from the Second to Seventh Centuries', in Welch and Seidel 1979, pp. 53–81.

Su Bai 1999a

Su Bai, 'Several Questions Related to the Buddhist Statues Unearthed from the Hoard at the Longxing Temple in Qingzhou', *China Art and Archaeology Digest*, vol. 3, no. 1 (April 1999), pp. 11–12.

Su Bai 1999b

Su Bai, 'Qingzhou cheng kaolüe / Some Remarks on the City of Qingzhou', *Wenwu*, no. 8 (1999), pp. 47–56.

Su Bai 1999c

Su Bai, 'Longxingsi yange / Evolution of the Longxing Temple', *Wenwu*, no. 9 (1999), pp. 37–42.

Su Bai 1999d

Su Bai, 'Qingzhou Longxingsi jiaocang suo chu foxiang de ji ge wenti / Several Questions Related to the Buddhist Statues Unearthed from the Hoard at the Longxing Temple at Qingzhou', in *Masterpieces* 1999, pp. 14–23, and *Wenwu*, no. 10 (1999), pp. 44–59.

Su Jinren 2000

Su Jinren, 'Qingzhou Longxingsi yaocang niandai kaozheng [Investigation concerning the date of the hoard find of Longxing Temple in Qingzhou]', paper read to the Shandong Qingzhou Longxingsi fojiao zaoxiang yantaohui (Symposium on the Buddhist sculptures of Longxing Temple in Qingzhou, Shandong), Hong Kong, February 2000.

Sun and Gong n.d.

Sun Bo and Gong Dejie, 'Linquxian Yishan Mingdaosi chutu foxing jianbao [Short report on the Buddha figures excavated at the Mingdao Monastery at Yishan in Lingqu]', unpublished MS, n.d.

Sun Xinsheng 1999a

Sun Xinsheng, 'Shandong Qingzhou Beiqi, Linhuai Wang xiangbei' / A Northern Qi Stone Stele Found at Qingzhou in Shandong', *Wenwu*, no. 9 (1999), pp. 71–4.

Sun Xinsheng 1999b

Sun Xinsheng, 'Shilun Longxingsi foxiang yaozang de shijian yu yuanyin [On the date of and the reasons for depositing the Buddhist figures at Longxing Temple]', *Zhongguo lishi bowuguan guankan*, no. 1 (1999).

Sun Xinsheng 2001a

Sun Xinsheng, 'Time and Cause for the Destruction of the Buddhist Statues from the Site of Longxing Monastery', *Arts of Asia*, vol. 31, no. 1 (January 2001), pp. 50–3.

Sun Xinsheng 2001b

Sun Xinsheng, 'Shilun Qingzhou Longxingsi jiaocang foxiang bei hui de shijian he yuanyin / A Preliminary Discussion of the Reasons and the Period in which the Buddhist Images from the Hoard at Longxing Temple were Damaged', in Wang Huaqing 2001, pp. 98–115.

Taishō 1960

Taishō shinshū daizōkyō / The Tripitaka in Chinese, Takakusu Junjirō and Watanabe Kaigyoku (ed.), Tōkyō, 1924–32, later edn, 1960.

T'ang 1936

Yung-t'ung T'ang, 'The Editions of the Ssu-shih-erh-chang-ching', *Harvard Journal of Asiatic Studies*, vol. 1 (1936), pp. 147–55.

Tang Changshou 1997

Tang Changshou, 'Shiziwan Cliff Tomb No. 1', *Orientations*, vol. 28, no. 8 (September 1997), pp. 72–7.

Tokiwa and Sekino 1976

Tokiwa Daijō and Sekino Tadashi, *Chūgoku bunka shiseki* [Historic traces of Chinese culture], vol. 7: *Santō* [Shandong Province], Kyōto, 1976.

Tsiang 2000

Katherine R. Tsiang, 'Miraculous Flying Stupas in Qingzhou Sculpture', *Orientations*, vol. 31, no. 10 (December 2000), pp. 45–53.

Tsiang Mino 1996

Katherine R. Tsiang Mino, 'Bodies of Buddhas and Princes at the Xiangtangshan Caves: Image, Text, and Stūpa in Buddhist Art of the Northern Qi Dynasty (550–577)', Ph.D. diss., University of Chicago, 1996.

Tsukamoto 1985

Tsukamoto Zenryū, *A History of Early Chinese Buddhism, from its Introduction to the Death of Hui-yüan*, Leon Hurvitz (trans.), 2 vols, Tōkyō, New York and San Francisco, 1985.

Wang 1984

Yi-t'ung Wang, *A Record of Buddhist Monasteries in Lo-yang by Yang Hsüan-chih*, Princeton, 1984.

Wang Huaqing 2001

Wang Huaqing (ed.), *Shandong Qingzhou Longxingsi chutu fojiao zaoxiang zhan / Buddhist Sculptures: New Discoveries from Qingzhou, Shandong Province*, Hong Kong, 2001.

Wang Junwei 1999

Wang Junwei, 'Shandong Changyi Baogaisi guzhi chutu shizaoxiang [Stone sculptures excavated on the site of the former Baogai Temple in Changyi, Shandong]', *Wenwu*, no. 6 (1999), pp. 82–5.

Wang Kai 1985

Wang Kai, 'Jiangsu xuzhou faxian beiqi tongzaoxiang [Bronze figures of the Northern Qi dynasty excavated at Xuzhou, Jiangsu]', *Kaogu*, no. 7 (1985), pp. 667, 658.

Wang Sili 1958

Wang Sili, 'Shandong Guangrao, Boxing er xian de beichao shizaoxiang [The stone sculptures of the Northern Dynasties from Guangrao and Boxing Counties in Shandong]', *Wenwu cankao ziliao*, no. 7 (1958), pp. 41–3.

Wang and Liu 1999

Wang Wanli and Liu Huaguo, 'Northern Wei Painted Statues from Qingzhou in Shandong', *China Art and Archaeology Digest*, vol. 3, no. 1 (April 1999), pp. 35–8.

Wang and Shou 2001

Wang Ruixia and Shou Linlin, 'Typological Analysis of Northern Qi Buddhist Statues Unearthed from the Site of Longxing Monastery', *Arts of Asia*, vol. 31, no. 1 (January 2001), pp. 41–9.

Wang and Zhuang 2000

Wang Huaqing and Zhuang Mingjun, 'Xi Longxingsi zaoxiang zhong de "Chilong" [Analysis of the "hornless dragon" in the sculpture of the Longxing Temple]', *Wenwu*, no. 5 (2000), pp. 46–61.

Wei Jin Nanbeichao 1988

Wei Jin Nanbeichao diaosu [Sculpture of the Wei, the Jin, and the Southern and Northern Dynasties], *Zhongguo meishu quanji, diaosubian*, vol. 3, Beijing, 1988.

Weifang 2000

Weifang wenhuazhi [Cultural chronicle of the Wei], Jinan, 2000.

Weinstein 1987

Stanley Weinstein, *Buddhism under the T'ang*, Cambridge, 1987

Welch and Seidel 1979

Holmes Welch and Anna Seidel (ed.), *Facets of Taoism – Essays in Chinese Religion*, New Haven and London, 1979

Wenwu 1983

'Shandong Wudi chutu Beiqi zaoxiang [Northern Qi sculptures excavated in Wudi, Shandong]', *Wenwu*, no. 7 (1983), pp. 45–7.

Wenwu 1984a

'Shandong Boxing chutu bai yu jian Beiwei zhi Sui dai tong zaoxiang [More than one hundred Northern Wei to Sui bronze sculptures excavated in Boxing, Shandong]', *Wenwu*, no. 5 (1984), pp. 21–31.

Wenwu 1984b

'Shandong Boxing de yichu tongfo yaozang [A hoard find with bronze Buddha figures from Boxing, Shandong]', *Wenwu*, no. 5 (1984), pp. 95–6.

Wenwu 1996

'Shandong Qingzhou faxian Beiwei caihui zaoxiang [Polychrome sculptures of the Northern Wei dynasty found in Qingzhou, Shandong]', *Wenwu*, no. 5 (1996), p. 68.

Wenwu 1997

'Shandong Qingzhou chutu liang jian Beichao caihui shi zaoxiang [Two polychrome stone sculptures of the Northern Dynasties excavated at Qingzhou, Shandong]', *Wenwu*, no. 2 (1997), pp. 80–1.

Wenwu 1998a

'Qingzhou Longxingsi fojiao zaoxiang jiaocang qingli jianbao / Clearing-up of a Storage Pit of Buddhist Icons in the Longxing Temple at Qingzhou, Shandong', *Wenwu*, no. 2 (1998), pp. 4–15.

Wenwu 1998b

'Chengdushi Xi'anlu Nanchao shike zaoxiang qingli jianbao / Stone Carvings of the Southern Dynasties in Chengdu, Sichuan', *Wenwu*, no. 11 (1998), pp. 4–20.

Wenwu 1999

'Shandong Huimin chutu yipi beichao fojiao zaoxiang [A group of Buddhist figures excavated at Huimin, Shandong]', *Wenwu*, no. 6 (1999), pp. 70–81.

Wenwu 2001a

'Xi'an faxian de Beizhou An Jia mu [The tomb of An Jia of the Northern Zhou dynasty, discovered in Xi'an]', *Wenwu*, no. 1 (2001), pp. 4–26.

Wenwu 2001b

'Taiyuan Suidai Yu Hong mu qingli jianbao [Report on excavations at the Sui dynasty tomb of Yu Hong in Taiyuan]', *Wenwu*, no. 1 (2001), pp. 27–52.

Wenwu 2001c

'Nanchang huochezhan Dongjin muzangqun fajue jianbao / Excavation of a Group of Eastern Jin Tombs at the Nanchang Railway Station', *Wenwu*, no. 2 (2001), pp. 12–41.

Whitfield 1982

Roderick Whitfield, *Paintings from Dunhuang*, The Art of Central Asia: The Stein Collection in the British Museum, vol. 1, Tōkyō, 1982.

Wiedehage 1996

Peter Wiedehage, in *Das Alte China: Menschen und Götter im Reich der Mitte, 5000 v.Chr. – 220 n.Chr*, Munich, 1996, pp. 356–8.

Wright 1959

Arthur F. Wright, *Buddhism in Chinese History*, Stanford and London, 1959.

Wright and Twitchett 1973

Arthur F. Wright and Denis Twitchett (ed.), *Perspectives on the T'ang*, New Haven and London, 1973.

Wu Hung 1986

Wu Hung, 'Buddhist Elements in Early Chinese Art (2nd and 3rd Centuries A.D.)', *Artibus Asiae*, vol. 47, nos 3–4 (1986), pp. 263–352.

Wu Hung 1987

Wu Hung, 'Xiwangmu, the Queen Mother of the West', *Orientations*, vol. 18, no. 4 (April 1987), pp. 24–33.

Wu Hung 2000a

Wu Hung (ed.), *Between Han and Tang: Religious Art and Archaeology in a Transformative Period*, Beijing, 2000.

Wu Hung 2000b

Wu Hung, 'Mapping Early Taoist Art: The Visual Culture of Wudoumi Dao', in Little 2000, pp. 89–92.

Wu Zhuo 1992

Wu Zhuo, 'Sichuan zaoqi Fojiao yiwu jiqi niandai yu chuanbo tujing di kaocha [The early traces of Buddhism in Sichuan, their date and the routes by which they were introduced]', Wenwu, no. 11 (1992), pp. 40–50, 67.

Xia Mingcai 1998

Xia Mingcai, 'The Discovery of a Large Cache of Buddhist Images at the Site of Longxing Si', Orientations, vol. 31, no. 6 (June 1998), pp. 41–9.

Xia Mingcai 1999

Xia Mingcai, 'The Discovery and Excavation of the Hoard of Buddhist Statues at the Longxing Temple in Qingzhou', China Art and Archaeology Digest, vol. 3, no. 1 (April 1999), pp. 9–10.

Xia Mingcai 2001

Xia Mingcai, 'Qingzhou Longxingsi fojiao zaoxiang de yishu tese / The Artistic Features of the Buddhist Statuary from Longxing Temple in Qingzhou', in Wang Huaqing 2001, pp. 46–83.

Xia and Wang 2000

Xia Mingcai and Wang Ruixia, 'Qingzhou Longxingsi chutu beipingshi fojiao shi zaoxiang fenqi chutan [A first attempt to establish the chronology of the Buddhist sculptures with mandorlas excavated at Longxing Temple, Qingzhou]', Wenwu, no. 5 (2000), pp. 50–61.

Xia and Zhuang 1996

Xia Mingcai and Zhuang Mingjun, 'Shandong Qingzhou Xingguosi gu zhichutu shi zaoxiang [Stone sculptures excavated on the site of Xingguo Temple in Qingshou, Shandong]', Wenwu, no. 5 (1996), pp. 59–67.

Xia Song 1986

Xia Song (984–1050), 'Qingzhou Longxingsi chongxiu Zhongfodian ji [Notes on the repair of the Central Buddha Hall of Longxing Temple in Qingzhou]', in Wenzhuangji, Wenyuange siku quanshu, Taipei, 1986, chap. 21, 8a–10a.

Yang Hong 1999

Yang Hong, 'Reflections on the Archaeology of Southern and Northern Dynasties Qingzhou', China Art and Archaeology Digest, vol. 3, no. 1 (April 1999), pp. 39–54.

Yang Xiaoneng 1999

Yang Xiaoneng (ed.), The Golden Age of Chinese Archaeology: Celebrated Discoveries from the People's Republic of China, New Haven and London, 1999.

Ye Changchi 1994

Ye Changchi (ed.). 'Yu shi', Ke Changsi Yushi yitong ping ['On Stone Inscriptions' and Ke Changsi's commentary on it], Beijing, 1994.

Yoshimura 1959

Yoshimura Rei, 'A Study on Ren-zhong Images of Vairocana Dharmakaya', Bijutsu kenkyū, no. 203 (March 1959), pp. 14–28.

Yu Shuting 1985

Yu Shuting, 'Shangxiabei suotan [A brief discussion of the upper and the lower stele]', in Yunfeng Zhushan beichao keshi taolunhui lunwen xuanji [Selection from the contributions to the conference on stone inscriptions of the Northern Dynasties in Yunfeng and Zhushan], Jinan, 1985.

Yungang 1988

Yungang shiku diaoke [Sculpture from the caves of Yungang], Zhongguo meishu quanji, diaosubian, vol. 10, Beijing, 1988.

Zach 1958

Erwin von Zach, Die chinesische Anthologie, vol. 1: Übersetzungen aus dem Wen Hsüan, Harvard-Yenching Institute Studies, vol. 18, Ilse Martin Fang (ed.), Cambridge, MA, 1958.

Zaoxiang 2000

Zaoxiang liangdu jing: The Buddhist Canon of Iconometry – A Tibetan-Chinese Translation from about 1742 by mGon-po-skyabs (Gömpojab), Cai Jingfeng (trans. and ed.), Ulm, 2000.

Zhang Deqin 1993

Zhang Deqin et al., Zhongguo wenwu jinghua / Gems of China's Cultural Relics, Beijing, 1993.

Zhang Yanyuan 1966

Zhang Yanyuan (9th century), Lidai minghua ji [Reports on famous painters from all ages], Congshu jicheng jianbian, Taibei, 1966.

Zhang Zong 2000a

Zhang Zong, 'Beichao zhi Sui Shandong fojiao yishu chayan xin de / Survey of New Discoveries in Buddhist Art in Shandong from the Northern Dynasties and Sui', in Wu Hung 2000a, pp. 61–88.

Zhang Zong 2000b

Zhang Zong, 'Exploring some Artistic Features of the Longxing Si Sculptures', Orientations, vol. 31, no. 10 (December 2000), pp. 54–63.

Zhang Zong 2001

Zhang Zong, '"Yanluowang shoujijing" zhuibu yankao [A study of the additions to and composition of the "Yanluowang shoujijing"]', Dunhuang Tulufan yanjiu, no. 5 (2001), pp. 81–116.

Zhao Zhengqiang 1996

Zhao Zhengqiang, 'Shandong Dongyingshi bowuguan guanzang zaoxiang [Figures from the storerooms of the Dongying Municipal Museum in Shandong]', Wenwu, no. 12 (1996), pp. 75–83.

Zhongguo diaosushi tulu 1983–87

Zhongguo diaosushi tulu [Illustrated encyclopaedia of the history of Chinese sculpture], Shi Yan (ed.), 2 vols, Shanghai, 1983–87.

Zhongguo fojiao 1980

Zhongguo fojiao [Chinese Buddhism], Beijing, 1980.

Zhongguo Linzi 2000

Zhongguo Linzi wenwu kaogu yaogan yingxiang tuji / The Archaeological Aerial Photo-Atlas of Linzi, China, Jinan, 2000.

Zürcher 1959

Erik Zürcher, The Buddhist Conquest of China: The Spread and Adaptation of Buddhism in Early Medieval China, Leiden, 1959.

PHOTOGRAPHIC
ACKNOWLEDGEMENTS

Plates
The works are reproduced by kind permission
of the lender, Qingzhou Municipal
Museum, Shandong Province. Copyright
of all illustrated works © The State
Administration of Cultural Heritage,
People's Republic of China/photos by
Wang Shude and Zong Tongchang

Other illustrations
Berlin: Museum für Ostasiatische Kunst, fig. 1
Binglingsi 1988, fig. 50 (p. 12, fig. 8), 71
 (p. 6, fig. 5)
Angelika Borchert, fig. 43
Contemplation 1997, fig. 76 (fig. 29)
Fujita Museum 1954, fig. 57 (vol. 1, p. 82)
Kijiru sekkutsu 1985, fig. 66 (fig. 17)
Klimburg-Salter 1995, fig. 49 (fig. 203)
Kurita 1988, fig. 79 (p. 202, fig. 410)
Liu and Liu 1958, fig. 54 (fig. 8)
Mathurā, Archaeological Museum, fig. 48
Matsubara 1995, fig. 38a (vol. 1, p. 220), 56
 (vol. 1, p. 199)
Miho Museum 1997, fig. 39 (p. 244)
Lukas Nickel, fig. 17–19, 22, 24, 26, 28, 30–3,
 58–9, 64–5, 67–8, 70, 73–4, 78, 80
New York: © The Metropolitan Museum of
 Art/Lynton Gardiner, fig. 11
*Nihon no kokuhō / National Treasures of
 Japan*, no. 16 (1997), fig. 53 (p. 6-165)
Qingdao Municipal Museum, fig. 35
Qingzhou Municipal Museum, fig. 20, 21, 47,
 55, 62, 75
Qingzhou yishu 1999, fig. 23 (fig. 2a), 29
 (fig. 48), 44 (fig. 137), 45 (fig. 138), 60
 (fig. 38), 69 (fig. 184), 77 (fig. 140)
Rhie 1999, fig. 4 (fig. 1.9), 5 (fig. 1.18)
Sirén 1925, fig. 63 (vol. 2, fig. 260)
Snellgrove 1978, fig. 40 (fig. 56)
Sofukawa and Okada 2000, fig. 6 (p. 159,
 fig. 138), 7 (p. 267, fig. 254), 12 (p. 149,
 fig. 113), 13 (p. 25, fig. 7), 14 (p. 24,
 fig. 6), 15 (p. 274, fig. 152), 16 (p. 330,
 fig. 261), 52 (p. 262, fig. 248)
Song Baoquan, fig. 25, 27
Tang Changshou 1997, fig. 9 (fig. 16), 10
 (fig. 15)
Katherine R. Tsiang, fig. 36, 46
Wang Huaqing 2001, fig. 2 (p. 31, fig. 1), 3
 (p. 32, fig. 2)
Washington (DC): Freer Gallery of Art,
 Smithsonian Institution, fig. 42
Wei Jin Nanbeichao 1988, fig. 61 (fig. 79), 72
 (fig. 88)
Wenwu 2001c, fig. 8 (inside back cover, fig. 1)
Yungang 1988, fig. 51 (p. 60, fig. 58)
Zhang Zong, fig. 34, 37, 41
Zurich: Museum Rietberg, fig. 38b

John and Tawna Farmer
Mary Fedden RA
Mrs Juliet Fenton
Mr and Mrs Bryan Ferry
Mrs Donatella Flick
Flying Colours Gallery
Mr and Mrs George Fokschaner
Mr and Mrs Robert L Forbes
Mrs Edwin Fox
Cyril Freedman
Mr Monty Freedman
Michael and Clara Freeman
A Fulton Company Limited
Jacqueline and Jonathan Gestetner
The David Gill Memorial Fund
Sir Nicholas and Lady Goodison's Charitable
　　Settlement
Mr and Mrs John Gore
Lady Gosling
Nicholas Gould and Rachel Selzer
Mrs Michael Green
Mr and Mrs Thomas Griffin
Mr and Mrs Clifford J Gundle
Mrs M R Hambro
David and Lella Harris
The Harris Family
Mr Andrew Hawkins
David and Lesley Haynes
Michael and Morven Heller
Robin Heller Moss
Mrs Margarita Hernandez
Mr and Mrs J Hodkinson
Anne Holmes-Drewry
Dr and Mrs Allan J Horan
Mr and Mrs Ken Howard
Mrs Sue Howes and Mr Greg Dyke
Mr and Mrs Allan Hughes
Mrs Pauline Hyde
Simone Hyman
Mr Oliver Iny
Sir Martin and Lady Jacomb
Mr and Mrs Ian Jay
Harold and Valerie Joels
Mr and Mrs David Josefowitz
Mr Paul Josefowitz
Sir Paul Judge
Mr and Mrs Richard Kaufman
Mr and Mrs Laurence Kelly
Rona and Robert Kiley
Mr D H Killick
Mr and Mrs James Kirkman
Mr and Mrs F Lance Isham
Tom Larsen, Holt Value Associates
Mr George Lengvari
Colette and Peter Levy
Sir Christopher and Lady Lewinton
Susan Linaker
Mrs Livingstone
Miss R Lomax-Simpson
Mr and Mrs Mark Loveday
Mr Charles G Lubar
Richard and Rose Luce
Mrs Gertie Lurie
Mr and Mrs Eskandar Maleki
Ms Claudine B Malone
Dr Abraham Marcus
Mr and Mrs M Margulies
Marsh Christian Trust
R C Martin
Mr and Mrs Stephen Mather
Pamela and Jack Maxwell
Mrs M C W McCann
Mr and Mrs Andrew McKinna
Mr and Mrs Bruce McLaren
Mr and Mrs Philip Mengel
The Mercers' Company
Lt Col L S Michael OBE
Mr and Mrs Donald Moore
Mr and Mrs Peter Morgan
Mr and Mrs I Morrison
The Mulberry Trust
Mr and Mrs Carl Anton Muller
Mr and Mrs Elis Nemes
John Nickson and Simon Rew
N Peal Cashmere
Mr Bruce Oldfield OBE
Mr and Mrs Simon Oliver
Mr Neil Osborn and Ms Holly Smith
Sir Peter Osborne and Lady Osborne
Mr Michael Palin
Mr and Mrs Vincenzo Palladino
Mr and Mrs Gerald Parkes
John Pattisson
Mr and Mrs D J Peacock
The Pennycress Trust
Miss Karen Phillipps
Mr Godfrey Pilkington
George and Carolyn Pincus
Mr and Mrs William A Plapinger
David and Linda Pohs-Supino
John Porter Charitable Trust
Miss Victoria Provis
The Quercus Trust

Mr and Mrs J V Radford
Mr and Mrs P V Radford
Barbara Rae RA
John and Anne Raisman
Sir David and Lady Ramsbotham
Mrs Pauline Recanati
Mr T H Reitman
Sir John and Lady Riddell
The Roland Group of Companies Plc
Mr and Mrs Ian Rosenberg
Alastair and Sarah Ross Goobey
Mr and Mrs Kerry Rubie
The Audrey Sacher Charitable Trust
Dr P B St Leger
Mr and Mrs Victor Sandelson
Mr and Mrs Bryan Sanderson
Mr and Mrs Nicholas Sassow
Mrs Sylvia B Scheuer
Mr and Mrs Stuart L Scott
Dr Lewis Sevitt
The Countess of Shaftesbury
Mr and Mrs Paul Shang
Mr and Mrs Richard Sherrington
Mrs Lois Sieff OBE
Mr Peter Simon
Mr and Mrs John Sorrell
Don and Susan Starr
Mrs Jack Steinberg
Mr and Mrs David Stileman
John and Sheila Stoller
Mr and Mrs R W Strang
The Swan Trust
Mr and Mrs David Swift
Mr John Tackaberry
Mr and Mrs John D Taylor
Mrs Jonathan Todhunter
Mr and Mrs Julian Treger
Miss Joanna Trollope OBE
Carole Turner Record
Mrs Kathryn Uhde
Michael and Yvonne Uva
Mr and Mrs Tim Vignoles
Visa Lloyds Bank Monte Carlo
Mrs Catherine Vlasto
Mrs Claire Vyner
The Walter Guinness Charitable Trust
John B Watton
Mr and Mrs Jeffrey M Weingarten
Edna and Willard Weiss
Mrs Gerald Westbury
Mr Randall J Willette
Mr and Mrs Anthony Williams
Mr Jeremy Willoughby
Mr and Mrs Ami Wine
Mr John D Winter
Miss Caroline Wiseman
The Rt Hon Lord and Lady Young of Graffham
and others who wish to remain anonymous

Schools Patrons Group
The Lord Aldington
Arts and Humanities Research Board
The Charlotte Bonham-Carter Charitable Trust
Mrs Stephen Boyd
Mr Robert Bullock
The Candide Charitable Trust
Mr Raymond Cazalet
Smadar and David Cohen
Mr Simon Copsey
Keith and Pam Dawson
Debenhams Retail plc
The Delfont Foundation
The D'Oyly Carte Charitable Trust
Mr Alexander Duma
The Marchioness of Dufferin and Ava
The Gilbert & Eileen Edgar Foundation
The Eranda Foundation
Jack and Greta Goldhill
P H Holt Charitable Trust
The Lark Trust
Lora Lehmann
The Leverhulme Trust
The Loughborough Fellowship in Fine Art
The Mercers' Company
The Henry Moore Foundation
Robin Heller Moss
The Mulberry Trust
Newby Trust Limited
N Peal Cashmere
The Worshipful Company of Painter-Stainers
The Stanley Picker Trust
Pickett Fine Leather Ltd
Edith and Ferdinand Porjes Charitable Trust
Rio Tinto plc
Mr and Mrs Anthony Salz
Paul Smith and Pauline Denyer Smith
The South Square Trust
Mr and Mrs Michele Sportelli
The Starr Foundation
The Steel Charitable Trust
Mr and Mrs Robert Lee Sterling Jr
The Peter Storrs Trust
Mr and Mrs Denis Tinsley

The Celia Walker Art Foundation
The Harold Hyam Wingate Foundation
and others who wish to remain anonymous

General Benefactors
Mr Keith Bromley
Miss Jayne Edwardes
Catherine Lewis Foundation
Lady Sainsbury
The Schneer Foundation Inc
The Rt Hon Lord and Lady Young of Graffham
and others who wish to remain anonymous

American Associates
Benefactors
American Express
Mrs Deborah Loeb Brice
Mr Francis Finlay
Mrs Melville Wakeman Hall
Ms Jeanne K Lawrence
Sir Christopher and Lady Lewinton
Ms Brenda Neubauer Straus
WPP Group

Sponsors
Mrs Jan Cowles
Mrs Katherine D W Findlay
Mr Edward H Harte
Ms Frances S Hayward
Mr and Mrs Stephen M Kellen
Mr James Kemper Jr
The Honorable and Mrs Philip Lader
Mrs Linda Noe Laine
Mrs Edmond J Safra
Mr Peter Schoenfeld
Virgin Atlantic

Patrons
Ms Helen Harting Abell
Mr and Mrs Steven Ausnit
Mr and Mrs Stephen D Bechtel Jr
Mrs William J Benedict
Mr Donald A Best
Mr and Mrs Henry W Breyer III
Mrs Mildred C Brinn
Dr and Mrs Robert Carroll
Mr and Mrs Benjamin Coates
Ms Anne S Davidson
Ms Zita Davisson
Mr and Mrs Charles Diker
Mrs June Dyson
Mrs John W Embry
Mrs A Barlow Ferguson
Mrs Robert Ferst
Mr Richard E Ford
Mrs William Fox, Jr
Mr and Mrs Lawrence S Friedland
Goldman, Sachs & Co
Mrs Betty Gordon
Ms Rachel K Grody
Mr and Mrs Martin D Gruss
Mr and Mrs Gurnee F Hart
Mr and Mrs Gustave M Hauser
Mr and Mrs John R Hupper
Mr Robert J Irwin
Ms Betty Wold Johnson and Mr Douglas Bushnell
The Honorable and Mrs W Eugene Johnston III
Mr William W Karatz
Mr and Mrs Gary A Kraut
The Nathan Manilow Foundation
Mrs John P McGrath
Mrs Mark Millard
Mrs Barbara T Missett
Mr Paul D Myers
Mr and Mrs Wilson Nolen
Mrs Richard D O'Connor
Mr and Mrs Jeffrey Pettit
Mr Robert S Pirie
Mrs Virginia Ridder
Mrs Nanette Ross
Mrs Frances G Scaife
Ms Jan Blaustein Scholes
Mr and Mrs Stanley D Scott
Mr and Mrs Stephen Stamas
Mr Arthur O Sulzberger and Ms Allison S Cowles
Mrs Royce Deane Tate
Mrs Britt Tidelius
Ms Sue Erpf Van de Bovenkamp
Mrs Vincent S Villard, Jr
Mr and Mrs Stanford S Warshawsky
Mrs Sara E White
Dr and Mrs Robert D Wickham
Mr and Mrs Robert G Wilmers
Mr Robert W Wilson
Mr and Mrs Kenneth Woodcock
and others who wish to remain anonymous

Friends of the Royal Academy
Patron Friends
Mr Brian Bailey
Mrs Yvonne Barlow

Mr P F J Bennett
Mrs V Bondarenko
Mr and Mrs Sidney Corob
Mr David Duncan
Mr Michael Godbee
Ms Katrin Henkel
Mr S Isern-Feliu
Mr and Mrs S D Kahan
Mr David Ker
Mrs Joyce Lacerte
Mrs Maureen D Metcalfe
Mr R J Mullis
Mr and Mrs Derald H Ruttenberg
Mr Robin Symes
Mrs Cynthia H Walton
The Hon Mrs Simon Weinstock
and others who wish to remain anonymous

Supporting Friends
Ms Corinne Aldridge
Mr Richard B Allan
Mr Ian Anstruther
Mr Keith G Bennett
Mrs Susan Besser
Mrs C W T Blackwell
Mr C Boddington and Ms R Naylor
Mrs J M Bracegirdle
Mr Paul Brand
Mr Cornelius Broere
Mrs Anne Cadbury OBE JP DL
Miss E M Cassin
Mr R A Cernis
Mr S Chapman
Mr and Mrs John Cleese
Mr and Mrs Chris Cotton
Mrs M F Coward
Anthea Craigmyle
Mrs Nadine Crichton
Mr Julian R Darley
Mrs Belinda Davie
Mr John Denham
Miss N J Dhanani
Miss Carol Dodds
Mr Kenneth Edwards
Jack and Irene Finkler
Mrs Patricia Glasswell
Mrs R H Goddard
Mrs D Goodsell
Mr R Gow
Mr Gavin Graham
Mr and Mrs Jonathan Green
Mrs Richard Grogan
Miss Karen Harper-Gow
Mr Malcolm P Herring
Mr R J Hoare
Miss J Horsford
Mrs Manya Igel
Ms Shiblee Jamal
Mrs Jane Jason
Mrs G R Jeffries
Mr Roger A Jennings
Mr Harold Joels
Mr and Mrs J Kessler
Mrs L Kosta
Mrs Carol Kroch
Mrs Joan Lavender
Mr and Mrs David Leathers
Mr Owen Luder CBE PRIBA FRSA
Miss Julia MacRae
Mr Donald A Main
Lord Marks of Broughton
Mrs Janet Marsh
Mr J B H Martin
Mrs Gillian McIntosh
Mr R T Miles
Mrs A Morgan
Mrs Elizabeth M Newell
Miss Kim Nicholson
Mr Robert Linn Ottley
Mrs Anne Phillips
Mr Ralph Picken
Mr D B E Pike
Mr Ian Poynton
Mrs Beatrice Prevett
Mr Benjamin Pritchett-Brown
Mr W S C Richards OBE
Mrs Elizabeth Ridley
Mr F Peter Robinson
Mr D S Rocklin
Mrs A Rodman
Mr and Mrs O Roux
Dr Susan Saga
Lady Sainsbury
The Rt Hon Sir Timothy Sainsbury
Mrs E M Sandelson
Dr I B Schulenburg
Mrs D Scott
Mrs Josephine Seaton
Mrs E D Sellick
Mr and Mrs Richard Seymour
Mr R J Simmons CBE
Mr John H M Sims
Miss L M Slattery

Dr and Mrs M L Slotover
Mrs P Spanoghe
Professor Philip Stott
Mr James Stuart
Mrs J A Tapley
Mr W N Trotter
Mr and Mrs Ludovic de Walden
Miss J Waterous
Mrs Claire Weldon
Mr Frank S Wenstrom
Mrs Sheree D Whatley
Mrs Jacqueline Williams
Mr W M Wood
Mr R M Woodhouse
and others who wish to remain anonymous

CORPORATE MEMBERSHIP OF THE ROYAL ACADEMY OF ARTS
Launched in 1988, the Royal Academy's Corporate Membership Scheme has proved highly successful. With 104 members it is now the largest membership scheme in Europe.

Corporate membership offers company benefits to staff and clients and access to the Academy's facilities and resources. Each member pays an annual subscription to be a Member (£7,000) or Patron (£20,000).

Participating companies recognise the importance of promoting the visual arts. Their support is vital to the continuing success of the Academy.

Corporate Membership Scheme
Corporate Patrons
Andersen
Bloomberg LP
BNP Paribas
BP Amoco p.l.c.
Debenhams Retail plc
Deutsche Bank AG
The Economist Group
Ernst and Young
GlaxoSmithKline plc
Granada plc
John Lewis Partnership
Merrill Lynch
Radisson Edwardian Hotels
Royal & Sun Alliance

Honorary Corporate Patron
Credit Suisse First Boston

Corporate Members
Accel Partners
Apax Partners Holding Ltd
Athenaeum Hotel
Aukett Europe
AXA UK plc
Bacon and Woodrow
Bank of America
Barclays plc
Bear, Stearns International Ltd
BG plc
BMP DDB Limited
Bonhams
The Boston Consulting Group
Bovis Lend Lease Limited
British Alcan Aluminium plc
The British Land Company PLC
BT plc
Bunzl plc
Cantor Fitzgerald
Cazenove & Co
CB Hillier Parker
Christie's
Chubb Insurance Company of Europe
CJA (Management Recruitment Consultants) Limited
Clayton Dubilier & Rice Limited
Clifford Chance
Colefax and Fowler Group
Cookson Group plc
Credit Agricole Indosuez
De Beers
Diageo plc
Dresdner Kleinwort Wasserstein
Eversheds
F&C Management plc
Gartmore Investment Management plc
Goldman Sachs International
Govett Investment Management Limited
H J Heinz Company Limited
HSBC plc
ICI
King Sturge
KPMG
Linklaters & Alliance
Macfarlanes
Man Group plc
McKinsey & Co.
M & C Saatchi
Morgan Stanley & Co International
MoMart Ltd
Newton Investment Management Ltd

Pearson plc
The Peninsular and Oriental Steam Navigation Company
Pentland Group plc
Provident Financial plc
Raytheon Systems Limited
Redwood
Reed Elsevier plc
Rowe & Maw
The Royal Bank of Scotland
Schroder Salomon Smith Barney
Schroders Investment Management Limited
Sea Containers Ltd.
SG
Six Continents PLC
Skanska Construction Group Limited
Slaughter and May
The Smith & Williamson Group
Sotheby's
Travelex
Trowers & Hamlins
Unilever UK Limited
UBS AG Private Banking

Honorary Corporate Members
All Nippon Airways Co. Ltd
A.T. Kearney Limited
Derwent Valley Holdings plc
London First
Reuters Limited
Yakult UK Limited

SPONSORS OF PAST EXHIBITIONS
The President and Council of the Royal Academy thank sponsors of past exhibitions for their support. Sponsors of major exhibitions during the last ten years have included the following:

Allied Trust Bank
Africa: The Art of a Continent, 1995*
Anglo American Corporation of South Africa
Africa: The Art of a Continent, 1995*
A.T. Kearney
231st Summer Exhibition, 1999
232nd Summer Exhibition, 2000
233rd Summer Exhibition, 2001
The Banque Indosuez Group
Pissarro: The Impressionist and the City, 1993
Barclays
Ingres to Matisse: Masterpieces of French Painting, 2001
BBC Radio One
The Pop Art Show, 1991
BMW (GB) Limited
Georges Rouault: The Early Years, 1903–1920. 1993
David Hockney: A Drawing Retrospective, 1995*
British Airways Plc
Africa: The Art of a Continent, 1995
BT
Hokusai, 1991
Cantor Fitzgerald
From Manet to Gauguin: Masterpieces from Swiss Private Collections, 1995
1900: Art at the Crossroads, 2000
The Capital Group Companies
Drawings from the J Paul Getty Museum, 1993
Chase Fleming Asset Management
The Scottish Colourists 1900–1930. 2000
Chilstone Garden Ornaments
The Palladian Revival: Lord Burlington and His House and Garden at Chiswick, 1995
Christie's
Frederic Leighton 1830–1896. 1996
Sensation: Young British Artists from The Saatchi Collection, 1997
Classic FM
Goya: Truth and Fantasy, The Small Paintings, 1994
The Glory of Venice: Art in the Eighteenth Century, 1994
Corporation of London
Living Bridges, 1996
Country Life
John Soane, Architect: Master of Space and Light, 1999
Credit Suisse First Boston
The Genius of Rome 1592–1623. 2000
The Daily Telegraph
American Art in the 20th Century, 1993
1900: Art at the Crossroads, 2000
De Beers
Africa: The Art of a Continent, 1995
Debenhams Retail plc
Premiums and RA Schools Show, 1999
Premiums and RA Schools Show, 2000
Premiums and RA Schools Show, 2001
Deutsche Morgan Grenfell
Africa: The Art of a Continent, 1995
Diageo plc
230th Summer Exhibition, 1998
The Drue Heinz Trust
The Palladian Revival: Lord Burlington and

His House and Garden at Chiswick, 1995
Denys Lasdun, 1997
Tadao Ando: Master of Minimalism, 1998
The Dupont Company
American Art in the 20th Century, 1993
Elf
Alfred Sisley, 1992
Ernst & Young
Monet in the 20th Century, 1999
eyestorm
Apocalypse: Beauty and Horror in Contemporary Art, 2000
Fidelity Foundation
The Dawn of the Floating World (1650–1765). Early Ukiyo-e Treasures from the Museum of Fine Arts, Boston, 2001
Fondation Elf
Alfred Sisley, 1992
Friends of the Royal Academy
Victorian Fairy Painting, 1997
Game International Limited
Forty Years in Print: The Curwen Studio and Royal Academicians, 2001
The Jacqueline and Michael Gee Charitable Trust
LIFE? or THEATRE? The Work of Charlotte Salomon, 1999
Générale des Eaux Group
Living Bridges, 1996
Glaxo Wellcome plc
The Unknown Modigliani, 1994
Goldman Sachs International
Alberto Giacometti, 1901–1966. 1996
Picasso: Painter and Sculptor in Clay, 1998
The Guardian
The Unknown Modigliani, 1994
Guinness Peat Aviation
Alexander Calder, 1992
Guinness PLC (see Diageo plc)
223rd Summer Exhibition, 1991
224th Summer Exhibition, 1992
225th Summer Exhibition, 1993
226th Summer Exhibition, 1994
227th Summer Exhibition, 1995
228th Summer Exhibition, 1996
229th Summer Exhibition, 1997
Harpers & Queen
Georges Rouault: The Early Years, 1903–1920. 1993
Sandra Blow, 1994
David Hockney: A Drawing Retrospective, 1995*
Roger de Grey, 1996
The Headley Trust
Denys Lasdun, 1997
The Henry Moore Foundation
Alexander Calder, 1992
Africa: The Art of a Continent, 1995
Ibstock Building Products Ltd
John Soane, Architect: Master of Space and Light, 1999
The Independent
The Pop Art Show, 1991
Living Bridges, 1996
Apocalypse: Beauty and Horror in Contemporary Art, 2000
Industrial Bank of Japan, Limited
Hokusai, 1991
International Asset Management
Frank Auerbach, Paintings and Drawings 1954–2001. 2001
Donald and Jeanne Kahn
John Hoyland, 1999
Land Securities PLC
Denys Lasdun, 1997
The Mail on Sunday
Royal Academy Summer Season, 1992
Royal Academy Summer Season, 1993
Marks & Spencer
Royal Academy Schools Premiums, 1994
Royal Academy Schools Final Year Show, 1994*
Martini & Rossi Ltd
The Great Age of British Watercolours, 1750–1880. 1993
Paul Mellon KBE
The Great Age of British Watercolours, 1750–1880. 1993
Mercury Communications
The Pop Art Show, 1991
Merrill Lynch
American Art in the 20th Century, 1993*
Paris: Capital of the Arts 1900–1968. 2002
Midland Bank plc
RA Outreach Programme, 1992–1996
Lessons in Life, 1994
Minorco
Africa: The Art of a Continent, 1995
Natwest Group
Nicolas Poussin 1594–1665. 1995
The Nippon Foundation
Hiroshige: Images of Mist, Rain, Moon and Snow, 1997
Olivetti
Andrea Mantegna, 1992

Peterborough United Football Club
Art Treasures of England: The Regional Collections, 1997
Premiercare (National Westminster Insurance Services)
Roger de Grey, 1996*
RA Exhibition Patrons Group
Chagall: Love and the Stage, 1998
Kandinsky, 1999
Chardin 1699–1779. 2000
Botticelli's Dante: The Drawings for The Divine Comedy, 2001
Redab (UK) Ltd
Wisdom and Compassion: The Sacred Art of Tibet, 1992
Reed Elsevier plc
Van Dyck 1599–1641. 1999
Rembrandt's Women, 2001
Republic National Bank of New York
Sickert: Paintings, 1992
The Royal Bank of Scotland
Braque: The Late Works, 1997*
Premiums, 1997
Premiums, 1998
Premiums, 1999
Royal Academy Schools Final Year Show, 1996
Royal Academy Schools Final Year Show, 1997
Royal Academy Schools Final Year Show, 1998
The Sara Lee Foundation
Odilon Redon: Dreams and Visions, 1995
Sea Containers Ltd
The Glory of Venice: Art in the Eighteenth Century, 1994
Silhouette Eyewear
Wisdom and Compassion: The Sacred Art of Tibet, 1992
Sandra Blow, 1994
Africa: The Art of a Continent, 1995
Société Générale, UK
Gustave Caillebotte: The Unknown Impressionist, 1996*
Société Générale de Belgique
Impressionism to Symbolism: The Belgian Avant-Garde 1880–1900. 1994
Spero Communications
Royal Academy Schools Final Year Show, 1992
Thames Water Plc
Thames Water Habitable Bridge Competition, 1996
The Times
Wisdom and Compassion: The Sacred Art of Tibet, 1992
Drawings from the J Paul Getty Museum, 1993
Goya: Truth and Fantasy, The Small Paintings, 1994
Africa: The Art of a Continent, 1995
Time Out
Sensation: Young British Artists from The Saatchi Collection, 1997
Apocalypse: Beauty and Horror in Contemporary Art, 2000
Tractabel
Impressionism to Symbolism: The Belgian Avant-Garde 1880–1900, 1994
Union Minière
Impressionism to Symbolism: The Belgian Avant-Garde 1880–1900, 1994
Vistech International Ltd
Wisdom and Compassion: The Sacred Art of Tibet, 1992
Yakult UK Ltd
RA Outreach Programme, 1997–2000*
alive: Life Drawings from the Royal Academy of Arts & Yakult Outreach Programme

* Recipients of a Pairing Scheme Award, managed by Arts + Business. Arts + Business is funded by the Arts Council of England and the Department for Culture, Media and Sport.

OTHER SPONSORS
Sponsors of events, publications and other items in the past five years:

Carlisle Group plc
Country Life
Derwent Valley Holdings plc
Fidelity Foundation
Foster and Partners
Goldman Sachs International
Gome International
Rob van Helden
IBJ International plc
John Doyle Construction
Marks & Spencer
Michael Hopkins & Partners
Morgan Stanley Dean Witter
Prada
Radisson Edwardian Hotels
Richard and Ruth Rogers
Strutt & Parker